Looking
to Heaven

My art is largely the result of passion and one must not at once assume that there must be an element of lack of control, of unruliness, of lack of balance, and imperfect judgement, because of my work being produced that way. If I feel passionate about something then I see and understand and can express what I feel. If I do not love and am not happy then I see and understand nothing.

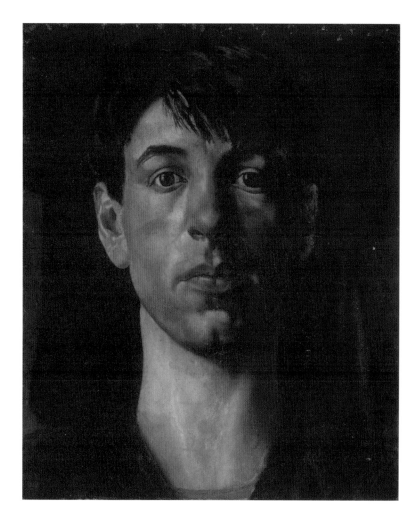

STANLEY SPENCER
Looking to Heaven

UNICORN

First published 2016 by Unicorn Press Ltd

A catalogue record for this book is
available from the British Library

ISBN 978-1-910065-59-4

Editor: John Spencer
Consultant: Carolyn Leder
Project Editor: Johanna Stephenson
Printed in Slovenia for Latitude Press Ltd

Cover and page 3: *Self-Portrait*,
oil on canvas, 1914 (Tate, London)
Page 1: Drawing from a sketchbook, 1907
Right: Stanley Spencer's paint palette

Contents

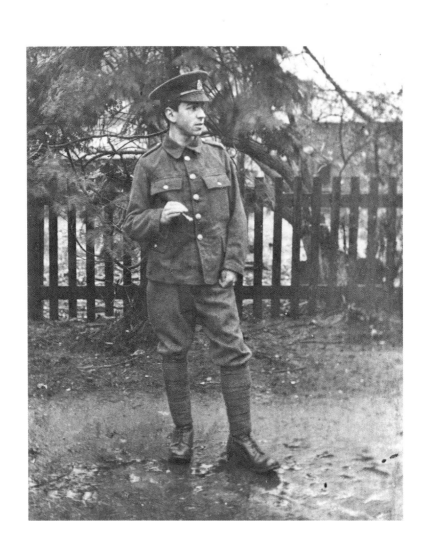

Preface

Stanley Spencer made numerous attempts to write his autobiography. These notes were written in about 1935.

The only thing that tells me that I can write my life in this way is the desire and wish I have to do so. Later I may be able further to express how these views arise.

I like the perfect spacing and timing of a cat's life, suggested by its behaviour, and my wish to include all that my inclination includes and selects is in order to keep to a liked-by-me tempo, which admits of the proper recital of all I wish to say.

About the joins: the reason why do I not necessarily keep consecutively in the purely physical time sense to the relating of my life is because two isolated incidents, happening at opposite ends of my life, or in different places, or in different mental associations may be (as far as being related spiritually in me) so near to each other as to be twins; or they may be dissimilar and their dissimilarity may suggest something in my mind that is very much to do with each, in which case, here again, I wish to mention them together. I dare say I shall by nature be inclined to describe things in this way. Whatever is together in my thought is its most vital togetherness.

And so my life begins where I wish it to and my selection of where is of the same order of circumstance and consequence as what a bird flies to first thing in the morning. I hope I can accomplish that degree of directness and purpose. I wish it to be me, in the sense of including my satisfied desires and wishes. If it means not budging, it does not matter.

I think I could have reached all I wanted without going far from the kitchen door; and I think it would have suited me to be tied to Ma's apron strings. Mostly in the kitchen or the bedroom, or a visit or two in the locality and a talk and cups of tea. I wonder if children ever used to be tied to their mother's apron strings; they might have been, while the mother was shelling peas or washing clothes or sewing, etc. Before the 1914–18 war, when I used to push Ma about in the bath chair, I could look at things with the impersonal eyes of

Opposite:
Stanley on leave in Cookham, 1916

an animal; when returning with the chair empty I felt, oh, superb! I felt as light-hearted and free as the sky and clouds: I felt like a case returned empty. At all times in my life, if and when I was called upon to do any job that I was obliged to do but was not my own work, I was always glad when the work was such as to allow the free wandering of my thoughts. This is why I did not much mind the simple jobs in the hospital at Bristol, such as scrubbing the floors of the dispensary, bathrooms, lavatories, corridors, etc. Every portion of floor scrubbed was because of all I contemplated on as I did it, a kind of work completed.

<p style="text-align:center">* * *</p>

I wish to include anything that I have ever thought, felt or done – have it all – being myself gives me a feeling of need for it. In order to make me in this book I need all the ingredients that I know in myself. I hate to exclude anything. My intention is to first write and include everything as if it was not for publication, then get it read by everyone who may be concerned in it, who will cut out anything they object to. I have an idea that when the deed is done, that anyone who might object and might have good reason to, will as far as possible not do so, for the sake of preserving the character of the work. I don't intend to treat one of the best things in myself with disrespect and I dislike intensely the way that sexual experience is only permitted to appear in order to be ridiculed and jeered at. Either the sexual act is interrupted in the most brutal way or the consequences of it are terrible. The kind of attitude towards sex that I dislike is such as one finds in *The Golden Ass* of Apuleius, or in Swift.[1]

I have always felt a need and a power in me to behave in a way that my normal behaviour never made possible: a great urge for self-expression, a wish to arrive at myself, to be and to behave as I would if I were in heaven. It was simply that most of what was me of which I was conscious in myself was not living in this world at all. I kept feeling sure that this me, which I could see, could be just like that which I saw, in the real day, with someone besides myself. When I think of the parts of my life that I can regard as of any real moment or meaning, I think only of times when I have been working

1 *The Golden Ass* was a collection of tales with recurrent themes of cheating lovers, adultery and sexual violence. Jonathan Swift (1667–1745) included satires on human sexual depravity in his *Gulliver's Travels*.

and the sexual times. But it is necessary to point out that other times and occasions, providing they are an integral part of the sexual or working life, are important also.

Fucking is often a part of some work I am doing, and the experience is incorporated in my doing the work. This is not unusual: it is often regarded as a kind of thing separate – I don't know what form, but separate. There with a woman all my life, taking an occasional walk, I should go out now and then to get a few notes, but all I needed would be within walking distance. I hate being entertained but I love entertaining myself.

I don't think anything can be taken for granted and the way I would describe an experience of feeling would soon show that. I love the ungainly, clumsy or thought to be ridiculous positions and happenings that occur in the bedroom and in bed. Anything that is part of what I am desiring is desirable. The behaviour on these bedroom occasions is more me than anything except my work, and my work is often a desire to express something that has been inspired by the bedroom experience. I think I could live a happy life if I had all the canvas, etc., with me in a bedroom and remained there with the woman all my life, taking an occasional walk.

Editorial Note

Preparing Stanley Spencer's autobiography for publication has been a complex editorial challenge. He wrote prolifically: there are some two million words in the Tate Archive alone, filling many notebooks and diaries, numerous lists, reams of manuscript and typed sheets, and hundreds of letters. His writing is often difficult. Beginning with a thought, he wanders off down many paths and then, just as you hope he will resolve the original thought, he's off again, not always getting back to a now-forgotten idea. And he frequently wrote in pencil on thin paper, or squeezed his thoughts into small spaces when he ran out of space, in the margins or round the little drawings that punctuate his writings. Many hours have been spent transcribing and deciphering his handwriting, comparing, dating and arranging different versions. He made several attempts to write an autobiography himself, changing his mind each time about how to approach this: 'I don't want a tidy book', he declared; 'life is not tidy'.

Stanley wrote at least three introductions to 'My Life', each of them jumping through the decades from the start of his life. As a consequence, it has been said that editing Spencer's autobiography is an almost impossible task. Our approach has been to arrange his writing into three volumes: this, the first volume, covers his early life in Cookham and at art school, the beginnings of his career as a painter and then his life as a medical orderly and on active service in Macedonia during the First World War.

Our starting point has been the Spencer family archive, much of it unseen outside the family since Stanley's death in 1959. In addition to this and the Tate Archive, material has been gathered, for instance, from the archive of the Stanley Spencer Gallery at Cookham, Berkshire Record Office, The Beaufort Archive at The Glenside Hospital Museum and the National Trust relating to the Sandham Memorial Chapel at Burghclere. Our initial aim was to include everything. However, some of Stanley's writings exist in several versions and in these cases we have used the version in the family archive. His many letters to his sister Florence (Flongy), friends Henry Lamb, Jacques and Gwen Raverat and others are an important part of the jigsaw: while some of these overlap and repeat

an idea or thought, no attempt has been made to edit these out, as such repetitions are revealing in themselves.

Punctuation, spelling and grammar have been corrected only where necessary, in the interests of clarity, but Stanley's quirky turn of phrase and word-play have been retained as far as possible. No attempt has been made to bring some of his more uncomfortable observations into line with modern thinking.

Although not a traditional Christian, the Bible was very important to Stanley and he saw parallels between his earthly surroundings and his vision of heaven. This is of course well known in his paintings, but it also shines through in his writings. He had a wide-ranging and eclectic literary knowledge, drawing on a remarkable range of classical, contemporary and children's writers, metaphysical poetry and theological treatises, all of which informed and enriched his view of the world. His writings are peppered with such references (flagged here in footnotes), giving some indication of the workings of his observant, retentive and endlessly creative mind.

Throughout his writing Stanley is self-obsessed and opinionated, but also loyal, dutiful and courageous. Full of energy and always having something to say, he was also interested in people. He was an avid reader, requesting that works by Milton, Shakespeare and Donne be sent to him during active service in the First World War. In his letters from Salonica, it was 'more books please', 'a pencil and paper', 'Giotto or Raphael' – and requests for news of his brothers Sydney or Gilbert, both of whom were also on active service.

Many books have been written about Stanley Spencer over the years. He has been variously presented as a village simpleton, an eccentric, haunted by the erotic, a recluse, an egoist, a victim of circumstance – and also a visionary, a complete original, difficult and challenging, and one of the greatest British artists of the twentieth century. But here his story is told in his own words: our task has only just begun, but we hope that Stanley would approve of our efforts – and that we are doing justice to the project that he began so many years ago.

Cookham

FERNLEA

Stanley Spencer was born at Fernlea, his parents' house in Cookham, Berkshire, on 30 June 1891. He was the eighth of nine surviving children of William Spencer, organist and piano teacher, and his wife, Anna Caroline Slack (Annie).

The story of my childhood is really the story of how I became an artist. And in this way it is important to me. I was not able, as children usually are, to make original drawings of what I saw. I was not looking at or observing anything particularly: it was more it was seeing me and reminding me of the home I was in.

As I am kicking a ball, say, up and down the back passage, the front gate opens and a child goes up to the front door to have his violin lesson. I am aware of the great possibilities of life. The sense of wonder is then. On the event in the afternoon at the back gate, looking up the street and down the street and talking to Eliza Sandall, these occurrences and happenings were the momentous reminders of the life I was living.

There were many of these moments and my wish in recounting them is my hope to show how they bear on my later and grown-up development.

This joy I felt was a Godsend because my abilities were nil.

＊ ＊ ＊

In my brother Will's diary is the statement of babe born, and that a crow came down the dining room chimney into the dining room. Will opened the window and it flew out.

＊ ＊ ＊

I saw once a photo of myself as a child of 2 or 3 and on the ground, in front of the group I am in, there is a piece of white paper. I was informed that I refused to have my photo taken unless and until that piece of paper had been put there.

＊ ＊ ＊

Opposite:
Detail from *Mending Cowls, Cookham*, oil on canvas, 1915 (Tate, London)

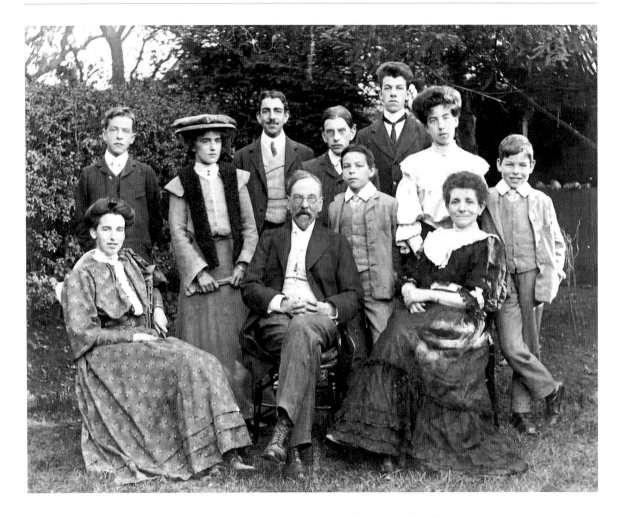

The Spencer family, *c.*1906. From left to right: Florence, Sydney, Natalie (Harold's first wife), Horace, Pa, Harold, Stanley, Percy, Annie, Ma and Gilbert

The following account of Spencer family life was written by Stanley's brother Harold in 1949.

When Stanley was very young, Harold, being ten years older, often acted as temporary nurse. Harold remembers being handed a bottle of milk by Mother and told to feed Stanley. After Mother had left the room, Harold amused himself by trailing the long tube of the feeding bottle around the legs of a chair and watching Stanley crawl after it with his mouth wide open.

Every day Harold had to practise the violin; then Stanley would sit quiet, like a mouse, all the time listening to music, or peering at a children's bible, which had been won by one of the children at Sunday school. There were pictures in it. Stanley would examine them over and over again, every way, even upside down.

Will, who was the eldest, was at this time having piano lessons from Father. Will showed very early signs of abnormal ability in music; he was brought to the notice of Sir Walter Parrott, Royal Organist of the Chapel Royal, Windsor, who in turn introduced him as a boy prodigy to the late Duke of Westminster. The Duke was so impressed with Will's playing that he offered, there and then, to send him to the Royal College of Music at his own expense. This, however, had to be deferred, as Will was too young to enter the College as a student at that time. Later, he became one of the College's most distinguished pupils.

Will took a great interest in the small Stanley and often took him for walks. On these occasions Will would slip a book of poems into his pocket, from which he would read aloud while walking, as Stanley trotted by his side.

When the younger children were naughty, Mother would say: 'Pop-pop', which they knew meant a smack. Sometimes, when Stanley was quite good, Will or Harold would say: 'Stanley, pop-pop'; at this, Stanley, his eyes filling up with tears, would protest indignantly: 'I aren't pop-pop!'

Harold can recall quite plainly how one evening at tea, Father talked about Africa. He mentioned a place known as 'the dismal swamp'. The very sound of the name upset Stanley, who burst into a fit of wailing: in some way the words 'dismal swamp' frightened him. After this, Harold, being the mischievous one, and fond of teasing, found 'the dismal swamp' very useful for keeping Stanley good when he had to mind him. To suit his purpose, Harold was guilty of transferring this terrifying portion of Africa to the bottom of the garden at Cookham.

Sunday was a great day for the children. In the afternoon Father would take them all out for a walk – all nine of them – the children always tried to persuade Father into taking a certain route, in the direction of Cookham Moor. This was in the hope of meeting Mr Lambert, who lived there. He often took a walk on Sunday afternoon. After greeting Father with 'Hello, Spencer. I see you're out, as usual, with the tribes of Israel', he would dip his hand into his capacious pocket and distribute small silver coins to the whole tribe.

Nine children sat around the table at teatime. Mother sat in Father's place then, at the head of the table. It was usual for the children to have three slices of bread and butter each on their plates.

In the centre of the table was a large plate, piled high with slices, from which everyone who still felt hungry could help themselves. If by an oversight there were two instead of three slices on Stanley's plate, he would stubbornly refuse to begin his meal until he had the usual three. No amount of coaxing or scolding would induce him to commence; instead, he would hold his cup full of tea at a perilous angle over the tablecloth, Mother leaning forward from her place at the top of the table, her hand poised over Stanley's, ready to smack him should any of the tea get spilt. Greatly daring, Stanley would jerk his hand the tiniest bit until a little of the tea made brown spots on the tablecloth. Down would come Mother's hand in earnest – and there would be another tablecloth to wash.

About this time, another regular walk with Father was along the towpath, facing the Buckinghamshire bank of the River Thames. At intervals along the towpath were heavy swing gates. Stanley would not at that time pass through any of these gates with the other children: Father must, he insisted, walk through first, close the gate after him, and then come back again to where Stanley stood looking on and fetch him. The other children would look back at the lonely little figure waiting for Father to do this.

Father wanted all the children to be musicians. Already, at this time, the three eldest showed pronounced musical dispositions. Will played the piano, Annie the viola and Harold the violin. Father insisted on rigorous practice. The boys were threatened with 'an office stool' if they failed to do the required amount, but it was to Percy that this dull lot was eventually to fall, as he was not considered talented enough in the art of music to merit any special training. Percy was the practical one. He was the down-to-earth member of the family who was, even when quite young, relied upon to do those useful, everyday things that are so necessary. Will, brilliant artist as he was, was quite hopeless in all practical matters and his indifference to all worldly things often brought despairing protests from Father. Then Will would quote from the Bible and the matter would drop.

Annie, who came after him, used to get into a frenzy of annoyance with Will when they played games together. She could not understand his somewhat involved explanation of any particular game. Will would go on patiently trying to make himself clear, but after a time she would burst out with: 'I don't know what you mean!'

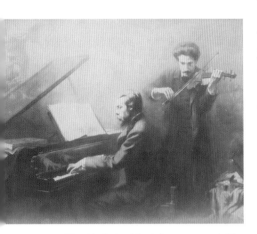

Harold playing his violin, accompanied by his father

This was a signal for her to sweep away the toy soldiers or bricks which Will had arranged with meticulous care. Will would give a despairing cry at this, which would bring Mother into the room. Mother often had to leave her work in order to settle disputes that went on in the dining room where the children played.

Annie, as she grew older, became deputy mother to the younger ones, even to Harold, who, although he was next in age to Annie, had been delicate and did not learn to walk until he was four. Beautiful days were spent out of doors with Annie, roaming the country lanes around Cookham. The most loved of all was Mill Lane, which was surrounded by fields filled with wild flowers. The children would sit on the high stile that separated the fields from the roadway until Annie would shepherd them all back to the house.

The house stood in the middle of the village street. It was exactly like the house next door, where Uncle Julius lived. The children loved Uncle Julius: he played rounders with them and was a very jolly companion to go out with. Uncle Julius said that Father was too morbid a companion for the children, as he had once chanced upon Will and Harold sitting on a tombstone in Cookham churchyard while father read aloud a dismal and depressing poem to the two little boys.

Cookham High Street in 1900

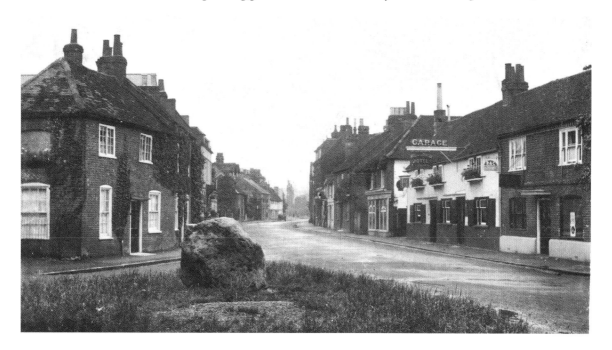

Anna Caroline Spencer (Ma)

In the evenings the elder children would sit and listen for a tap on the wall from the house next door. Then they would rush into Uncle Julius's house, where Aunt Jenny would allow them to play games like draughts and Ludo with her children.

After Harold in age came Florence, the only other daughter in the family. Harold felt a certain jealousy towards his younger sister. Mother had petted Harold quite a lot because he was delicate. When he grew stronger and could walk about and was learning the violin and having school work with Father in the schoolroom at the end of the garden, Mother often used to make a fuss of Florence, quite unaware of how jealous Harold was. But Florence grew up into a studious, somewhat aloof little girl, who went to school in Maidenhead and made her own friends.

At home, Florence's boon companion was Percy, next to her in age. Percy was left by the rest to find his own feet and by dint of courage and strength of character not only found them, but kept then firmly planted. Harold remembers when he and his cousin Helena teased the younger Percy mercilessly, to an extent that, Percy decided, warranted revenge. Fetching from the kitchen a broom with long, hard bristles, he proceeded to scrub first Helena's face and then Harold's with the business end of it. Harold told tales to Mother and Percy got punished!

When the children were sent to bed, they often stood gazing out of the bedroom window before undressing. They liked looking at the chimney cowls with the light shining on them. It was always exciting to look at the neighbouring roofs from their place at the window, just as it was exciting to view things upside down when lying on the hearthrug, which made things look different.

A very special treat, in the summer, was to be allowed to sit up late on Saturday nights. Then Father would take the children to a brick arch which spanned a single-line railway at the end of Lovers' Lane. They would hurry to be in time to say 'goodnight' to the engine driver, and the children would listen eagerly to hear him shout back. Sometimes, if the train was nearing the arch while Father and the children were still some way off, they would race down the lane and it was thrilling when they were only just in time.

Another summer night's outing that was much loved by the children was a night walk to Maidenhead Thicket to listen to the

nightingales, Father holding Stanley and Gilbert by the hand because they were the youngest. Harold remembers the soft summer night air, filled with the honeysuckle smell, and how still they all kept until, out of the deep quiet, came the song of the nightingale. All the children, even the very small ones, were very still while the nightingales sang.

Another pastime was hunting for bullets in soft ground around the Army rifle range on Cockmarsh. These the boys afterwards disposed of to an old rag-and-bone merchant at the back door. The few pence he gave them for these strange articles was spent in the village at Miss Johnston's, who sold sweets.

A great favourite among sweets was 'Yanky-panky', which came in different-coloured layers. Miss Johnston also sold papers, and weekly pennies were spent on the *Children's Companion*, each fresh number eagerly looked forward to by all the children.

In spite of having nine children and Father to look after, Mother found time to read the books that were published in those days. When a passage from any of these books struck her as more than usually good, she would copy it in her own handwriting. She made hundreds of entries in her notebooks. Mother had a pleasant mezzo-soprano voice and sang the ballads popular at the time. The boys took it in turn to play for her, but as he grew older it was Sydney who most often accompanied her.

Father's interest was poetry. He would buy what were then known as the 'Penny Poets', and after a hard day's work teaching at school, giving music lessons and taking choir practice he would read, sometimes aloud, from these little books. Every night Uncle Julius would bring the *Westminster Gazette*, which he read in the train coming down from London and then passed on to Father. Another of Father's pastimes was a game of cribbage. He would get different members of the family to play with him. To entertain each other, the boys often used to cheat. Then father, with an exclamation of disgust, would stop playing and take his very odd supper: a glass of milk with two ginger nuts and a lump of sugar. And then it would be bedtime.

One day the family were all seated at table for midday dinner – all except Stanley and Gilbert. In answer to Mother's questions as to their whereabouts, no one had seen them. After a few minutes, two very small figures with very white faces passed by the dining room window and disappeared into the wash-house at the back.

William Spencer (Da)

Annie went out of the room to fetch them. She came back without them and told Mother that they would take no dinner that day as they were very sick. They had been smoking a plant known as 'old man's beard'.

After Percy came Horace, the most adventurous of all the Spencers. Horace dominated Sydney who, like Will, was gentle and sensitive. A favourite game of Horace's was playing 'coaches': he would pile up chairs, boxes and anything he could lay his hands on. He would then climb on top of all this and pretend to drive a pair of magnificent horses, while Sydney would sit quietly in one of the boxes on the floor as the passenger. Sometimes Sydney would gently suggest that he might be the driver, but Horace never permitted this as inactivity as the passenger did not appeal to him.

Father liked gypsies and would watch them and talk to them, fascinated by their simple, carefree life. Horace inherited this liking for gypsies, and one time left home and stayed with them: like them, all through his life he was a rover. He was also a born leader, and found no difficulty in capturing the imagination and often the hearts of the many different kinds and races of people he encountered in later life.

About this time a boy of 14 years of age appeared at the Queen's Hall.[2] He played Beethoven's *Emperor* concerto: the audience went mad with delight and recalled him again and again. Finally he was carried, shoulder-high, from the platform. Here indeed was a genuine boy prodigy. The boy was Willie Spencer. No amount of praise or applause could cause Will to be anything but modest about his art: his naturally retiring nature and quiet sense of humour prevented him from any sort of showmanship. He did, however, allow himself a joke on one occasion, when he had a Collard & Collard full grand piano delivered to the house at Cookham, without telling his parents a word beforehand. He had won this piano at the Royal College, in open competition, for the best pianoforte playing for that particular year.

Harold had also started to play the piano at a very early age, but Father said that Harold must change to the violin, as he could hardly be expected to have outstanding talent for that instrument that would in any way compare with Will's astonishing gifts. As the boys grew older they played together at local concerts. Rehearsals for these concerts often ended in disputes, which really

2 London's premier concert hall, opened in Langham Place in 1893, the original home of 'The Proms'. It was destroyed by an incendiary bomb during the Blitz in 1941.

only amounted to good-humoured banter. There was no doubt that Will was the more gifted of the two. But Harold, being more aggressive, frequently dominated Will, who followed Harold's lead and interpretation of the classical works they performed. In these early days Will submitted to the stronger-willed Harold, and in the beginning it was to Will's advantage to do so. Later, his intellectual superiority and cultured artistry placed him well before Harold in the world of music.

Christmas at Cookham. Lovely Christmas, looked forward to for weeks. Harold could remember the plays the children did in the schoolroom, the party next door at Uncle Julius and Aunt Jenny's. How they played games and pulled crackers, the paper and tinsel all over the floor; how when they were tired they sat round the room and Uncle Julius sang; how Annie watched the small ones in case they ate too much; and Annie's distress when she was asked to play the viola and found that her bow was missing. Harold lent her his bow and told her she must keep it. Annie was very grateful to Harold and thanked him warmly. How was she to know that it was her own missing bow that Harold had given her, which he had borrowed without permission?

Christmas over and back to school, Father taught the whole family, boys and girls together, with certain other children who lived in the village whose parents wished them to have more or less private tuition. It was dull, hard going to wade through Murat and translate into English, but Father, as schoolmaster, insisted on it. The boys, growing inattentive, would wile away some of the time by tying the girls' plaits to the chairs. This was enough to start a war of the sexes as soon as school was out.

Sitting on the wall at the bottom of the garden, it was easy to look over onto the garden plots that belonged to Uncle Julius's tenants, and chat with them. The tenants' names were Turner, Plumridge and Sandall. Sandall's daughter came in and cleaned the house for Mother. There were also maidservants in the house: Harold could remember Lizzie Nash and Emily Potter. Each in turn seemed part of the family.

Harold had very little recollection of Gilbert, the youngest of all, except that when he was born Harold was allowed to go into Mother's room and look at the new little brother. He laughed at

Gil's cherub face, the more so because his ears were odd: one looked different from the other.

He had a much more vivid recollection of Sydney, nicknamed 'Bori'. This name came about when Sydney, on seeing the northern lights, the aurora borealis, in his excitement at the marvellous sight, cried, 'oh, look at the Auri Bori Ballis!'

All the children got the craze for cycling at the same time. Harold, foregoing sweets and the children's paper, started the hard and lengthy process of saving his weekly penny to buy a bicycle. When he had saved a respectable amount of pennies, Father rewarded him by buying him the longed-for bicycle and Harold went riding all round the countryside. Later, Sydney had a bicycle which Horace borrowed more and more frequently. After a while, Sydney's good-natured unselfishness broke down and he would wander round the house muttering to himself, 'Ever-ry-day'. Then the family knew that Horace had ridden off on Sydney's bicycle again, and that Sydney would have to walk if he wanted to go out. Sydney never lost his gentle, unselfish nature: when he grew up a bit he was the pet and darling of all the elderly maiden ladies in and around Cookham.

Cycling never, at any time, ousted the joy of having a boat out on the river. The proprietor of the Ferry Hotel lent the Spencer family a rowing boat every season. There was a boathouse attached to the hotel and this was a great source of interest to the boys. Harold would later look back and recall the dimness of the boathouse after the hot glare of the sunshine outside, and in his mind's eye see the many pairs of oars placed against wall and the upturned boats and the piles of coloured cushions stacked high in the far corner. Great days were spent fishing, the boat moored in a backwater of the Thames. Tea was packed in a basket and taken along in the boat: one of the elder children would boil the kettle on the bank and wash the cups in the river when a picnic meal was over. At intervals the boat was rocked by the horse-drawn barges that plodded up and down the river. Once, when the bargee had his back turned, he failed to see the little rowing boat bobbing alongside the bank, and it was only by vigorous shouting that Father and the boys were able to attract the man's attention – otherwise the little craft would have been crushed against the bank, where it would have capsized and its occupants thrown into

the water and drawn underneath the barge. Everyone felt that they had had a lucky escape.

Percy, who was one of the taller members of the family, started to take the still very tiny Stanley for walks. The walks were long and the pace fairly smart. Stanley, in spite of his so much shorter legs, strode manfully beside his taller brother, dogged and determined to finish the walk. But Percy made those walks longer and longer and set the pace at such high speed that Stanley was almost running. And then, one day, Stanley was beaten. He lay down by the wayside and watched Percy stride off in the direction of home, unrepentant and alone.

Will was taken to hear the organ at Hedsor, where Father was organist, even when he was a very small boy. He had a habit which caused endless merriment to the rest of the family: he would, when deep in thought or conversation at table, point to different articles, such as salt or mustard, and everyone handed him what he pointed at until he had collected everything round his plate. Everyone laughed at his bewildered expression when he realised what a clutter of spoons, forks and dishes he had collected. Will never seemed interested in food as a rule but he had a great fondness for plum cake.

Because Stanley walked slowly when he was out by himself, people in the village used to laugh at him. One day, Stanley was walking very slowly, when he met Mrs Pullen from the village. Seeing how slowly Stanley walked, she called out to him, 'Hurry up, Stanley, you'll be the last up when the trumpet sounds at the Resurrection!'

In time Stanley and Gilbert entered Maidenhead School of Art. Two of their fellow pupils were Hatty Fish, who afterwards became well known for her very original drawing in 'Eve', and Gladys Peto, whose charming work became familiar as advertisements all over the British Isles.

Some of Stanley's pen-and-ink drawings were shown at the art school exhibition. The local people viewed them with amazement and a little misgiving. His art master was anxious that Stanley should conform to more conventional methods, and it was this that caused the first rumblings of rebellion that continued throughout his training.

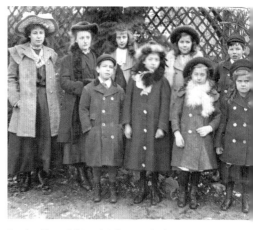

Stanley (front left) and Gilbert with the Bailey girls, neighbours from Cookham, *c*.1900 (photographed by William Bailey)

* * *

In 1945 Stanley made another of his attempts to begin writing his autobiography. The following passages were copied out by Hilda, whom he had married in 1925.

I see down on the left and below the little bedroom window the kitchen window, and next the scullery door and window, from which rises the steam from Ma's doing of the Monday washing. The steam rises above the privet hedge and woody nightshade surrounding the outdoor lavatory and above this the big yew tree, the cherry and the far bigger walnut tree that seems like a neighbouring planet, a Jupiter come very near, and which rises from the narrow walled-in garden high up to the light of the Cookham day.

Its topmost crests of leaves could hardly know where the trunk and roots lived, whether in our garden or in neighbouring gardens. It lived a polyamorous life. One system cast a pleasing shade over some high-class girl cousins who kept a trap and lived next door; they had more money than we had and flowers in the flower beds, etc. Its central part, mostly branches, made a high arching hood over the bare earth at the bottom of our garden, in the other corner of which its trunk unobtrusively stood. To the right of us its under-branches could be heard when we were in school, slithering and bumping about on the corrugated roofing. The school was situated in Mrs Sandall's garden.

Beyond this the tree descended into gardens belonging to working people, farm labourers, etc. And the walnuts themselves that rattled down the corrugated roof on that side seemed soon to take on the character of those sort of people. As to the far side, away from us like a high mountain, it fell away to a strange and inhuman country.

In order to trace what was happening on that side, one would have to go back up the garden and out into the street and down it, past a few houses and the King's Arms Hotel to where the Fly proprietor had his carriages and horses.[3] There, standing and leaning about in the carriage entrance, one would see the ostlers desultorily cracking walnuts in the palm of their hands, a thing we could not have done if we had tried and would not have dreamt of

3 The Cookham Fly was a transport hire service, the county equivalent of the city hansom cab. Founded in the 1850s, when the Great Western Railway opened between Maidenhead, High Wycombe and London, to transport commuters home from the station, it continued until the mid-1950s.

doing on our side of the walnut tree world. And yet here the walnuts seemed to fall in with the way the men handled them, the way they took them from their pockets, looking at something in the village as they did so, the walnuts seeming to enjoy the easy de-husking and pleasing crack in the palm and becoming one with the somewhat bumptious, nonchalant way of the ostler. No shame at all. Were they the same as the dining-room ones that my father would now and then take from his pocket and put on the sideboard with one hand, looking at them thoughtfully as he did so?

The rooks inhabited or visited the topmost branches and leaves of the tree, as also did an occasional kitchen chair leg. Like myself in my visits, it would only go for a moment but stay for a year and one would see it swaying among the bare twigs in the winter. The rooks had walnuts in their open beaks and such walnuts had another destiny.

On our winter walks we would go to Cockmarsh, a great plain two miles or more from our tree or, as far as one could see, from any walnut tree or tree at all, and there, lying about would be the shells. The rooks I think take them there, as in such a place they could eat in peace as they could see about them for a considerable distance whether any other rook or person was near enough to snatch the thing from them.

From the same window, to the right of the walnut tree were the malthouses, which seemed to be always looking at something or looking somewhere; when they veered round towards us they seemed to be looking up and looking at something above our nursery window, and when turned away to be looking somewhat down. The earth by the base of these very big malthouse buildings was never visited by us, so they were a presence in the maze of Cookham. From wherever seen, they were somehow benign. As a child I should have liked to be where some huge Buddha had been put up. To go to some corner of the village and find God sitting there must be a wonderful thing for a child to experience. The malthouses with their white wooden hoods served very well as reminders of religious presence. A fortnight ago I saw some in Kent, they were just by a football match going on, with the dark border of spectators.

These Cookham buildings must have been about 50 feet high and the wooden hoods about 15 feet high. I did not know or think

that there was anything special about what I could see from this window: they were the facts of my life and were joined in with the daily happenings. In fact, I was rather wishful to be able to see further round to the right and to what Belmont next door (we were Fernlea) could see. But I never saw and to this day I wonder. From what I have said, it does seem that the view from our own window was good. If that was so, what I want to show is that had it been a plain brick wall and I had been the same person I was, that then somehow the wall would have joined the view. For everything is a stepping stone to vision. One sees the possibility of a realisation of meaning and wonder and everything then becomes a means to that end; one feels this possibility as indwelling thought, whether there is any manifestation of it or not. All I know is that I will know what to do the moment the occasion arises.

At the Slade there was a sketch class and periodically a subject was set: that is, all students were to do a picture on a given subject. Before I knew what the subject might be, before I was at the Slade, when I was going to the local technical Institute at Maidenhead, and before that, I knew what I wanted, it filled me with this great joy even though it was not clear. I only knew that whatever the subject, it would be the instrument I needed to reach to where I wished to get to. Neither did this mean any disregard of the subject. For instance, the subject 'apple gatherers' was set, and we students all did our version. That subject lent itself, as one might say, to this Cookham locality. Again out of the nursery window, in the odd-shaped enclosure formed by the malthouses and the garden wall, all of which was darkened by shadow, could be seen many apple trees. At a certain time of year, tops of ladders would appear here and there. Then there was Jack Hatch[4] in his orchard, and the sacks. But strange to say, I had got my eyes so fixed on the goal already that I don't remember thinking consciously or in particular of apple gatherers. The subject had a twofold job: it had got to be apple gatherers and it had got to take me to where I wanted to go. If you take a horse that can pull like I have seen Clydesdale horses do, that is one thing, and possibly the old coaching horses looked able to do the distances they did. But this subject had to be a Tang horse: I understand that they were placed on graves to carry the departed souls to heaven.[5] When one considers the vast journey to

4 Son of the coal merchant.

5 Glazed ceramic horses of the Chinese Tang dynasty (AD 618–907) were often made as funerary objects.

be traversed and its nature, its mysterious tracks, and what realm it is finally to inhabit, I can see why they are as they are: they seem already a part of heaven.

What course did my apple gatherers take? It's a long time now since I took that trip or anything like it and I can only give a sort of parable parallel of it. I was filled with a sense of longing, of longing to be united with some wonder that was going on full strength around me. I longed to join in, to declare and make known, 'revive thyself in the midst of the years'. It was as if everyone was in Heaven and somehow did not seem to be aware of the fact. Everything wonderful was tantalisingly there, there for all to have. I was looking for some equivalent or some part of the meaning to me. The church had done itself alright and the fields and cows and hedges, etc., all seem to be saying 'What about you?' to me.

The point I wish to make about the nursery window view is that I don't want anyone to say: 'Ah, yes, I knew there must have been something with a view like that from the nursery window, beautiful view, no wonder he is such a good artist, ought to have done better really, with a view like that and such conducive circumstances.'

Alright then, taken inside the nursery, three iron beds one big and two small. Four of us in the bedroom, board floor, through the cracks of which, when big enough, one could see the mice. The spring had gone at the foot of the big bed and one night our conjurer brother (Horace) said to Gilbert and me that by going under the bedclothes he had the magical powers of going over to the malthouses and that they would give him some wonderful things that he would bring us. Away he went under the bedclothes and soon appeared with some odd rubbish that he had got out of a trunk under the bed, by putting his arm through the broken springs. This was to us wonderful and the articles came in for appreciation that they had never known in their non-rubbish days.

I give this picture of the inside of the nursery in much the same way as I did the view from its window, in a somewhat conventional way: beautiful (but would have to call the inside of the nursery squalid – call in the sanitary inspector!). Four and sometimes five slept in the same room. It was better, in fact, when it was five because the fifth was at the same school as the fourth; we younger three would be regaled with their school talk when they came to bed later.

This state of happiness or hopeful expectancy causes me to see everything in its final, redeemed and perfect state, the state in which it actually is all the time.

* * *

In the games I played in Fernlea garden, the gap against the walnut tree trunk was 'home'. Before that time, holding Pa's hand was home, and from that vantage point I could survey the world, secure and happy in all I saw.

When I was young, a very kind builder who lived near used to give me and my younger brother his out of date wallpaper books. We weren't very big, but the wallpaper books were. We used to take the books up into the nursery, put them on the floor and then we would both squat down – we didn't have to go down very far – next to each other. I would sit at the end where you lifted the lid of the book up to open and my brother Gilbert would sit in the place where you let the lid down.

It was a big undertaking: I would lift the lid up until it had described a quarter circle, making a murmuring noise at what the opened lid revealed, such as children do when they see a very nice rocket. I would hand the lid over to my brother, who still remained in darkness and ignorance, and as he let the lid gently down and the beauteous page slowly dawned upon his youthful intelligence, his murmur would join mine, so that we would both be in perfect concert as the lid completed the half hemisphere. We were so generous with our appreciation that often by the time we arrived at the drawing-room wallpaper we found, to our consternation, that we had completely run out of our store of appreciation, and so had to pass on through all the magnificence of shiny hall paper, drawing room, ceiling, cardboard pages with dimples… All these had to be looked at in silent approval. We especially loved attic wallpaper; it was the dining-room stuff that we found tedious. 'Only that much more, look, Gil', I would say to my brother, bending up the amount of pages to show him the thickness. After fairly galloping through the red glories of the drawing-room paper we, even in those days, felt we could breathe a little more freely when we got to the smooth, shiny kitchen papers like imitation wood, and still more freely when we came to the nice, wholesome enamel papers of the butcher's or dairyman's shop.

<center>❊ ❊ ❊</center>

My father used to be worried that we were so often cooped up in a nursery but I preferred being up in the nursery to going for a walk. In that nursery there was all that wonderful world under the bed, and the cracks in the floor. They were ordinary board floors and the cracks between the boards had got rather wide, so that you could really see down through the cracks between them. One of the little games we used to play: Father used to give us cardboard boxes to cut out, to make little sort of farms, and then we got sprigs of yew from the garden. We stuck these little yew-tree sprigs into the cracks and made little plantations, rather like an orchard, and cardboard ladders up into them, and little figures going up into the trees looked very good with their legs missing from among them, and chest of drawers handles seen showing among the branches, and our sister Annie towering above, practising her viola with the music on the mantelpiece.

But down at the bottom of the garden, Annie would be 'Miss Spencer', because down there was our little school, a corrugated schoolroom; that was the seat of education for me. In the school there were round tables, I think two, an ordinary, egg-shaped sort of cast-iron stove. I remember its shape very well: I think that shape has influenced my life a good deal. And there was a fender round it.

The school, properly speaking, was in what we called Eliza's garden – that was next door. It was a lovely spot really. There was the school and then the bottom of our garden at the side of it. And there was a fairly high wall that separated our garden from Eliza's garden. In our garden there was a fairish number of trees. There was a lovely yew tree, the kind of yew tree that branches out from the base and goes out, making a most lovely shape – a sort of great triangular shape. Behind that you could see the walnut tree going up, soaring away forever like a huge great sort of planet Jupiter.

I was happy because everything had for me such a wonderful meaning, and in childhood, probably the only reason why I didn't either put anything down or attempt to do so, was that like a child I took everything for granted. This wonderful kind of heaven that I was in was a permanent thing. It so happened that I was born in Cookham. And it's rather lucky that it's got these commons round

Fairy Goblins emerging from High Corn,
pen and ink on paper, 1906

it: there's Odney Common, Widbrook Common and Cockmarsh. They're all quite different in their character, and this was observed and felt by everybody, and by myself as a child among them. And I think that there was a feeling in me that I wanted in some way to join in this kind of wonder that was going on everywhere.

❊ ❊ ❊

When my eldest brother, Will, played the piano a kind of human blossoming and flowering occurred in our garden. From the nursery window (which was just above the room in which he was playing) we could see village people appearing among the privet and the Wooster girls[6] would sit on the wall. This was all done silently.

From this window I used to blow bubbles of all sorts of sizes and kinds. I can hardly think of any lovelier game. Some were tennis ball size, some were teams of little ones, careering off suddenly, bolting round the corner and possibly darting back into view and away until, being small and uncoloured, they become too much of the grey of the sky to see… The bubble is gone, yet its presence still is there; it has ceased to be, just there become a spirit. Gone to God and left a drop of soapy water on the grass. I would blow a large one holding the pipe upside down and blow, blow, blowing it so that the wind whirled inside it… It would wobble and tremble and go all shapes and even wrinkles in the breeze, and glide into the honeysuckle hedge at the corner of the coal cellar and break at the first twig. But the size I was partial to was one about the size of a football. It was good the way they bounced about, going squash-shaped or sometimes caught underneath, losing all dignity and going quite absurd-shaped and remaining so for a few moments, and then recovering and being normal and round again. Then it would make a good getaway. And nothing being in its path, it would go grandly off. It was going up and nothing could prevent it from reaching its complete lifespan. Being big, I could still hold it in view when it seemed above the walnut tree. It just went on to its union with space.

Then I liked to put the pipe down into the basin and blow into the soapy water and froth it, which made a mass of hexagonal round-topped bubbles, heaping up and up, and the pipe could move about, right down in that intricate transparent world of every shape, without

6 Neighbours Dot and Emily Wooster, daughters of the local butcher, were classmates of Stanley's.

breaking any one shape. The pipe end could go in and out of these little rooms without opening the doors or breaking anything. Marvellous.

The bubbles, together with the wind and air, had a different kind of selectiveness than I with my ability or a bird with its flying capacity will have, and because of this I can mentally become a bubble and I get into those places in the garden and in the garden's air. Or changing the world into various rooms of the spiral bubbles, I can pass into all these places without interrupting or disturbing anything. I can be here and there and not bust, but pass slowly in among the branches and foliage of the tree.

* * *

Until I was eleven my hair was long and straight, and in the effort to give it some curl it was tied up every night in rag curlers: little bits of rag of any sort. I can remember pushing them on one side in order to avoid lying on top of them. They remain in my mind as a symbol of that happy time.

* * *

Note:
Hair cut at Bourne End. Felt I had 'lost caste', especially with it being done at Bourne End. Refused conscientiously to be confirmed. Went to Cookham church and Wesleyan chapel, but not Sunday school.

* * *

My father was I think choir master and maybe sometime organist at St Jude's, Whitechapel, where Canon Barnett was. I believe Canon B. was quite fond of my father. One Sunday at lunch there, an educationalist was discussing with Canon B. the question of what one does on Sunday and he turned to my father and said, 'And what do they do at Cookham Mr Spencer?' and my father said: 'The publicans and sinners go upon the river and the philistines walk along the bank.'

* * *

Three Goblins, pencil, pen and ink
on paper, *c*.1906

I used to go to the Wesleyan Chapel at Cookham in the evenings. I loved the gentle atmosphere that belongs to or is characteristic of the poor slummy people who came chiefly from Cookham Rise to it. When I see Mr Francis, the baker, and think of the years and years I sat and listened to his sermons, which, if a little insipid sometimes, were gentle and homely, I am filled with the atmosphere I remember as a child. I could not bear (and did not stay for) 'prayer meetings' and there always was something I would, at times, avoid about them (I mean that 'Revivalist' element, which was depressing). But they were homely and I felt it was a comfortable surrounding for me to be and feel productive in. Strangely enough, it was far more real than any society where the critical element and atmosphere is characteristic.

In a blind sort of way, being 'entirely sanctified' was a way of expressing something they felt in themselves, and when they felt themselves to be so they would (only I kept my eyes down and felt I dare not look) go and flop down somehow, God knows how, just under the auditorium.[7] My eyes were well down and I was trying to imagine what shape they were in, on that sacred piece of ground that 'counted' for 'coming to the Lord', just that patch of hard linoleum floor. It was only a small patch, room enough for one man only, and when I heard someone pass up by my pew and get down there, I felt it was a sort of spiritual apotheosis of a grocer, or whatever he was, taking place. It seemed to be the 'take off place' for their Methodist heaven. When I tried to imagine what it was like, he seemed, in my mind, to be Mr So and So, the grocer or confectioner. Yet he was more intensely and passionately that, so that his black frock coat was making shapes that only heaven or entire sanctification could cause, and his watch chain and all his Sunday attire would be a wonderful thing to behold, and so comforting and reassuring to the spiritual needs one feels. I did not imagine him kneeling facing the auditorium, but just flopping and crumpling up in a wonderful ecstasy expressive of all that Wesleyan conception of goodness, etc. He would be, I hoped (to quote a favourite New Testament phrase of theirs), be 'received into everlasting habitations'.

* * *

7 The auditorium was a raised wooden
railed-in stage.

When I was at school I obviously wanted more to be thought clever and remarkable, than to be so, for the pleasures that such capacities and peculiarities might bring. I do not think unkindly about myself in this; but I should like to warn any who, like me, suffered from too great a fondness for vainglorious praise, that the results of this may not seem apparent or serious, but they are so, for it simply meant this that I might at times be doing things quite unintelligently, like reading a book and not understanding a word of it for the sake of being able to say that I had read it. Carlyle's *French Revolution* is my blackest mark in this respect:[8] not only did I destroy what little sense I had by utterly brainlessly reading three quarters of the silly, affected book, but I never finished it, thus depriving myself of the award of being thought I was something I wasn't. It's always rather fun to be thought something you know thank goodness you aren't. I remember feeling a little pleased when one day an old woman in the village, seeing Hilda[9] and me going out in the car, told someone who was wanting to see me that we had 'both gone to Ascot' (the races being on).

To be thought what I wasn't arose from enviousness in school finding everybody able to do things and me not, and herein may be seen how the cultivating of a child's mind to think about what is usually taught must be mastered if one is to have any credit for being any good at all, would certainly tend to blur the vision that a child might have of what he or she meant to do, and certainly tend to undermine, by the continually crushing fact of being unable to do the usual subjects; what little confidence the child had got, the continual crushing atmosphere would, at least in weak cases such as myself, make me wish to be thought good at what one was not good at, and leap at a consolation prize every five minutes to be reminded that you have forgotten this and forgotten that, and each time you are reminded it is as much a shock as when you are reminded that you left something valuable belonging to someone else in a train.

To walk up with one's lessons feeling in a happy mood because one feels certain one has got them right; and then the dreadful shock and utter surprise and the disapproving look and 'wrong, wrong, wrong', and great black lines scored through it all.

I would go back to my seat feeling that my heart would break. I did not envy pupils for their learning but for being able to live in the

Dictation and spelling corrections from one of Stanley's school exercise books

8 *The French Revolution: A History* by Thomas Carlyle (1795–1881) was published in 1837.

9 Stanley met Hilda Carline in 1919 and they married on 23 February 1925 at Wangford parish church.

There was an old Woman

Pages from a sketchbook, 1907

10 Francis Carruthers Gould (1844–1925) was a political cartoonist whose caricatures of Joseph Chamberlain invariably showed him with a prominent, pointed nose.

unharassing atmosphere of always being right and of never leaving anything in a train.

How could I enjoy anything if I had not done my lessons properly?

There were several bad results from this. For instance, when my inclination for art began I thought, 'Oh well, if I am good at art, it won't matter so much about being bad at everything else'. I remember hoping that mathematics would not be needed, and a few other unmasterable subjects. The fact that in school one is forced to do things and therefore one develops the habit of doing things unintelligently, i.e. without knowing why one is doing them, is responsible for much aimlessness and lack of purpose and direction later on in life. The purpose of all learning should be solely in order to enable one to experience all one wishes, to experience the completeness and fullness of one's powers in order that their joy may be full as it is the natural bent of our natures to grow to the fullness of our spiritual stature.

But education is usually a hectic rush to make a person capable of earning his living when the time comes for him to do so. And so as I say, to draw anything for which I could get credit was such a relief that I got into a habit of doing things partly for pleasure but partly for hope of praise and credit also; and as I say, my very earliest essays at anything at all were for praise and credit primarily, and if one could combine a little pleasure with the getting of praise and credit, well and good. Had I not had this ready-to-praise audience round me at this time when I felt so crushed, I might never have survived to a sufficient extent to enable me to recover any purposefulness in life at all. As it was, it did cheer me up no end; I felt that I should be able to live a happy life after all, and a great deal of the happy temperament which I think I possess was greatly developed just at that time.

What I drew then was bad and silly and done unconsciously, for reasons stated. I did such things as continually copy Chamberlain's nose from F.C. Gould's cartoons and I tried to do illustrations to fairy tales, and young people do get a great thrill of pride when they wake up one morning and find that they can draw a knee or hand so that it looks like one – or am I the only one that did? The pleasure of feeling able after years of being unable! It was no wonder I glutted myself on what I was able to do and avoided what I did not feel so sure about. But this only doing the things which would give me

pleasure, and the consequent happy frame of mind I got into acted as an agent to bring me back to my true course. It seems to me an extraordinary thing, but apparently I possessed as commonplace a little mind as anyone could wish. Listen if you can bear it to what I liked: Arthur Rackham, Heath Robinson – but I did and could see that Dickie Doyle was better. There were no art books in our house at all except a big red heavy volume of the Royal Academy for one of the years, full of Val Prinseps,[11] *Bent but not Broken*[12] and Tucker.[13] There was Ruskin's *Seven Lamps*,[14] with his architectural drawings, very memorable I thought then but quite beyond me, and the reading was even more difficult still. I felt gloomy: even art might not be all roses. But I became critical of my efforts to do funny drawings. I did not think them a bit funny or comic, and neither were they.

I had always felt that the drawings in the Brer Rabbit[15] books were homely, and I rather like another kind of homely quality that Edmund H. New managed to get in his illustrations to Gilbert White's natural history of Selbourne.[16] I thought well, it's obvious that these artists have a definite style of their own: they all do one thing and keep to it. I obviously felt the desire for employment and to have something that would keep me regularly employed. I did not like the disordered state of mind I experienced when I did not know what to draw, or why, or wherefore. The fact that I had not the least idea how to draw did not seem to trouble me much; though in fairy tale illustration I did feel a little hampered but soon got over it. I felt that the drawings weren't quite up to the praise I received for them; before I had been too busy enjoying the atmosphere of approval and praise. Also, because I was getting a little more enjoyment from the drawings than usual, I felt I could dispense with a little of that part of the fun. Nothing seemed quite right, however, not that at this time I wanted anything at all personal, but I felt it was in some way necessary to be unique: all these inferior aspirations were the result of being blinded, preventing me from seeing my true image. But at this time I had a desire to find in myself and my powers an outlet for feelings that were by no means vainglorious, though they got mixed with them. This more integral development arose from several diversified and trivial activities, but which all led to one to me important and concentrated desire. I found that this feeling of exaltation and happiness that had always realised itself in me as a child, at such times, for instance, when I was in bed

11 Val Prinsep (1838–1904), British Pre-Raphaelite painter, was Professor of Painting at the Royal Academy from 1901 until his death.

12 Painting by Arthur Wasse (1854–1930) exhibited at the Royal Academy in 1886.

13 Arthur Tucker (1864–1929), landscape artist who regularly exhibited at the Royal Academy from 1883.

14 First published in 1849, this was theorist John Ruskin's first book on architecture.

15 The Brer Rabbit tales date from the nineteenth century, with the central figure a trickster rabbit who succeeds by his wits.

16 Edmund Hort New (1871–1931), leading illustrator of his day, also provided designs for William Morris and taught drawing to T.E. Lawrence. Pioneering naturalist Gilbert White (1720–1793) published the first edition of his *Natural History and Antiquities of Selbourne* in 1789.

Page from a sketchbook, 1907

and my mother and our servant were sewing by oil lamp and with the sewing machine. Later on in childhood this was realised by the pleasing diversion of being employed in doing something (that was when I just drew for the fun of being clever); it was now demanding a new kind of 'stimulus' and a more exacting kind, as this asked for something in return. But I have not yet finished with this early stage of my development: I did not like to have to do anything in fits and starts, spasmodically. I wanted that sewing machine situation to go on and on permanently, so to speak. I enjoyed the harmonious sense of order, and for that reason I liked things to come easily.

Still in this early stage, I began to feel that feelings other than just those that served as drawable material were also capable of being drawn. Not just fairytale illustrations drawn in the style of, and more or less copied from, other fairytale illustrations, but what one could observe for oneself. I had no initiation, inventiveness, humour or ingenuity or originality whatsoever. I noted that E.H. New drew birds and when one day I found a dead thrush, still warm, I spread out its wings and did a drawing of it. But although the drawing was bad, yet I felt a new kind of contact with the life had been made: the thrush had lived in our garden, had been in all sorts of ungetatable places in our pear tree, our walnut tree, our yew tree and all the places we weren't allowed to go to in next door's garden. I was drawing something that was to do with all those places. I drew it on our lawn. I then found a fossilised or dried-up frog just by the stile in the Marsh Meadows where Berries Road entrance is. I drew that and thought of the Marsh Meadows.

I noticed at this time that I did not like the way I could make a thing look realistic by drawing it in a stylised manner; I had got past that, apparently. The moment when I realised there was to be a next stage, with its new and real kind of interest in life, was when one day I was doing a drawing of Eliza Sandall's cottage from her garden. I felt there was something that was very much my business, and I wished it was my father's business also. But – and this was the important discovery of the second stage – I noticed that the feelings I had were in no way to be found in any real artistic form in the drawings I made. The drawings did not speak to me in any way of those feelings. I was before an instrument I could not play; I was dumb before this new and true love. I wanted – even then – a drawing to be more definitely 'Cockmarsh', more definitely Eliza's garden than these places were in nature. I wanted to say 'Cockmarsh' in a creative way and for there to be no doubt about its identity. These feelings were not so clear and emphatic in my mind then as now, because for ages after this I continued to do drawings of old houses in Cookham. But doing this gave me the chance of a long stay in cottagers' gardens, which was a most inspiring and adventurous experience, squatting there among the hollyhocks and runner beans. I could see now why it was that I had been unable to form any ready-to-hand style or identification mark proper to me. Before, I had simply felt the need to get going on

something, something I should like to do, and knew that I should never reach that point until I could see that that something identified itself with me. But this identifying demand, probably originally emanating from my desire to bring a bit of kudos to myself, did eventually bring me to the point where something genuinely good was formed. At least so I think. I realised that I felt something, and that utterly apart from anything that might accrue therefrom. There was something outside myself that was me, just as I liked to be recognised when met and not feel I might be confused with anyone else. I felt I wanted the whole of me to be clear and unmistakable: the 'Cockmarsh' of me, the 'Widbrook' of me. All these 'outside me's were lovers and the more certain I felt I had seen that they were, the more they eluded me. The fact that I might now have to use what sense and brains I had did not worry me much. It took me all this time to arrive at the point at which many others have arrived when they are about three or five years old.

Page from a sketchbook, 1907

I mean this that my growth was not a natural growth, in fact it was not a growth at all, certainly not artistic growth. I wonder to this day if I ever had any real artistic roots. Certainly there is no trace in those pen-and-ink drawings I have described of any of the qualities found in my later work. One could say one has real artistic roots if one's expressed efforts bore at all times a mark showing clearly that they all sprang from a root within the individual. I am always suspicious when I hear of these sudden changes; how some artist has 'completely changed his style' in a few days. If I hear of a leopard changing his spots, I know it is not a real leopard.

Page from a sketchbook, 1907

* * *

Notes:
Enjoy copying an engraving of a singing Thrush
Copy swallows out of 'Great Thoughts'
Enjoy being employed and engaged in work
Do little pencil drawings of figures
Hans Andersen's 'Twelve by the Maid'
King of the Golden River
Goblins and Acorns
Write about a barge
Want to draw the places in Cookham
Draw poem and ink sketches in hook of tree up the Strand…

* * *

When in my youth I considered my part in the Grand Vision, I thought that perhaps my capacity of seer and painter would give me my title to the share in the Glory, but I rather wish I had taken a peep and seen what I was up to when I did wish to express some feeling I had other than these ambitious wishes. What did I imagine when some urgent desire came? It was no Minerva I conceived of, but a local village girl, and when I desired a place it was usually an attic or kitchen, or when a garden it was the back garden and the most domestic part of it. Everything in me gravitated towards homeliness. My only friend was Charlie Rowlands, who was cowman over the road at Ovey's Farm. I spent most of my time in the cowshed.

MAIDENHEAD TECHNICAL INSTITUTE

In 1906 Stanley had announced his wish to become an artist. His father, although he had expected his children to become musicians like himself, arranged for him to have lessons in watercolour with Miss Dorothy Bailey, who lived across the road in Cookham. The following year Stanley was enrolled at Maidenhead Technical Institute, within walking distance of home, where he attended art classes with Mr Cole.

The Technical Institute… I remember the strange effect in my mind of seeing one of these highly finished stipple drawings of the Gladiator taken from its most foreshortened angle. It was in the east end of the room. I love to think of the Athena heads that lived on shelves in the east end and the Lorenzo Medici head among the capitals and beyond the first curtain. At night it was mysterious. I could worship every hard-edged shadow the gaslight made on the casts. I was always a little awestruck by them and when I saw the way the master, Mr Cole, handled them in shifting them about, I somehow knew that my awe was not the kind of attention I was meant to pay to these casts. It looked very good seeing him carrying them. And also, he was as much a declaration of the school atmosphere that pervaded that place as the casts were. The masters and mistresses and students and caretakers of the school were very pleasant to me.

The tall, thin, chocolate-coloured curtains, each about 15 feet high and nearly as wide, which divided this room into compartments, are still in my mind. It was in the evening when different classes were held that they were drawn across, but never right across, and one could get all sorts of glimpses of the different classes. I felt Mr Cole must change into someone else when he left some students, who were far advanced in the throws of stippling some Greek cast such as the Discobolus, for someone behind the curtain was doing a still life of some flowers. It seemed a bit of a come-down to hear him tinkling the watercolour brushes just behind, and saying 'Patience, patience'. But he was kind to me and I was thankful to have his 'patience' said to me. But Mr Cole seemed to look very askance when, at a late stage of my stay there, I began to wish to do compositions and illustrations to stories, etc. Town Councillors in this part of the country don't

take kindly to that sort of thing: letting the students indulge their fancy; just a bit risky, that. No doubt that was the reason for the unacceptable resistance I experienced. But Mr Cole managed to get together a little show of compositions and I, because I was not under the Board of Education supervision to the same extent as other students, was allowed to do or attempt an illustration of Sir Roger de Coverley in church. It was to me a spiritual experience to find myself able to establish here in this atmosphere something that was truly me, and it slightly lessened the hardness I felt in the world that this school seemed to represent to me.

The walk back to Cookham along the lonely Upper Maidenhead road did not seem so far, not that I ever minded that three-mile walk home, only it was a bit frightening by night. Passing by the churchyard of St Luke's, the feeling of it all being in a sort of enclosed world and not in the world I live in was rather good. The gaslight made it seem as if the tombs were in a room and not out of doors. Once past the pub and the few workman's cottages, then things looked more real and the smells began to come off the fields of mangelwurzels and sheep. The sheep used at first to startle me a bit with their human-like coughs. When I got past the 'half-way' house, a small, isolated little square cottage, having no sign of life, I began to feel Cookham was in the air, and when I saw the gate over the railway leading to Accommodation Road, I fortified my heart (as the Mohammedans say in 'Arabian Nights') and braced myself to enter Cookham.

<p style="text-align:center">✳ ✳ ✳</p>

In Stanley's 1907 sketchbook, among the drawings, are seven pages written in pencil:

This is a story.

Once upon a time there lived, in a house on a hill, a little man. In the country the people feared him so much so that if ever he shut up his house and went down into the country the people used to retire from their gossip, close their doors, bolt them, and devise excuses for so doing. This they did by having a meeting every night which was conducted in a strange manner. Sometimes the meeting was short

because the 'excuse' they already had in hand was not yet exhausted. At other times, when their 'excuse' was used up owing to a recent visitation, there used to be quite a row.

The most prominent people of the village would sit on their couches, running their fingers through their hair and casting frantic glances at each other in hopes of finding somebody who looked as though he had an inspiration. Well, they were a poor, ignorant sort of people and the little man knew it, he knew all about their private meetings and their silly scratched-brain excuses. He lived on the hill, as you already know, but that hill had some very quaint characteristics.

Up the side of it, which was fairly steep, was a range of fairly steep, worn-away chalk steps which were cut into it (the hill being composed of chalk) by the little man to make access to his house easier and more comfortable – 'anything for comfort' was his favourite say-word. In the close background to the house was a forest (that sounds something like a fairytale), which spread out on either side of the house for about 50 yards. It had a charming variety of trees and it made one feel how much the Almighty must have worked at this glorious scheme when he said, 'Let the earth bring forth grass and

Pages from a sketchbook, 1907

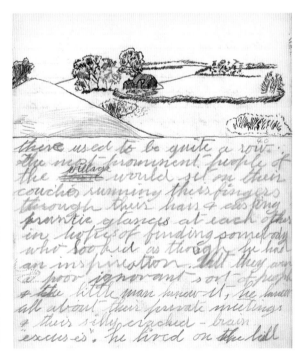

the herb yielding seed, and the fruit tree yielding fruit after his kind, whose seed is in itself, upon the earth'.[17]

Bordering the forest was a rusted-looking fence. It was new once, made by the hands of men, but now it had been softened and suppressed by wild nature's ways into something which was both typical and in keeping with its surroundings.

In the middle of this forest was a clearing of about 80 yards; this will be described later on.

On looking at the house, you could well imagine seeing an ogre come out with a bouncing bound to catch you. 'A timely meal', he would say, though I doubt whether you would agree with him in that matter.

This abode, although it was not unlike some of the houses down in the country, was a place worthy of description. To begin with, the windows looked like a number of chemist shop windows for the fact that they had not got to the sign, namely the coloured waters. Some of the windows had stained glass: through this glass everything looks so weird and uncanny that one didn't feel inclined to have a second look. But at other times everything looked so charmingly pretty that one could scarcely keep one's eyes off. How the way this little man used to make certain his windows look pleasant sometimes and nasty other times was by having a number of enchanted canvases which he placed about two feet from the window. When he heard of pilgrims coming from a distant place he put up the nice canvases with the pretty pictures on, on which the figures moved like magic; but when he wanted the people to keep away from his house he used to erect the ugly canvases with hideous fiends and men with black wings on, ogres and witches, dragons bellowing flames out of their mouths: in fact everything that would frighten the people away.

17 Genesis 1:11.

Two Girls and a Beehive, oil on canvas,
c.1910 (private collection)

SLADE SCHOOL OF FINE ART

Stanley studied at the Slade School of Fine Art, the leading art school of the day, from 1908 to 1912, where his contemporaries included Mark Gertler, C.R.W. Nevinson, Paul Nash, Edward Wadsworth, David Bomberg, Isaac Rosenberg and William Roberts. There were also Gwen Darwin, Jacques Raverat, Darsie Japp, Rudolph Ihlee, his future brother-in-law Sydney Carline, Maxwell Lightfoot and Dora Carrington. Unlike most students, he lived at home, and was nicknamed 'Cookham'. He travelled to Gower Street each day, taking the 8.50 train from Maidenhead and returning by the 5.08 from Paddington in time for his tea. Stanley received a scholarship and a number of prizes. He was taught life drawing by Henry Tonks, whose teaching made a lasting impression on him. Tonks wrote to the Spencer family: 'In some ways he has shown signs of having the most original mind of anyone we have had at the Slade and he combines this with great powers of draughtsmanship.'

The Life Room at the Slade was very much in accord with my special likings and predilections for interiors. It had its own orientation; the windows were a long way up and what I specially like was that one could not see out of them. I still cannot believe that there was any exterior to these tall windows. I liked the shape of the room and the appearance of the 'donkeys'.[18] I had a feeling that my first efforts of my early days of my first year there would take place in the end of the room nearest the entrance door and that I would end my days at the Slade in the far west end corner. I never liked being on the higher donkeys, but preferred the low ones and liked it when fenced in by a row of high donkeys.

I liked also the narrowness of the passage leading to the Life Room door, caused by the crates either side for holding the drawing boards. I was impressed with the mixture of statues and students – especially when the girls sat whatever on them and had their lunch, etc. I still accepted everything as I did at Cookham … I never regarded the different arrangements in the Life Room or passages or elsewhere in the school as being things needed for a purpose and put there for purely utilitarian purposes. The paint on the girls' frocks and on the walls or the ledge round the room and the pipes and

18 Low stools on which art students would sit astride to work.

stage and the mysterious black mass behind the stage were things which gave me particular feelings, which I think in painting I can convey. The great blackness behind the stage was I believe a mass of hot water pipes.

I suppose I have some sort of homing instinct and, like birds who build nests wherever the shape of some objects will serve that end or who lodge wherever they can, so I am always finding spiritual nesting places or some sort of lodgement for what is myself, and just as these pipes serve as nesting places for birds, so they are places where I can find my several spiritual homes. And my nesting habit never destroys, but emphasises and brings out the sense and purpose of the things I make a home in.

* * *

While as soon as I began to study drawing at the Slade I could feel myself developing, in some sort of way, towards being able to draw, and could feel also that this would enable me to cope with the matter I had to express, yet nonetheless I did not study with any degree of intelligence, and the result of this was that I noticed that when any of this ability showed itself it had nothing to do with what I was trying to express. It was simply some object or place drawn in a way that showed this particular species of ability; a thing which had no connection with the thing drawn. They were not a perfect marriage between artistic capacity and special personal feeling. To express what I felt in Cookham with the particular kind of capacity I developed at the Slade might have been utterly and idiotically wrong. My knowledge developed by the experience of a series of drunken experiences, one not being in any way related to the other. It was only by a fortunate accident of circumstances that I found that here and there that the quality I sought in my drawing had a sort of twin relationship or fellow feeling for some feeling I had for some situation I wanted for a picture. I hoped in a very unintelligent way, when at the Slade, that perhaps what I learnt there might 'come in handy' some day.

* * *

During my Slade period the interests that I had were drawing in the Life Room, which had a special meaning, and the particular quality I sought to achieve in drawing, a romantic meaning somehow in the drawing itself I felt to be possible. Then the occasional Sketch Club competition for Composition, which was a unique outlet and [an] Aladdin door leading into all, and exactly what I wanted. That this was a meaningful and helpful thing to me is shown in the list of my compositions for that period, all of which subjects were 'set' by the Sketch Club committee. These were:

1. Maternity
2. Shopping
3. Last Day
4. Scene in Paradise
5. Jacob's Ladder
6. Descent from the Cross
7. Jacob & Esau
8 Excommunicated
9. Jepthas' Daughter
10 Job & the Comforters
11 Nativity
12 Man goeth to his long home
13 Apple Gatherers

But all these subjects were only one half of the matter and as always I had my own Matrimonial Agency, and each of these subjects in turn would be brought into contact with the 'Oracle' at Cookham; it was when these unsuspecting subjects came into contact with that, that the, to me, important things happened.

* * *

Stanley met artist Gwen Raverat (née Darwin, 1885–1957), later part of the Bloomsbury Group, at the Slade. It was through Stanley that she met fellow student Jacques Raverat (1885–1925), a young Frenchman, whom she married in June 1911. Jacques died from multiple sclerosis in 1925.

*c.*May 1911
Fernlea, Cookham

Dear Mr Raverat

I quite understand and deeply sympathise – England is genteel but not all of it; Cookham, for instance – you get up on to the hill and gaze down on flat country with, every now and then, a smooth flat, dreamy square field of red earth (read this passage rapidly, it is as though one's brain is bumping against one's cranium). I go to church every Sunday and wear my 'Sunday-go-to-meeting-clothes' like all good little English boys should, and in the afternoon I sit and pore over T*he Sunday at Home*[19] or *Pleasant Sunday Afternoon*.[20] (I hope you enjoy all this.) I must get inspired on Sunday. Somehow going into a room and finding one's father snoring, asleep in the armchair, takes all the guts out of you, especially when he has a handkerchief over his face! But my daddy is a good daddy, although he does go to sleep on Sunday afternoon…

I rose from the dead last night, it happened like this. I was walking about in the churchyard when I suddenly flopped down among the grave mounds. I wedged myself tightly between these mounds – feet to the East – and died. I rose from the dead soon afterwards because of the wet grass. But I did it in a very stately manner.

I have nothing more to tell you just now, more later on.

Your loving
Cookham

19 *The Sunday at Home: A Family Magazine for Sabbath Reading* was a weekly magazine published in London by the Religious Tract Society, 1854–1940.

20 Publication of the Pleasant Sunday Afternoon Society, a semi-religious social group founded in 1875.

* * *

18 May 1911

Dear Higgy[21]

Here followeth things seen, done and heard. I went and heard Ysaÿe and Pugno[22] the other day (they were in stature like Tweedledum and Tweedledee) I don't remember if you were at home after I had heard them or before I heard them. If only man could marry woman as that fiddle married that piano, in the true sense of the word, mark you!

Every week I draw in Wilcox's studio. I took that painting – the Donne one[23] – and showed Tonks. He criticised as follows: 'I don't like it as much as the drawing. It has no colour and is influenced by a certain party exhibiting at the Grafton Gallery a little while ago (Post-Impressionists) – the damn liar! However, I sold it to Raverat for 6 guineas and Tonks is going to have my next. I am inspired of late. I hate people individually, but I glory in human nature; sounds paradoxical, but it's true.

Our lib- no, labernum hangs its yellow breasts on high – oh bunk!

Yours
Stan Spencer, First Earl of Cookham

* * *

Undated

Dear Syd

I do hate to think of you waiting all this time for a letter.

At the present moment I'm so excited about my composition for 'Leisure' (the subject set by the Slade for the summer holiday picture) that I can scarcely tell t'other from which.

I have done a 'gooden', as Lightfoot[24] would say, of 'Maternity' also set by the school. I have also done two large posters for the Y.H.L. bazaar: they were hung outside the tent where the concert was held on the lawn of Medmouth Lodge, so that everybody saw them.

21 Higgy was the family nickname for Sydney, seventh of William and Annie Spencer's nine children.

22 Belgian virtuoso violinist Eugène Ysaÿe (1858–1931) and French pianist, organist and composer Raoul Stéphane Pugno (1852–1914) were renowned for their chamber recitals

23 *John Donne arriving in Heaven*, 1911 (Fitzwilliam Museum, Cambridge). This painting was bought by Jacques Raverat in 1911 and acquired by the Fitzwilliam Museum in 2013.

24 Maxwell Gordon Lightfoot (1886–1911) was a contemporary of Spencer's at the Slade.

John Donne arriving in Heaven, oil on canvas,
1911 (Fitzwilliam Museum, Cambridge)

Now let us turn from these people who are ever attempting and never accomplishing to those great masters and their accomplishments. To begin with we will take Sydney Spencer's hand,[25] now in the property of ur-er-er, I dunno, let's see, I had it in my pockets sometime ago – humph – well wherever is it? I've lost it. Please, Higgy, I will be good; let's hope so, at least. I can't criticise but I'll try. You are observant, that's good. You copy too much, that's bad. This is what Tonks says: don't copy, but try and express the shape you draw; don't think about the paper and the flatness of it, think of the form and around this form. Think of that index finger you did: is that all you can see or feel? Think of those bones, those beautiful sweeps and curves they have. Think more of the governing lines, the aspect, the feeling the finger gives you.

Expression is not style. Don't think about style: if you express the form, the 'style', as some people love to call it, is there. This is how Tonks goes sometimes: 'I am afraid that drawing would not be much use to me.' Yes, it would not be any use to him because it does not express anything. This is one of the many objects in drawing. Make it useful. Take your drawing of the hand to a man who has never seen a hand and say here is a drawing of the hand. He would have to say 'I see'. Now you take him for a walk and he looks across the meadows and sees a haystack. I have no doubt he will cry 'oh there it is! There is the hand at last'

Photos don't express anything and your drawing is too much of a photograph. It's rather rude to criticise an old master like this, but I must say you are observant and careful.

Gil and I went down to the orchard with Amy Hatch.[26] Down Mill Lane and through that big iron gate on the right where Annie use to take us. It's delightful, just like fairyland. Strawberry beds and cherries, everything you could wish for.

I must stop now, Higgy dear.

Your loving Brer
Stanley

* * *

25 Sydney had sent one of his drawings to Stanley for comment.

26 One of the Spencer cousins.

[*1948 note added by Stanley*]
This was written by me when I was staying with a Mr Harrison (in Somerset), a friend of Tonks, summer 1911. I was lonely and homesick.

Undated

Dear Gil and Syd

This man is a farmer, a writer, a keen follower of art. He has a very red face, snow white hair and pointed beard, he is tall and rather stout. I like him because he is so honest and yet so free, severe only to be kind.

Of course I can walk well-nigh everywhere because well-nigh everywhere is his! And that which isn't I can walk on because nobody wants to get into his bad books. Nobody about, old everything, old house with old fireplaces, old beams and such like.

> Goodbye
> Love to Amy
> Stan

P.S. Remind Pa to send the drawing to Mr Lois.

<p style="text-align:center">* * *</p>

13 June 1911
Fernlea

I have read and am going to reread *Macbeth*, *Hamlet*, *Othello*, *Romeo and Juliet*.

Dear J & G Raverat

Con-grat-u-lations[27] (thank goodness that's done. I don't know, though, the long words are usually the same as short words). As soon as you have more babies than you want you might give me one. Must have a wife before you can have a baby! Rotten I call it! I used to be forced to eat my bread and butter before I could

27 The Raverats were married on 7 June 1911.

have any cookies, same thing! I don't think there is any 'Excuse or justifiedness why you two should not be joined together in unholy matrimony' but you might have let me know earlier. You must excuse my churlishness, but it is your fault, you should not have reminded me of it, I feel bursting with sauce. My God. If I'd heard the banns!! Enough's enough.

I have given up drinking tea and feel a great deal better for it. I don't get indigestion nearly as much as I used to, nor am I constipated much, nor persp'. If I knew anything about you I could say something, but I don't. I am writing a long letter to you.

Your loving
Cookham

* * *

After 13 June and before July 1911
Fernlea

At the bottom of this garden, which is very small with a high wall all round, is a little sort of house and there is the bakehouse and the smell of cake, bread, etc. – like this: [drawing]

I have just received your looked-for letter, Jacques. I am extremely sorry for your father about this money because the ambition he seems to have in building a fortune must have received a horrible shock. It at any rate does not reflect any dishonour upon him and so his capacity as financier would not be questioned. I have a respect for almost every kind of ambition because you will find that nearly every man who has no ambition, or absolutely no desires, is a godless man. Of course he is; he is not a human being, not made in God's image, he is an outcast. I should be grieved if you have to give up your Croydon home and Mrs Banfield. Let me know what happens as soon as you receive any further news. I feel a little anxious, and I certainly ought to be told if anything happens.

It was grand to have a letter from you I wish they came more frequently. I wish you sent bellyfuls once a week instead of once in one or two months.

I have not been feeling at all well lately but I've worked all the

Colonel Ricardo (seated front left) and others, including William Spencer, Stanley's father (back right), during the Cookham Coronation Festivites, 1911

time (very foolish in some ways, not in others) except in the early mornings. I took my share of sleep. My head was like a cartload of bricks: I have not had such a headache for many years. I am better now. You must remember that I talk to nobody; of course I gossip when it is to be had, but that is not always. It is disgusting how wealthy men in England become bankrupt and in a short time are wealthy again. This seems to be done by leaving nearly all his assets to his wife three years previous to his becoming bankrupt. So that when he becomes bankrupt paying (I have known it) 6d in the pound, devouring widows' houses and anything you like, he still can live in his palace and is only a little inconvenienced by bankruptcy. Disgusting. And meanwhile kneeling in Cookham Church to give prayers for his recovery to prosperity – that of course because he gave money, not his, to the Church.

Just think of this. There was a man in the choir who went with another man's wife and it was very disgusting. Eventually he was expelled from the choir by the vicar, one of the bloodiest I know. Now listen to this: there is a rich Colonel[28] in Cookham whose wife died some years ago and who is alone with another man's wife every day and it seems to me all day. This woman's husband goes to London by the 9 o'clock train. I do not know how they behave but I do know this: the way the Colonel looks at this woman is awful, she is tall, handsome and young, and they go about on horseback together.

Now for the part that makes me quite mad. This man has 'done' a great deal for the place (Cookham): he has given a fire station, a fine library and room, a fine cricket ground and cricket things. That is all very good of him. There is one other thing that he has done: he has 'done for' Cookham Church. He has put up a rood screen in the nave where it borders the chancel, so that instead of getting a fine space there you get to this crude screen, which in design, proportion and in every other way is absolutely unsuited to the architecture. Of course there was a 'vestry' meeting to see if the people of Cookham wanted this and it seems that they did, except my father and Sir George Young.[29] I really must ask him if he can do anything to get rid of it. I feel it terribly: why do the wicked flourish? When Sir George comes to church in the morning, which he does almost without fail, he holds his hat up to the eye which would see the wretched screen. It is fine the way he sticks to the church, which on Sundays is largely composed of people

28 Colonel Francis Ricardo (1852–1924) of Lullebrook Manor was a great benefactor of Cookham, said to be the inspiration for Kenneth Grahame's Toad in *The Wind in the Willows*.

29 Sir George Young (1837–1930), 3rd Bt, of Formosa Place, Cookham, was a neighbour and friend of the Spencer family.

with fat white flesh; a lot that come I am almost certain are Jews. Well, of course something must be done for the Colonel, so he is made the people's churchwarden! And Dr Batchelor (vicar) b-sucks the Colonel to all further order. This is is kind of thing is repeated everywhere.

I have done a lot of clever things lately. One of them was quite elaborate [drawing]. The little black dog jumped on to the donkey,[30] upset linseed oil, which went onto the sofa, and knocked the looking glass over. I just saved it but in doing so knocked my knee against a stool, which fell right into sister-in-law Natalie's[31] lap (she had an extra fine dress on): the palette, colours, oils, brushes, all went into her lap. I managed, after much labour, to get most of the paint out with petrol. Although I do not like her, she behaved very graciously and said it was the dog's fault, which is not quite true. The stool had three legs. Things like this always depress me. I think it is the devil: this afternoon I was taking my little pot of linseed oil off the chest of drawers; it slipped out of my hand and went all over the chest of drawers. Later I knocked ink over the table and floor. Later I knocked the looking glass clean off donkey but it fell onto the sofa. In doing this I smashed a beastly little jug to splinters. I'm all of a muddle but I feel hopeful.

Gil and I have rather got the 'pip' about your news so let us know by little notes from time to time how things go on. I always thought Gwen Raverat was a domestic animal and so is Jacques – no, he is not, he only relies on commonsense; that is different. I have thoroughly enjoyed your letter and keep on reading it: not because it is wonderful (it certainly is noble) but because I see you in it. This sentence looks like testimonial. You know Hall Caine[32] has advertised his latest book in very brave style and in it were several testimonials, one from the Revd F.B. Mayer. But the day after there was a notice in the paper to say that it was a mistake – Poor 'all Pain! There was a lovely photo of him in his dressing gown and pyjamas. His brows were knitted: I suppose that meant he was thinking.

I think Gil wants to see you because he said very dolefully when he heard of your misfortune, 'then I suppose that means we shan't be able to go to Croydon', but I told him that I thought that would be alright.

I saw a huge hayrick on fire the other day, it was a wonderful sight. I tried to look at the sun through the great sheets of flame, but it was a little too low, but I did look at the brilliant silver sky

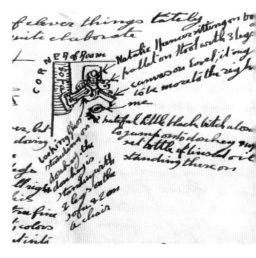

30 Artist's stool.

31 Natalie was the first wife of Harold Spencer, the third of the Spencer siblings.

32 Thomas Hall Caine (1853–1931) was a prolific novelist, playwright and political activist, one-time secretary to D.G. Rossetti, and famously one of the best-read writers of his day.

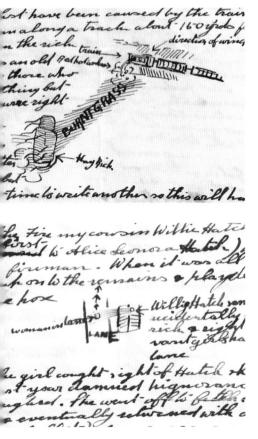

through the flames. You know how fine that is. The fire must have been caused by the trains whitch run along a track about 160 yds away from the rick. There was an old man up there who said nothing but 'arr' and 'y'were right'. I do hate writing an untidy letter like this but I have no time to write another, so this will have to do.

I liked the part about the little mason 'all over stone-dust'. I have some imaginings of Vézelay. It must be the very opposite of 'spottyness'. The north-western part of Cookham is rather spotty: 'pleasant spots', 'nice bits'.

Love from
Cookham

Up at the fire my cousin Willie Hatch (3rd cousin to me, first to Alice Leonora Hatch) was the leading fireman. When it was all but out he got up on to the remains and played on it with the hose [drawing], Willie Hatch sending water accidentally over top of rick and right onto servant girl in the lane. When the girl caught sight of Hatch she called out 'Just your damned hignorance' and we all laughed. She went off to fetch some more [illegible] and eventually returned with a chauffeure (I can't spell it). Of course as soon as she once again saw Hatch she opened fire on him and we all stood round and fairly bashed ourselves in the [illegible] – we had a good half an hour of it. There was a self-conscious visitor man named Pinder-Brown (What!) who made a few judicial statements. Willie was very sensible: he just made the woman say certain things and then denied them and said no more but went on quietly smoking.

I like to sit and stretch and feel myself all over and have my mind entertained like this.

Gil is getting on. I like the way he paints short grass and little 'startled' (they look so) flowers. It is all very strong and decided and straightforward; he is writing. Write <u>now</u> and say how things are.

* * *

1 July 1911
Fernlea

Dear Higgy

Thanks so much for that 'nasty ugly face'. I am sure it must have been a terrible wrench to you to have parted with it, and I expect to feel like Charles Lamb's boy in 'A dissertation upon roast pig',[33] buoyed up as one is on such occasions with a sweet something of self satisfaction, but, 'His better feelings return and he burst into tears'.

I hope you will forgive me, Higgy dear, but I've been and gone and done and struck a bargain with Ihlee,[34] it happened like this. I was up at Ihlee's the other day and he gave me about 30 half-used tubes of oil paint. After that he asked me to let him have that drawing of Dot Bailey for 2/6d, which I did. After that he said: 'If you give me the half crown back I will let you have the box as well as the paints.' I walked away with about 15/- worth of colours and a lovely oak box about the size of our 'Crayonette' box.

I have had this term: scholarship, box of paints, reproduction of Philip IV of Spain (Velázquez) from Wadsworth,[35] Dürer's head from you, extra prize of £1 0s 0d (not even third), a prize divided between four: Gertler,[36] Carline,[37] Camilla Doyle[38] and myself.

Brown[39] said he will buy some of my work – I don't know that he will – because I need money.

Will[40] is sending me 10 shillings for my birthday. Yesterday (Tuesday morning) Ihlee, Japp[41] and myself went to bathing down Odney. Ihlee didn't go in. After we had had our bathe we saw a 2¾-foot punt, into which Ihlee and I jumped. We went ting-tinging down towards Odney weir. Suddenly Japp suggested that we should shoot the weir, to which Ihlee replied: 'I feel game'. Suddenly, and to my relief, Japp realised that the bars were down and so we had to go without that pleasure.

Japp heard Harold play angelically last Saturday and now I will say good day Higgy.

From your loving Brer
Stan

33 Published in 1823, Charles Lamb's humorous essay describes the accidental discovery in China of roast pork.

34 Painter Rudolph Ihlee (1883–1968) studied at the Slade 1906–10.

35 Edward Alexander Wadsworth (1889–1949) was a contemporary of Spencer's at the Slade.

36 Mark Gertler (1891–1939), studied at the Slade 1908–12.

37 Sydney Carline (1888–1929), Richard and Hilda's brother.

38 Painter and poet Camilla Doyle (1888–1944) studied at the Slade 1905–10.

39 Frederick Brown (1851–1941) was Slade Professor, 1892–1918.

40 Stanley's eldest brother.

41 Darsie Japp (1883–1973), soldier and artist, studied at the Slade 1908–9.

P.S. I was a horrid swank yesterday at the college assembly. It was very pretty to see the whole of the professional board troop in in their lovely robes: the Provost wore a flowing red one, a most gorgeous sight.

✷ ✷ ✷

July or August 1911
Applehayes
Clayhidon
Wellington
Somerset

Dear Jacques and Gwen

I have written that letter and hate it – it is so young. I do not mind being young, but it comes out in the most objectionable manner in my letters.

I am in Somerset doing watercolours, for one month which (thank the Lord) will end next week, when I shall return to Cookham – my paradise.

Oh how pleased was I to receive that card! You would not believe what a nice feeling it gave me – and oh the pictures, that is all I can say of that. You must let me see those 'Vezlery' things again sometime[42] – and the Giottos.

Oh dear! I like saying 'Oh' because it does not mean anything and yet it is so expressive of what I feel. What about the picture? I think it ought to have a white frame with about the width of this:

I have done nothing, since that picture isn't that fine. Tonks thinks that I am full of ideas – he knows me not. I hope you will write again soon and correct this. I am convinced that I shall never do anything unless I am in Cookham.

Yours very sincerely
Cookham

42 Probably the stone carvings on the capitals and portals at the Benedictine abbey church of Sainte-Marie-Madeleine at Vézelay in Burgundy.

Ihlee gave me a thing called 'the bride' (Mughal school) you must see it. I saw in the book a Giotto called *Joachim among the Shepherds*.

* * *

August 1911
Sunday

Dear Jacques and Gwen

I am glad I took some pictures away with me because I felt as if I was bringing a part of you away with me.

I wish you would come and see Cookham: the people are too awful, the sort you cannot see and live, but the land in parts I know you would love.

I heard these words sung in church tonight:

by many servants of Satan,
Lord now lettest thou thy servant depart,
in peace, according to thy word.
For my eyes have seen thy salvation.

I will write when I am more settled down. I still have that empty feeling but that will be alright in a few days.

Love from
Cookham

I wish you would write in as few words as possible the Marconi Case. Don't do any cursing of the Jews. Has the American Co. any thing to do with the English one?

* * *

9 August 1911
Fernlea

Dear Raverat

That letter quite excited me. What am I up to? Why did I go down to Somerset and paint water? I'll tell you. I have never been away from Cookham before, and thought that the change would do me good, and it has done me good. I am thinking of an idea I have now. I am quite ambitious, more ambitious than I have ever been before. My life would be an enjoyable one if I spent about six months in London a year and the rest in a room in Cookham, but then of course difficulties arise. I like first formulating my ideas in Cookham. But I must live in London because I want models. And I must keep in touch with London. I am dripping with the heat.

> Your loving
> Cookham

* * *

August 1911
Fernlea

Dear Jacques and Gwen

Neither Gil or I will be able to come to Croydon for some time yet. Gil must finish his big picture. I wish you could see it. I am on the verge of beginning a picture and am in a state of great excitement, quite a treat to feel like it. I shall spoil the whole painting if I leave Cookham now. I believe it would kill me.

I hear the voice: 'this is the acceptable year of the Lord'. I want to draw everybody in Cookham, to begin at the top of the village and work downwards.

What I think is wrong about you two is that you do not realise how different you are, the one from the other, I think you should bear this in mind, else you must get confused.

We bathe in Odney Pool every morning and we both feel grand.

It does us a world of good. Without those pictures you lent me I should expire.

Cookham

This is all I have time for now.

<p style="text-align:center">* * *</p>

21 January 1912
Fernlea

Dear Jacques and Gwen

As I simply cannot write you a letter without either working myself to Glory or else into an informalness, I am going to let you know from time to time what I am doing by giving you 'extracts' out of my 'Diary' – my life, you know … From about 9 in the morning until 3 in the afternoon I go on with my Apple picture[43] begotten in the reign of our most gracious sovereign Lord King George, 1911. I like those Church things: 'We have done those which we ought to have done and we have left undone those things which we ought not to have done'.

… I do love thinking about Sir George Young – not by reason, only by instinct. I do not know him to talk to. I do not think he would understand me at all. But directly I see him I am chunk full of the Holy Ghost. I used to like Soloman[44] at the Slade, because he reminded me of people playing things by Mendelssohn in the house next door to us years ago.

Sir George Young has translated Victor Hugo's poems. I don't know if you have read them. I love reading them. In the end of the afternoon I read them and the Bible, and in the evening the same, until the spirit moves me, and then I am bound for heaven or hell. Let me know how you spend your day.

God bless you both
With love from
Cookham

43 *Apple Gatherers*, 1912–13.

44 Gilbert Bernard Soloman (1891–1954), painter, studied at the Slade 1907–*c*.1911.

＊＊＊

There were great points of sympathy between Gil and I even then – here is an instance. I hit Gil (not very hard) Gil bellowed like a bull and then of course I cried. If Gil cried I cried and if I cried Gil cried. Ma comes rushing into the room 'What is it?' 'I've hit him I have, I hit him I have, oh Gil', 'Oh Stan', 'Oh Gil', 'Oh Stan'... I will tell you another. We were both just outside the kitchen door seated in high chairs, and no doubt feeling the dignity of it; were talking over things in general when Gil says very mysteriously: 'Stan, what are Angels?' 'Ow', says I very knowing and wise, 'great big white birds wot pecks'. Gil after digesting this peered about for a white bird wot pecks and was not long in discovering one that happened to be a certain member of our family, so Gil outs with it: 'Is [Annie] an Angel?' 'No' says I, very contemptibly. 'Not great big squashed fat things like her'. I knew something about females then, as you can see.

＊＊＊

27 April 1912
Fernlea

Dear J & G Raverat

I would like to come on Tuesday next at about half past 3 please, and I will try and get Bobby[45] to come too. I will bring my BIG picture. You won't like the detail, but then it's my joy to do the detail, same as it's your joy not to do so. I think I can do a kind thing, and I know how to, but thought about searching after females and never did!

Yours ever
Cookham

45 William Patrick Roberts (1895–1980), painter, studied at the Slade 1910–14.

RETURN TO COOKHAM

After graduating from the Slade, Stanley returned enthusiastically to his beloved Cookham to paint full-time. This was a happy and creative period: he planned and painted prolifically, surrounded by the sounds of family life at Fernlea and the familiar noises of Cookham outside. He continued to exhibit and sell his work. During these years he produced a fine series of works painted in a mood of great confidence: 'When I left the Slade and went back to Cookham I entered a kind of earthly paradise. Everything seemed fresh and to belong to the morning...'

12 September 1912
Fernlea

A girl is having a singing lesson downstairs.

Dear J & G Raverat

I don't know why you sent me such a nasty card. I liked the picture but I did not like the writing.

Charlie Rowlands says that the world is coming to an end because the world is so wicked and because of the rain. I am not pleased with my summer picture but I have an idea.

I can't help thinking about Joachim; he has made me feel quite lightheaded.

In Cookham the idle rich have been having a sort of competition for the best buttocks and busts. Ladies patrolled the street daily. Boneless, utterly. There is one thing: they keep the dogs from barking. I want you to come and live in Cookham for a time and I never want to leave it. To show you how much I love Cookham, it is like this: [drawing]

Joachim[46] is going to be very good and so are the shepherds. I am doing a portrait of Alice Leonora Hatch, the farmer's daughter.

I have taken little compositions down to a little place I know and buried them in the earth there and left them there, and while I went up to and down to London I often thought of them. This is sentimental but that does not matter, I shall go on being so. This is all very confidential, mind.

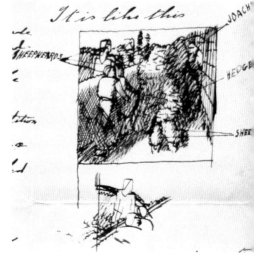

46 *Joachim among the Shepherds*, 1913
(Te Papa Tongarewa, Museum of
New Zealand, Wellington).

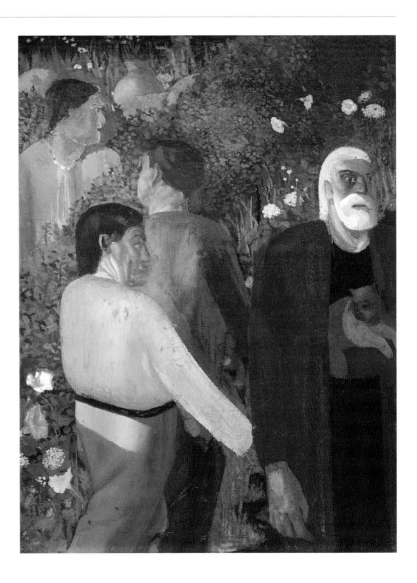

Joachim among the Shepherds, oil on canvas, 1913 (Te Papa Tongarewa, Museum of New Zealand, Wellington)

As I am a highly principled young English gentleman, I don't think I can call you by your Christian names. No I can't, really, I don't know why. I am no reasoning animal.

Yours ever
Cookham

I will write again soon but I think of Joachim.

* * *

25 September 1912
Postcard from France

Mr and Mrs Raverat

Roger Fry[47] is very anxious to have my 'Donne' picture[48] in an exhibition at the Grafton Hall and Clive Bell, whoever that is, wanted your London address. I shall go to London tomorrow, I think, and give it to him. Do you know Bluett's address? If I can get the drawing I would rather send that than painting. I am all of a muddle and the post is just going.

Please accept every inch of Cookham's love.

* * *

12 November 1912
Fernlea

Dear Jacques

I had no chance to write to you until just now. Just let me tell you a little business first. I spent the day with Japp yesterday; he introduced me to Clifton (Carfax) man.[49] Nice man in many ways …. I badly wanted to show you to him as early in the week as possible, when he will frame it and send it to the New English,[50] among other things that he is sending. I have permit for sending it signed by Brown & Pursell, and they have not seen what I am sending.

Now I have got your address I have not a moment to spare. I have to get this composition done today if possible.

See you and Gwen I hope, on Friday. I hate writing these 'not a moment to spare' 'yours in post' sort of letters.

Love from
Cookham

* * *

47 Painter and critic Roger Fry (1866–1934) was a member of the Bloomsbury Group.

48 *John Donne arriving in Heaven*, 1911 (Fitzwilliam Museum, Cambridge), was shown in Roger Fry's seminal *Second Post-Impressionist Exhibition*, Grafton Galleries, 1912, where it was hung in the same gallery as works by artists including Matisse, Vlaminck, Picasso and Wyndham Lewis. The English section was selected by the art critic Clive Bell (1881–1964).

49 Arthur Clifton at the Carfax Gallery. Also known as 'Carfax & Co.', it was founded by William Rothenstein (1872–1945) in London in 1899 and was closely associated with the Camden Town Group and the New English Art Club.

50 The New English Art Club (NEAC), a fine art exhibiting society founded in London in 1885 as an alternative to the Royal Academy of Arts. Spencer became a member in 1919.

In Praise of Cookham.

O COOKHAM, sheltering in the vale,
 And shaded by thy hanging groves,
Soft watered by the silver Thames
 Who loves thy meads, and lingering, moves
As though reluctant to forego
 Thy scenes of beauty and repose
For yonder city's madd'ning roar
 Which day and night no respite knows!

Soft are thy charms, yet thou hast bred
 A race of brave and sturdy wights—
Men who at risk of private loss
 Have dared to stand for public rights.
Strong are thy sons, thy daughters fair
 As those, who when the world was young,
From their bright seats the angels charmed,
 And o'er them Love's soft fetters flung.*

To us thy very stones are dear,
 Thy breezy uplands, grassy plains,
Thy sedgy meres, the wild fowls' haunt,
 Thy footpaths fair, thy winding lanes;

* Gen. vi., 1, 2.

Book of verse written by William Spencer, Stanley's father, and published in October 1912

51 The description fits *Zacharias and Elizabeth*, 1913–14 (Tate and Sheffield Galleries & Museums Trust).

November 1912
Fernlea

The picture is called *Zacharias*.

Dear Jacques and Gwen

My composition has gone to the NEAC. I do not know if it is accepted: the price of it is £6 6s 0d. It is not quite as I want it.

I enclose a thing that is something like what the big picture is going to be. Please send it back as it is useful to me.

This looks rather swanky but the picture is not that. Send it back as soon as possible. I am going to do it on a smooth canvas 56 x 56 inches. The man with the bunch of ivy is wearing a kind of goatskin short coat.[51] This, with slight alterations, is a place in Cookham.

My letter is three whole sheets long: how long is yours?

Cookham

* * *

14 November 1912
Fernlea

Dear Jacques and Gwen

I might come earlier than you invited on the chance that you might be able to tell me where I could get a second-best-Sunday-go to-meeting pair of ready-made clothes, as I have only got one of my brother's cast-off tweeds. Now that I am a rich man I mean to look nice, like Japp. Oh, he is a real gentleman. How can I like Japp, or how can Japp like me when he loves such a person as his wife?

I think I love Japp at the root, but when I got home on the night following the Thursday I went to see him, I went to bed and groaned. I dunno why, my mind was confused, scattered and restless. Of course there were grand ladies there who spoke just so, and delicately indicated their thoughts with their long fingers, which kept dodging

about in front of a huge black mass of furs And God knows what.

I will show you when I see you.

Love from
Cookham

* * *

18 November 1912
Fernlea

Dear Gwen

Clifton the Carfax man has just written to say that he intends to buy the two compositions I have sent to the NEAC for £6. I am pleased about this because it shows there must be some demand for my things – let's hope there is. If you would like these for the same price, let me know as early this week as possible. If I do not hear from you this week, they are Clifton's. I should not buy them if I were you as I think that the painting I am going to do of it will be much better. I expect everybody to buy my pictures, that is why I write to you like this. Jacques introduced me to such a nice woman on Friday, he will tell you who she is (I would very much like to see her again), and the man she was with, Stevens I think is his name. I felt so comfortable with him, you can see me talking to him [drawing].

I look comfortable, don't I?

I liked some parts of the acting very much and some not at all. They think they have to act an emotion when they really ought to experience it.

I hope you are well and that I shall be able to see you as soon as convenient to you, and that your father is better.

Love from
Cookham

I wanted to write you long before now but was not sure of address.

* * *

Gwen Raverat's father, Sir George Darwin, died in Cambridge on 7 December 1912.

15 December 1912
Fernlea

Dear Gwen

I have heard of the death of your father and hope you will not make yourself ill, but be like David after the death of his child: 'Then David rose from the earth and washed and anointed himself and changed his apparel and came into the house of the Lord and was fulfilled. Then he came to his own house, and when he required they set bread before him and he did eat.'[52]

I have taken a little kitchen in an old cottage at the bottom of Cookham Village and I feel very drawn towards it,[53] you must see it when you come to Cookham. I have a huge Bible, a nice clean kitchen table and a window looking towards the East! I don't like windows looking any other way. I don't know if you feel with me on this point, but East means a great deal to me.

There is a bit in this garden, outside this kitchen, that is alright and I hope to do something alright.

Gil (my brother) is getting on alright, he has done some more good heads and two good hands.

Tonks thinks he might go to the Slade, for a term at any rate. I think it would do him good in many ways. I think Tonks is a good man for young men to know, I think he brings them to their senses without putting anything unnecessary into them – and Gil does want putting together.

Please write as soon as you can, though I expect you are both very busy.

Love from
Cookham

52 2 Samuel 12:20.

53 This is Wisteria Cottage, where Stanley painted *Zacharias and Elizabeth* (Tate and Sheffield Galleries & Museums Trust) and *Self-Portrait*, 1914 (Tate).

* * *

1912–13

When at the end of each day it became too dark to paint in the kitchen at Wisteria Cottage, where I was painting the *Apple Gatherers*, I sometimes used to stand for a few moments outside on the little landing and look from the cottage window towards the still bare branches of some spindle-like trees, which were hidden in a confusion of overgrown yew hedge and shrub, where a blackbird, to which I would listen, could just be seen in the dusk making a little darkness, only to be accounted for by its presence among the criss-crossing twigs and thin branches. The notes sound more local and more imminent as darkness falls and then a dark object passes diagonally down among the twigs onto the inviting and homely darkness below. Looking across to the left, I used to see, in the light of the slowly strengthening moonlight and last pale influence of daylight, Colonel Ricardo's chestnut trees standing at Lullebrook End. As the moon began to cast a faint gleam on their dome-shaped tops, I would listen, and in a few moments the sound of owls hooting was wafted across to the window. Although it was only a few moments (while I counted to ten sometimes) between the blackbird retiring below and the owls beginning, yet in that short space the translation of the the evening to the verge and beginning of night seems as great as the passing from this life to the next. The thought of the blackbird flying up again into the branches, after that pause when the owls had begun hooting and that faint gleam of moonlight had appeared in the trees, seemed impossible and less likely than resurrection from the dead. One had to say to oneself that the blackbird was there in those bushes somewhere, but a vast overlaying of circumstances, of Roman empires, of dark ages and whatnot, seemed to come between and make the fact of the blackbirds being there not a tangible thing at all.

* * *

Spring 1913
Fernlea

Dear Jacques and Gwen

Why I think letter writing is so hard for the person whose interest is not in that kind of thing is because, in getting rid of a lot of superficial stuff, he runs the risk of getting rid of valuable energy. I mean he gets rid of it the wrong way but then no matter what a man of God does, he cannot help this.

I think that is just the difference between a man and a woman.

I thank you for the gouges, a Wycombe chair-maker is sharpening them for me. I want badly to come and see you and where you live. I want to see you in the country.

I am going 'like hell for leather' at my Apple picture[54] because Butler (secretary of the Contemporary Art Society) has written to me asking me if I have anything I should like to show at their show. I can't help thinking that, with Butler as secretary, there will be a good chance of selling my Apple picture to the society. In the chance of doing this I shall ask £150 or perhaps £200! Oh my! Just see me knocking about 'down west' with Lord Howard de Walden[55] on one arm and Lord Henry Bentinck, MP,[56] on t'other. 53 Grosvenor St W., that's where he lives. And to think, to think, that a few moments ago I was playing marbles round the back lane (there is only one back lane in the world and that's in Cookham) with Georgy Gamlin and Paul Lucey. I beat them with ease every time. I am, seriously, very good at it. I want to measure the distance I even shot one day.

I put complete trust in Gil (my Gil): he is doing good landscapes. The finish of them is so intense.

Love from
Cookham

* * *

54 *Apple Gatherers*, 1912–13 (Tate), shown at the Contemporary Art Society: *First Public Exhibition in London*, Goupil Gallery, 1–12 April 1913.

55 Thomas Scott-Ellis (1880–1946), 8th Baron Howard de Walden, lived in Belgrave Square and had inherited the Marylebone Estate on the death of his father.

56 Lord Henry Cavendish-Bentinck lived at 53 Grosvenor Street with his brother, Lord Charles Cavendish-Bentinck, from 1905 until 1919. They were the younger brothers of the 6th Duke of Portland.

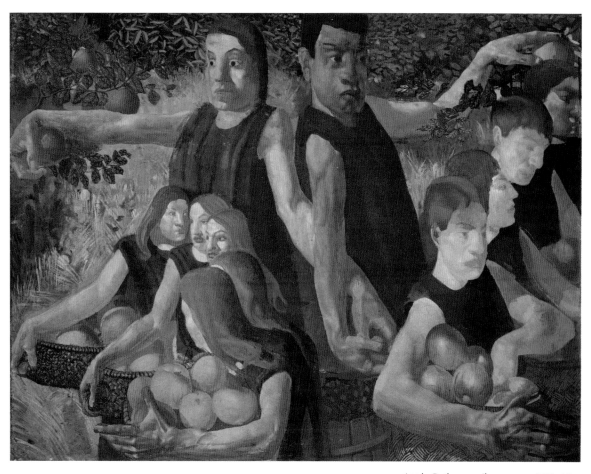

Apple Gatherers, oil on canvas, 1912–13
(Tate, London)

Saturday, March/April 1913
Fernlea

Dear Jacques and Gwen

I went to the dentist in the afternoon and he was pleased with me because I had kept my teeth so well, which I have done. I don't mind the 'drill' that he uses as long as it misses on the sensitive part but I hate it if it does not do that.

I wish you could have seen the result of your letter to Gilbert. Although, as you know, the letter is quite simple and mainly about the size of the crucifix, the kind of wood, etc., yet it would have been worth your while to have come to Cookham just to hear it read

aloud by my mother as it was last night. She sort of nods with each sentence you know.

Almost directly I arrived home my mother told me (both doors shut fast) with the most elaborate detail about the behaviour or rather misbehaviour of our new maid. It is a business and does Mother no good. My father tried to get into the kitchen to see me and ask me how I got on – but he only saw me, that's all. The doors being closed again, my mother went on, 'well I tell you my dear', etc.

Although just now I feel horribly lonely, yet in a few days time I shall be quite fit again. I enclose my father's latest poem, which I think you will like; it is exactly like my father and so English.

Gilbert will write to you himself – he is writing now – such writing – wait and see. You can see that he can carve by his writing: I should think he could do some fine lettering. Gil has just made a statement that he is going to do a study of the crucifix in clay, but he must not, and you will agree that it will be better that he should make some very good drawings of it. Clear drawings, say four, front, back, side, and perhaps a three-quarter view. Anyhow, anything rather than clay. My God, that is how things go on at South Kensington!

I do dislike interfering with Gil but this was important. I wish you would say how you think he should do it. If you remember there was a figure leaning against the cross in the picture: would you like it in the carving?

Thank you for the letters. I remember that when I was with you last I agreed with you at the end of that argument we had on the necessity of 'thinking'. I quite agree with you about the grass and the same lack of unity and oneness I feel in the whole thing but – when I have got it all in figures and everything, I shall be able to get the thing together because it can be done.

Your sermon is alright, though taking it as a sermon preached at me, I wish to ask you a question. What do you mean by personality? When you look at my picture you might be taking what is the very 'inspiration' to be the personality. If you take personality to mean a sort of 'style', a way of painting that an artist has noticed as peculiar to himself and on that account develops and introduces it into every picture he does, then I agree with you for condemning it as wrong. Do I do this sort of thing? I think perhaps you meant that I

unconsciously introduced personality into my pictures. That I think is true, but then who does not? But this is getting too thick. Why do you think I might bear malice? I think you cleared your throat a bit in the sermon part. I do not think specially of detail. The detail happens to be a part of the idea. I absolutely and entirely agree with you about the lack of thought, how it has made the picture so meaningless. I think I can benefit myself by your sermon.

I must get to my elm tree on the dusty road in the boiling sun.

Love from
Cookham

* * *

12 April 1913
Fernlea

Dear Jacques and Gwen

I have been to the Contemporary Art Society at the Goupil Gallery. It is rather an interesting exhibition, there are many 'styles' there you, know. My work[57] is in the corner, it looks 'done up', just as I do when I have had too much to eat. A picture is there and it is called 'Interior with figures' and is by Duncan Grant. What is so funny is the expression on the faces of the man and boy: you see they have been sitting there for hours and hours. His other work is bad. Your pictures that you have lent me have comforted me very much; they make me feel good. There is a picture of a lion coming out of the sea,[58] one of its paws is uplifted and is resting on an open book – do you remember it? I do not know quite if I like it, but I shall remember it until I am dead. This picture is by Carpaccio. I like the shape of the borders round the sculpture works in the Giotto Campanile.[59]

I have read *Dr Faustus* and am reading *Tamburlaine*.[60]

Last Saturday I went up to Stokowsky's. I drew a boy named Tulio. In the afternoon I went to the Queen's Hall and there we heard Sir Henry Wood conduct a choraliospiel[61] and another tremendous thing of Bach's, and I also heard the 9th Symphony again.[62] After it was over I wanted to go home and to bed, but we went to the British

57 *Apple Gatherers.*

58 *The Lion of St Mark*, 1516 (Palazzo Ducale, Venice) by Vittore Carpaccio (*c.*1450–1525).

59 The free-standing Campanile (bell tower) of the Cathedral in Florence, begun by Giotto di Bondone (1267–1337), painter and architect, appointed supervisor of Florence Cathedral in 1334. His design was altered later.

60 Both by Christopher Marlowe (1564–1593).

61 Spencer's word: a choral work.

62 Ludwig van Beethoven (1770–1827).

Museum and looked at the Elgin Marbles and Egyptian work, and then Stokowsky drew Tulio until 10 o'clock that night and expected me to do likewise! On the following Sunday we both went for a little while to the Brompton Oratory and heard those boys sing a Mozart thing. They can sing. It is such a quiet, homely little choir.

I have finished the woodcut[63] and enclose proof of it. I think when I do it again, I shall cut the hedge more. What I cannot understand is how you get so deep down into the wood without in any way injuring the sides. I want my cut to look clear; it looks untidy.

I want to go on a long tramp with you some day, but I shall have to keep a firm hand on my thirst. I get ravenous for ginger beer on draught. There is too much gas in the bottled ginger beer and when that comes up from my insides and escapes down my nose, well, I tell you it is a most unpleasant sensation.

Love from
Cookham

* * *

5 May 1913
Fernlea

Dear J. and G. Raverat

I was glad to have the letter. Do not say, as you keep saying at the end of your letters, that 'it is a stupid letter but better than nothing'. I feel as though if I don't slap you on the back, that you will not write to me again. That is just the feeling that sentence gives me. Your letters make me want to eat and work.

I hear that the London General Omnibus Co. is going to run a service through Cookham. Cookham is taking 'great strides' and is fast becoming a popular riverside resort. I walk down my heavenly little lane and turn the corner to look at something that means everything at once; this is what I see: 'Get it at Harrods'. This is printed on a van that was standing outside the house of George Young, son of Sir George. If you know God, tell him that he is in danger of the judgement.

63 *Joachim among the Shepherds*, 1914.

My love for Cookham is so strong that even things like this only annoy me, nothing more.

Pa just gone by.

I wish you would write, Jacques, you are becoming quite a person of the past. It's such a very nasty sort of feeling. Tell me what Jacques does if he is in the armchair, tell me when he blinks. Tell me what he eats, what he drinks. (Important what he says. Oh! very important!) Say something about him that will make me feel that he is not in the past.

I am going on with my 'Joachim' painting.

What is the latest of that composition you were thinking about when I was with you?

Those pictures you have lent me, what a comfort they have been to me. I look at them in bed and my bed gets into what you might call a tidy mess. I don't look at them with an artistic eye, I look at them with a curious eye.

Is Garnet a Jewish name? I believe it is. My Grandma on Mummie's side was a Garnet and every body says it's a Jewish name.

Brer Gil, Japp and myself went for a perfectly glorious walk into Buckinghamshire, we met nobody.

Japp was so nice, tears burst into my eyes as I think of him. Japp had chickens' eggs and so did Gil and me. Japp said disdainfully 'I will have plovers' eggs tonight'.

He revealed himself a great deal to me, not by speech but by his manner. What a pity it is he depresses me, because I love him. I do not think he is over happy. He has got another baby girl and he's quite bucked about it, it must be grand. Ma told him babies are not so tiresome when born in the spring as they are when born in the winter. I told Japp I was born with the June roses but he didn't say nothin'. He seemed quite disgusted.

I'm going to bed. God bless you.

Cookham

My bedroom is very nice, quite inartistic. Over the washstand there are two text boards, old fashioned ones, in frames. One says 'The Lord is my help' and contains a picture of bluebells and the other says 'Pray without ceasing' and contains a picture of daffodils and

jonquils (I cannot spell narcissus quite correct). They are there just as naturally, as you see them on the walls of little old rooms belonging to old-fashioned people. These have been on this wall a good deal longer than I have been alive.

* * *

Undated
Fernlea

Dear Jacques and Gwen

I will come and see you, Gil too. A weekend. When please can we come? I have more questions to ask; have you any? I wrote you a long letter, no good. I decided to talk to you about it, it is something that will help you to understand why I have for such a long time deprived myself of the greatest pleasure I have that is the pleasure of coming to see you. I am right in one way and wrong in another. I am fed up with the letter writing. It will be refreshing to see you instead of having to write to you. There's nothing like seeing: talking can go to the winds then, though it cannot in a letter. In a letter you have to keep on, like Gil says sister Annie does. Yap yap yap, yap yap yap, and no stops. Still, what she says it is interesting.

This is all the news.

Gil has done a good picture of Cain and Abel and one I think I told you of a woman lifting a boy over a stile, I like this better.

I had a letter from purchaser of Zacharias. He wants to see the painting I am going to do with it. His name is Frank Rinder[64] he lives at St John's Wood. Imagine my picture going there! He offered me £10 10s 0d and I accepted it, a very decent offer. I think I shall take the money I have in the Post Office savings bank, which comes to just on £50, and make it a deposit account in the London County and Westminster Bank. I think you can get 4 per cent in this bank, and it is a very safe one. I already have a current account in it. It is too 'current' for me.

Do not say anything of Ma's illness in any of your letters to me, for I like her to see them and she is not to know what is the matter with her.

He describes the drawing he bought as 'gravely designed' and 'suggestive'. Here is a bit of news I have just received from our doctor.

64 Frank Rinder (1863–1937), art collector and critic.

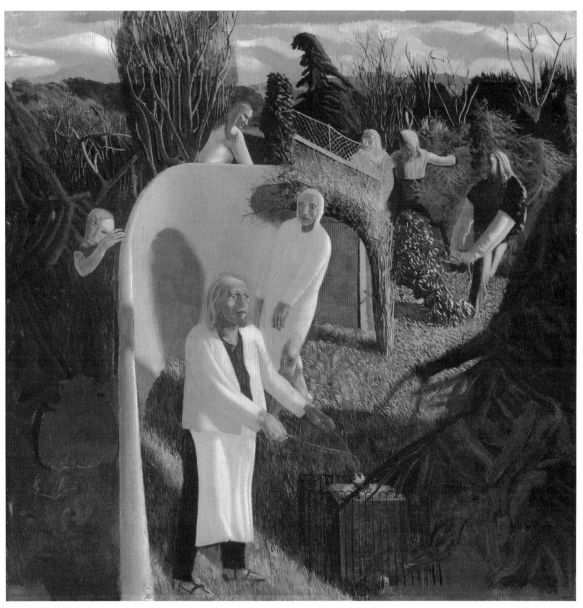

Zacharias and Elizabeth, oil on canvas,
1913–14 (Tate and Sheffield Galleries
& Museums Trust)

He tells me that my mother has, he fears, a disease in the something that encases one of her lungs. This being so causes the extraordinary amount of phlegm she is constantly spitting and coughing up.

I wish you, Gwen, could get to know her, it would put some real joy into her life and that is just what she needs.

Japp came down to see us in Cookham yesterday, he was very nice and he enjoyed himself, as he always does. He liked my Zacharias picture very much and could not understand why people had said to him that it was all a muddle, 'for I', said he, 'find it extraordinarily clear' – although Japp has a long way to go before he understands my work. Yet I feel glad that he likes this Zacharias picture.

Gil said something about my picture yesterday morning to me, when I was going over his work and advising him about the reaction to show Japp: Gil suddenly told me that my picture (I have drawn it out on the big square canvas) had got a cosy feeling in it. The word 'cosy' to you might seem wrong and meaningless but to Gil and me this word has a meaning that would be impossible to describe. He has never said anything about anything of mine without my first having to ask him to do so. That this time he shot it out as though it was something he felt very strongly made me very pleased.

Another bit of news is that Japp has bought the picture I did years ago of the two young women, the fence and the beehive – you remember it well.[65]

I am absolutely starving for music from the 9th Symphony again. It seems years since I last saw you. Am going to Mrs Sargant Florence's[66] at home on Sunday, I wish she would teach me how to paint in tempera but I doubt if she does teach. I wish I could play the piano or organ. I am just beginning a book of Bach's pieces for children edited by Walter Carroll. I am determined to struggle through this little book somehow and get the correct beginning.

My brother Sydney has passed his entrance exam and is now a real live Oxford undergraduate.

I hardly know our Doctor at all. I took a letter I had from Japp this morning into my mother's room, to show her. 'I should like to show it to Doctor Ellis, dear.' When she goes away to a boarding house she usually tells anybody she meets – she does not mind who it is – the whole history of her 'symptoms' or of our family or anything

65 This appears to be *Two Girls and a Beehive*, *c*.1910 (private collection). Yet the catalogue raisonné lists it as purchased from the artist by Sydney Schiff. (In 2001 the picture belonged to Lord and Lady Irvine.)

66 Mary Sargant Florence (1857–1954) was a painter in watercolour, tempera and of decorative murals, and a suffragette.

you like that does not concern or is of no interest to anybody, at least the kind of people she meets. We do laugh so.

Let us have a time for us to see you.

Love from
Cookham

* * *

May 1913
Fernlea

Dear Jacques and Gwen

Last Sunday I went and saw who do you think? Mrs Sargant Florence She lives about five miles north-west of us at a place called Marlow. She is a suffragette militant, I believe. It is very depressing to see the way this woman works, especially as I know she will never do any good. Of course she spoke about the 'cause': I do not know quite what she means. I know that a 'cause' is a thing invented by women but she was too intellectual for me. I took with me some drawings of mine and a 'sketch' book of Gil's work (I brought it down to Croydon with me). It contained a study of his Crucifixion composition (you, Jacques, liked it better than the actual composition) and a good drawing of my head, side face looking down. I came away from Mrs Florence's with it under my arm. When I got to Marlow church it was gone. I went back and looked for it but it was gone. It made me feel so ill that I hardly knew what I did.

Of course when I got home and told the news, my father was grieved, but that was only natural. He has been very nice to me over the 'picture business' as you say. It did depress him much more than it did me: it made me mopey on the morning of the arrival of the news, and that is just about all.

I have just heard good news I will sing a psalm of thanksgiving:

jingle go jang my joy my joy
jingle go jang my joy:
Gil's book is found!

my joy my joy
jingle go jang,
my joy.

Pa wrote to a Miss Ferle, a schoolteacher asking her if she would ask her children if they had found the book. A little girl said that a little boy (aged 5) who lived opposite her had found one.

The streets of Marlow, on the night of my losing it, were packed with visitors. The book arrived at our place tonight with new and original illustrations. Enclosed is one of them. In my last letter I told you all about Cookham. Gil is going on with a landscape at present, as he has not yet got the wood for his carving. He has done some drawings for it, which are not bad but not quite the way he should do drawings for a carving. Still, they will do; the shoulders are good. He will not tie himself down to them as he might do if he did some very good drawings. I am getting on with my Joachim picture,[67] I wish you could see it. I will let you have the opportunity of seeing it before anyone else, except perhaps Tonks. Three years ago he offered me £15 for a small painting, and a few weeks ago he reminded me of the fact.

If either of you should come to London, come and have a look at Cookham. I haven't drawn a very encouraging picture of Cookham, but on Sundays it is quite quiet. I went to an anti-militant suffragette meeting the other day. You will be amused to hear that Gil and I are gentlemen in favour of woman's suffrage. I signed a card (the first to do so, I believe) then Gil did, then Frank Godfrey. It was fun, we were among the very roughest lot and every time I tried to sign I was bumped and shoved all over the place and called all sorts of names. It was not until Gil and Frank arrived was I able to sign. A lot of these men wanted to chuck us in the Fleet (a little tributary of the Thames). Rotten eggs were thrown, but without effect, except to drive Mrs Woodhouse from her huge hammock into her house. The whole time this meeting was going on she was swinging herself gently to and fro and gazing out at the crowd. She has one of the most horrible faces I have ever seen. Although of course there is no such thing as representation in the Houses of Parliament, at the same time I don't see why a woman who pays taxes, etc., should not have the same privileges as a man – if they are privileges. What a pity

67 *Joachim among the Shepherds*, 1913.

it is that England is so civilised. Here is an instance. Gil says to me something about the wretched visitors, Pa objects and says they are very nice, etc., and so we have to respect Mr Benjamin.

I feel too weary to tell you anything about Cookham. When I have done with Marlowe, which I haven't yet, send Cobbett.[68] I went to the dentist three times. I will give him your address again. Japp wrote to me a nice letter asking if I would have my Apple picture photographed and offered a good price for two prints; he said that Henry Lamb wanted one. Lamb liked my picture very much and wanted to buy it but he is too poor. Do you know Lamb? I do not.

Here is the photo (enclosed) I think it looks much nicer than in the original. I like the arm of the woman on the extreme left, particularly in this photo.

Promenading has begun in Cookham, but things are not yet in full swing: that won't be until Ascot races. On Ascot Sunday there are over ¼ mile of motors on either side of road leading to the river. Two punts have just gone by, and yet another two, purple and blue, both lots.

I am trying to learn an organ fugue in the church: Our Father which art in heaven. It is very easy and in C major; it is very fine as well. It can be managed on the piano.

I wish, when before I went to the Slade I used to go with my brother Sydney up to Hedsor church and blow the organ for Pa, that he had known Bach as he does now. For then it used to be Tchaikovsky, Brahms, etc. He used to do Handel: it was Handel who first brought me to any right mind about music. Or rather encouraged me in the right direction.

I went and showed my photo to Pryce-Jones, chemist, Cookham.[69] He has a delightful apprentice named George Augustus Hands. We call him Gus and he rides up and down the street with his hands in his pockets and winks at and chats with all the pretty girls, of which there are many. Would you not like to be able to do this, Jacques? I should like to, but it is too difficult. One has to be born to it. Oh dear, there goes Mr Farrer: he is a good bit over 6ft, flabby, effeminate, and the defender of women against white slave traffic for this district.

This is Friday and I have just finished my day's work on my painting, much to my surprise. I went on painting and looking forward

68 William Cobbett (1783–1835), parliamentary reformer and pamphleteer, whose *Rural Rides* (1830) describes rural poverty.

69 Spencer later made a portrait drawing of David Pryce-Jones, entitled *The Chemist*, 1931 (Stanley Spencer Gallery).

to my tea, which seemed to be a long time coming. I was rather surprised to see Alice Leonora Hatch[70] come for her music lesson (she usually comes at 6 o'clock) I went into the music room to see what the time was, found all the clocks wrong, as I thought, went downstairs found tea over and Gil's tea ready for when he comes in off the quarter to seven train. I asked Ma if we were going to have any tea, and she said: 'stupid boy, you've had it. You had it at 4.30!' I cannot understand it.

My long lost love is an innocent one. She talked to me against these new mauve-red jerseys that are so fashionable. She now wears one. She jilted me, you know. There are so many handsome youths about in Cookham that it is quite impossible for me to compete with them. So I have ceased to lovemake. I ceased exactly two years ago.

It is very queer that a man like Marlowe should have professed himself to be an atheist. I mean that he did not seem to realise that in spite of his calling himself an atheist, he was a man of God.

Gil has come back from doing a drawing of a tree. He had not been doing it long before a girl came along and commenced 'sketching' nearby him. It reminded Gil so much of Camberwell School of Arts and Crafts that he had to come straight home.

Cookham

Write as soon as you can.
You may keep this photo.

* * *

May/June 1913
Fernlea

Dear Jacques and Gwen

Gil is going to the Cookham Cricket Club dinner, which is being held at the Bel and the Dragon tonight at 7.30. Gil, being a member, had a card of invitation from 'the Colonel', who is giving the dinner.

Gil is not like George Hatch, farmer; his daughter, Leonora, told me in awestruck voice that her dad is 'an honourable member'. It is a pity he has been saving up for this feast and he hoped to

70 Daughter of George Hatch, farmer, who lived at Ovey's Farm, Cookham.

bust himself and now today his throat was troublesome and so he fears he will not be able to do himself justice. This east wind and the blight, is damnable and does Gil no good and gives me the fair pip.

The dinner will be rather fun, for the cricket team that Cookham played this afternoon was composed of policemen and they are also going to the dinner and of course they will sing songs, as also will many of the Cookham men, particularly the Hon's.

What I like about Gil is that he is of the 'people' he has just gone by, down to this affair with many other young men. You know what I mean, artists are usually so eccentric and inhuman, like John, for instance. I expect now that the policemen are singing, 'singing with full throated ease'.[71]

I 'move' among the very best Society in Cookham. There is Charlie Rowlands, the man who milks the cows: he tells me such buckswashing[72] tales that were I ever to tell anyone he would be imprisoned, of course he comes out with them without encouragement or condition. Then there is dear old 'Fan' Hatch, she and I are great chums. She is always talking about money and property. Her aunt, so she said was very fond of her, and Mrs Hatch of her aunt. This aunt had a lot of money and when she died she did not leave Mrs H. any: 'no my dear, she gave me a dusty old 'quiver' and I did look through the pages in 'opes that I should find a £10 note, but no, not a soo – not a soo' – and she drew her mouth into a little round o like that. You know this sounds all very amusing in a way but you would soon get tired of it. Here is an extract from a little conversation I had tonight with Charlie Rowlands, Charlie White and Mrs Johnson about Jo and her daughter. Mrs Johnson looks after and cleans the church:

Charlie R: What'cher artful! What be y'at?
Me: What, Charlie?
Mrs J.: Good evening, Mr Spencer.
Me: Good evening, Mrs Johnson.
Miss J.: Good evening, Sir.
Me: Good evening, Miss Johnson.
Charlie R.: I can't 'ave this roamin' about.
Mrs J.: I was sorry to 'ear about the property.

71 John Keats (1795–1821), *Ode to a Nightingale*, line 10: 'Singest of summer in full-throated ease'.

72 Stanley's idiosyncratic spelling: swashbuckling

Me: Be so hard on old Samey Sandals if he has to go, and then there is Liza too, she'll feel it…

Miss J.: Yes, and then Mrs Rolf'll die and then 'er property'll be sold and then where will they be?

Me: But they would not want to go into those cottages.

(Sanitary arrangments discussed at great length)

Mrs J.: I'd like to know the rights of this 'ere Lewis person.

Me: I'd like to know how the Charity Commissioners carry it out.

Charlie R: Same 'ere.

Mrs J.: Well, Mr Llewellyn says as how there had been two vacancies and how there had been three happlications and all three been accepted, and as how the governors had been oversteppin' the hinterest.

Me: They must be fools. I wonder how Mr Llewellyn is?

All: Is he bad?

Me: Shingles in the head. Poor old gentleman.

Mrs J.: You don't say! Well, I was coming away from the church a few days ago and I met him. He was outside his place and he says to me 'good afternoon Mrs Johnson', so I says 'good afternoon'. ''tis', so he says to me, 'we have had a nice rain', so I says 'we 'ave sir, and I 'opes it'll do some good'.

Me: Well I don't know, that is what I heard anyway.

This is word for word what was said. It is not funny but I like it better for that reason. Charlie White came later carrying the jug of beer for 'is dad: he spoke so, but even if I understood I could not put it down.

Your letters are never dull, Gwen Raverat, and the part about the money business is as clear as daylight, 'orribly clear, and I like that about the master of Trinity. He's an Englishman isn't he?

Who are Le Nain[73] and Jacques-Louis David?[74] Never heard of them. That was a long letter and I was grateful for it, but I have sent you heaps as long and much longer. Show you how grateful I am: I read it heaps of times.

Cookham has lost one of its little ones, a little boy son of Mrs Rocket. She was some years ago, and when not married, a servant of ours; her name then was Rose Grimsdale and I like her very much. The boy, five years old, fell into the river and would have been

73 Brothers Louis (*c*.1593–1648), Antoine (*c*.1599–1648) and Mathieu (1607–1677) Le Nain were seventeenth-century French portrait painters.

74 Jacques-Louis David (1748–1825), influential French neoclassical painter.

drowned had it not been for a little chap named Binfield who went in and fetched him out on his back. He took him into 'the Colonel's', where he was given a hot bath. But I heard a few days after that he had pneumonia. Mrs Rocket asked Gil for a fairytale book and a picture book, so Gil took some round. Pa went to see how he was yesterday and a few moments after he left, the child died. Both the mother and father will feel it very much, they are very fond of their children. Of course they are very poor, but it was nice to see them all together. I don't mean that they are all so blasted devoted – I don't know that they are.

This is how Mrs Rocket stands, with her hands on the clothes post like this: [drawing] – while all the little kids play round her with their wheelbarrows, saucepans, etc.

I am alright, so is Gil. He is a great narrative writer: if there is anything funny in what he writes, he writes it not because it is funny but because it is a necessary part of the narrative.

Cookham

※ ※ ※

Stanley's correspondence with Australian-born painter Henry Lamb (1883–1960) began in 1913. Lamb had trained as a doctor but abandoned his studies in 1904. He studied at the Chelsea Art School under Augustus John (1878–1961); an accomplished pianist, he also kept a library at 3 Vale Hotel Studios in Hampstead, to which Stanley was a frequent visitor – and to which most of Stanley's letters are addressed. Lamb served as a medical officer in the First World War, on active service in France, Macedonia and Palestine.

1 June 1913
Fernlea

Dear Mr Lamb

Your friend Mr Japp told me that you liked my picture at the Contemporary.[75] It gives me pleasure to enclose herewith a photo of it. I think it looks better in this photo than it does in the original. I

75 *Apple Gatherers* was shown at the Contemporary Art Society: *First Public Exhibition in London*, Goupil Gallery, 1–12 April 1913.

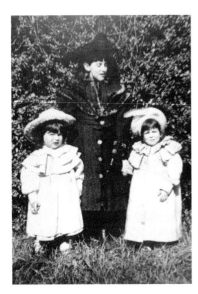

Annie Spencer with Gilbert (left) and
Stanley in their coats and bonnets, 1895

76 'Nohow' and 'contrariwise': Tweedledum
and Tweedledee in Lewis Carroll's *Through
the Looking-Glass and What Alice Found
There* (1872), chapter 4.

hope to see you someday – I don't go to London now and so hardly ever see anybody or any works of art. Japp comes to Cookham sometimes and tells me about everything – you know he knows everything.

Yours very truly
Stanley Spencer

* * *

24 June 1913
Fernlea

Dear Jacques and Gwen

Cookham is fast coming to a head – crisis next Sunday. Still, there are left reminders of what Cookham used to be like from the point of view of its people. For instance, sometimes when I am in the Marsh Meadows I see an old lady walking along a footpath which runs across these meadows. She is a very old Cookhamite and has walked across these meadows ever since the world began. When Gil and I used to go out for our afternoon walk with sister Annie, we used to wear little white caps like this and coats like this [drawings].

I remember this old lady and the mysterious effect she had on me. She still wears the same clothes and same old-fashioned boots. My sisters had a nasty way of getting miles ahead of us without our realising it. In those days Gil and I did justice to our lungs: 'Wait for me, Annieee!' was heard everywhere in Cookham.

Cookham in the times of Charles I must have been heavenly. There are some very young children in Cookham that give me more joy than I could well describe to you in this letter. Oh how I envy that nurse! Everything is spotlessly clean. You can just see the little boy's head above the grass. Just a little bit of silky gold mist. What I should call a broad baby with eyes, I don't know. I should like to dwell on this matter until I have decided but it cannot be done, nohow, contrarywise.[76]

My grand aunt Hatch was a character. On the occasion of my Grandma's death, she was asked how the funeral went off. 'My dear,

delightful, and the sandwiches were delicious.' She had corkscrew curls, I can't draw them. But all real grand aunts have them. She went for a trip on the river and returned full of it. 'My dear, there were Mr and Mrs Orley, Mr and Mrs Philip Wig, and the Woodbridges: better society I was never in.'

Ma tells me these little bits. She tells me many little things like this and I love listening to them.

Monday 23rd
Yesterday was terrible. It is no good trying to look upon it in a stupid artistic way, to gaze upon the morning marshes and say 'by Jove! What life!' etc., nor yet to look upon it like an inane philosopher (I know many). After the people had got on the river there was a silence, as there usually is, an awful sort of quietness. During that silence iniquity was behind the hedges and under the overhanging trees. This is quite true.

Friday
Yesterday two aeroplanes came down on a common not far from Cookham village, one a biplane the other a monoplane. Of course I like the monoplane better than the biplane, it is so simple. This morning I got up at 3am to see them go off, a sight worth seeing. It seems a rare job to get the engine going. It's like this 'ere (I expect you know but I want to tell you): the aviator gets in while another man goes to the propeller, huge and threatening in appearance, and takes hold of it and calls out 'off!' and the chap in the car says 'off!' and the man turns the propeller the wrong way round. Then the propeller chap calls out 'contact!' and the chap in the car says 'contact!' and then the propeller is turned the right way round.

I like to think of these aviators, to see them fly into 'the Chambers of the South': that is what they do.

Brother Syd has been playing some Chopin things out of a French edition of Augenois: *Pièces de Clavecin.* Brahms and Chrysando. They fill me with extraordinary feelings, nice feelings, a feeling (I'm great on feelings) I had when I was six years old.

We bathe every day Gil, me and Syd. Syd goes underwater a lot but not so much as he used to as once, in going along the bottom as he usually does, he got into one of the deep holes and when he

thought, casual like, that he would come up, he found that he had a long way to go. When he did get to the top, he let everybody know it. Some of these holes are 20ft deep. It is awkward for people punting, they have to punt like this: [drawing]

It's wonderful what a man will do when he has got a nice fat Jewess in the punt with him.

I am gradually beginning to see my coming composition but I do not want to talk about it till I have it quite clear in my mind. I wrote a lot of matter which I decided not to send. It was written when I was in one of those moody conditions. Moods are horrible but there is one comfort: they pass off. That godless, hopeless, incompetent feeling is not always in you, you have only to say 'make me to hear joy and gladness; that the bones which thou hast broken may rejoice'[77] and if that does not satisfy or relieve then time will.

I have noticed in Cookham church there are a lot of squares in the roof of the choir like this. There are 40 squares and they are about 6ft square. The borders are thin strips of oak, I should think.

Write me another letter.

Gil's picture for Slade composition promises to be good. Very good.

Cookham

I am painting my head.

✳ ✳ ✳

Summer 1913
Fernlea

Dear Jacques and Gwen

We got the postcard and letter. We only have a small apple tree, which generally yields about a basket, if that, but they are splendid eating apples, Ribston Pippin or Cox's Orange. I hope you will send some, because Mother loves little presents like this. That is the blessing with these sort of people like Mother: you can give them pleasure. She has been reading Cobbett and when she talks about

77 Psalm 51:8.

him she looks like she does when she talks about her 'brother John' (a rather narrow-minded strict Methodist).

I was also very sorry not to be able to come apple gathering, I love doing things like that when I am not 102 in the shade, which is just about what I am now.

As you say it is the joy to feel that you have got hold of something. To have husband or wife or child is all fun and important, but if you are not sentimental you still feel miserable, and cannot enjoy these benefits, when God is not in you. Seek ye first the kingdom.[78]

I have had a letter from Japp to say that Henry Lamb will buy my Apple picture, that he will give me £30 for it and that if he has to sell it, which he might have to, he will give me all the profits above £30. Is not that very good of him? What pleases me is that he buys it because he wants it. I am going to let him have it at this price.

I have also had a letter from Bobby: a tale of woe, 30 shillings in his possession – not a word of this, mind: he is also receiving epistles from people such as Burt, for instance. Bobby encloses a letter from him, as I imagined from the first time (I did not see the letter) teaching Bobby to suck eggs.

We are having Bobby down here to Cookham on Saturday week. Bless 'im. I think he will like it.

My picture will be alright and when I have got it well on the go and Gil finishes his picture we will both come for a weekend. I think it the best plan to pay short visits, though not always.

If I sell something at the NEAC won't that be grand? It would be a good plan if when Gil is hard up, I help him and when I am so he helps me.

I feel too much of a 'dog' to write. I want to get to the picture. Goodbye; send the apples.

Cookham

My German sister-in-law sends 'greetings' and now you have started it, my Daddy is writing all his poems in a gilt-edged notebook and beginning words such as 'Incense sweet', etc., with a red letter. We can't find out who it is for.

* * *

78 Matthew 6:33.

August/September 1913
Fernlea

Dear Jacques and Gwen

I have not done anything to my 'Joachim' painting[79] for a long time. I feel almost lost about it, but I should do it. I am still painting my head.[80] I'm nervous about this new idea of mine but I do not wish to speak about it. There is a fine photo of Dr Butler,[81] Master of Trinity, in *The Graphic*, almost life size, and is, so sister Florence says, exactly like him. She once met him and had to travel with him to Cambridge alone and he was talking all the time to her and telling her lots of things, and she knew all the time that he was on the verge of falling asleep; but do you know, there seems to be something very God-like about him, though he seems quite unconscious of it.

I feel very curious about people's heads. I have quite a passion to make a thorough examination of their heads; there are some heads which seem to form an idea in you. My German sister-in-law, Johanna, who is staying with my brother Will, her husband, in Cookham has a fine head, although it is German. She is fat, not flabby, thick-skinned, short, has little tiny, kind, humorous brown eyes and is about 46 years of age, horribly intelligent. I wish she was not German: there is something about Germans that I cannot do away with. I think that English people are the only essential human beings. This is due to inspiration from God, not patrotism.

I do not feel like writing my 'official' letter just now. I got everything quite safely and you sent me the Vézelay card. At last I got the Bathsheba. I noticed it was missing when you gave me a lot a long time ago, I hope you have got all the ones you have given me. What annoys me is that I do not feel barren, and yet I am not producing anything. Still I keep hopeful about certain things. I have made up my mind not to come and see you until I have a respectable amount of work to show you, and for this reason: not, as sister-in-law Johanna says, because I do want to appear pee-fect, but because it is so depressing to show yourself and nothing else. But I do long and long to see you.

I like those little red books you sent to me, they are sentimental, but I like them, I mean I like him, G. Macdonald, in a way. Cookham is still full of 'Sport' hunters, but it is much nicer now than at Ascot

79 *Joachim among the Shepherds.*

80 *Self-Portrait*, 1914 (Tate), on which he worked for nearly a year. This was Stanley's first painted self-portrait (see cover and p. 3).

81 Montagu Butler (1833–1918), Master of Trinity College, Cambridge, 1886–1918.

time. The flower show, except for the rain, was very nice. Of course the vegetables found it rather embarrassing: I saw some potatoes blushing and wondered why. I soon found out: they had got first prize. The vegetables have not been good this year, neither the fruit, but these potatoes had that lovely 'bloom' on them, pink they were, you know. but I prefer the good old earthy, hardy potato.

Thanks for the postcards, they greatly frighten me although I like them. It seems, by what you say on my card, that you do send me pictures that you have not yourself. I always carefully keep them. My brother and his wife are staying at a very old public house (it is a very high-class hotel: it is quite small, homely and very old) I went into the garden of this place the other day, I had never seen, neither had I been in before.

It is interesting to watch a boy like Gil, because you see everything that you have long suspected of being in him, come out quite clearly, it dawns on you very much as stars do in twilight. It makes me realise something, which is that I know a lot about him. He used to make little miniature carts, carriages, wheelbarrows. They are rather clumsily done but the proportion of them is extraordinarily good, and he seemed to be able to get it without any trouble – and you know how difficult it is. I must get him to do some more in his spare time. He is, according to 'people', rough and uncultured, but then I agree with you about this generation. I will get an introduction for you to a man that a friend of my brother's knows, who can swear for five minutes without ceasing and without using any one word more than once: there's glory for you!

Monday
We had an old servant of ours here today. Her name is Annie Timms but we called her Alice, and I love her very much. She is now Mrs Low and she once was in danger of being Mrs Walker. But Walker went out with girls, and now she is Mrs Low.

Tuesday
I have received your letter, and thank you for it, I read it many times. It will be nice when you know my mother, because although she is quite unsophisticated and extremely childlike in her ways, she is essentially a mother, I mean a mother by instinct and by the

ruling of a subconscious energy, God, that she is almost unaware of. She used to nurse us when we were ill and if only a mother realised what she was doing towards the encouragement of the affections towards herself of her children when she did this thing, and also if she were humane, children would not be so shamefully arrested as they are.

Friday

I have just got the two little books and I have written my name in them, so you won't see them again. You are right: I am quite certain I shall not despise them. I do not like either of your woodcuts, but I hope you will take little notice of this, God damn. I think the picture is mannered and affected. This opinion may be due to God and it may be due to the devil: Jacques will say the devil, I say God. It is better that I should say this than that I should harbour these sentiments in my mind; it would be wicked to do that. If this should happen to depress you, and it ought not to, you will remember what good reasons I have for saying that you are wrong.

I am very anxious about this portrait of myself, it gets bigger and bigger, but this is not such an unfortunate habit as was the habit of 'poor' Helps[82] – you remember him – he would begin his portrait in the extreme left-hand top corner, hoping to have it finished before it had escaped out of the right-hand lower corner; he fought against this habit hard, but I often had to remind him that he was painting the air on the right of his canvas. I had to tell him several times: 'I went and shouted in his ear' before he realised his error, and when he did his disappointment was great.

I must go to bed as I have to be up in the morning at 5.30 (I find I can do this quite easily and I get two hours' work done before breakfast). I end this letter to Jacques. I wish I could unscrew my head and send it (per parcel post) to you and Jacques, so as to see you both; of course you would return it to me – carriage forward.[83] Remember that you have done something that no women seem to be able to do in the present day, you have made a 'home' and I know what a home is.

Love to you and to Jacques
Cookham

82 Francis Helps (1890–1972), painter and teacher, studied at the Slade 1908–*c*.1914.

83 That is, delivery pre-paid by the sender.

5.30: I should love to live near you in Croydon, but I shall not be plaguing you with little Cookhams yet.

I would just love to hit someone; the people of Cookham – the younger members – chiefly the girls, are suffering from 'peace of mind' do you know what I mean? They have thought it out, brought it to a conclusion, and now they walk about the street with a coat over their shoulders. Complete. Complete … at the age of 22. I really am going to do a picture of Hell, and this will be in it. I have thought of a splendid idea for the frame, it is going to be strings of exercises by Charles Hallé,[84] thirds chiefly, and a nice little portrait of Charles Hallé in the centre.

Here is a bad drawing of Gil, but very like him. I am pleased to hear such news of Michael, I wish he would write. Remember me very kindly to Mr and Mrs Banfield.

I will get Gil to write another of those letters. Don't you think there is something fine about Gil's face? Return drawing, unless you want to have it.

<div align="center">* * *</div>

10 October 1913
Fernlea

Dear Mr Lamb

Thank you very much for the £30.[85] Of course if you at any time should feel you could give me more I should be very glad to receive more but I do not want you to feel obliged to give me more, because you are not. For the sum you have so kindly sent the picture is yours. I should like very much to meet you at Mr Japp's one day while you are in London.

It was very good of you to try to get the Contemporary Art Society to buy my picture. I did not expect them to. I should be interested to know the 'friend' who conveyed your bursaries to the society.

I think there is some hope in the Contemporary, after all C.K. Butler did buy two commissions of mine. But I think *Apple Gatherers* was rather a shock, however I did not intend to upset the gentleman's digestion. I do not think he will visit to me again in a

84 Sir Charles Hallé (1819–1895), pianist and conductor.

85 This refers to Lamb's purchase of *Apple Gatherers*.

hurry; he will look before he leaps you know.

Do you happen to know Mr Henry Brenil? He is a member d'Honneur of the Union Internationale des Beaux Arts et des Lettres and has invited me to become a member; I accepted. Is this society any good? I do not know it. I thought it would be nice if I wanted to exhibit in France.

I have just been to the Post Office with the cheque and I find I am too wealthy. I cannot put it in the Post Office Savings Bank.

My younger brother Gilbert (a year younger than myself) has done a big picture for the Slade competition. I wish you could see it when they are on view at the Slade School.

Yours very truly
Stanley Spencer

<p style="text-align:center">✣ ✣</p>

24 October 1913
Fernlea

Dear Mr Lamb

Thank you for your letter. I should like to see you and I will bring you your picture on whatever day you should suggest as convenient.

Many people have tried to convert me to Hampstead Heath, but with all its fine trees, wonderful views, etc., I always get horribly depressed whenever I go there. Mr Edward Marsh[86] wrote to me a day or so ago asking me if in the event of my Apple picture not being sold, I should be willing to let him have it for £50.

I told him it was sold, and asked him to communicate with you. I have written accepting an invitation from him asking me to lunch someday next week. I have left him to choose a day and when I know it I might be able to see you on that day. Any day except the day of my visit to Mr Marsh will be convenient for me to bring the Apple picture. You will need to give me full directions as to how I am to get to your place, etc., as I am not used to London and get very puzzled sometimes. Japp tells me to 'fight against it' but I cannot, somehow. I am disappointed that Japp is not in London. I wanted

86 Sir Edward Marsh (1872–1953) was a patron of the arts and friend of many poets, including Rupert Brooke and Siegfried Sassoon. He published five anthologies of *Georgian Poetry* between 1912 and 1922.

to see him and his new little baby, have you seen it? I was rather overawed by Japps's grand home in Tite Street.

You will not think me ungracious if I refuse your kind invitation after November 1st to stay with you; I have not been away since last March, I have refused all invitations since then. Even invitations from Mr Raverat (do you know him? Both he and his wife are good to me). I also refused Japp's kind invitation, and many others. I have done so because I have something on the board and I want to get it done. You see, this place Cookham has a lot to do with this new picture I am going to do; it has everything to do with it. If I go away, when I come back I feel strange and it takes me some time to recover from those feelings. If only I had a little room in Cookham that I could invite you down to. I had a little, very little kitchen last winter and that is where I did your Apple picture, most of it. I want to get a cheap heating apparatus for our old attic.

I should be interested to see Mr Anrep's exhibition.

I like your portrait of a young man at the Contemporary. I wish the National Gallery was in Cookham, but I have many reproductions of fine pictures of old masters lent to me by the Raverats. They stimulate me; they 'quicken' me, do they not do so to you?

Yours very sincerely
Stanley Spencer

* * *

27 October 1913
Fernlea

Dear Mr Lamb

Thank you for your very nice letter. As I had intended to try to get all my 'business transactions' done this week, it did not occur to me that you had invited me so as to enable me to do my business under more convenient conditions.

It does disturb me if you're among my best friends when I want to be doing something, you quite express my feelings, and I am very sorry for you Mr Lamb if you are constantly having to see people.

It would be impossible for me to do anything if I was placed under such circumstances, but I am going and I expect I shall have to do a good many things that I shall now be calling impossible. But I think that by living in the country and seldom seeing anybody, I think that by so doing I have done myself good and not bad.

Will it be convenient to you if I bring my picture up to you on Monday next, November 3rd? I feel cursed about that picture, because all the time I am wanting money I am wanting you to keep the picture. You understand that I can wait, you see that for another year also I shall not be having to spend a lot, I seldom do, and if I live as I have done until now, I shall be able to go through a year without danger. I tell you, I do not worry about money but I think about it.

I have not yet heard from Mr Marsh about going up to see him.

I am very interested about this F rays business.[87] If it is true that it is impossible to prevent these waves from exploding things, what will become of war? We shall go back to the days of archery. I shall ask Japp about it; he knows everything, at least he told me he did.

Yours very sincerely
Stanley Spencer

I should very much like to see you in Cookham – particularly in Cookham. I should like you to stay at our place but although my parents would be ready and glad to have any of my friends, at the same time I do not ask them to do these favours because my mother is so anxious that the visitor shall be comfortable that she is determined to do everything herself, and of course this often makes her unwell. You see she is the mother of nine children and she has always been the 'organiser': she has nursed everyone of us herself through almost every kind of illness and we are all well. If we do not allow her to do things for us now, she gets very miserable. So I let her make me a piece of toast, it's quite pathetic.

✳ ✳ ✳

87 Infrared rays enabling remote detonation of explosives discovered by Italian inventor Giulio Ulivi (1881–1948).

October/November 1913
Fernlea

Dear Jacques and Gwen

Lamb tried to get the Contemporary Art Society to buy the thing.[88] He said 'What can one expect of these Fishmongers', but I do not altogether blame the Society. Bobby came down. I will not talk about what he was like because I do not believe you like him. I think he enjoyed himself. Of course, he liked all the parts I disliked. Still, I did not talk about any place I liked. I do not like doing that except to Gil. What is that book you are sending me? Who are the Karamazoff Brothers?[89] Bobby reads Steinberg, Oscar Wilde and all the rest of these sort of things. They won't do him any harm, but when I am interested in a book all my attention and thought is on it. He said: 'Yes, but how do you know if a man is or is not worth reading unless you have read one of his books to see?' I'm out for a row; I want to say something against the bloodiest kind of man.

Why did Mr Rupert Brooke write an article on America?[90] I feel desperate against him, the best way for him to avoid doing this kind of thing would be for him to – (too strong, bad temper). Of course, I only imagine Mr Brooke to be like this, I do not know him, I hope he is not.

Gertler is coming on Monday, it cannot be avoided. I want to see him, but not in Cookham. He is bringing Edward Marsh, you know. There's Gertler praising me to everybody, Bobby told me, I wonder if he would if he knew what I thought of him. I must let him know. I might sell this painting of my head I am doing. I have begun my composition and am itching to do a painting of it, but I must get ready. I should just love to get into Cookham church, lock all the doors, get into the chancel roof and away we go. It stimulates me to think of this.

Gertler is not coming down on Monday: I wrote him a letter and in it I said this: 'I was sorry that you gave up painting in your old way, because while you did these things which were dull, you were in a fair way towards doing something good. Then you seemed to lose all faith and patience with your work and began trying to paint like

88 *Apple Gatherers.*

89 *The Brothers Karamazov* (1880) by Fyodor Dostoevsky (1821–1881).

90 Rupert Brooke (1887–1915) published an article in the *Westminster Gazette* (1913), later published as *Letters from America* (1916).

Cézanne, and you were incapable of understanding him. Wadsworth was without convictions and that naturally led him to do this kind of thing (he reminds me of warm cabbage water) but you, you ought to be ashamed of yourself.'

That part in brackets I should not have said. This is why I wrote this peculiar letter to him: it was because for some time past he has been thinking of doing me a good turn and I felt I did not want him to do anything for me without first of all letting him know my feelings towards him. My feelings towards Gertler are not malicious, and I did it intending to do him good. This is how he answered me: 'Dear Spencer, I am not in the habit of being dictated to. I consider your letter was an outrageous insult. Remember you are not in the position to criticise other people's work and you have a long time to wait before you ever will be.'

This was all, also his name and then, I cannot think why, his address written under his name; it was also written at the top of the page. I expect I have done wrong and yet I cannot see what else I could have done. If I hated Gertler, which I do not, I should simply have told him not to attempt to do anything for me and also not to come to Cookham. But I did once feel rather interested and curious about him. I have written to him: 'Dear Gertler: I wrote that letter because I could not allow you to do me any favours without first letting you know my feelings towards you. If it was insulting, I apologise, but it was not insulting. You owe me an apology. Thank you for any kindness you have done me. Unless you regret sending me that letter, I forbid you to write to me again.' I do not know why I wrote all this matter out, but – I don't know – just as I want to be perfectly quiet, these depressing things come along. Of course, Wadsworth deserves to be called any name I could lay my hands on, but there is no necessity – and even Wadsworth I like very much.

I have got the book. I have in my possession belonging to you a book of Keats, a book of Cobbett, large photos and picture postcards, all of which are being kept carefully. My teeth are fine and I keep them clean.

Mr Edward Marsh has written to me that he would be willing to give me £50 for my Apple picture. I have told him about Lamb wanting to sell it. I have heard nothing from the French Internationale thing.

The book you have sent me[91] I am reading carefully and enjoying. The chapter called 'The Old Buffoon': Fydor Pavlovitch seems not such a buffoon as Miusov, does he? I am full of curiosity about this book and can hardly keep myself away from it.

Cookham

* * *

November 1913
Fernlea

Dear Mr Lamb

I will come on Monday and will arrive sometime between 11 and 11.30. Will that be too early? I much want to see you and will you take me all over the place? I want to go to the National.

Yours sincerely
Stanley Spencer

* * *

7 November 1913
Fernlea

Dear Mr Lamb

I enjoyed my outing with you, and also going to see Japp. I went and saw Mr Marsh on Wednesday and I like him very much. There was no political significance in my visit, except he did say that he was always spending and he never knew at what time he might have to spend a lot. But as you say that he is holding his offer[92] open for a certain time, I do not think there is anything to fear from his saying this. But if you cannot raise more money than Marsh has offered and cannot manage to keep it yourself, let Marsh have it.

Of course he showed me all his pictures. I looked three times at a little pen-and-ink drawing of yours. I liked it best of all things there

91 Dostoevsky's *The Brothers Karamazov*.

92 Of £50 for *Apple Gatherers*. Henry Lamb had bought it for £30 in October 1913 (see p. 30).

except a drawing by Roberts that he did when he was twelve years old. Have you seen it? It is a head and it is good, one of the best he's ever done. Roberts is now doing something for Roger Fry! Did you ever hear of his 'one day' workshop. It fell through; sole survivor Duncan Grant.

Yours very sincerely
Stanley Spencer

* * *

1 December 1913
Fernlea

Dear Lamb (can I drop Mr?)

Marsh says he has had a letter from you to say that Professor Sadler offered £50; he also says that if there is such a difference made between his offer and Professor Sadler's, such as £50 or 50 guineas, that he (Marsh) would also offer 50 guineas. That is what I understood him to say. If you must part with it I want Marsh to have it because he was first to make the offer and he kept it open for a good time. My new composition is at the NEAC but it is not quite as I intended it. Still, it will come all in good time. I will get Gil's picture photographed. What is the NEAC like? I've got a big square canvas at home here.

Yours very sincerely
Stanley Spencer

* * *

8 December 1913
Fernlea

Dear Lamb

Thank you for your letter and money less commission. I suppose you will charge that commission in your new shop. I am going to do

that picture that is at the NEAC on this square canvas.

I am going to have it out of this canvas if it's the last act, as Brer Rabbit would say, and if I don't succeed then 'Joe's dead and Sal's a widder' (to quote Brer Rabbit again). You might tell any rich friends of yours, as 'ow you know a chap as 'as a picture for sale as is well worth buying; I mean brother Gil's picture that you want a photo of. The picture is finished: we will send you one.

Enclosed is a receipt for £25 and a thing I did of the Apple picture. The first drawing I did of it. The great size of the two central figures was unintended and accidental: as you see, in this one they are normal size. And this picture is better for that reason.

I opened my banking account today. I shall be able to write out checks like Japp does, only I must get a nice desk like his. If you like this drawing I enclose, keep it; if you cannot make head or tail of it, send it back.

Yours ever
Stanley Spencer

Tell me when any more Beethoven quartets come off. Do you know Stolworthy? He once heard all Beethoven's quartets done in Vienna by a good lot of men. It is difficult to form a quartet because the men generally quarrel.

* * *

The following text was written at different times and is more a chronicle of events than a letter.

15 December 1913
Fernlea

Dear Jacques and Gwen

Last Monday week I went up to Hampstead and saw Lamb. I like him and do not feel him to be a low worm. I do not think his work is interesting, except sometimes. He was not well; he seldom is, poor man. He came with me to the Slade and saw Gil's picture and

was greatly impressed by it: you will try to see it when you get a chance. Ruth Humphries[93] got the prize. Gil got £6. I think it will sell eventually. I went to the dear old National Gallery and had an enjoyable time, except Lamb was going to show me a Mantegna, but of course that part of the world in which this picture was to be seen was closed under repairs.

There is a picture by Piero di Cosimo and it is called 'The Death of Procris'. Who is Procris?[94] Well I do not know if I like it or not, but it fills me with strange feelings. Lamb said it was the intellectual bawdiness of the thing that I liked, but I told him it was not that.

In the afternoon I went to Boris Anrep's show at Chenils.[95] I went to Japp's after that. It was nice to see him again. Lamb played some Bach and he would have played me some Mozart, but he had none with him. Japp did some of those Spanish things on the gramophone. Then Japp's little girl, Trinida, came in looking perplexed as usual. She did not know me. I used to play with her in a nursery in another place in Chelsea. A window overlooked chimneypots, smoke and sunset and all that sort of thing.

I went home and on the following Wednesday I went to London again. In the morning I went to see Bobby in his miserable little room (Hiller's room lent to Bobby). He is earning 7s 6d a day for Roger Fry, for his Omega Workshops.[96] I looked at a picture he is doing and I was disgusted. When I said how meaningless and insincere it was he flew into a passion, not because I did not like it, but because I, so he said, could not say if it were sincere or not, because his early work was also insincere. I suppose he thought by that that I did not know whether he had ideas or not just because I had never seen them. We then went to the ABC, he had his breakfast and told me something that took him most of the morning to tell me. I should like to tell you what it was about, but I cannot until I feel more certain. It is about his leaving the Slade. Do you know anything about it?

We then went to the National and then Bobby took me to Church Street and left me there. I walked down the street; I see no house called 'Trevelier'. I walked up the street; same again, everywhere was shops. At the back or rather side of a theatre there I looked hard for a door but you know, nothing but a sea of bricks. I asked a roadsweeper, he said it is a restaurant and I said 'Oh no it is a house'. It did not say so in Marsh's letter, but I had pictured in

93 Ruth Humphries was a close friend of Dora Carrington and Dorothy Brett (1883–1977) at the Slade.

94 The panel sometimes known as *Death of Procris* (*c*.1495) is one of Piero di Cosimo's best-known works. Procris, wife of Cephalus, was accidentally killed by her husband with a javelin given to her by Diana, goddess of hunting.

95 The Chenil Gallery, at 183a King's Road, Chelsea, opened in 1906. It was run by Jack Knewstub, brother-in-law to both William Orpen and William Rothenstein.

96 Established by Roger Fry, Vanessa Bell and Duncan Grant in 1913, Omega Workshop was an artists' cooperative in Fitzroy Square.

my mind a lovely house, a cosy dining room with the firelight under the table and all that, you know, early Victorian furniture, room very dark except for fire, wife, children and nurse. That is what I wanted. This is what happened. I asked another man and he pointed straight at a restaurant. It disappointed me. I walked up to the place, a nasty white place. I went in. I went up one flight of the nasty bare stone steps. I had a horrible feeling that in a minute I should smell carbolic disinfectant or something else, you know: Fitzroy Street. Well, I saw the door of the bar, as I thought, as I passed to go upstairs, so I came back and gently pushed this door open, and lo! There was a whole live restaurant and all the people eating, and a man came and took my coat off. Well, I thought, the thing's done now, but I said 'I am expecting Mr Marsh' and then I sat down and soon in came Marsh.

I could not help being disappointed. I had expected something so different. He wore his monocle and looked exactly like a Private Secretary[97]; that is nothing against him. He said, directly he met me almost, that Lamb had taken a dislike to him and that he could not think what he had done. He then spoke about Gertler. He said that what Gertler was really angry about in my letter was the part where I said he did not understand Cézanne. I then went and saw Marsh's 'Gallery' and there I saw a Seabrooke[98] that I actually liked and one thing by Currie[99] that I liked. I cannot bear him.

I should like to see Seabrooke again. Marsh has a nice photo of him and he has a big photo of Rupert Brooke. Marsh has given me his Georgian poetry book[100] and in it there are some things by Brooke and I like them. I drove from Marsh's to the Admiralty in a taxicab.

I have today ordered from Newman a 56-in square canvas for this new picture of mine. I must get Mrs Sargant Florence – who lives not far from here at Marlow – to give me lessons in fresco cheap. I know her and have been to her twice.

Damnation, it's nothing but little letters to write. I am having requests for my work, this sounds good, but it aggravates me to exasperation: you see, I have no blasted work and I have to say to people like Marchant & Co.,[101] 'Please sir, I haven't any'. What must they think? But I try to keep their interest alive by telling them that it is quite possible that in the year 1937 I shall perhaps have one or two pictures for them to see. No, but it is a terrible handicap in prospect of my making any money. But I don't care, why should I,

97 Sir Edward Marsh was at this time Private Secretary to Sir Winston Churshill.

98 Elliott Seabrooke (1886–1950), landscape painter who studied at the Slade 1906–11, was influenced by the work of Cézanne.

99 Painter John Currie (died 1914), formerly at the Royal College of Art, was briefly a contemporary of Spencer's at the Slade.

100 *Georgian Poetry*, an anthology of poems written during the reign of George V.

101 William Marchant & Co., London art dealers, successors to the Goupil Gallery.

102 *David and Bathsheba*, c.1912, sold at Sotheby's, *The Evill/Frost Collection*, 15–16 June 2011 (lot 147).

103 Spencer had met Geoffrey Keynes (1887–1982), scholar, surgeon and brother of economist John Maynard Keynes, through Edward Marsh.

104 *Maternity*, 1909.

105 Maxwell Gordon Lightfoot (1886–1911), contemporary of Spencer's at the Slade, who had committed suicide in September 1911.

106 Conceited, self-important.

107 *Woman feeding a Calf*, 1909 (Tate).

108 *Scene in Paradise*, 1911 (Slade School of Fine Art, University College London).

109 *The Descent from the Cross*, 1910.

110 *Two Girls and a Beehive*, c.1910 (private collection).

111 *Jacob and Esau*, 1910–11 (Tate). Bequeathed to Tate by Ruth, Lady Gollancz (*née* Lowy), 1973, whose family used to take Stanley and Gil boating from their house by the Thames.

112 Also known as *The Last Day*, c.1909. Sold at Sotheby's, *The Evill/Frost Collection*, 15–16 June 2011 (lot 9).

113 *David and Bathseba*, c.1912.

114 Possibly study for *John Donne arriving in Heaven*, c.1911.

115 *John Donne arriving in Heaven*, 1911. The picture was purchased by Jacques Raverat from the artist in 1911, two years before the date of this letter to the Raverats.

116 Presumably *Dot and Guy leaning against a Wall* (whereabouts unknown). Dot Wooster and Guy Lacey were at school with Stanley and, during break, they would lean against the orchard wall to talk.

117 Presented by Marsh to Tate on the reopening of the gallery, 1946.

it's not my fault. I have just today sold a picture I rather wanted to keep. It was done at the same time as the David one with the chain round his neck.[102] Mr Keynes's[103] address I want please. My composition is nearly finished I enclose just a rough idea of it but it is not quite what it is like. I have sent my composition to the NEAC. I do not yet know if it is accepted. I hardly saw it when it was finished; it is not quite right.

I want to bring all my pictures together at the end of my life and look at them altogether. I will just 'run over' my work, first there was that thing called 'maternity'.[104] Lightfoot's[105] admiration of this made me play 'biggity'[106] (in the story of Brer Rabbit Brer Fox always likes to play biggity before Brer Rabbit, and that is why Brer Fox got into such a lot of trouble). I still have it. The next was a girl with the calf.[107] Ihlee said I should have a rare job to beat it, I still have it.

The next was one of my young ladies on a seat down on Odney Common. She was seated with her back to a young man, a friend of hers named Joe. It was one of the nicest pictures I ever did and it had Cookham church in the background and a goat in the bottom right-hand corner. Destroyed by accident. The next thing was I believe a picture that is in a portfolio in the Slade School. The picture is supposed to be Paradise.[108] The next I believe was called *The Descent from the Cross*:[109] Tonks has got it. Next I believe it was a kid kneeling on a seat with a widow. I have it. The next was a painting of two girls in a garden with a beehive.[110] I am glad to say I have it. Next was. I forgot before this painting came a picture called *Jacob and Esau*.[111] Then came a picture that was really great. It was called *The End of the World*.[112] I have just sold it to someone I do not know who, Tonks sold it for me (£6 6s 0d) I wanted to keep it. There were heaps of babies in it and a carthorse and two donkeys and two cows bellowing at nothing.

The next picture was the David and the chain.[113] Butler has that. The next was a picture of Christ in a vineyard with two girls. I want to see it again: Tonks has got it. Next came, I believe, the John Donne thing: I don't know if Bluett has sold it.[114] Next came, Oh hotel a seekin' that 'next came' does not give me time to breathe. Next was the painting you have of John Donne.[115] Next came that girl looking over wall and man leaning back against it, it was a painting.[116] Next came the *Apple Gatherers* composition.[117] Marsh, who is coming

here next Sunday, has got it. Next I began a painting of it. Then three bad pictures followed: one, a man going round a fir tree, two *Job*,[118] and three, the thing I did for Crosby Hall. Shloss has it. Next came Slade summer picture, and that picture begat the Joachim thing that followed. Butler has it.[119] Next was a woodcut and painting of it. Did I tell you I sold one to Japp for £1 1s 0d? Painting not finished.

I then did composition called *Zacharias*.[120] The canvas has arrived square. Gil and I are both agreed that a 'square' canvas is a bit of alright. At the bottom of Cookham village is a cottage, and in the back of this place is a little bedroom, and in this bedroom is a window which overlooks the very piece of land that is to be one of the most important things in this picture. But I cannot go in to this house now because it is let to a Lloyd Georgian land valuer or something of that kind; he is what Pa would call a good Liberal. You see, last year at this time this cottage was empty. I understood that they were leaving now, but I asked Peggy (Alice Leonora Hatch), when she bought the milk, when she thought these people would be leaving (her father owns the house: he is our cousin – no, he is my grand aunt's son). Peggy's head was slightly tilted to one side as she gave me the information to the effect that the people would not be leaving till New Year, and hopefully not then. I could have smashed her but I did not. I only said 'damn them'.

I am now reading *Tom Jones*.[121] I once read a funny play by Fielding called *Tom Thumb the Great*.[122] I did so a long time ago and I remember at that time I liked it. I will read it again. I am disappointed with the Karamazov book. I do not think I should get on with Russians if they were all like they are in this book. I do not see why these three young men talk so much about their souls, and in such a way; and if they did, what they said was not interesting and as unnatural as anything could be. I expect that this is untrue but I must say something: the book got on my nerves. I am going to keep the book because parts of it are fine. If you have only enough apples for yourself do not send us any. But Ma grows 'receptive' at Christmas and she said that if you had any apples to spare they would be 'very acceptable'. Ma makes wonderful custard (egg custard) and the apples with it is – well, you will taste it for yourself one day.

I wrote out my first cheque this morning. Lamb is going to try to

118 Possibly *Job and his Comforters*, 1912.

119 *Joachim among the Shepherds*, 1913. It is possible that C.K. Butler had one of the studies, not the final painting.

120 Possibly one of the studies for *Zacharias and Elizabeth*.

121 By Henry Fielding (1707–1754), first published 1749.

122 First published 1731.

sell Gil's picture, he thinks it will be difficult. I am most likely going to exhibit a bit of my past works (already exhibited ones) at Chenil's, along with Bobby, Currie and Gertler and some other wretched creatures. It will cost me a mere nothing and might look rather interesting to see a number of my works together instead of one here and one there. I shall not think about one-man shows until I am fifty, and then if I have enough money I shall not have one at all, unless a private one for my own pleasure. What a quartet, Bobby, Gertler, me and Currie! But if anyone prejudiced his mind against my work just because I was seen with these men, he ought to be ashamed of himself.

Cookham

Please send me your letter: I want it.
I have sent woodcut to Mr Keynes.

* * *

30 December 1913
Fernlea

Dear Jacques and Gwen

Thank you very much for the figs and the book you sent me. I am very pleased with the book. We had our usual Christmas Day gathering and a family gathering, and as perhaps you would be interested to know the different members of the family who were in our house on this day, I will tell you. First there was sister Annie: she is the eldest except brother Will, who is in Germany. Then comes Harold: he walks about with a book on 'journalism and syndicalism' under his arm and Lloyd George[123] ever upon his tongue. Father's voice almost gets 'ushy with emotion when he talks about Lloyd George.

It is rather fun to have Harold in the house sometimes because he always treats Gil and me as young children, and in fact we feel exactly like we used to feel 12 years ago when we're with him. You see he brings us regularly a Christmas toy, one each. He is now about 33, and as he used always to give us toys, he has got into the habit of doing it. So of course we received our presents this Christmas, which

123 David Lloyd George (1863–1945), later Liberal Prime Minister, was Chancellor of the Exchequer at this period.

was a race game, very well made, and some fishing line and floats. Brother Will is nearly 40.

I have just received your letter so I must cut this letter short. Thank you for the figs, all such presents make Christmas Christmassy. Gil is making a set of chessmen out of teak. We are getting very hot at the game. Of course you will come down (both of you) any day you possibly can. I have nothing to show but Gil has the big picture you will want to see and it will do you good to see it. It is one of those few pictures that does this. Cookham is very nice, no nasty people about; this is why I cannot yet begin my picture. I forgot I have not told you: Gil has not yet gone back to the Slade. The Slade does not reopen until 14th January. Marsh asked my advice about a frame for my Apple picture. I advised a narrow one, a margin. He wrote back to say that he was sure it ought to have a broader one, that he was off to Rome and that he wanted it ready for him on his return. Of course if I do not write to the framer for a 'broad' frame there will be a row. But Jacques, imagine sitting down and ordering a man to frame your dancers in a frame you utterly detest.

You will do all you can to enable you to come down, and come down as early in the morning as you can.

Cookham

My mother and father would be very pleased to see you. Last Saturday we walked from Watlington to Cookham, about 20 miles.

<center>✳ ✳ ✳</center>

*c.*1914

Dear Syd

I could not find time to write and thank you for the Salon book which I received on Thursday, as I had to work like hell on some paintings and also to pack on that day.

I like looking at these books as you never know what you might come across. Bonnard[124] and Delacroix[125] are I think good men, but I would not be certain. The journey home quite frustrated me.

124 Pierre Bonnard (1867–1947), French artist and lithographer, a founding member of the Nabis group.

125 Eugène Delacroix (1798–1863), the leading exponent of Romanticism in French art.

The old man that I drew was most pathetic, he had knocked off work owing to the heat and looked very ill. His face was beaten and cut with the sword of age. You could divide his face up into sections like a puzzle. You will see the drawings when I bring them to the Slade.

It does seem nice to be in Cookham again, but I am sorry you had to go so early.

Brer Stan

* * *

14 February 1914
Fernlea

Dear Jacques and Gwen

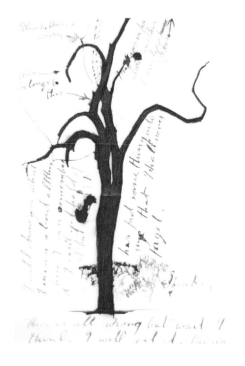

I got home alright and the bag of apples arrived soon after. I have sent you back your knapsack. I think I am a lot better, my bad throat nearly gone, though yesterday it was worse than it has been before. It was so depressing, it made me feel so low. And then I felt depressed but that was only because I was unwell. I have today been trying to draw the tree I mentioned to you, it is something like this [drawing].

Although I shall not be able to touch those Bach fugues you are giving me for some years I expect, and perhaps not at all, it depends if I practise. I ought to be able to manage one of them – yet I do see them in my mind and when Sydney has played one to me a few times I can go through it with the book before me, in my mind, and the book keeps me from going wrong. Gil has finished *Treasure Island* and then I finished it.

Sunday morning
Do not take any notice of the trees I have drawn; they are nothing to me. I have not yet seen my mother but my father went and saw her the day after my return and he told her of the quince jellies and apples; she was very pleased and gave orders for them to be placed in the pantry on the second shelf. She will be pleased with the little pots.

Gil's visit to you has done him a world of good. I hope we shall

both be able to come again, say in May, if you are not away. I must not stay away so long again; it got on my nerves, I began to think you did not exist – you know what that kind of thing makes you feel like. My mother has gained 2lbs, all but an ounce, in weight. I like your sister very much. It was a shame the way you teased her, though. I think the thing that annoys her most was not because you have an aggravating way of arguing – you have not – but because you were right and she was wrong.

I will write again presently.

Is the painting of your Christ on the ground with Mary and Elizabeth away? I did not see it. It would be worth your while to write to Gil as well as to me.

* * *

7 March 1914
Fernlea

Dear Lamb

Thank you for your letter. Come on Thursday as early in the afternoon as you can and stay for tea and go back as late as you possibly can.

On Wednesday Gilbert goes to London to the Slade. It will be very nice to see you. I have soon to go to London to see the dentist and I want as usual to see everything. I want you to play me something, I would like to make a thorough examination of your room, I mean the things that are in it. I did not get time to look at the books when I last paid a visit.

If you cannot come Thursday, come Wednesday. Thursday would be more convenient for us.

Stanley Spencer

Gil has some good things to show you and I have practically none except some rather old work, some recent, and my big Zacharias picture,[126] just begun. You can see it but you must only say nice things about it.

126 *Zacharias and Elizabeth*, 1913–14 (Tate and Sheffield Galleries & Museums Trust).

* * *

1 April 1914
Fernlea

Dear Lamb

Thank you for your letter. If you think your friend would give me £1 1s 0d, then ask that, but if he is poor or will not give me this much then charge him £0 10 0d (I do get muddled – that is the wrong way to write that sum: 10/-).

Japp gave me £1 but I know it is not the usual price for a woodcut.[127] I only have one thing by Lorenzetti and that I bought from a rather interesting Italian model. It is called *La Pace*,[128] which I suppose means Peace.

If you have any Lorenzetti you can give me, give them to me by return of post if possible? I am getting a very good collection of postcards. I do not put them into a book because I like to look at them separately. I take one out according to how I feel and I put it somewhere in the room so that I can look at it if I feel inclined; it sort of keeps me company and makes me work.

I did never see Spencer Gore.[129] I spent this weekend with Marsh and I heard about it and then I met Albert Rothenstein.[130] The second time I have met him and have spoken to him and I do not like him at all.

If anybody talks or writes to Gil about buying his picture I will let you know. He sold his 'feeding pigs' composition to Eddie Marsh for £5. I think that is not bad. I sold two drawings of heads to him. If I can do heads and sell them, that will be a great help. I have to get some printers' ink from London tomorrow; Gil goes to London and he will get it, I will then do you your friend's print. Who is he? Gil has got that blue alright in his picture.

I will not give your love to Zacharias. I am doing a small painting of it as well.[131] I do this between 5 and 9 in the evening.

Yours
Stanley Spencer

127 Probably *Joachim among the Shepherds*, 1914.

128 From *The Allegory of Good and Bad Government*, a series of frescoes by Ambrogio Lorenzetti (*c*.1284–1348) in the Town Hall in Siena.

129 Spencer Gore (1878–1914) was a leading member of the Camden Town Group, which helped to introduce Post-Impressionism to England. Gore died of pneumonia on 25 March 1914, just a few days before this letter was written.

130 Albert Rothenstein (1881–1953) anglicised his surname to Rutherston in 1916. The brother of Sir William Rothenstein, he was also the uncle of Sir John Rothenstein, Director of the Tate Gallery 1938–64, who became a friend and supporter of Stanley Spencer.

131 This may refer to his small study for *Zacharias and Elizabeth* (private collection).

Do not forget the Lorenzettis. I rather liked the way we sneaked about London, didn't you? I met a French sculptor named Gaudier,[132] a 'London group' man. He did that thing like to cannon balls bursting, you remember. He fought in Apachas (is that how you spell it?) and gave them all a bad time of it, once in France.

* * *

4 April 1914
Fernlea

Dear Lamb

I have received book and letter by first post and then cheque and P/O and letter by next. If you cannot get another book like it, ask Mr Kennedy to let me have this one because I want to keep it very badly, but I expect he is in the same position.

I have tried to get that blasted pictures ink. Percy Youngs said he used to sell it but now the man who used to make it for him has retired, got a £1,500 car; I had a ride in it the other day… He now only sells ridiculously dull stuff.

I went down and drew in a house containing a tall man and short woman (his wife), a boy about six, a boy about three and a girl about one or two. The man is Irish. I wish you could see the boy about three. I can show you what his head is not like – very disgusting, I had to cross them out. I am going to have another go at him.

I shall want to come to London to see you and hear you play before you go back to Ireland, and of course you have to come here also, but I do not want you yet. Let me alone: that is what I feel like and I hope you feel the same. I will not be long with the woodcuts.

Give my love to Japp if you see him, I suppose he has left his London home.

Stanley Spencer

Lorenzetti seems not finer than Giotto, but I have not thought, or considered their differences; they are very different. Is Masaccio a

132 Henri Gaudier-Brzeska (1891–1915), artist and sculptor, who moved to London in 1911.

Sienese man too? And also Masolino da Panicale?[133] They of course have feelings that Giotto and the rest of his time never had.

* * *

19 April 1914
Fernlea

Mother sends her love to you and thanks you for your kind enquiry.

Dear Jacques and Gwen

It seems years since I saw you. We are both in splendid health. My mother is better from the point of view of weight and her coughing is not so bad. I have seen a lot of Lamb lately. When I was having my teeth done a few weeks ago he had me at his place and he played to me – God only knows what he didn't play to me. I went there twice and he did heaps of Beethoven's late work: the Diabelli Variations.[134] I was glad to hear a lot of Mozart. I should think Lamb must have very nearly mastered all the mechanical difficulties of the piano. Nothing seems to hinder him and of course in that way his playing is very good. Is also extraordinary the way he gets everything clear; it was very helpful, though I felt, well I did not feel what I feel when you, Jacques, play, and that was disappointing because it did not mean that his playing was Godless.

There are a lot of things I could say about him but it is difficult and might exasperate me because I should be so anxious to show you that he was a good man. I have also spent a weekend with Eddie Marsh. I had Currie and Gaudier for dinner one day, and Gertler and a man named Nash[135] the next. I am glad that Gertler has agreed to be friends again. We agreed unconditionally. Marsh took me to tea at Miss Nesbitt's. The elder of the two Miss Nesbitts[136] is very nice. She is an actress and she seems to be so unlike what I imagined actresses to be like. There was only one person out of the people I met there that I liked and that was Donald Calthrop,[137] 'Puck' at the Savoy *Midsummer Night's Dream*. He seemed very homely and serious-minded.

Isn't *Timon of Athens* fine? Lamb gave me a book called *The Basilica of Assisi*. Did you go to this or was it too far away? Did you get photos of outside views of buildings? I wrote to you at Florence.

133 Masolino da Panicale (1383–1447), Italian painter and collaborator with Masaccio (1401–*c*.1428).

134 Beethoven's great piano variations on a waltz by Diabelli.

135 John Nash (1893–1977) was Gilbert Spencer's best man at his wedding to Ursula Bradshaw in 1930. His brother, the artist Paul Nash (1889–1946), who had been at the Slade with Stanley, paid his first visit to Edward Marsh not long before this letter was written. Since Stanley knew Paul Nash, it seems likely that in the letter he was referring to John Nash.

136 Cathleen Nesbit (1888–1982) was engaged to Rupert Brooke when he died in 1915.

137 Donald Calthrop (1888–1940) was a stage and film actor.

Gil has had his teeth done by the same man that did mine. He has done them well. I took some heads up to Marsh's and also Gil's 'pig feeding' composition[138] and others. He bought Gil's 'pig feeding' one and gave him £5 0s 0d for it. He also bought two heads of mine for £3 each.

I will close this letter now, but just let me tell you how I began today. I got up and went and had a bathe with Gil, Guy Lacey[139] and brother Syd. Then I had breakfast, then I went down our garden and into Eliza's garden, full of dustbins, ivy and wallflowers. Mr Sandall was sunning himself among his growing lettuces, very tiny so far. He is over 80 and tells me about all the places he has built, places that I thought had never been built, but had been for all time. I want you to come to Cookham if only to see him, though I am afraid he does not like strangers. He was a good builder and worked under my Uncle John and Grandpa Spencer.

I will write again later.

Love to you from
Cookham

* * *

27 April 1914
Fernlea

Dear Lamb

I want you to come down and to go for a walk, only you must name day, not me. Neither Gil nor myself know anything about birds but brother Percy does, he seems to have eyes in the back of his head, for he can find birds' nests and anything of the kind without looking for them. I should like him to go with us on our walk as he knows how to avoid highways and long dull roads and he is tall and a great walker, and he is not an artist. He is something in Holloway & Greenwoods building firm. He earns his money by getting the aforesaid gentlemen out of 'scrapes'. He said when I said about his accompanying us that he would very much like to but that he thought perhaps you wanted to go alone with me and Gil. I said you

138 Gilbert's sketch *Feeding Pigs* was his first work to be bought, by Edward Marsh.

139 Stanley's friend Guy Lacey, whose widowed mother kept the boatyard by Cookham Bridge before it was sold to Frederick Turk in 1911.

were not such a particular gentleman as all that…

I do not suppose you could face a swim the morning after, about 7? The sun is sometimes quite warm and the water is actually getting warmer. I am trying to do my Zacharias thing in basso relievo: is that what they call it? I am doing it with modelling clay but I am going to do it with stone; I do not like clay. I itch to do trees in it, not damnable conventional trees but trees as they are in my painting of this picture. Have you read Stead's *Books for the Bairns* in the edition of Brer Rabbit? If not, let me know. The Assisi book has quite inspired me.

Stanley Spencer

Come soon – soon as you can.

* * *

7 May 1914
Fernlea

Dear Lamb

Thank you for your letter and for asking me up to hear the Mozart thing? I shall come and will you get any time to play me the Diabelli Variations and the lot of other things you have played to me? Is it a long while to Whit Tuesday, because my brother Percy Julius says that day is more convenient to him. I will ask him and see what he says: is a week next Sunday the day you suggest? My brother said: 'Tuesday is the day but … keep it dark, call it Monday; we don't want God to know'. He said seal the envelope but I did not think it is necessary and it would look suspicious.

There are some wonderful things in the second book of Bach's *Preludes and Fugues*: the 5th fugue, the 9th and 14th prelude. I think that the first note of the triplets ought not to be accented; my father said it ought to be and also that the first note of a triplet is always stronger than the others.

Keep the woodcuts.

* * *

12 May 1914
Fernlea

Dear Lamb

Thank you for the books. I expect I will get through the play but not the other book. I will try. I have written to brother about walk next Sunday and expect to hear if it is convenient to him, by tomorrow's post, and then I will let you know.

What do you think this man will give Gil for his picture? I will get Gil to finish it: he only has to finish the hedge I think. Has he seen it? Have you a photograph of it? And are you in good picture and dealing form?

Wednesday
Of course you will use your own discretion as to what to ask, etc. It is rather grand to have a private picture dealer. Brother has just written to say 'I don't much care about Sunday walking myself, more especially as I'd like to see the country in its workaday clothes and moreover, on a weekday we should miss a certain number of motorcars which we shall be sure to find on a Sunday'. But... Whit Tuesday is usually looked upon by wealthy gentlemen as a holiday; as a motoring day. Brother then says 'if you cannot postpone the walk until the Tuesday after Whitsun, next Sunday will suit me alright'. Whit Tuesday is on 2nd of June. It is such a long time.

I have read and in many ways enjoyed the play. I can imagine Mozart being inspired by it.

Stanley Spencer

* * *

24 May 1914
Fernlea

Dear Lamb

Expect me by train you mention in letter. I will bring the books up with me. I read a good bit of the other book but I could not get rid of the author's personality so I dropped it. I wish you could lend me Boccaccio book you gave me to read one night; or a less gorgeous edition of it if you have one. I have read a lot of Shakespeare lately. He is about the only playwright that I can follow, although of course I have to read anything of his aloud at times before I clearly understand, and sometimes six or seven times. I feel very curious about this 'ere majic flute.

Stanley Spencer

* * *

Undated
Fernlea

Dear Jacques and Gwen

I am sorry I have not written to you before now, I did not feel like it; you know those exasperating periods when it annoys you to hear your own tongue. Yet just at those very times you find yourself entering with heated blood, into inane, pointless and fruitless arguments. Some years back my mind was constantly on what I was doing and what I was going to do, now my mind is continually upon unimportant things, and the horrible thing is that they satisfy me and keep me away from what I want, and it is very difficult for me to take my mind off of these asinine sentiments. But as there is nothing to be gained by writing about these things – unless you know how you could help me out of these bad habits – I will cease and tell you about *The Magic Flute*. I went with Lamb to hear it. I think you heard it when it was done in Cambridge. The scenery was not a bit like I thought it was going to be, for instance at the very beginning, Tamino being chased

by a dragon: this is what I thought, a great heavy massive group of trees, say chestnut trees, and Tamino a rather slight youth silhouetted against the dark trees, very Mozartian. But instead of trees it was rocks and a lot of searchlights, and one of them would keep following Tamino about. And Tamino: ugh! A swarthy, muscular man. But Pamina (Claire Dux)[140] is alright to my thinking. Her voice is nearer than any I have ever heard to what I like a soprano voice to sound like. There are a lot of things that move me very much, for instance no. 9 Finale, no. 11 Duett, no. 21 Finale and the thing that Pamina sings when Tamino will not speak (one of his tests) to her. I read the English translation of the play and also a book about it, written by a man who thinks he knows everything and everybody else knows nothing. I wonder if Mozart was so moved by Freemasonry. Of course you have all sorts of hints, and then the mystic notes. I can't help feeling there is something not quite healthy in parts of this opera, but then what was the poor man like when he wrote it?

Gilbert has done a good drawing of a head today at the Slade. It is an old man's head and it reminds me of those old apostles by Donatello. I expect you have seen them, or reproductions of them. Roger Fry used to show us them on the screen at his lectures and they looked fine on the screen. I went to the Whitechapel show and did not think anything of it. Are you doing any pictures?

Would you just look among your reproductions and see if there is a photo of my Apple picture among them? I think there is. If there is, could you send it me with your promised letter? When you are in London or anywhere near us, just come here and do not be afraid of causing inconveniences. It is a nice change for my people to see you. Though Ma is not particular about anyone (except of course bad people), there was no need to make the excuse at the top of your letter to Ma because she was particularly impressed by you, Jacques, and could speak highly of you without reverting to her dear brother John (my good uncle, a very strict Methodist who died before I ever saw him), a person she seldom escapes.

I must get this letter off.

Love from
Cookham

140 Clara Dux (1885–1967), the Prussian soprano, made her London debut in 1911.

＊ ＊ ＊

12, 15 and 17 July 1914
Fernlea

Dear Jacques and Gwen

Thank you for your letter. I have not even got over the enjoyment of the last one and that is the truth. I think I have got rid of oiliness in my present landscapes, which I am very keen on, but there is one thing has made me quite itch to begin it. It's a big yew tree in Cookham churchyard and it fills the canvas in such a wonderful way. Trees mean a lot to me: some trees.

I have been prejudiced against thinking – I will tell you why. I used to go, for ages every day, to lunch with Nevinson[141] and Wadsworth, and Wadsworth used to get me to study the anatomy of his 'thoughts' upon art and how to paint and draw – in the practical way, mind. This sort of thing went on for what seemed to me years until at last one day Wadsworth came in absolutely desperate. But I think I told you how that on this occasion he advised me to give up 'art': 'I have had experience; you have not. I have passed through all the stages an artist can go through; Rembrandt and all the rest'. He went on like this and Nevinson looked very glum. It is extraordinary, but on this occasion I was silent. I thought perhaps he was ragging, until one day I asked Nevinson and he said Wadsworth was doing the same thing to him; delivering these lectures. I thought when I heard Wadsworth going on, 'If you had not interfered you would never have got yourself into a muddle', for Wadsworth is a horrible man to me. You understand, I only tell you this to show you that it was more or less through listening to these people's rubbish that made me so prejudiced against thought in every way; and I repeat I agree with you that my work has suffered on account of this prejudice. I knew when I was doing that face (not the neck) that I was copying form without understanding it, but that is away from the argument, since that was caused by – not lack of thought – but the lack of idea.

15 July

I have been longing to think about something, but it seems to me

141 C.R.W. Nevinson (1889–1946), artist, war correspondent and author, was at the Slade 1909–12.

that my time is taken up too much with all sorts of damnable trivial little things. You see, all day I am doing my landscapes and I am hard at it, and as you say it is refreshing me a lot; well in the evening I generally like – especially when feeling like I do now – to let myself live in that which is going to produce something, and not to waste all those precious moments in writing some wretched letter. It took me the whole of this evening to write a letter to Lady Ottoline Morrell;[142] the lady who bought Gil's picture. I like her very much. The letter was quite short, and nothing in it.

And another thing, I don't want to pay a flying visit to God. I want a long time with him; to walk with him like Enoch did. Do you ever feel like this?

17 July

I have just seen Mr Rupert Brooke and he says you two are in London for a few days. If this is so, would it be possible for me and Gil to come up and see you? I should not want to if it was in the least degree inconvenient and you would tell me so if it was. I like Rupert Brooke. He is a good man and I think he must be an Englishman – must be, you can't get away from it. I am going to hear *Figaro* tomorrow. I read a brief of the libretto but it seems too complicated. I must see you before you go away. I have nothing to show or say.

Love from
Cookham

If I cannot see you, you'll have to write a lot to me, that will be the penalty.

* * *

Within a few weeks of the outbreak of war on 4 August 1914, Stanley's brothers Percy and Horace joined up. Henry Lamb, who had studied medicine before abandoning it to become an artist, enlisted in the Royal Army Medical Corps. Stanley and Gilbert then joined the Civic Guard; they were persuaded by their parents to join the Home Hospital Service in the Royal Army Medical Corps rather than volunteering for active service; Gilbert enlisted first.

142 Lady Ottoline Morrell (1973–1938), influential patron of the arts, one-time lover of Henry Lamb.

12 August 1914
Fernlea

Dear Lamb

I should like to be able to do something. Gilbert is keen on joining you but he cannot ride, though he is keen on learning. It is intolerable to be out of it. I cannot think. If you know of anything that either Gil or I could do, let us know. I expect it is rather selfish but I am determined that Gilbert shall not volunteer for foreign service; there is not the least necessity for him to do so. It would be better if he could simply put his name on the list of those to be called if required, so that he could get on with his picture (it's going to be finer, much finer, than the last one). I do not see that I could be of any use, except of course if there are other duties to do besides fighting. What ghastly things those Liège forts are.

There seems to be no sport in war now. I would like you to advise us what to do.

My eldest brother came over from Germany the Thursday before the Tuesday on which war was declared between England and Germany. He came for his holiday knowing nothing of the war. His wife, who is a German, is in Germany. Brother Percy (he went for a walk with us when you were here) thinks of enlisting in the Queen's Westminster's or something like that. When I feel the horror of this war most is when I go to bed.

You know you can come here when you like, only we cannot put you up for the night now because every bed ,and more than every bed, is taken. How will Japp get back? If I go to war I go on one condition: that I can have Giotto, the Basilica of Assisi and Fra Angelico, in one pocket and Masaccio, Masolino and Giorgione in the other.[143]

Cookham

Stanley Spencer is only my professional name.

* * *

143 Stanley had been collecting Gowans & Gray pocket books on artists since 1907.

August 1914
Fernlea

Dear Jacques and Gwen

What ought Gilbert and I to do this war? My conscience is giving me no peace, yet though that is true, I have managed to do a composition and a lot to my big picture and also to the landscapes I have already told you of. This new picture is of the visitation of Mary and Elizabeth.[144] I have been so disturbed that I have not been able to concentrate to my attention on this picture.

I will send you a drawing of it. Advice from you would relieve me greatly, even if you said I ought to go to the Front. It is sad enough here. My brother from Germany cannot in any way communicate with his wife, who is a German. He is quiet about it, but I see the effect sometimes. Ma has gone to Eastbourne; Gilbert saw her to Victoria all the way up in the train. She, as she always does, fell into conversation with the people in the carriage. 'The Germans 'aven't got to know 'eart', says the man she is talking to. 'No' says Ma, 'they are not very artistic.'

What do you think of this idea? In Maidenhead 3 miles from Cookham there is a Civic Guard, drilled by a Sergeant Guthry. A lot of young men are being drilled by him without belonging to the Army. A gentleman in Cookham is getting up a batch of young men to go over to Maidenhead and be drilled by this man.

Saturday 29th

Yesterday night Gil and I had our first drill. Horribly monstrous and the Sgt Major has a rasping voice, though in spite of that and his awful severity, I believe he is a good sort. It is so extraordinary how those men can terrorise you. This man made us all feel very uncomfortable and I remember the feeling of relief when he said we were getting on alright. I still feel worried, not so much about myself as about Gil. I feel sure that soon he will be asked for the regulars, or at least he will feel he ought to go into that or the 'Terriers'.

I wish you could see his picture.

I think this having military training without belonging to the Army is bad, because it leads men to think 'well, since I can get

144 *The Visitation* (Hunterian Art Gallery, Glasgow). The picture has traditionally been dated 1912–13, but it appears on the evidence of this letter that it was painted in 1914. There does not appear to be an alternative version of the subject.

trained without belonging to the Army and' (under his breath) 'it looks respectable and eases my conscience considerably, I will join this and not the Territorials.'

Today the sergeant gave out the notice that a Lord Desborough[145] had enquired at the War Office about our drilling without joining the Army and that the War office approved of it, though I still feel it is wrong, and oh it is monotonous! No wonder Army men have no brain. I do not know if he is a good man or what he is, but I have the feeling that I should not want to see him drilling a lot at the other end of the field and me being drilled by someone else. It is good for me doing this sort of thing, you have to keep well awake. But I do miss my dreamy evenings; but it is not possible to enjoy them now. All the same, I itch to begin the painting of this new idea.

Love from
Cookham

* * *

September 1914
Fernlea

The apples have come and look very promising. The carriage was 2/9d.

Dear Gwen

Please send the coat if it is not too much trouble. Mother is going to write.

I have done another thing: a man lying on a bed in a running position with three people praying behind him.[146] There is a lot of space round the bed. It would be fine to do another picture the same size (square) of Christ and the Centurion, and let the two pictures appear beside each other with a little space between. Gil has nearly finished his big picture. The coat will do for him if not for me. I will write again when you are in France. Give mine and Gil's love to Jacques. Ma was going to write but she thought she had better not do so just as the apple season commenced. It is impossible to get her

145 William Henry Grenfell, 1st Baron Desborough (1855–1945), athlete and politician, was President of the Volunteer Training Corps, which passed more than a million people into the regular Army. Incidentally, Desborough had a house, Taplow Court, Bucks, near Cookham.

146 *The Centurion's Servant*, 1914 (Tate).

to understand the necessity of men joining. 'My dear, it's brutality, I hope none of my sons will ever kill a man. Dear Mr Johnston used to say that whenever he saw a soldier he shuddered.'

We are getting neater in our drilling. I am 5 feet 2 inches, the man next to me last night was 6 foot! Mountains like that were all around my position and I stood feeling that every minute I would be the next.

Love from
Cookham

* * *

*c.*September 1914
Fernlea

I received the Assisi, looks alright.

Dear Jacques and Gwen

Gilbert has sold his big picture to the Contemporary Art Society for £100.[147] Lady Ottoline Morrell was the person who bought it, and Lamb worked the sale. You can guess how pleased Pa and Ma were. Tonks was also pleased, but nevertheless spoke very seriously of the dangers of early success, and I am glad to say Gil listens to him and takes notice of what he says. I have 'finished' my painting of myself[148] and I am now, in the morning, painting my big picture,[149] in the afternoon, a distant landscape of green trees and green fields and the River Thames, and in the evening a view of the back of Cookham village.[150] I have also just begun a painting of a corner of the back lane, which I am very interested about. I mean I am painting it because I have a great desire to do so. Gilbert is going on with the thing he began last summer of elm trees; you saw it, with those distant white clouds against the dark elms. He is also painting a distant view of Cookham village. Remember the place where you saw the man shearing? Well it is in a meadow next to that – next but two to that meadow I should say, in which Gil stands to get this view, and he gets a part of that row of elms that perhaps you noticed on the left as you went through the sheep-shearing field.

147 Gilbert's 'big picture' would appear to be *The Seven Ages of Man* (Art Gallery of Hamilton, Ontario, Canada). It was purchased by Lady Ottoline Morrell for the Contemporary Art Society for £100. Gilbert recalled that he used 'my brother Stanley and Peggy Hatch as the lovers'.

148 *Self-Portrait*, 1914 (Tate).

149 Presumably *The Centurion's Servant*, 1914 (Tate), 114.5 x 114.5 cm.

150 *Cookham*, 1914 (Tullie House Museum and Art Gallery Trust, Carlisle).

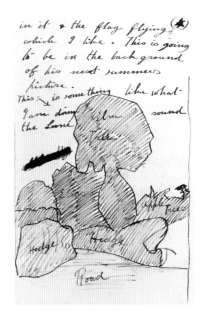

in it & the flag flying (⭐)
which I like. This is going
to be in the background
of his next summer's
picture.
This is something like what
I was doing [illegible] round
the Leve [illegible] Tree

What I like about this painting is that he has got the different greens; not variations of one green, but each green as separate idea. He has got the Crown Hotel in it and the flag flying, which I like. This is going to be in the background of his next summer's picture [drawing]

* * *

October 1914
Fernlea

Dear Jacques and Gwen

It was kind of you to send the money, 15/-. Gil's picture has just been photographed so I can send you a photo soon. I get too tired in the evening to do anything after drill. But still the discipline and exercise will do me a lot of good. I have got another of those little books I showed you when I last saw you. This one is Orcagna, Lorenzo Monaco and Masolino da Panacale; that's alright isn't it?

If you can think of anything I should like to read, tell me because I feel that when I'm too tired to think about my work, as is more often the case now, I can read.

I can't understand Turner. There is one thing, *Lausanne*,[151] a sort of reddish coloured thing, which gives me a very definite feeling. Then you turn to another thing of his of the same period – his greatest period – and it seems to be a dead thing to me, although everyone else goes mad on it; and this makes me feel that what Turner meant is not a bit what I feel in Lausanne, but that the meaning it has is something I have put into it myself. I cannot say that I am not capable or have not got to the 'point' of understanding Turner, because if I said that, how could I understand Beethoven? This drives me to the conclusion that Turner is bad, but that is just what he isn't, so there I am.

Wilson Steer[152] has joined the Special Constables.

What a damnable shame that you have left Croydon for good. I do long to hear you play it again, Jacques, it's a chronic longing, this is, with me. I have said before and I say again: your playing is a necessary thing to me. Lamb has lent to my brother Will the Beethoven Diabelli Variations. The Arietta in Beethoven's Sonata

151 J.M.W. Turner (1775–1851) painted a number of watercolours in Lausanne in 1841.

152 Landscape painter Philip Wilson Steer (1860–1942), was Professor of Painting at the Slade and an official war artist during the First World War.

Op. 111 is a thing that Will played, and he played Op. 110 and 106 (Hammerklavier). The slow movement makes me feel that the world is nearly coming to an end.

Do you know of any book on Roman Catholicism – a good book? I have to listen to the conversation of these Godforsaken Protestants and they are such a devil-ridden impossible people that I get nothing but the superficial side of the Roman Church. I cannot help feeling that Protestantism has caused all these things: Congregational Church, Wesley Church. The death of painting and music. Agnosticism. When he is approached on the subject of religion he quietly smiles, buttons his coat up, looks self-contained and says 'agnostic'. I knew a student at the Slade who did this to me. The Church of England is a manufactured article. The only reason I liked going to Cookham church was because the building had a wonderful influence over me, and who built Cookham church? It is early Gothic and in it there are several things, reminders that once it was a Roman Church. This Protestantism is like a disease, cholera or something, it comes and when it comes it repeats itself and gets worse. The Protestants are independent of the Roman Church, and directly that happens everybody says why should I conform to the laws of any church, and so at last we get a thousand and one ghastly little theories that are simply blighting every living thing. I think it is important that people should realise that Protestantism is one of the most secret deadly implements of the Devil. I was glad, when I said to a man that the Protestants are responsible for all the bad things (of course there are other evil bodies), that Gil, who never opens his mouth about anything, said 'that's true'. I have no proof for what I have said, I have convictions.

My pictures are not the product of Protestantism. I do not see how Roman Catholicism in England could be as great as it used to be now that they have none of their fine old buildings.

Cookham

The coat woollen thing and drawing block, etc., got here alright. Thank you for them.

* * *

1 October 1914
Fernlea

Dear Lamb

Thank you for the letter and book. I think the book is very good but it does not give the things by Orcagna that Raverat once lent me: very evil pictures of hunters discovering decaying human bodies; they hold their noses and the horses are very evil-looking. But what a book! I think they all three are great, though Masolino stands far above Orcagna and Monaco, I think. I have had 2 ideas lately. The first one I seem to have lost sight of in carrying it out, but the second one I feel alright about. It is a man lying on a bed in a reclining position; there are three people praying along the side of it.

I want to do another picture of Christ and the Centurion. I have an idea having a relation to the one I have drawn in this letter, which I am now painting, and when I have got more done to it you must try and come and see it.

If you are sure you could do without the Diabelli Variations for a time, my brother would very much like to have them. There is such a lot of rubbish and so little really great music in our house. All my brother's music is in Germany. Mind you, I shall want to hear you play those things because your playing exists to me (you may quote to this in your advertising column).

I must get to this bed picture: this will be the first picture I have painted in a room.

Yours ever
Cookham

Gil gets gold prize for his picture today. When you can come, come. But if you wait a week or so I shall have a lot more done to my picture.

✳ ✳ ✳

The Centurion's Servant, oil on canvas, 1914 (Tate, London)

October 1914
Fernlea

Dear Lamb

Thank you for the Diabelli book. Will has played me some of them. But I do not like to ask him to play them all at one time because you get so done up. Come down when you can. I have nearly finished my new picture and I should like you to see it. The old one is going on alright. Gil's picture is packed and gone to London. Have you seen Japp? I'd just love to see him again. He seems too much a thing of the past. You will have to see Gil's picture at the Slade or somewhere in London. I do wish artists could live on a more businesslike basis with the people who buy their pictures, but it is no use speaking about that now. I am sorry that the people who have my pictures are not more deserving. I wish I had them all myself; I would not burn them.

Cookham

* * *

23 November 1914
Fernlea

Dear Lamb

Do you know any decent regiment that would have me or Gil? We both feel it is impossible to settle down because to work at our job one has to enjoy things and I find that impossible; at least I can enjoy, but then there is the constant shock of realising what is on. There are such a terrible lot of slackers about that I think it is necessary for people like me to join up; it is sickly in Cookham. I am quite sure I am as strong as thousands who are fighting: the more beastly the stories become the more I feel I ought to go or do something. Gil walks about like a lump of lead. I believe that with all the monotony of training I should be happier doing that than here in Cookham trying to work. I wish they had mules in the Army, then I could be dressed up as a dwarf and Japp as the Red Cross knight. It seemed

so funny you asking me if I was going to a party at Lady Ottoline's because with the exception of letters from you I have no letters from London at all, and I have not been there since last April and I write this letter in that little attic that I told you used to be my studio. The only society I have is apples, straw and downstairs a room full of chaff: a very popular member of society. This is a wonderful room…

The one great drawback to our going [to war] is our mother. I think I would get in if I showed them I was not going to be put off without a lot of worrying. What does put me off going if anything does is the thugs one meets in the Army. I hope I can see you soon.

Yours ever
Cookham

* * *

4 December 1914
Fernlea

Dear Lamb

I was horribly disappointed not to be able to come to London. Gil was in London at the Slade so I could not let him know. My throat is still rather nasty and my mouth is full of ulcers around the rim of the tongue. I have been rotten and feverish and once delirious since last Friday. I have had the doctor twice and he says I am going on alright. I have such delightful dreams at these times. I quite agreed with what you said about me at Marlow. I am in danger of becoming smug. What you said was necessary and beneficial. It certainly cleared the air, though I did not enjoy the process. I will send the picture to Hampstead as soon as I am well. Let me know your address in France.

Yours ever
Cookham

I have some of those sulphur tablet things for my ulcers. I say sulphur because they burn like it.

* * *

Sergeant Percy Spencer

23 December 1914
Fernlea

Dear Jacques and Gwen

I am still reading Dante: I have only just finished Hell. I like reading a thing like that very slowly. It is wonderful the part where Virgil embraces and carries Dante. I am reading Cary's[153] translation, which seems as though it must be poor but still it gives you some sort of idea. I feel in very good thinking form and feel every moment that I shall get at something, I am well on the track of something. Are you working or are you in the Army? I feel that if you had the experience with your father as Gil and I have had with our mother, you would not join without feeling an awful brute.

Of course we could both get in with the simplest ease if we liked to try. My brother Perce entered as a common Private and is now a Lance-Sgt.[154] My brother Horace, who works near Nigeria somewhere is guarding prisoners.

I should like to read about some of those saints of the early Church. I remember Gertler telling me that he had just read a wonderful life of St Francis and I remember you were reading a book of St Thomas Aquinas, there may be a good translation of that. You can see piles of books all about Martin Luther,[155] but everything else is hidden and hushed up. You hear that England was never anything till 'the new learning' began, then you hear more than you would wish to. I have ploughed through Chambers Encyclopaedia to see if I could find one man that was not the son of a Plymouth Brother, but he is not to be got. No, but seriously, I do long to see something that was not written by one of these gentlemen. You must understand that I have had a thorough grounding in Wesleyan Methodism. I have listened to a thousand sermons and I would like something to counterbalance this. I have come out of the chapel sometimes shaking with emotion. Gil and I used to get so excited sometimes that we felt that we could not face the prayer meeting. By the time I had reached prayer-meeting pitch I was ready to break down. The end of the prayer meeting was always ghastly.

153 Henry Francis Cary (1772–1844) published a blank verse translation of Dante's *Divine Comedy*, beginning with *The Inferno* in 1805–6.

154 Percy Spencer was highly successful in the Army: he rose to the rank of Sergeant within a short time of enlisting and was a commissioned officer by 1917.

155 Martin Luther (1483–1546) was a seminal figure in the Protestant Reformation in sixteenth-century Europe.

The man would say in a whisper, 'is there any poor wandering soul here tonight who has not heard the call of Jesus? He is always passing by, he is passing now…'; a long pause. 'Will brother Hopgood lead us in prayer?' Of course I used to come out feeling that I had done wrong in not going up to the bandstand and acknowledging my conversion as you are supposed to do, though I never knew one man ever do it in our chapel. About all this there was a wretched, clammy atmosphere and it used to get well hold of me, and it is not gone yet. They used to have these meetings in the evening because the blood sucks to the head in the night. I expect you think that I have exaggerated, but if any fool, a shop walker or some other kind of 'local preacher', came up to me and began to work upon my feelings, he would succeed. Of course it is some three years since I left the chapel.

It is very funny, the difference between the wounded soldiers and the ones not yet gone to the Front. The ones just going look earnestly at you and say, 'be a man, wilt th'a join? I'll even ask thee again, wilt th'a be a man and join Kitchener's Army?' During the pause he holds up a pack of cards; down go the cards, and then volleys of abuse. Needless to say, this man is a Northcountryman; one of the Darkhams. 'We are British, British'. I am glad I was born where I was born. The wounded are always quiet and never say a word about our not joining. These selfsame 'steady' Darkhams went into the bicycle shop in Cookham and began recruiting. There was a youth there, lolling about, and they attacked him with gusto. But that mere boy had been in a very severe bayonet charge in France, had distinguished himself but in getting away had been shot through the eye from a German in a tree. These men I expect thought he had a cold in his eye, as his eye was bandaged up and they would not believe him when he told them. Of course there are several youths that Gil and I have known, Cookham boys, killed, but I used not to mix with them like Gil did so that it means a very little to me; but it fairly gets at Gil, who goes about like one possessed. You saw Gil when he was having the happiest experience of his whole life, and that is true. I know that from him. I wish God could suspend such people as Gil during time of war.

I do not think that to keep out of the thing because you are valuable in other ways is possible: you cannot juggle with your

feelings like that. I would like you to say what you are doing and what you expect to do. It will be a great strain for your father if you go, won't it? I should like *The Possessed*:[156] I feel quite ready for another dose. Now is the time to fast and do nothing but that, yet I doubt that is true. I did my bed picture while the war has been on and that has come off alright. I have finished it and sold it to Lamb.

I saw Japp, he came here in his brother's motor and we had a ride for the first time in our lives in a private car.

As you say it does seem nasty to sit comfortably by the fire and listen to the maid tell you as 'ow 'er brother , who is at the Front and has been since war began, is smothered with bugs and fleas and can't take his shirt off because it would fall to pieces if he did. But I expect to see and hear about this kind of thing. I do not suppose that you are in imminent danger where you are, are you? Gil is always on about you leaving Croydon altogether: he can't understand it, and constantly refers to it. I have explained to him and he has read the letter in which you gave the news. He never says a word about you. In fact he has only said one thing about you, Jacques. He said something that very much struck me but I only remember that the word 'sacred' came into it.

My brother Will plays the piano casually, casually and badly playing Beethoven, and then he all of a sudden seems to change and the change is so certain that it comes on you before you are prepared, and you know what that is like. I wish you could hear him play the 111th Sonata and the Diabelli things. I feel sure you would agree with me that unconsciously he's a great man. Your letter was fine, write another.

I think your Judas picture is good. It is very depressing: the relations of the figures to one another are all damnable. I do not know if that is what you intended. I think the two men standing is the most really evil thing I've ever seen. I feel that I have clearly understood this picture and now I feel perhaps I shall be better able to understand 'your next'.

Love from
Cookham

156 Dostoevsky's satirical novel was translated into English by Constance Garnett.

Don't you think in my John Donne picture I have got what you talk

about? I mean the thing does not rely on just colour or shapes on a flat surface, but much more on the way they make you feel space, and as a student named Hope Johnson said (you remember him), 'You want to walk round the figures'. The fact is they are in space. Is that what you mean?

I will write to Bowes & Bowes[157] for *The Possessed*. I see you have told me to. She must be a remarkable woman, that Mrs Garnett. I have not yet thanked Mrs Darwin[158] for 'the shirt' and she sent it to me about four or five months ago. I intended to make her a small drawing of my bed picture and have not done so.

Gil says if he marries he will marry a good healthy skinny (servant), so he says.

* * *

25 January 1915
Fernlea

Dear Lamb

Shall I send the bed picture to your place in Hampstead or keep it here until your return from France, where I imagine you now are? I will send it to France if you would rather I did that. I have begun a new picture and so has Gil. I have today got a green that is a green in the picture I have just begun, which is of people coming out of graves,[159] and I will make a drawing of the incident when I know where you are.

I do not expect you to have time to write so just drop a card.

My brother Will played us the Diabelli Variations. He has gone to Basle to meet his wife. It was madness for him to stay here away from her. Gil is doing a Crucifixion[160] and I will try to get him to show you what it is like.

Yours ever
Cookham

* * *

157 Cambridge-based bookselling and publishing company.

158 Lady Maud Darwin (1861–1947), Gwen Raverat's mother.

159 *The Resurrection of the Good and the Bad*. Spencer painted two versions: oil on paper, 1914, and oil on canvas, 1914–15.

160 Gilbert Spencer, *The Crucifixion*, 1915 (Tate). It was first owned by Desmond Chute.

February 1915
Fernlea

Dear Lamb

Thank you for the postcards (three), it relieves the monotony of seeing the same people every day to receive things like that now and again. Have you any money, because if you have and if you can let me have some if I should suddenly pounce upon you for any, tell me so in a letter and I will tell my Pa and Ma, who are both worried now that my eldest brother, Will, has gone to Switzerland (in hopes of seeing his wife), for that means a loss of money, though he still hopes to send some. It is just my parents 'morale' that wants improving. You know that neither Gilbert or I need any money now – that we have, Gil £85 or something like that and me £50.

My brother Will seems to be going through a perfect ordeal. Gil is doing a big picture of the Crucifixion and I am getting on with the people coming out of the graves. The enclosed is a tracing of the drawing I did for it. We have just had a telegram from brother Will to say his wife is with him.

Yours ever
Stanley Spencer

I don't think this thing is anything near as good as the bed picture. I did it this shape because there is a place like this in Cookham Church, not that I should ever do it in there, no, if I did, I might get depressed by it and never want to go into the church again.

✳ ✳ ✳

March 1915
Fernlea

Dear Jacques and Gwen

I have been thinking such a lot about two pictures I want to do that I have not felt settled enough to write. One of these pictures is of

men working in the Cookham cowls, putting the cowls on to the malthouses.[161] The other is of people down at the boats going on the river.[162] If you can let me know where you are for certain, I could show you what they are like. Gil is going to Dover with a Slade man named Bains. My brother Perce is in France. I will write a proper letter when I know where you are and when I have got a pen. I have done a lot since I saw you but I have got a lot to do, which is a very good thing. Gil is only painting the grass so far in his picture. I don't think I like those absorbent canvases.

> Love from
> Cookham

There is a very fine sort of atmosphere about Oliver Gotch I think, don't you?

I am sorry to have discussed this Army business so much but I want to know if you have any advice to give. I have finished *The Idiot*[163] Mrs B. Darwin sent to me and I do not know her address. I think Dostoevsky must have suffered a great deal in writing his books. I think what you said about him is true: that he is a saint; and in fact he reminds me of Christ. I should have the same feeling of fear for him as I should for Christ. And another thing, Dostoevsky will not be snubbed, you can't do it, no matter how you try. He makes the purpose of his books too clear to be snubbed.

You know what an Englishman's idea of a 'manly' man is? I could not explain it in all its details but it is generally, quiet, reserved, level-headed, and above all, self-possessed.

Level-headed and self-possessed: they are the keynotes. In spite of my not agreeing with the above being called a manly man, I think I have been influenced by this idea, and if you knew my family more you would not wonder: they are so strict, especially my brother from Germany, though his strictness is preferable to new movements! It is very boring at times, for instance when we were marching last night. Gil accidentally caught sight of a boy falling full sprawl with a large can of milk. It proved too much for Gil and he started giggling but managed to suppress it before Sergeant noticed. I told Will this and he immediately began to cross-question me as to whether the sergeant was angry, whether the boy was hurt, etc.; if you cannot

161 *Mending Cowls*, Cookham, 1915 (Tate).

162 *Swan Upping at Cookham*, 1915–19 (Tate). Abandoned when he joined up, this was the first painting that Stanley completed when he returned at the end of the First World War.

163 Dostoevsky's novel was first published in English in 1887, and by Constance Garnett in 1913.

give him satisfactory information, there is no peace until he gets it. I feel somehow I have rather gone off the track. I meant that there is a great difference between the English youth and the Russian youth, though the difference I think is only that they behave differently. I hope that Gil and I will not be put into another 'squad' as I do not want to leave this Sergeant Major Baldwin.

⁂

24 March 1915
Fernlea

Dear Lamb

Thank you for the postcards and your letter. I have been working very hard lately. I have had a lot to do, I am glad to say. I have got such an idea for people going on the river.[164] It does not sound much, but you wait and see. I am also doing a picture of men putting cowls on the Cookham malthouses.[165] This is going alright except that I have a feeling the thing will not give the feeling of it being particularly the Cookham malthouses, but that they might be malthouses in Wycombe or anywhere.

Would you send my Zacharias picture to the NEAC? I think I had better.

Do you know Frank Rinder?[166] He bought my Zacharias composition and very likely he will come and see the painting.

I like living in my pictures, at one time being in one part and another time in another part. I do quite a lot of travelling in my pictures.

Well, I have no other remark to make, except that brother Perce, whom you know, is a sergeant and at the Front in France, but I expect he will be alright as he is orderly clerk.

Yours ever
Cookham

164 *Swan Upping at Cookham.*

165 *Mending Cowls, Cookham.*

166 Frank Rinder (1863–1937), scholar, art historian, writer and critic.

Gil goes on alright and seems to have an idea. I enclose photograph of my picture. It is the only one I have until Gil comes back from

Dover and prints some better ones. I think I shall get a proper big one of it, and also of the bed one.

I have just received your postcard. The two men and boat in the foreground of the enclosed drawing are too high up in the picture; also, the man with a Swan in a bag (a swan upper) is not quite big enough. Otherwise it is more or less like the original drawing.

The clothes of the men in the picture will be not the clothes that the men wear.

* * *

Stanley met Richard Carline's brother, Sydney Carline, when they were students together at the Slade; they shared a drawing prize in 1909. Stanley began corresponding with Richard in 1915.

2 May 1915
Fernlea

Dear Carline

Thank you for your letter and offer to let me have one of your drawings I should not take one except for the fact that I really want one, and since I do want one I am going to have one, but only on this condition: that if ever you feel you would like to see it or have it back you will write and say so. I gave a drawing away a little time ago and now I ache to have it back and do not like to ask for it, so I know what it is like. I know that if I had money I would buy back every picture I've ever sold.

I have thought of having one of your roundabouts but I think it seems such a pity to take something out of the book; I mean that when I look at your roundabouts pictures I feel they are all linked one to the other, that to understand one you must see the others. The last book that Hartley[167] has shown me has in it four or five pictures of roundabouts.

I have just been interrupted by one Jack Hatch, son of the coal merchant, who has told me that the old man in the room below this can't write, can't read, has not the slightest idea how old he is, and washes his shirts on Sunday. He sings very well. He talks

167 Richard Hartley was a close friend of both the Carlines and the Spencers.

to everything, to the chair, the wood, to the fire. But to the stairs leading up to his room he addresses most of his conversation.

I should like to see the first book of drawings that you gave Hartley for me to see again. I want to look at the roundabouts and animals again. The roundabouts in the 'last' book are fine in a different way to the ones in the 'first' book.

In one in the 'last' book you have drawn the base of the roundabouts, and also the left-hand side. I have put a cross on the page facing the drawing I mean. On the page immediately preceding this drawing is another which I think is wonderful, and so does brother Gilbert, but it does not move me like the one with the base, which is largely to do with the feeling I get from it. I believe you rather look down on these roundabout drawings don't you? Perhaps they are not so good as other things. I understand these more; that is how it is. I feel that if I had done a picture like the one I speak of, I should want to make a very perfect finished picture of it. Why? Because I should want to. I shall not decide what to have until I have seen the book you first showed me. In that book there are at the beginning of it some roundabouts pictures. They give me the most extraordinary feelings. Do you do paintings of these ideas? If you do I shall come and see them.

This letter is rather rambling but then today is Sunday. Of course you may go into the Slade and have a look around: you could ask to see Gil if you felt timid. If you go there, do not stay too long at the school. I stayed much too long.

I hope that if I choose a picture that you particularly wish to keep, you will say so.

Give Hartley that first book that you showed me, for me to see again; Gil has not seen it.

Yours ever
Stanley Spencer

4.30pm: and now to push my mother from Maidenhead to Cookham in her bath chair up and down the switchback road in the blazing sun:

It was very nice to have you to see my pictures. You allowed the pictures to look at you, which is a thing that hardly anybody ever does. I should like your brother Sydney's address.

* * *

May 1915
Fernlea

Dear Carline

Two roundabouts ones please. I have taken them out and I shall mount them, though not on huge flapping mounts.

I cannot help feeling that some people's studios ought to be like those old shops where we used to have ha'penny dips, a shop that is full of all sorts of things.

Think how nice it would be if instead of all this New English Art Club, London Group, Society of this that and the other, etc., we each had a studio and in front of the studio a little shop with a shop window full of all sorts of things, and someone behind the shop door to call 'shop' when anyone comes in.

That is why I like seeing old Clifton at Carfax & Co.'s place, because it is so much nicer to see a picture in the hands of a thorough businessman. You see people admiring a picture that is sold and then you see the picture dealer 'work' them off it and onto a picture that is not sold.

You might if you like send to the NEAC, but if there is any possibility of selling the thing without exhibiting it, I say by all means do not send it. What I say is if you can afford to wait a bit before you exhibit, do so. Of course it all depends on how you are situated.

I remember I told Jacob Epstein[168] that I thought his advertising himself was no good. 'Well', he said, 'if I did not advertise and exhibit, I should never sell anything'. And perhaps that is true. I do not like his work and he is a Jew and you could not say a worse thing about a man than that.

I will, if you do not mind, mention you and your works to Henry Lamb when I write to him. You see he belongs to no school, he went about with John[169] many years ago but they 'fell out'. John certainly influenced his work, which he knows I do not like. The interest he takes in my work is not like Roger Fry's sort of interest, which, as a lady said to me; generally lasts for about three weeks.

168 Jacob Epstein (1880–1959), pioneering sculptor and artist who often produced challenging and controversial works.

169 Henry Lamb was a follower of Augustus John; both were founder members of the Camden Town Group.

If I took an animal out of your book it would be as bad as taking a few bars out of a piece of music, so I shall not.

Yours
Stanley Spencer

I got your letter this morning, thank you for it. I think Gertler's old works are much better than what he does now. Since there is a human being for nearly every letter in the alphabet in your family, please put Stanley Spencer Esquire because there is a Sydney in our family.

* * *

8 May 1915
Fernlea

I hope you do not find this letter wearying.

Dear Jacques and Gwen

It was such a great joy to get a letter from you. I wish if you feel you cannot write letters that you would send me a picture postcard or something just to let me know that you are well. Since you travel about a lot, there is every reason why I should get a bit anxious. I have – when I have not been working – been reading Dickens, *David Copperfield* and *Great Expectations*. If you have not read *Great Expectations*, you should. Dickens is so kind and simple and he has some of the very finest Christian feelings in him; and as to his jokes, well the more he repeats them the more I laugh. Now wouldn't you like to go and be assistant to Joe Gargery in his blacksmith's shop? And then there is Wemmick, whose mouth when he is at Little Britain, is like a post office.[170] But it is his home at Walworth that is so good. You remember the dear old 'aged parent' or rather 'aged P' as he was called by his son John? His son had to nod to his father and then his father would say 'alright John, alright my boy'. I love it when Pip goes to see them how Wemmick 'calls' across the moat that goes round the house, which is only about a yard

170 John Wemmick's 'post-office mouth' gave him 'a mechanical appearance of smiling'.

wide and across which you could shake hands: you remember, they have a little drawbridge and all. Do you remember Mr Jaggers, 'the solicitor' who would never 'admit' anything and always suspected everything right down to his boots, which he would stand gazing down upon 'as if he suspected them of having designs against him'? I love acting Mr Jaggers and the handkerchief: 'No, exactly so…'.

It is just the Dickens atmosphere that rather sickens me. Well, so much for that, as Tonks says. By the way, Tonks is back at the Slade. I hope Gil will try and get into something, it is terrible to be a civilian. God says 'you must go, but I give you the power to obey or disobey this command'. You do not go, then you feel something has gone from you. You feel you are being prolonged by your own power. No longer alive, no. Alone, godless and altogether inhuman. You must not think that I get these feelings, I have them sometimes but very seldom. But I assure you I should feel much happier if I heard from you often.

Anyhow, don't 'dictate' to your wife. You dictated something to Gwen at the end of her letter to me. I wonder you don't have your meals in another room, Gwen. That's what our Ma says to our Pa sometimes. Only I do not think it would do with Jacques; he would look so damnably pleased.

There were two weddings and a few funerals at Cookham church this afternoon. Pa played at one of the weddings because one of the girls being married was one of his pupils. I heard Pa playing the Wedding March. I was outside.

I have not heard of Peter Phillips.[171] It has a little about him in Grove's dictionary.

After I have read Dickens I feel I want to read Shakespeare and so I have read *King Lear* again for the seventh or eighth time. The ending of Act III Scene IV is what I get great feelings from.

It is such a funny position Gil and I hold in family and surroundings. You know how 'virtuous' the Germans are. (I would rather bury my face in their putrifying dead bodies than see that virtue.) My parents and 'friends' say 'they are certainly very brave': why, of course they are brave, the very Devil's angels are that, and morally virtuous too, and I dare say if my people were to see them they would think them 'the most decent, well-spoken fellows they ever wished to meet'! These people do not seem to have a sense of

171 Peter Phillips (1561–1628), priest, virtuoso organist and one of the great composers of the Counter Reformation, features in the *Grove Dictionary of Music and Musicians*.

smell – that is it, that is what is needed. Have I ever seen a German, hardly ever, can I smell 'em, can I not! Lord how they buzz. And the smell settles and becomes dirt. When you keep scrubbing it off, still the dirt comes. I wish I could reveal to a man what evil is: that it is nothing to do with whether he visits the poor or needy or not, but just the way his hair grows at the back of his neck. Look at a Jew's hair, or a Germans – or rather for God's sake, do not.

I know what you dislike about Lamb, as much as you know yourself, to me there is something German in him.

I have not seen Lady Ottoline Morrell since I have seen you. You seem to be concerned, are you? It makes me laugh because she no more interests me than Professor Brown or the Provost. There certainly is an unpleasant atmosphere in being in her presence. Poor, silly woman, I could not help feeling sorry for her when she was worrying or pretending to worry about what Rupert Brooke called her.

She, at last, made a statement to the effect that R. Brooke was jealous of H. Lamb because H. Lamb had taken a girl from R. Brooke, and that she believed that R. Brooke thought she had something to do with it. So I said: 'That is not true. A very mean thing to say and I do not believe it', which she did not seem to like, for later on she turned to me and said: 'Well, I am sorry you don't like me', to which I replied, 'hm, har, hm, ha' or the other way about, 'ha, hm, har, hm'. She may be wicked, she may be, but I feel she would like to be good. It is the atmosphere that goes against her more than all the wicked things she is supposed to have done. There are many things that I like about her. I believe she is a lot more sincere than she is supposed to be. But this is wasting time.

Since I have seen you, I have been thinking of no fewer than six new ideas and one old one.

The cowl picture[172] depresses me to the extent that I do not know how to bear it. I wanted it to look like somewhere, and it looks as if it might be somewhere else, that is the whole trouble and a great trouble it is. The next is a picture of people going on the river.[173] When I think of my John Donne picture I feel this is all wrong, and yet in many ways it is very fine. I am doing a painting of it on a canvas as tall as me, nearly. The cowl one is a big one too.

I have also nearly done the Resurrection one.[174] Then after the riverside one, I had a great idea about the Last Supper.[175] I have often

172 *Mending Cowls, Cookham*, 1915 (Tate).

173 *Swan Upping at Cookham*, 1915–19 (Tate).

174 *The Resurrection of the Good and the Bad*, 1914–15 (private collection).

175 He painted *The Last Supper* in 1920 (Stanley Spencer Gallery).

thought about it, but nothing came. And now something has come. But it is questionable. So has something else that is the same and something else that may be but I doubt it. I feel 'rather' sure that it is good.

You will find notes on the backs of enclosed. I want to feel certain, I can't stand this 'sort of' idea. I have never touched the John Donne. But I shall. The pictures I have enclosed are all that I have time to do just now. They are the riverside one, the cowl one and a picture of Christ revealing himself to the two men of Emmaus.[176] I will do a painting of it about 3½ft wide. It will not be square. That is when I get a chance. I know this if I do not soon do it, I shall go off into gas. It is this fidgeting and having to wait. I get to feel quite exhausted sometimes.

Well, now I think I deserve a letter from you Jacques. I should also like your feelings about the things Gwen. I will try and get Gil to write and make a little drawing of an idea he has for the mocking of Christ. A great back view of a soldier on left and holding in right arm a straw up to Christ's face. Soldier on right with his fat, flat hand about to slap Christ in the face. He is also spitting at him. It is wonderful the way a flag hangs above one of the soldiers' heads. I have enclosed several photos that you lent me some time ago, or rather I took them. I have lost one and torn another in half accidentally. I am sending a composition of the painting enclosed to the New English. Are you sending anything? My brother in France is still quite well.

Lately Gil and I have been wandering about in the ghostly malthouses on top of which are the cowls. This is Gil looking into the place where they dry the malt.

Mr Alf Hatch, Cookham coal merchant, who is rather fond of money and who lets me have my dear little room for the very reasonable sum of eighteen pence a week, had a conversation with me full of regrets that times was so hard and money scarce. 'Ah Stan', says Mr Hatch, flopping his great hand out, palm upwards, 'it's nice to 'old out the hand sometimes, old boy', and his eyes would moisten with the thought of anticipated gold.

I would particularly like to see a photo of Rupert Brooke's front face, if you could get me one. I do not want that beautiful profile of him.

I just now did this so beautifully to my sister that she said 'oh, don't!' She was quite disgusted. My grandpa Slack was always a

176 *Supper at Emmaus*, studies, 1915. He also painted *Supper at Emmaus*, 1915, pencil and oil on paper, which Gwen and Jacques Raverat were the first to own. But it is small (21 x 18.5 cm), not the larger size he was contemplating.

'good' thrifty man. My Ma could not talk to him sometimes, because if she did he would turn round to her saying: 'my dear, don't talk to me, I'm coining.' These people look upon it as a sin not to try and make money, saying 'one must live', and to that reply 'one mustn't' or 'it all depends'.

I had a nice letter from Rupert Brooke just at the commencement of war. He seemed to be very fond of you. I have sold my big head painting[177] to Eddie Marsh for £20, also a landscape for £15.[178] I consider myself fortunate to get that in these times. When I was in the barber's yesterday a married man who had been a soldier in the South African war and who was just re-joining for the Front talked a lot to the barber about how he had done his bit and was waiting for the young men to go, but how they did not seem to. He waited for me to stand up; he sat down, leant back in the chair, looked me up and down: 'Now, Master Spencer, you ought to be in the Army, you know. Here am I, a married man with children, but I am going tomorrow, yes, tomorrow.' My answer was to stand and look at him, feeling like an idiot and a lout, and the fact that the barber had parted my hair made me feel more so. I felt it got on the soldier's nerves. 'I've got your name down. Why haven't you joined?' I tried to become dignified, but only became more foolish. 'Well at any rate', I said, 'I hope you will believe me that there is some honour in a civilian and that when he says he cannot, it is because he cannot.' And so I strode out feeling I had made a thorough mess of myself. My walk seemed guilty and my trousers flapped in an annoying way. However, these sort of things are only unpleasant while they last, and after that often amusing.

I hope I shall see you again soon, though work is the only thing you can enjoy, and then it has got to be very good. I want to know how to work in fresco. I am going to do some woodcuts but I find that the lines have to go more less one way, which I do not like.

With love from
Cookham

* * *

177 *Self-Portrait*, 1914 (Tate).

178 Possibly *Cookham*, 1914 (Tullie House Museum and Art Gallery Trust, Carlisle).

13 May 1915
Fernlea

Henry Lamb Esq.
On active service, France

Dear Lamb

I want to ask your advice about brother Gil. I feel sure that staying out of things is doing him a lot of harm. He is doing the St John's Ambulance exam and will be sure to pass, and if he does he will be bound to want to go into something.

1. Can Gilbert come to you?
2. What exactly would he have to do?
3. Ought he to do something in England first, to break it quietly?
4. Would he ever be able to see you?
5. He is sensitive: would it give him the horrors?

If you could have him out there and keep an eye on him ~~and see that he is not~~ He is very keen on music so if you ever get a chance you could play to him. You see I want this, that if Gil goes into anything, he shall have someone who knows him and can keep an eye on him. He cannot speak French. Will that be a drawback? I have a feeling that he would have to volunteer for field service but perhaps that could be permitted; they would have to keep him.

It is the hilly landscape that I have sold for £15.[179] I do not think much of it. It will be rather nice: Mr Alf Hatch, coal merchant and distant relative of ours, from whom I rent this little room, is letting his house and coming with Mrs Hatch, Jack Hatch and their old servant to live in this very cottage, like they did 3 years ago, when I had this room. They generally let their house for the summer. So I dare say I shall hear a lot about as how times and money issues is harsh, and 'Stan, its nice to 'old out the 'and sometimes, old boy', and then there will be Jack's everlasting 'Jes-so, Stan, Jes-so', which, being interpreted, meaneth 'just so'.

Alf Hatch has fallen quite head over heels in love with the bed picture. I enclose drawings of my recent pictures.

179 Presumably *Cookham*, 1914 (Tullie House Museum and Art Gallery Trust, Carlisle).

✳ ✳ ✳

27 May 1915
Fernlea

Henry Lamb Esq.
On active service, France

Dear Lamb

Thank you for your letter and, good Lord, the best cards, which I will keep for you but I expect I shall demand so much for storage.

As to how much this 'so much' will come to, I cannot say. I hope for your sake it will not come to much. But I find I have already taken about five of the pictures into my bosom. Some of them I do not like. I should like to do carving in wood or stone. I have often wanted to make bas reliefs of my bed picture and the men on garden seats that I sent you. Think how grand the bed picture would look.

Gil's exam is tonight. His Crucifixion painting is fine: it is nearly finished. It is very stimulating to look at it.

I will let you know if there is anything to report.

Yours ever
Cookham

Gil has got orders to go to Eastleigh. He has passed his St John's Ambulance exam. Gil will of course join the RAMC. I remain at home. I am an exception: one of those special kind of horrors. I can only live under specially arranged circumstances. A person with a peculiarity. And you know how intellectual people talk about these 'exceptions' – 'ah, but you have only seen him, but to know him you must…' – and then they give the directions of the game, and as they do so they give you a sort of 'inner soul' look.

It is not that I am what I say, on the opposite page, but that not being in the Army I feel like that. And the feeling is damnable.

✳ ✳ ✳

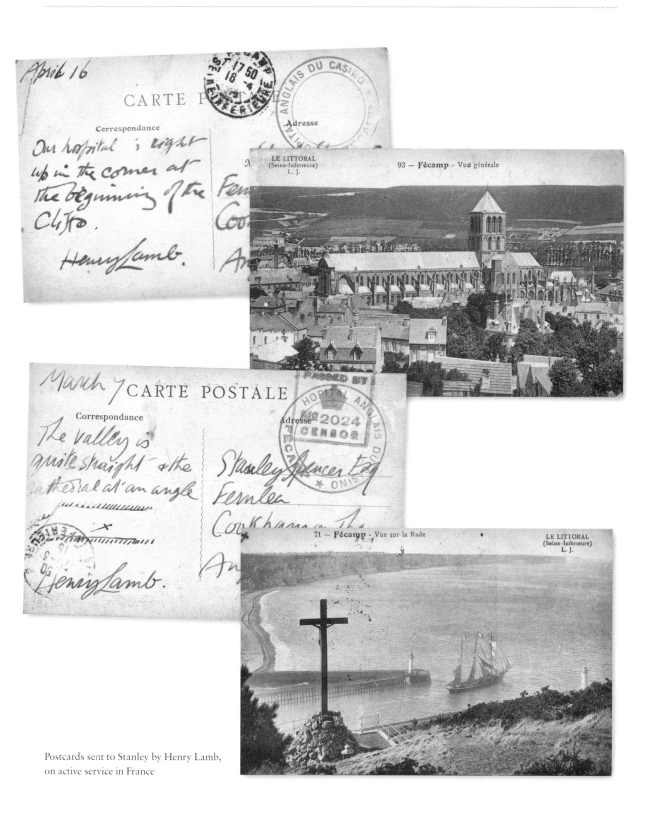

April 16

CARTE P[OSTALE]

Correspondance

Our hospital is right
up in the corner at
the beginning of the
Cliffs.

Henry Lamb.

Adresse

LE LITTORAL
(Seine-Inférieure)
L. J.

93 – Fécamp - Vue générale

HÔPITAL ANGLAIS DU CASINO

March 7 CARTE POSTALE

Correspondance

The valley is
quite straight & the
cathedral at an angle

Henry Lamb.

Adresse

Stanley Spencer Esq
Fernlea
Cookham on Th
An[gleterre]

PASSED BY
No 2024
CENSOR

HÔPITAL ANGLAIS DU * ONIS

71 – Fécamp - Vue sur la Rade

LE LITTORAL
(Seine-Inférieure)
L. J.

Postcards sent to Stanley by Henry Lamb,
on active service in France

May 1915
Fernlea

Dear Jacques and Gwen

Gil has passed his St John's Ambulance exam and has got orders to hold himself in readiness to go to Eastleigh. He wanted to go to France but I expect he will go there in some months, to make room for another batch. That is how it is done. It is so jolly to see Gil look like his old real, natural self.

I dare say there will be some young men who will be very annoyed that such 'talent', etc., should be thrown away. But to be a great artist one must first be a natural, everyday human being, and that Gil could not be, remaining where he was.

I think in your letter to me you have judged me too much on my Zacharias, Apple picture way of working.

My bed picture is an example of how a picture ought to be painted. Everything is that picture, the colour particularly, was perfectly clear, and the way to get the colour decided in my mind before I put the brush to the canvas. The result was it was done in no time. It was done like clockwork, and you know there is not much room for 'sentiment' in clockwork. I feel that people like Giotto and Fra Angelico knew their job in exactly the same way and in precisely the same spirit as the bricklayer knows his. What pleases me is that I have learnt the reason why a picture should be done so as to let one see the idea without having to plough through incompetence and details that have no fundamental bearing on the idea; that is not an original part of it. That is why I have taken the window and all the green creepers out of my Malthouse idea, and all very much for the better. I have made other very great improvements. I had the proportions of the distant cowl with the roof in foreground like this: [drawing] Now I have got it as I wanted it: you cannot quite tell what a difference it would make by these diagrams, but there is a vast difference.

What you write about the Emmaus picture is painfully true.

You might write to Gil else you will never get one from him.

* * *

*c.*June 1915
Fernlea

Dear Jacques and Gwen

Gil joined the RAMC some weeks ago. He was sent to Bristol to an asylum converted into a war hospital.

He begins work at 5am and goes on till 8pm, with half an hour for meals. I feel that what he has said in his letter is true, that they mean to kill him if they possibly can. He says the way he is living is not healthy. That the men are horrible… and that they did not examine him but merely looked at him. They have not inoculated him yet and there is a case of [illegible] in the next ward. He wrote the letter to us in bed as he did not get time to do it during the day. He has no rest. I'm looking down the list of names of members of the St John's Ambulance Association, I see there is a Major G.H. Darwin. If he is any relative of yours, or if you know him, you might ask him if he could help to transfer Gil to a more decently kept hospital and where the men are treated as they should be. I enclose a copy of Gil's letter.

I am getting on very well with the St John's Ambulance work and I expect the exam will be in about three weeks or earlier. I shall not go to Bristol.

Cookham

Gil has sold his landscape of Cookham for £10 10s 00d.

* * *

19 July 1915
Fernlea

Dear Lamb

I have not done any painting for a month now because of the St John's Ambulance exam. I have at last given way, though while I was painting I stuck to it manfully. But now that my Ma's attitude

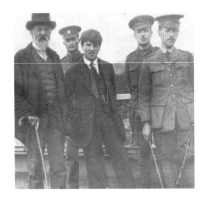

Stanley with his father and brother Sydney (right) with soldiers on Cookham Bridge, *c.*1915

has altered and has proved that she can do without us, without dying, as she thought she would, and also Cookham having become completely stripped of its youth, I feel I can no longer stick living here but must exist somewhere else, suspend myself till after the war. I have finished my cowl picture and I have done a lot to the riverside picture.[180] I think I told you Gil went to a hospital at Bristol: an awful place and an awful hospital. I may go there and I may go to Eastleigh. Where ever I go it is bound to be vile but I am prepared for anything. I expect my duties will be cleaning out lavatories and taking the 'pan' round the ward. It seems such rotten luck that Gil and I had to do this instead of being Tommies. I should have thoroughly enjoyed being a Private in the Berkshires. I mean I should have liked the training. Ma has got an idea that the RAMC is not dangerous and that one does not go to the Front, etc. I shall let her think that. Gil is sticking his hospital work alright but he does not look well. They never get out in that place.

About my bed picture, Pass says to me that he thinks it would be wise for you to make a solemn declaration about the payment of the picture to your executors, saying that in the event of your bursting, you wish them to pay me. If you don't do this and you do burst, then there is nothing to tell your executors that the picture was bought and there I should be without a brass farthing and the picture unsold. This seemed to me so businesslike and reasonable that I said I would ask you.

21 July

I have just heard that I leave for Bristol hospital on Friday morning (23rd July); the hospital is the same one as Gil is in. It will be nice to be with him, though he might be moved later. Are you doing any of the operating work? I shall only be an orderly, the same as Gil. The sergeant of St John's Ambulance who trained us is a ganger on the GWR line, one George Shirvill. He is a big, heavy, kind-hearted old chap and he reminds me of railway bridges and crowbars. I like to go to his little cottage and have a chat with him. He has great contempt for 'good Samaritans' and policemen, and a great respect for beer and for the oil of his joints.

180 *Mending Cowls, Cookham* and *Swan Upping at Cookham.*

Yours ever
Cookham

* * *

July 1915

Dear Syd

This is such a nice pen that I feel I can write you a letter.

I got your card but I cannot afford to buy any pictures. Lamb sends me postcards from France, where he is working in a hospital at Fécamp, Le Havre.

I have begun to do the picture of the good and bad people coming out of their graves,[181] and I am giving the bad ones a nasty time. I made the earth on their backs a lot thicker today. As to the one down in the bottom right-hand corner, he can't escape. I have got him absolutely set. I feel like God when I look at him peeping out of a nasty gash in the ground. In the one with the good ones coming out there is an oldish man with a purple cape; his hands are feebly placed on either side of the split open grave out of which he has come half way. He has kind of mutton chops but looks all the better for them. In fact I am seriously very pleased with him.

It is a good job about Will and Johanna getting together again.[182] Gil is doing a biggish painting of that Crucifixion composition that he was doing when you were here. I will try to write to you later but I do not write letters to anybody because I do not like it. If I get interested as I sometimes do, all turns out to be vanity, so I will close Higgy dear.

With love and kisses from
Stan

181 *The Resurrection of the Good and the Bad*, 1914–15.

182 Stanley's eldest brother, Will, and his German wife, Johanna Ohlers, had been separated due to the war.

First World War

MEDICAL ORDERLY AT THE BEAUFORT WAR HOSPITAL, BRISTOL

Despite his own preference to join an infantry regiment, in July 1915 Stanley acquiesced to his parents' wishes and followed his younger brother into the RAMC, having initially trained as a first-aider in the St John's Ambulance Corps.

23 July 1915
Fernlea

Dear Jacques and Gwen

I am leaving this morning for Bristol. I am going to the same hospital as Gil is in. I send these cards that you lent me a long time ago. I was examined by my own doctor yesterday and he says I am quite alright, quite sound. I will let you know my address as soon as I can; I expect it will be:

> Pte S Spencer RAMC
> Beaufort War Hospital
> Fishponds
> Bristol

I will write to you as soon as I can when I am there, and you write to me.

Cookham

* * *

The day upon which I was to join up I had to meet a party of St John's Ambulance men and to proceed with them from Maidenhead station to Bristol by the noon train. I should have gone from Cookham station to Maidenhead, but the day being a sunny July day, and wishing to leave via Sutton Road and Widbrook Common so that I could have one more walk over that common as a civilian, I decided to walk it. I also felt that if I left the village at the eastern

Opposite:
Detail from *Travoys with Wounded Soldiers arriving at a Dressing Station at Smol, Macedonia*, oil on canvas, 1919 (Imperial War Museum, London)

end I should not get the rather melancholy feeling which I always experienced when I left the village by the western end. So in a very summery suit, a straw hat and a mackintosh, I slipped away, calling out goodbye to Pryce-Jones the chemist as I went round Chapel Corner. Then I passed and look down Mill Lane, secret and peaceful, but not for me.

When I got past Sutton Croft I noticed a big thunderstorm brewing over in the direction of Cliveden Woods, and before I got to the red brick wall it was beating down. I kept as close to the wall as I could, as it was sheltering me to a certain extent. It did not rain so heavily across Widbrook, but when I got to North Town Moor it became positively vicious and quite upset my mental equilibrium, which on that day, owing to the circumstances, had become very shaky. For some unexplainable reason this storm gave me a kind of pre-vision of what I was to see and experience, and my thoughts became wretched and I felt very harrowed. My straw hat was all limp and sticky. Why God should have put such a damper on my patriotic ardour I couldn't understand.

And then the very thing I did not want happened. I met my father on Maidenhead platform with his bicycle. He had cycled in from Cookham so that he could say goodbye to me. I met Mr Shirvill (our St John's Ambulance instructor) and he thanked us all for our present to him, which was a walking stick with a dog's head on it. I do not know why I should have remembered this, unless the fact that at the most important moments of my life I generally remember the least important detail is an explanation. I got into the train with several other recruits, and just as the train started my father called through the carriage window to the man in charge of us: 'Take care of him, he's valuable', which made me feel very awkward. Why should I not be left to look after my own affairs now, I thought, like those other young men? Their Pas and Mas have not come to see them safely packed off. I felt so horribly like the curly-headed little boy going out into the wide, wide world all by myself.

On the journey I could not help seeing the great fields full of ripe corn, wheat, barley, oats, red wheat – or is it American barley? Anyway it is a bronze red. There were great spans of mustard round about Frome. But it was all forbidden fruit to me, and that is perhaps why it all seemed so extra sumptuous and tempting. I remember

some malthouses. I remember these because, being so accustomed to seeing only our own cowls on the Cookham malthouses, any cowl different from those seemed deformed. Of course they were not, they were simply different forms. It is so when studying the nude: when the model is changed, the new model seems almost deformed. In Bristol I noticed a number of Lascars, or black men of that type, strolling about in the Tramway Centre, and also a painted idol of some king, sort of Gog or Magog, at the corner of a street. Also some ships on the Avon. Later I observed innumerable arrows directing us to Colston Hall, at which place we were to be enlisted. I also saw a great hoarding encouraging the recruits to join the Bantams. There was a great cock painted on the placard, a cocksureish sort of cock. I wished very much to join that unit but I had decided to join the RAMC for the sake of my parents.

I next found myself in the upper room of a cheap restaurant. I sat at the table along with the boys who had come with me. I looked out of the window across to a lonely window opposite; through the window I could just see a large white rocking horse, which seemed to be in a perfectly empty room or cupboard just large enough to accommodate it.

After enlisting at Colston Hall I was careering on my way to Bristol Lunatic Asylum (Beaufort Hospital), riding on top of a motor bus. I observed, on my right, an open space railed in on the side bordering the road by a high iron railing. This enclosed a long, weary, grey building which was called 'Children's Home'. No building could look more grim and forbidding, and one could not help picturing thousands of Jane Murdstones stalking its corridors within.[183] I tried to picture a child but failed. I felt as if the whole order of childhood had become extinct. But getting to Fishponds, I was pleased to observe that this was not the fact.

Among the people walking to and fro on the pavement below I picked out several RAMC men, and among them my brother. He was swinging his swagger cane about and looking very reckless and irresponsible. But as soon as he caught sight of me his chin dropped and his face assumed a gloomy and stunned expression. He had been writing to me to dissuade me from coming to Bristol, as he didn't wish me to experience what he was experiencing and he was annoyed to find I had taken no notice of his advice.

183 Jane Murdstone is a cold and intimidating character who terrifies young David Copperfield in Charles Dickens's eponymous novel.

It was all uphill to the Beaufort Hospital, an alley having a thoroughly Salvation Army feel about it. At length we got to the top of the hill, where the walls on either side of the road widened and circled round into a road which crossed this road at right angles; on the further side of this crossroad was a wall with a gateway through it, over the top of which could be seen the workhouse. I came to the gate leading into the asylum grounds a little before getting to the George Inn. This gate was as high and massive as the gates of Hell. It was a vile cast iron structure. I love such things. Its keeper, though unlike that lean son of the hag who kept the gate of Hell, being tall and thick, was nevertheless closely associated with that rapacious gentleman, being the man who had charge of all the 'deaders' and did all the cutting up in the post-mortem operations, etc. I could imagine him cutting my head off as easily as I could imagine him cutting up chunks of beef: his eyes were beefy. But as soon as I had passed through that gate and was walking down the drive, all my patriotic ardour, which I had struggled hard to retain, seemed again to leave me. A great clawing death seemed to be sitting or squatting on all my desires and hopes. Everything seemed so false; the day did not seem like day to me, and the men did not belong to day. I felt that these beings, should they journey to where my home is, would evaporate into nothingness long before they got there. Even the trees and laurel hedges were affected: they were so deadly. Had someone been round in the morning and dusted them with a duster? A cobweb had been missed here and there. The ground was hard and had a ring of iron about it. The lampposts, signposts, railings and trees seemed to be riveted to the ground: a steel-like uniformity prevailed and nought could prevail against it.

The Sergeant Major, a gigantic man with eyes that paralysed me with fear, walked about the ground with his forefingers stuck into his two lower tunic pockets (the pockets, owing to his fatness, being kept tight closed, his fat thumbs sticking forwards); he seemed to be well aware of this fact and to take pleasure in it. It was no doubt reassuring to him to see such order as was everywhere prevalent in his domain, the 'work of his hand'. If nothing could prevail against the uniformity of which he was supreme architect, how could anything prevail against him?

As I walked towards the building my brother pointed to its tower and said: 'Look at that clock! Mad!' We were escorted across the

courtyard and along a kind of loggia or veranda – really the place along which all the food was conveyed from the main kitchen to the wards – and then a sharp turn to the left and along another, then up a stair and along a wide wallpapered corridor (very old-fashioned wallpaper) and at length into a ward, an empty one in fact. I believed that this wing of the hospital was uninhabited, yet I could hear laughing and talking going on. I looked at the pictures on the wall. They were of the Victorian *Pears Annual* nature and they have associative interest for me. I cannot imagine anything more incongruous than the feelings I had on that summer afternoon, sitting on the spring mattress of one of the many empty beds in that ward. Everything seemed to me to be directly the opposite to what, under natural circumstances, it should have been. The ward, with so many pictures depicting child life, seemed more like a nursery, and yet I had to 'fit in' to this nursery a great hulking man was sprawled in the empty bed opposite me: a man who had come straight away from a corn merchant's yard, a man used to heavy outdoor work, carrying bags of flour about.

I ventured as far as the door and into the smaller ward, and then into the large corridor through which we had a little while ago come. I noticed that in it there were several 'cubicles' and they were evidently inhabited: by whom, I wondered, and went back to my ward. I looked out of the window. Below, in the middle of the paved courtyard that was in the centre of the lawn, was a small arcade with open sides. I noticed some consumptive cases in bed under it. The courtyard seemed a sort of dream land and I wondered if the patients in the beds were real. I was so oppressed with the feeling of unreality that when, at length, one of the patients rose a little off his pillow, I experienced quite a queer sensation. This court seemed to have no outlets or inlets and to be quite deserted save for the patients in the centre.

I felt pleased to think that with the advent of tea I should have to take some sort of action to get it. And so, en masse, the four of us made our way, with fear and trembling, to where we had our food, which was in a large room having a long, broad table in it. I sat down at one end and felt bewildered, as I had just come from where there were only four of us at the table: my mother, father, sister and myself. We were served by several lunatics. They were all tall and some very gaunt. There were Frank and Charlie and one who never

spoke except when he heard a dog bark in the distance, when he would tell us someone had thrown himself off Clifton Suspension Bridge. This man was just about as high as Clifton Suspension Bridge, and he had a way of clearing the plates away that was fascinating. As he came down the table, pushing a dumb waiter, he would reach his great arm out and scoop the plates off the table, shooting them onto the trolley. And yet they never broke.

Now and then I was hired from ward 4A to scrub the stoned-floor bathroom of the medical inspection ward, and I used to rather enjoy it. The orderlies might give me a bit of cake or something nice and the Sister would condescend a little. I liked the surface of that floor and the colour was very good, some parts faded India rubber red and some more ochre and some peach-like. The bathroom of 4B (shared by 4A), was quite different. It was more jolly and matter-of-fact and had a deal board floor and a free and easy entrance and exit.

At the extreme opposite end of the hospital, on the western end wing, was ward 12B, which was a repeat of 4B only the opposite way round. I once penetrated as far as the entrance to this ward and saw 4B in reverse; behaviour in reverse. The meaningfulness in the inverted atmosphere of 12B showed how much I had established the feeling I had about 4B. It was very strange that when I looked at the patients I could never believe they had been ordinary soldiers: to have seen any of them submitting to discipline would seem very extraordinary, a kind of shock. I didn't feel so interested seeing a patient when he had completely recovered with his new khaki suit issued to him, how at once he seemed to 'lose caste'. He was no longer what he was in that hospital: to me, patients both young and old seemed not to have been wounded in this war, but in the Boer War or Crimean War. To me they seemed always to have had those wounds, were never otherwise, and had always been in that hospital. I could not imagine them before they were wounded and what they would have been like. To be wounded seemed to be a profession.

My first consciousness of being launched out into the wide unknown world began with my finding myself in a kind of large bedroom full of pictures similar to the ones in my bedroom at home (Fernlea). How I could say to myself, well, it's alright, things are not so different after all; you've just come from your bedroom where

you worked, and now you are almost back again in it. But apart from the disconcerting fact that I had prepared myself for something different, what about that corn merchant's man lying on the spring mattress on the bed opposite, and Smith's bookshop youth sitting and writing on another bed? It was a case of a bookstore man, a corn merchant's man, a gardener's man and myself having discovered that we had each made some awful mistake and were in a trap and the stupefied expression on each of our faces proclaimed this fact. We each had to find our levels in our own way. It was a case of every man for himself, and this instinctive feeling produced an atmosphere at once of unfriendliness between us; we each became to each other a symbol of our own helplessness. This consciousness, as those minutes dragged on, of a growing estrangement was terrible, and all this happening in a big room similar in feeling to the cosiness of one's own bedroom at home.

After all this description the impression might be given that I was in some way interested in painting all these wretched experiences. But as far as my intentions in my pictures are concerned, nothing could be further from my desire or intention. My intention was to attempt to express the very happy imaginative feelings I had in that hospital, revealed through my different performances and leading to a kind of redemption of the atmosphere and feelings that the place and circumstances gave me. Everything that never got ticked off by the SM, like trees, rain, or sunshine and birds singing, must in some mean kind of way be siding with him. If the SM said to the Colonel 'beautiful day', I felt that my presence would be spoiling it. The rain and the hospital drives were all SM days. I had, as I said, a longing to experience all these hospital performances, minus the harassing atmosphere I lived in, and my pictures were largely an outcome of this wish.

* * *

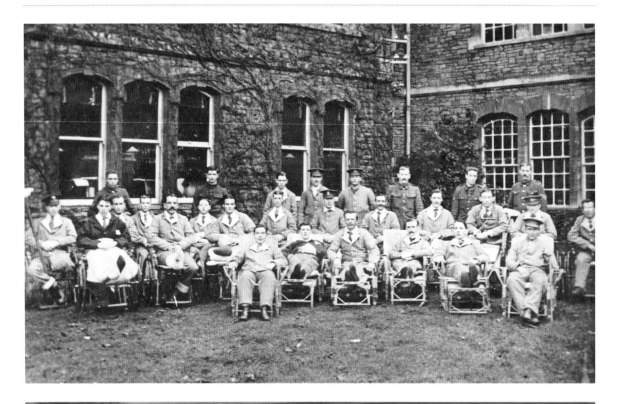

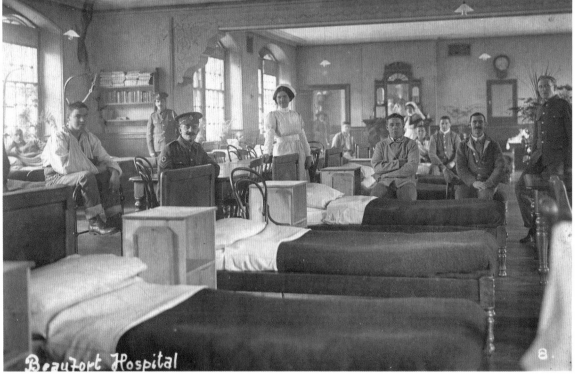

Beaufort Hospital

Undated

Pte Stanley Spencer No. 100066
Beaufort War Hospital
Fishponds
Bristol

Dear Lamb

Excuse this rough way of writing but I get no chance to write in a proper way. I love the idea of your getting a commission in the RAMC and taking me for your servant, but do you think it could possibly be done? If you can send me some money, send it direct to

> W. Spencer
> 'Fernlea'
> Cookham on Thames

I only want some to keep my current account alive.

Gil has gone but he went some time ago. It was awful the first few days after he went. I felt quite sick with loneliness. I will write later. If you join the RAMC and wanted me with you it would have to be the regular.

I have not answered your letters as I should but they have kept me alive.

> Yours ever
> Cookham

* * *

I was rather relieved that I was now a proper settled-in hospital orderly. When I first arrived there, I did not like the fact that for several days I still had to wear civilian clothes, the clothes I had gone in, gay summer clothes, straw hat, a nice little Aquascutum mackintosh coat, of which I was fond. Now the straw hat was all sodden with the rain and storm I had been caught in on the day I came so that it was all wavy. And how, while wearing civvies, was

Opposite:
Staff and patients at Beaufort War Hospital during the First World War

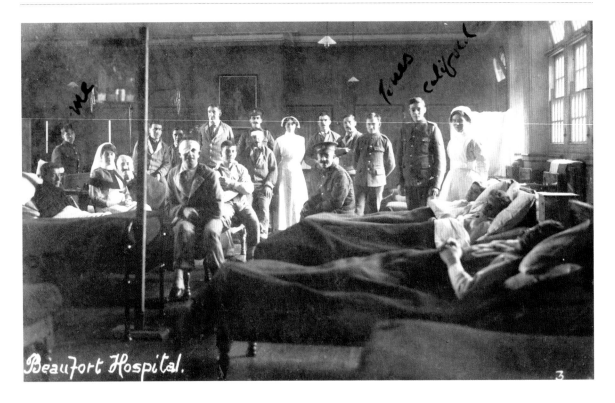

Beaufort War Hospital, 1915: Stanley is standing on the far left

I to convey the fact that I was not doing it out of show-off? It had the appearance of bravado, the sort of thing a civvy orderly might do but no one else. During those days I was treated in the matter of 'don't think that because you are in civvies, you're going to get less discipline then if you were in khaki'. 'Here I am', I thought, 'walking about in Bristol. What is this awful tangle I have got myself into? Why don't I just walk off? A Beaufort War Hospital Sergeant has just walked past and instinctively I look to see my Aquascutum coat is not looking too civilian. I suppose it should be properly buttoned up. Am I not wearing Army socks and should I not salute an officer?' I remember feeling awful in that town. The prettier the girls looked, the more I felt the SM's dog feeling about them. I had often felt in peacetime that it was extraordinary to be able and entitled to see lovely girls without any payment, to have such luxuries and extravagances seemed somehow wrong and that if they knew also what I was I would be disqualified from being a human being. But now I felt the more luscious they were, the more they belonged to the SM and to the crushing, intimidating atmosphere under which I was suffering. No matter how kind I felt, now the feeling that had prompted me to have no truck with them in the past was apparent.

They belonged to a world that was pre-eminently the realm of a slap-up affair with the SM and everything all complete and going strong, with concerts for wounded soldiers and goo-goo eyes. It was now clear to me that I was paying the price of this aspect of life around me. The luxuriousness of Chopin was being paid for. I was a person who had been caught by the SM trespassing on the preserves of civilian life, pretty girls and Chopin.

* * *

My new life was not simply dodging the SM; I never attempted to dodge any of the inevitable parades, etc. My dodging consisted not in that, but in meeting squarely all the innumerable un-analysable mental shocks that continually beset me, such as catching sight of the pendulum swinging in a clock in the place where the orderlies had their food, or suddenly becoming unbearably dispirited on seeing a particular orderly who was just a nasty hooligan and who, apparently because of that, had been so highly approved of by the SM that he wore civilian clothes, not the sort of civvies one is dished out with at the Army headquarters, a sort that gives you the feeling that things are only another sort of khaki. There is a false note somewhere in those Army civvies. I donned my Army civilian clothes and if I inadvertently saw a Colonel, still felt that I should salute or something. There is something of the same mentally crushing nature in them that there is in khaki, the same ne'er-do-well, hangdog feeling. But this chap was quite different. They were just his clothes and it was difficult to conceive of him not in them. He could play with the Sergeant Major's dog, an ominous sign to me that something unpleasant was brewing. No doubt Satan hoped I was going to be idiot enough to stop on my journey across the yard with my tray and actually smile at the dog's antics, but he was mistaken. Everything that had a friendly appearance was 90 times out of 100 not so. I did not know that this dog was the SM's but I thought it safest to assume it was. In passing it I felt all apologetic; sort of saying to myself, 'Yes, that's alright, I realise it would be dangerous to be the least degree out of my slot: there is the SM's dog and although I am not the SM's orderly, I am working in a hospital that is the SM's and therefore in a sort of way I am part of him myself.' I could not presume to be his dog nor yet

Stanley with staff at the Beaufort War Hospital, *c*.1915

his cufflinks. The orderly had a blue striped shirt with stiff cuffs; I remember them. I can remember his hands, their thickness. I might be one of the stripes in his shirt.

There now, I am feeling more comfortable and as I crossed the courtyard I feel I can hold a tray of bread, butter, sugar, Monkey Brand,[184] etc., a little steadier. I am also protected by the thought that I know that that man could pick a quarrel with a stripe on his shirt, and that stripe would be me; he could pick me out anywhere. But he would be more likely to fall foul of his trousers buttons, being very fat as he was. I would look to the other stripes on his shirt anxiously to ensure that I looked the same. But that I was never able to do, not for any fault of mine but because being small, everything was far too big for me. I should imagine the expression of my face crossing that court would be stern (although hopeful) but guarded – not a bit of it: terrified and furtive, more likely. Why should I have been so sensitive to these things, I wonder? Because I had always been rather easily crushed and because I was sociable and loved human contact, when it was harmonious, and horrified at any sign of hatred of myself in anyone.

This civilian-clothed orderly was so dead right in his slot that he did not have to wear civilian clothes in order to maintain his 'civviedom'. He would casually throw over his shoulders a khaki tunic: felt cold probably, nice warm material, why not make use of it? Or when he joined the theatre troupe in some comic sketch he might appear on the stage in a very smart khaki uniform. What makes it so smart? Ah, wait a minute, what about that cuff? It's different, there's a bit of something pretty round it. He's just passed out in khaki-wearing and was just showing us the miseries of what he was like when he did wear it...

After the theatre was over, the great throng of people (patients' parents) prepared to leave. Lovely girls: how far removed, all unfriendly, or at least ungetatable. Now and then, when I would be pushing a patient on his bed or a wheeled trolley in the corridor, some lovely girl would lean over the man and I would try to get a bit of kudos too, rather like a footman on the back of the Queen's carriage. But orderlies were unpopular: they had not been to the Front. I would get more out of the back of the girl's head than the patient got out of the front of it. I would tell myself that at any rate

184 Household soap widely used for cleaning and polishing.

the back of her head was gazing into my eyes. After this throng of people had appeared so that the corridors were a seething mass, out would come the privileged orderly, talking and chatting all the time and getting front views of girls' faces. We, the other orderlies, all shrivelled up: even the smartest thought it advisable to join us a little more than he had done a few moments before.

There were certain things that should be explained here. There was hardly any time of day, except from about 3 to 9.30pm, when this corridor hadn't some sinister atmosphere pervading it due to the disturbing crises that continually occurred there: the sort of little accidental explosions, explosive molecules floating about in the air that went off at any time and gave one a start. I was looking from the courtyard into the corridor one day, the sun making it look gloomy from the outside, and suddenly I heard the SM shout out what sounded to me like 'devil!' The fact that I quickly realised that he said not 'devil' but 'Deborah' if anything made the remark more disconcerting and me more conscious of the dangerous atmosphere I was moving in.[185] It would be absurd for the SM to call me 'devil' when he could frighten me by simply lighting his cigarette.

It will be clear to anyone that there is nothing facetious in what I have said and what I am saying when I say that the only time I felt really happy at Bristol War Hospital (in peacetime an asylum) was when, on my evening off, I would have a shave with all the other orderlies in a little place where there was a lavatory seat that proved to be the SM's 'special'. I don't know if kings on their thrones are apt to be more terrifying than when they are not, but the SM on his lavatory seat, especially when in for a big session, was quite the contrary. I suppose he felt sort of apologetic. Unfortunately, though, the only time that the SM became friendly was on this one humiliating occasion. Yet the time was nonetheless happy, despite the inconveniences attending it. The dense atmosphere, mingled with scented cigarettes that the orderlies smoked, seemed to remove any feeling of unfriendliness and made me feel that all was well. It was rather the feeling that one has when a thunderstorm has been a long time gathering and there are dreadful flashes and earsplitting crashes then at last comes the rain. I don't mean that the SM was constipated, and nice to us when he got relief. It was somehow that up there our status seemed off-stage.

185 'Deborah' acted as the Sergeant Major's orderly. The man washing the floor in *Scrubbing the Floor* (Sandham Memorial Chapel, Burghclere) is thought to be a composite figure based in part on 'Deborah' and a 'shell-shocked soldier'.

This crushing atmosphere I describe is what I am usually able to defeat in ordinary life by means of my own creative feelings. Although I could not say I overcame or defeated it during the war, yet almost all the time I felt that in time I would get through it all. 'Deborah' was the surname of one of the 40 male psychiatric inmates who had been kept in when the asylum had been converted into a hospital. Mercifully, it was he and not the hospital orderlies who usually washed this red-stoned corridor. He was short and fat and slunk about, just short shuffling steps, and he never looked up. If he did, it was only when he thought no one was looking. He had a face like Abdul the Damned,[186] long, fat and egg-shaped with a short, scrubby white beard and bald head. He looked like a short and rather sly disciple. He could, I felt, claim some sort of mystical discipleship with the Sergeant Major. If the SM was God, Deborah was Saint Peter. When he washed the floor he knelt down with his back to you, now and then peering sideways and downwards across his shoulders at you. As he lifted the wet rag out of the bucket he slowly raised himself to a vertical kneeling position, arm extended straight out in front of him, rag hanging down; his hand opens, and plop goes the wet rag. Down he bends, takes hold of the end of the rag and slowly swishes it about. Although this was maybe a part of his mental illness, I felt I would like to do things that way. I felt that in that state of mind and mentally moving at that speed I could take things in: I could contemplate, and nothing would disturb me. Although Deborah was mischievous, I envied him his fearless, quiet, easy glances. When the SM and civvy orderlies were no more, this old man and the sun and the blue sky would remain. He was an emblem of peace, despite the dislike I could not help feeling.

After 5.30pm in that corridor, incidents liable to occur there presented themselves. There was the question of the bed patients to be taken to the theatre. 'Courtney must go this time', says Sister, and a trolley must be bagged (there were only a few to go round). It was an occasion when one was expected to be 'smart' or 'cute' and quick and know all the dodges; but none of these things could I be or know. Every second lost meant another trolley lost, another place in the theatre's gangway bagged; and there was the chap lying helplessly in his bed on the ward, a cosy scene all clean and nice but a disturbing one when you knew you had to have all that shifted to

186 Turkish sultan depicted as an evil despot in the 1935 film of the same name.

the front row of a crowded theatre at the far end of the hospital, and that in 15 minutes' time the theatre trolley might be in use. In that case I must approach the Corporal who best knows how and where to get one. After some delay a trolley is produced and off I go with the patient.

If ever I get to any nice, jolly or grand affair that is not my business, my inclination is to take a back seat. In this theatre my personal instinct is to slink in through the door at the back of the hall and slide along the wall, or not to go to the place at all, but slip along up to my own bed in the barracks (the wards then being empty) and read or write. But behold, have I a man of like nature in the bed on the trolley? On the bed is a 'fearfully charming' swell who should have been an officer; or rather bullying, clever and very much a front-seat sort of man, so I am for it either way. Down the gangway of the packed theatre I go, the glare of the stage meeting me full in the face, aware that I have failed to observe several desperately important police signals. The stage slopes downwards towards the floor of the theatre and seems like a gaping hell, or maelstrom to which I am helplessly gliding. I stop feeling numbed and unable to muster courage to swoop outwards to overtake bed in front of me. I know that the patient would insist on my doing so, and I don't at the moment, knowing that it would be grossly unfair and improper to the one in front. I have betrayed myself, and my cowardice to him. He, by way of being rather pally with me, in a jerky Oxford voice: 'I say, oh, I say, what are you stopping here for?' Then I make a futile effort and get him to where he is determined I shall get him, no not there but nearly so, and get terribly ticked off by a Sister. The patient says nothing until I have got him jammed in somehow; he hisses at me in a subdued voice as I leave him (orderlies had to leave the patients in the theatre, they were not allowed to see the show): 'You know, Spencer, you really are a bit of an ass' – said in a voice which seems to say 'Well, I suppose I must continue to be friends with you but this is a sad disillusionment'.

Then there was the time of midday, fetching the dinners on the dinner trolleys, and says Sister S.: 'Tell Mrs D. (the head cook, head of the kitchen) that there was barely enough for 22 patients, let alone 30', and then with similar slaps I am called upon to administer to this formidable lady. I have to say something, as I know I shall be

Stanley, Percy and Sydney Spencer on leave in Cookham

questioned on my return. I was continually in the position of being a buffer between two crushing parties.

Further downstairs were the stores, where one met two very nice men: the Staff Sergeant Quartermaster and his assistant. This man had nothing to fear from the Sergeant Major. If the SM was Mussolini the QM was the Pope and the life he lived in those stores was quite monastic. There was just a little space in the wall and a short counter set at an angle, and when you got up to it you peered into a large glass-roofed room with a wide gallery all round it, on a level with where you were standing, and from whence one looked down onto the well of these big stores. I could never 'place' the whereabouts of these stores, so clean, tidy, quiet, peaceful and friendly. Why? Because the Quartermaster never got fussed or riled and was persistently pleasant and always, through all circumstances, friendly. Of course he had nothing like such a difficult task as the SM. He had always been there in the stores during peacetime asylum days and he just carried on. Still, it was always an oasis with him there.

* * *

July/August 1915
Beaufort War Hospital

My number is 100066

Dear Jacques and Gwen

I should very much like you to send me some books to read. Send me one and then when I tell you, send another; do not send a lot at a time. I am in the next ward to Gil's but that is not fixed. I can lift stretchers about, but I don't have much of that kind of work. There may be a lot of work and then a long period in the day when you simply have to sit about, and that is when I like to read a little till I am wanted. I think being in this will do me no harm; good in many ways. Of course Gil is a strong boy and he naturally wants something a little more spicy and exciting, and there is none of that here.

I tried to draw a patient yesterday, I only did it because he begged me to; he has a fine head. He is the illest in our ward. He is out of the ward in a sort of open covering; he has a whistle and when he blows you have to run to him as fast as you can, or woe betide you. Well they are just playing 'God Save the King' in the theatre.

I must stop here.

Gil went home today for his day and a half. My brother Perce is home from France and Lieutenant Sydney is home from Oxford. I could have had a day but that would have meant two journeys in one day and then up at 5 next morning. That would have been too tiring for me. You can imagine how strange it all seemed to me to suddenly leap from a quiet life at home alone to a roaring great hospital, and to sit at a table along with all the men: all yelling for their food, which in my opinion has been quite alright. Anyhow, I get a very good appetite here and that is a very good thing, for if that was not so I should go under. It was so pretty today to see a man in my ward named Riddle – who is a soldier who has served his time (16 years) and who had re-enlisted at the time of war and got wounded through the lungs – get out of his bed, dress, and go outside and sit in an armchair. He is an oldish man, very morose, largely to do with his illness, of course. If you had seen him the day before you would not have thought it possible.

Well, I will write again soon. You must write to me as often as you can; just short ones will do if you can't write long ones. I think you might get us an introduction to your friend in Bristol. Your friends generally seem alright. Well, I must close this document. I find after a week's work that I can get on alright.

Gil and I both send our love
Cookham

Don't forget to send some books.

* * *

Everything in this hospital was so instant and so quick to take on. Every bit of change, no matter how slight and no matter how quickly and often these changes occurred, would be felt at once, and the arrival

of a convoy (200 or more would arrive in the middle of the night) was the most disquieting and disturbing change in this respect. One had just got used to the patients one had, had mentally and imaginatively visualised them. One's imagination, once it had taken in a whole affair, cannot conceive of anything in that affair being altered or different, or being added to or detracted from. Thus there are four beds that way, and in that little recess one bed. Numbers one and three of the four beds are occupied and so is the recess bed. They are now familiar entities – there is one whose name I can't remember, but I remember the names 'Good, Riddle, Courteney, Haynes', as complete worlds. Not only has each a character, but each is inseparable in my mind from the bed they respectively occupy. They are significant, and the beds they occupy, through their respective occupying, are significant, and so are the beds which are unoccupied. These are as yet my unborn creations; a new sort of spiritual limb I am going to grow in the night. What will they be like, and what will the world be like tomorrow; what about Courtney and Haynes when the beds between them are filled? That significance will remain as an eternal factor but another God-creation takes place during the night and I will find it in the morning. To put it crudely, imagine England completely emptied of English people except six, and then suppose the country overnight becoming entirely populated by Indians or Chinese or an unborn race, there in all those familiar places associated inseparably with who lived there, now a new kind of association begins altogether. I would gaze at each empty bed and find it impossible to conceive that anything could fill it that had for me the significance that the filled bed next to it had, and yet I knew somehow tomorrow it would be filled, and if not, then certainly in a week that wonderful meaningfulness would surround this bed as it did round the next. Once a ward and its four or five patients had assumed this special meaning, I then had the feeling about it that I have about a family I am very familiar with. After having become thus with some family, you know what a strange feeling you have when you are informed that there are two other daughters or two other sons in it that you had no idea existed. You are aware of looking at those you know in quite a new and different way. You have to reconstitute your conception of that family. Especially if the unknown members are very integral and effective members of it. Even with the ones in the family you have always known, there is

something you have perhaps seen but have never been able to account for and have always regarded as a natural characteristic, but which all the time was a quality produced by continual contact with this unknown member or by the exactness of its position in the family, such as being one of six children instead of one of four.

* * *

*c.*August 1915
Beaufort War Hospital

Dear Jacques and Gwen

As you truly said in your letter, Jacques, there is a lot of beastliness in the Army; but it is far more horrible to be in a place where the sergeants know nothing about drill. We never drill and I long for it; I know what it is like. If I can I am going to transfer into something else. I would give anything to belong to the Royal Berks. Of course, the work might be too much for me. But the most exhausting kind of work is the work that you have to do at irregular times and in a place that has not the feeling of work. There is something so damnably 'smug' and 'settled down' about this place. If I had the responsibility of a ward I should have to lift a man for a long time while his back might be cured with some oil and powder to prevent bedsores. Well I can't do that, I have not the strength and it takes a strong man to do it.

It is the utterly selfish spirit of these orderlies that makes me wild. If you have anything that you think I might try to join, tell me of it because the life here is too unhealthy. If I am capable of working here I would do as well and perhaps better in the Army. Being here is wasting time and strength to no purpose.

Love from
Cookham

Every morning I have to go into the ward at breakfast and say to everyone that asks me what there is for breakfast. I have to answer: 'Nothing'. I am not going to do this a day longer than I can help.

You would not be able to stand it yourself. All that I ever do in this place is sweep, wash and give bedpans and bottles to patients. I do that all day long from 5 o'clock till 8 in the evening.

* * *

In the midst of that unfriendly atmosphere I needed to find some friend: some great comfort to myself. This was encouraged by the conviction that in spite of the circumstances, I could still live and move in that state of inspired and creative peace that was the kind of air I required if life was to be bearable. It would have been impossible for me to be complacent or stoical, or insensitive. At any time in my life, to have to do anything I had not previously felt to be a spiritually, imaginatively constructive act was pure mental agony. To have to sweep the floor, to go and get the broom and start doing that bit of floor by that bed: where was I going to get the energy to perform that act? In this great world of nothing, how could I summon up enough interest to enable me to be very careful that that particular bit of nothing was correctly done? On the other hand, I knew that the main method of Army intimidation, though it might be a way of getting these things done, was not going to be inflicted on me. I was 'for it', as they say. I was in a trap. But it would have been unlike me to settle down to a pessimistic rat-in-a-trap sensible accepting-the-situation-attitude. The demand in my feelings for an uninterrupted awareness that the Kingdom of Heaven was at hand was something more than a product of my 'in extremis' state. I had at all times felt the need – largely the result of my pre-1914/18 war Cookham experience – for everything I did to be a recognisable expression of my self and my feeling. I did not despise the jobs I was set to do and I would not in the least mind doing anything at all, as long as I was able to recognise in it some sort of integral connection it might have with this spiritual me that demanded to be satisfied. I never showed the least disinclination to do any of the work and went at everything very quickly, as long as it was not too difficult. It was while I was actually doing things that, so to speak, I was still wondering how to get the mental energy to make the work bearable.

It was about this time, when I had been at the Beaufort for some months, that I had several visits from a young man[187] who, like a

187 Desmond Chute.

Christ visiting Purgatory, one day came walking up to me along a stone passage that had coloured glass windowing all down one side and a highly patterned tiled floor where no man had trod, and where only orderlies, patients, Sisters and SMs were to be seen. I had a sack tied around my waist and a bucket of dirty water in my hand. I was amazed to notice that this youth dressed in a civilian suit was walking obviously towards me, as if he meant to speak to me. The usual visitors to the hospital passed by the orderlies as they would pass by a row of bedpans. He walked as if he was approaching something pretty wonderful; the nearer he came, the more I was sure I was his objective. He asked me if I was who I am and I said 'Yes'. If I were able to express how much this hospital life and atmosphere was cut off and out of the power of any power other than its own, I could make it clear what I felt at that moment. I felt sure that someone whose son he might be must be on visiting terms with the head of the place.

Although the sudden appearance of this young man was a Godsend, he was terribly good and kind to me, at once seeing and appreciating the species of mental suffering I was passing through, yet except for helping me to keep myself still hopeful and stimulating my starving need for interest, my recollection of this incident and my several meetings with him were not as significant in the imaginative way as were the ordinary happenings in the hospital. I was glad he did not take the crude view of 'using influence' and getting me out of the place. Neither of us wished that: he could see as well as I that I merely wanted a way of meeting my experiences so that they would have some meaning for me. The problem was how to continue being me. I had a conviction, as I have said, that at no time and under no circumstance was the spiritual me incompatible with a constructive life. I knew that when I did the different jobs, they in themselves were not meaningless. My civilian friend told me to read Augustine's *Confessions* and in it there is a glorifying God in all His different performances. This struck me very much.

What art thou, my God, what, I ask, save the Lord God. For what God is there but the Lord, or what God but our God. Highest, best, most mighty, most all-mighty, most merciful, most just. Most far and yet most near, fairest yet strongest. Fixed yet incomprehensible, unchangeable yet changing all things, never new yet never aged.

Florence (Flongy) in the 1920s

Renewing all, yet bringing the haughty into decrepitude and they know it not. Ever busy yet ever at rest. Gathering yet never needing, bearing, filling, guarding, creating, nourishing, perfecting, seeking though thou hast no lack.[188]

And so I thought, bearing, filling, coming, going, fetching, carrying, sorting, opening doors, shutting them, carrying tea urns, scrubbing floors, etc. Yes, he was a friend indeed. I never disliked doing any of these things: since the war and before I had swept out the room where I worked and that sweeping up had become a part of the performance of painting the picture afterwards. I was always aware that there was a process of adjustment to my surroundings that had to take place in me. I had felt it in Cookham and now here in this hospital it was having a difficult task placed before it.

* * *

14 October 1915
Beaufort War Hospital

Dear Flongy[189] dear

Yesterday I was very casually looking through a *Punch* and I came across an article called 'Or Both', so I said, 'well I'm blowed here's Flongy out in the Balkans', to criticise it Flongy dear, I don't think it is as good or anything like as good as the one you did on 'rations': it has too much of the *Punch* stamp about it for me. But it made me laugh and it was as good as having a buckshee letter from you.

All of us boys in hospital are excited about the acceptance by Germany of the Washington note. The agreement to evacuate is practically an acknowledgement of defeat.[190] Anyhow, as far as Mr Wooster would say,[191] 'we've got'em on the run'. You have read the congratulatory messages sent to the Allies in the Orient; well, I partake of those cons and grats, Flongy dear.

How is Gil? You had not heard from him when you last wrote to me. I feel very hopeful. I feel sure that, as the paper points out, Germany's hand in accepting the note has been forced, owing to Austria's and Turkey's attitude. It is that, that makes me feel that good will come of it.

188 *The Confessions of St Augustine, Bishop of Hippo*, book I, chapter IV.

189 Flongy was Stanley's studious second sister, Florence.

190 This may refer to the 'Washington note' following the sinking of USS *Arabica* by German torpedoes off the coast of Ireland in August 1915. The German reply, on 18 September, resulted in the so-called Arabic Pledge, in which the Germans agreed to give passengers 30 minutes to take to lifeboats before their ship was sunk. This is presumably what Stanley meant by 'evacuation'.

191 Presumably the Cookham butcher, father of Dorothy (Dot) and Emily Wooster.

I am reading Izaak Walton's *Lives*:[192] you know that one of the 'lives' is Dr John Donne,[193] who has influenced my whole artistic life. You remember my picture of Donne going to heaven.[194] Must read his sermons some time. I want to paint this:

> Since I am coming to that Holy room
> Where with thy choir of saints for evermore
> I shall be made thy music, as I come
> I tune my instrument here at the door,
> And what I must do then, think here before.[195]

Walton quotes Donne's poem 'A Valediction: Forbidding Mourning'. I must quote to the first verse; the poem is one of his best-known:

> As virtuous men pass mildly away
> And whisper to their souls to go,
> Whilst some of their sad friends do say
> The breath goes now, and some say, No:
>
> So let us melt and make no noise,
> no tear-floods nor sigh-tempests move,
> 'Twere profanation of our joys
> To tell the laity our love.

The idea of the compass[196] which comes later in this poem is beautiful, I think. The other 'Lives' I intend to read, though of the subjects' works I know nothing. I should like to read George Herbert's *The Temple*.[197] My book of Crashaw is called 'steps to the temple' and is intended to be a book of poems leading the reader to understand, to be prepared for Herbert's book. But in the introduction to Crashaw's poems the editor thinks Crashaw's poems greater than Herbert's. There is an almost pagan passion in Crawshaw's divine poems which makes them so intense. I am also reading a book of poems by Victorian and Georgian poets. There are three of Swinburne,[198] and in spite of his affections I enjoy his poems, I think, more than any of the poets after Keats and Shelley. Of course, I cannot forget Thomas Hardy. I should love to read his

192 Vivid biographical sketches by Izaak Walton (1593–1683), best known for his celebration of fishing, *The Compleat Angler*.

193 John Donne (1572–1631), Anglican cleric and metaphysical poet.

194 *John Donne arriving in Heaven*, 1911 (Fitzwilliam Museum, Cambridge).

195 John Donne, 'Hymn to God, My God, in My Sickness'.

196 Donne's famous metaphor of the souls as a pair of compasses, separate parts permanently joined.

197 First book of collected poems by metaphysical poet and Anglican priest George Herbert (1593–1633).

198 Writer, poet and critic Algernon Charles Swinburne (1837–1909).

Wessex Poems again. I have only read two Hardy novels, *The Mayor of Casterbridge* and *The Trumpet Major*. [199]

Robert Browning[200] I find hard to understand; his manner of writing seems so complicated, but I think if I could understand him I should think him the greatest poet of the Victorian era. I know practically nothing of Chatterton's[201] or Francis Thompson's[202] work; I do not mean the Thomson of *The Seasons*[203] – no, no!

When are we going to get a really great poet like Milton?[204] There seems to be some sort of 'cult' running through the poems of modern poets; it is most insidious; no one seems to escape it, and it makes one fairly leap to Milton: conscientious he may be, but I think modern poets would do better by being more conscientious, to take themselves more seriously, but they won't do – that won't make Miltons. Desmond Chute read me some long poems and stories of John Masefield[205] which 'fascinated' me; they were 'enchanting'. I used to enjoy very much Desmond's readings from Walter Pater's *Marius the Epicurean*,[206] that is a great book. There are words in that book which ought to be carved out of rock.

Well, I could write a quite thrilling letter, telling of my experiences, but you will have to be satisfied with this.

I was allowed 'up' for two hours today.

Your ever loving brother
Stanley

＊ ＊ ＊

Although the MI ward, that is to say Medical Inspection ward, had the same regional feeling as 4B, just as any county in England might feel English, yet it had quite a different atmosphere. I hardly knew the MI orderly but I noticed one day that he had a way of stepping up into a little room opening into his ward, which looked as if it had a dressing table and looking glass. I had a feeling I daren't go near it and I found that this orderly slept in and owned it. I should have been disturbed if he had been shifted from it. Seeing the patients in beds that were nearly on a level with one's eyes when seen through the front door of a ward gave one a feeling of looking into a chancel (usually a little up from the nave). A kind of refinement pervaded and

199 The *Wessex Poems* by Thomas Hardy (1840–1928), set in the landscape of his native Dorset, were first published in 1898. *The Mayor of Casterbridge* was published in 1886 and *The Trumpet Major* in 1880.

200 Robert Browning (1812–1889), prolific Victorian poet and playwright, master of dramatic monologue and psychological portraiture.

201 Thomas Chatterton (1752–1770), often considered the first Romantic poet.

202 English poet and ascetic Francis Thompson (1859–1907), opium addict living in destitution in London before he began publishing his rhapsodic religious poetry.

203 James Thomson (1700–1748), Scottish playwright and poet, published *The Seasons* in the late 1720s; they are heavily influenced by the style of Milton.

204 Poet, historian and polemicist John Milton (1608–1674) was another great influence on Spencer.

205 John Masefield (1878–1967), poet and writer (and Poet Laureate from 1930).

206 Philosophical novel by Walter Pater (1839–1894).

I could not understand how it was that Sisters and patients seemed not to notice it. Did they ever use bedpans in that ward? Impossible, I felt. The letters MI, which symbolised to me some semi-cathedral or mysterious atmosphere, cleanness, clear-headedness, no fuss or noise, simply meant 'Medical Inspection'.

4B was a bigger, darker and rather more convincing ward than MI. I was an orderly in this ward and in 4A for a time. 4A was a long corridor ward with innumerable cubicles opening into it. 4B and 4A shared the kitchen. When I went to sweep the floor of 4A in that part where it joined MI, I felt almost as if I were intruding and trespassing in MI ward. I had a feeling that the Sisters, patients, etc. of MI were close to their domain as they caught sight of me sweeping, wondering how much closer that little thing from 4A or 4B was going to come, and yet I was obliged to sweep right up to the two steps that lead up into it, and to do this without giving the appearance of trying to ingratiate myself or look as if I was spying into their ward and this was not easy. I tried to get into a rhythm, which I hoped was noticed, and for it to be obviously a 4A man's sweeping rhythm. But there was the bothering question: was that first step an MI or a 4A step? If I asked that, would be too like an excuse for a chat or look as if I was grudging my share? If I did not sweep it, I might be 'ticked off' in the event of it being a 4A step by both wards. If I did sweep it and it was a part of MI ward, then from the Sister: 'Good heavens, what is that orderly doing in our ward with his dirty broom?' I was glad to get back to a bit of sweeping in 4B, where I knew my ground and where the broom could explore any odd nook, corner or cubicle, round the pillars, table legs, and under the beds freely.

I rather liked this 4B ward about 3.30 in the afternoon, which was the time when I usually took the dressing drums down to the polished steriliser somewhere at the end of a stone passage right over in the other wing of the hospital. When I started up in this ward, on this long journey I felt like some engine of a long train when starting to glide out of Paddington on a non-stop Irish-Mail-via-Fishguard journey. Somehow I felt exhilarated that there would be no stops, and peace at each end; not Sister S and head cook Mrs D. Of course there was the long row of bed ends to pass but somehow I could tell if I should be wanted. In the linen cupboard of 4B I used to shut

myself up sometimes and examine a little Gowans & Gray book on Benozzo Gozzoli.[207] I only used to remain a few moments, and now I remember that I did not shut the door. I never slacked; while there, I never wanted to.

* * *

7 December 1915
Beaufort War Hospital

Henry Lamb Esq.
Guy's Hospital, London

Dear Lamb

Thank you for the letter and cheque received yesterday. Of course you can have the picture after the show. You could have had it with you long ago if you had liked, if it had been possible. I should very much like to have your opinion of the other picture I have at the NEAC. How long should I have to wait if I want to be with you? I am most horribly fed up with this place. I wish I was out of the RAMC and in some infantry (Bantams). I get no exercise, drill, and that is what I thirst for. I know what drilling is. There is a notice up for those volunteering for foreign service and that makes me more fed up still. I only get the sort of work that exhausts. Ever since I have been here I have done nothing but scrub floors. And all that sort of thing makes me weak, not strong.

Yours ever
Cookham

I always write formal receipts like enclosed because Tonks says it is right to be businesslike. I have had some nice letters from him.

* * *

207 Benozzo Gozzoli (1420–1497), Florentine Renaissance painter best known for his murals.

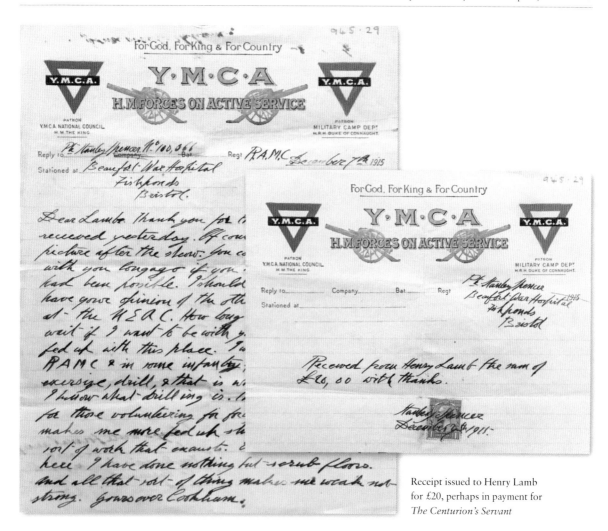

Receipt issued to Henry Lamb
for £20, perhaps in payment for
The Centurion's Servant

December 1915
Beaufort War Hospital

Dear Jacques and Gwen

A notice has been put up for volunteers and I have put my name
down. The notice was given three days before I signed and yet I was
the second to sign. I have not yet told my Ma and Pa but it cannot
be helped. I had a letter from Lamb asking me if would wait until
he had got his commission and then go with him as his servant, but
I am too impatient. I have been itching to get away ever since I have

been here. I have done nothing else but scrub ever since I've been here. That is four or five months. I think it has done me good. I think with pleasure of the number of men I have bathed. Every Wednesday morning I had to bathe patients, about six I did in an hour and a half. When I am ready for the Kingdom of Heaven, I shall tell God to take into consideration the number of men I have cleaned and the amount of floors I have scrubbed, as well as the excellence of my pictures so as to get him to let me in.

I must go out now,
Love from
Cookham

* * *

Undated
Beaufort War Hospital

Dear Flongy

Thank you for your letter, also thank you and Mr I. for the Bible. I do not apologise for not remembering to thank you for the Bible before now, as I had so many letters to write on the evening I wrote to you that I forgot. I put it into my pocket and it is still there: it fits my tunic pocket beautifully.

10 new orderlies have come to take place. They are men who have failed for foreign service. They speak very badly of Devonport, the headquarters. But they only spoke badly of it for two days, after which they all wanted to go back there.

There is a Sister H. here and she goes hunting. You know she hunts, she hunts for dust under the lockers. She is a crotchety Scotch woman. She told me that she never would allow an orderly to rest once during the day.

Sister H: Tell Chorge I want him.
Me: Tell who, Sister?
Sister H: Chorge.
Me: Chorge, you mean George.

Sister H: Of course

Me: Then say George and not Chorge.

Would you believe it that a Sister will do anything for you directly you rouse them ? Such is the perverse nature of woman.

She said to me the first day, she was in the next ward to mine: 'By Jove, boy, I will put you through it the first day I get you under me'. Lo and behold, the next day I was 'under' her. She began the day by standing over me and lecturing to me on scrubbing, while I scrubbed. I let her go on to the end, then I looked up at her and asked if she could see what she was doing. She smiled as I said, 'I've got you now, there you are standing on the piece of floor I have just scrubbed and now I suppose you will walk down the ward with filthy shoes after George has just polished the ward. So much for your lectures, Sister.'

Chute comes in in the afternoon and has a chat with me, which is of course fine. Sister H. says 'So you've been entertaining your friend this afternoon?' 'Yes', I say, 'I've been talking to him all the afternoon, and I have done nothing'. Sister says, 'Well, all the work is done and there is no reason why you should not take your leisure'. Thus you see we have tamed the shrew. I must close now.

With love to you and Mr I.
Your loving brother
Stan

✳ ✳ ✳

*c.*December 1915
Beaufort War Hospital

Dear Jacques and Gwen

I should very much like to hear from you as I think I shall soon have to be off. I am to be inoculated on Monday, I believe. Captain Freeman came again to examine the teeth and found mine alright. It is a feather in my hat to say that out of 41 volunteers all failed except 14. I am among that 14. I must have a photo of you two. I have

done several more drawings of heads and they are an improvement, I think. Of course I have to give them away.

> Love from
> Cookham

Gil is, according to a card received from another man that went with him, alright and well.

<center>* * *</center>

22 December 1915
Beaufort War Hospital

Henry Lamb Esq.
Guy's Hospital, London

Dear Lamb

I have just had a notice asking me to take my pictures away. I wish if you intend to take my bed one that you would also take the malthouse one.[208] If you could do this, would you let me know? I have got over inoculation alright: the first lot made me feel very bad but the second dose hardly touched me. Last night I went with an old Slade student to his place and heard a lot of Elizabethan songs sung by a Mrs Daniells, who had a good voice. She also sang some of the Susanna songs out of *Figaro*, which it was good to hear again.

I must write some bally letters, that I have not the least intention or desire to do. I have had a card from Gil and he seems more alive than he was when he was here.

> Yours ever
> Cookham

<center>* * *</center>

208 *The Centurion's Servant* and *Mending Cowls, Cookham* were both exhibited in the NEAC's *54th Exhibition*, winter 1915 (nos 80 and 150). Henry Lamb purchased *The Centurion's Servant* in 1915.

To leave that hospital at all seemed an impossibility, to leave it abruptly and to be precipitated on foreign service was just a foolish,

wildly romantic desire. I felt I should be as much trying to show off if I had pictured myself pushing an ambulance cart about Aldershot, as I should be if I pictured myself winning a VC. You know when you have been in bed for several weeks, the thought of just walking along the road down past your house is quite different when you hear it from your bed to when you yourself are walking along it. It was the thought of having dealings with things that did not belong to this restrictive Beaufort regime, everything that prior to their entrance to Beaufort Hospital had not yet been Beauforted. It seemed strange that they had been in contact with experiences in which the SM of Beaufort had no say whatever. Any other SM was just a pretence, this one was the only one. He was quite terrifying enough even though he did not wear puttees. If you did come anywhere near him when he did wear puttees, God help you. I could as well have imagined the Matron wearing them also: he was so not made for them. He terrified the Sisters. Even the most martinet-ish of them had to muster up courage to ask him a simple question.

Towards the end of my stay at Beaufort our Dardanelles one-legged patient came towards me on his crutch, one day when I was scrubbing the dispensary of 4B, and put a *Times* newspaper under my nose. It had a criticism of my paintings and the heading 'Stanley Spencer's vivid work', which made me feel a change was coming. I was completely surprised because I had no work showing anywhere as far as I knew, and it was not until ages after I learned that my father had been asked by the NEAC for some work. 'Is that you, you little devil?', says the patient. I had almost forgotten my fading past. It made a strange impression on me. I had become completely lost and it was extraordinary to see even a newspaper, and then all of a sudden this. An utter nonentity and then an article in the *Times* and in the *Daily Mail*. The Matron, who in stature vied with Queen Mary, came down through the wards with a veritable sheaf of dailies over her arm, determined to track down this great 'unknown'. Even she looked a little less grim and gaunt. These notices were very welcome to me. I had been terribly crushed. Such teasing remarks from Sisters such as 'when are you going to get that commission, orderly?' – obviously having scented that I was a bit different – or thought I was. I often wonder if those critics are aware that they most effectively put a stop to the pernicious system of bullying

me by Sisters that went on there. And I think, on the whole, other orderlies also benefited, and saw a certain amount of reflected glory, no doubt. The nurses in the hospital who were not VADs[209] were not Sisters but working-class women, the old staff of wardresses of the hospital in the peacetime asylum days. They were in almost all cases very nice and were very badly treated by the Sisters. They were quiet and old-fashioned; they said that the war was a complete eye-opener to them. In peacetime they lived a life completely within the walls, except in hours off, and if they went out they did not seem to notice the changes that were taking place. I particularly like Nurse H. and Nurse S. They were not Florence Nightingales, they were to be found in the hospital in the form of the ill-natured, conceited, cattish Sisters, who were also incompetent. Nurse S.'s face was placid but half-smiling. She never needed to ask you anything but you felt that she knew what had been happening. Nurse H. was an old-fashioned-looking nurse with black curls down either cheek. She had a hard time under the Sisters. They altogether exceeded their rights by making the nurses their servants.

When I had my one-man show in 1927,[210] Nurse H. wrote to me because she had read about it. She is now matron in a hospital in Birmingham.

209 The Voluntary Aid Detachment was formed to provide nursing assistance and support, e.g. as ambulance drivers, orderlies and cooks.

210 Stanley's first one-man show was at the Goupil Gallery, *'The Resurrection' and other works by Stanley Spencer*, February to March 1927.

BASIC TRAINING AT TWESELDOWN CAMP

*Although Stanley had applied for overseas service in late 1915,
it was not until 12 May 1916 that he finally left Beaufort War
Hospital in a small group of 14 men bound for Tweseldown Camp
in Hampshire, near Aldershot. Here volunteers were prepared for
active service as Britain prepared for the 'big push' – the offensive
on the Somme planned for late June 1916. He was greatly relieved
at the prospect of leaving behind him the grinding routine of life
at the Beaufort.*

At last the hospital, not wanting to lose us, was obliged to give it
out that orderlies were wanted for Field Ambulances. I and several
others put in for this and we were soon off.

But instead of going straight to a training depot at Aldershot
or near there, we were, for a short time, shunted off to a Naval
hospital depot (converted into an Army one) at Devonport.[211] This
was another vast place with great stretches of lawn in front of it. It
was difficult to make out what the situation was here. I remember
going in to a large sitting room belonging to the Sergeant Major
and being puzzled at the nice, easy manner of this great burly old
chap. He had a fine voice but the mystery of his pleasant manner
was cleared up by a still more obscure remark. He said, 'There are
two Sergeant Majors here'. Then, with almost a look of amusement
on his face, confided somewhat whisperingly: 'Have you seen him?
Sort of new kind of Godhead, two in one, not one incomprehensible
but two.'

I remember in a dim way standing stiff in the company of
hundreds of men out on the vast plain of green lawn in front of the
building and noticing in the great span of white steps (and these
steps were lined either side with men) a single figure, trim and neat,
gloves, Sam Browne, appearing on the top step, a smart-looking
young officer, apparently. He began to descend step by step, leisurely.
I noticed with a weak shock that his uniform, though similar to an
officer's, was not. He carried, as far as I can remember, a sword by
his side, but possibly it was only a highly polished baton or cane.
The officers were as terrified of this as we were. I was used to my
Beaufort one but this one wanted human banisters apparently and

211 Devonport is the dock district of
Plymouth, Devon.

he was a sinister piece of work altogether. In an officer this would have been theatrical and affected. But when the class of man who is no class does anything like this, look out for trouble. It was not affected, it was horrible.

There were difficulties getting food there. We were not apparently placed on the ration list, we were not 'indented for', so the only thing to do was to queue up wherever one saw a queue and try to get dished out with something without letting the man issuing the ration notice you. He was usually bending down and kept his eyes on the little canteen one held out under the sacred flow of tea. But I being short, my face or some part of it came below the rim of his hat and also something possibly un-Devonportish in my movement seemed to make him pause and an altercation would begin. I and others would be shunted to another queue, one to another, until at last when all the Devonporters had had theirs if there was anything left we had it. I doubt whether the SM (of the steps) or any of the officers of the hospital knew about our existence on their premises. We were never in the hospital at all, but wandered about the sheds at the back of it. We slept in a deserted schoolroom across the other side of the road. We used to walk down to Plymouth Hoe and there got into trouble for not saluting naval officers. In the end we nearly became like the old lunatic at Bristol who saluted everybody and loved doing it. He did it to imaginary people as well. Another 'loony' had a way of blundering through a glass-panelled door that was an entrance to a long dark passage, suddenly turn round, and with his great clumsy boots, run out again, shut the door, peer through the glass and then walk in.

Having no official status in Devonport Hospital – not even as orderlies – was very disturbing and we all felt relieved to at last set out for the station with the nice SM en route for Tweseldown Camp near Aldershot.

<p style="text-align:center">* * *</p>

Spencer had met his friend Desmond Chute (1895–1962) at Beaufort War Hospital (pp. 172–3). Chute, a young artist, poet and aesthete from a theatrical family in Bristol, was at the Slade for a year before the outbreak of war and became a Catholic priest in 1927. He was

to have enormous influence on Stanley's reading, introducing him to English poets, classical literature and early French writers.

12 May 1916
No. 100066, Pte Stanley Spencer
7th Company RAMC Military Hospital
Devonport

Dear Desmond

This is my address till, as far as I know, Monday, when I believe we go on to Aldershot. I have brought my Shakespeare with me. The journey was wonderful. The clouds projected downwards below the hills. The trees were extraordinary. I did not realise I was looking out across the sea till I saw a ship up in the clouds and came to the sensible conclusion that the sea was under it.

 Love from Stanley

Remember me to your Mother and Aunt, and to all the rest of your friends, who I will try and write to in time.

<div align="center">∗ ∗ ∗</div>

After two grim days at the RAMC Training Depot at Devonport, without food or accommodation, Stanley's group of volunteers was despatched to Tweseldown Camp.

We all knew the agony of the feelings that we had as we marched towards the open gap in the hedge which opened out into the square, a great place where we were going to do company drill for hours on end, all the morning, all the afternoon, and for all the days as far as we could see. If only that approach had been a little longer; it was on us and there we were. The route marches, except for the full packs, etc., were sometimes quite enjoyable. We had several bands in these battalion marches, and everything was better than the square, even though I felt often in an agony of fatigue. Tall men,

put forward for appearance sake, would forget to step short so that we would often have to run to keep up, and over arched bridges this sort of thing often occurred. Yet somehow I never fell out. Nearly six months of this and I was on the list for foreign service. But the purpose of these descriptions is not to reveal the boredom of war training, etc., but the periods of significance of feeling that here and there occurred. The discipline of Tweseldown, though terrific, was a little less personal than it was at Beaufort so that the trees, flowers, streams, etc., seemed to make SMs and Sam Brownes merge and to a certain extent disperse into the general elements

* * *

13 May 1916
RAMC Military Hospital, Devonport

Dear Desmond

We left the hospital yesterday, Friday, morning. I swept the ward out yesterday morning with George Saunders. I felt a bit sad, poor old George was so upset. The journey was wonderful, the clouds were particularly beautiful. You remember what I told you on the card. This is something like what I meant. ([small drawing in pencil] Drinkwater said that he used to work on some very high hills and that the clouds used to touch the hills where he was at work. Just imagine what a feeling it gives you when you think of a man working on the earth just at the place where it touches the sky. There were some trees I saw something like this: [drawing] Nothing like it.

It was an extraordinary sight to suddenly see the sea. I have only seen it once before in my life and that was only for a few minutes. You remember the book next after the Cyclops book? Well, we came to a part where the rock projected into the sea and in front of it another piece of rock something like this: [drawing]

16 May 1916
Between the space of time between this line and the one above I have been from Devonport to here, Aldershot, and my address is now as follows:

No. 100066 Pte Stanley Spencer
No. 3 Hut D Lines
'W' Company RAMC
Tweseldown Camp
Near Farnham
Surrey

It was a relief to me to come here, you can't imagine how the loathsome, tidy, patched-up Plymouth – and in fact all the western part of England that I have seen – have this plastered-round, 'finished' feeling, and to come back to mellow old England with red brick building and red earth and green fields (not brown)!

When we got to Fleet we got out and had to walk with full kit (kit bag and all) for nearly **three** miles along a straight road. We were just pouring with perspiration but it was great fun after ward work. Tomorrow we go on a route march, so I understand. There is no hospital work here. It's Field Ambulance work and I think we are for that. I saw one go out today. It was a wonderful sight, wagon after wagon and the thick-necked horses.

Later
Lights out just sounded. Here we are, rows, two long rows of us in the usual hut. Just lumps on the floor like this: [drawing]

Wednesday
First thing this morning we were out on the parade ground in our shirtsleeves and slippers doing Swedish drill,[212] after that with a roaring appetite we sat down to a big bowl of tea and some bread and butter and bacon and tomatoes. Very good. After breakfast cleaned up for parade at 8.30, paraded, and then were told to go off to several large wagons, which we began to shove and haul along. It was perfect. I felt as if my soul would bust for joy. It is extraordinary how these experiences quicken my whole being.

Yesterday we went for a ten-mile route march. A whole company ('W' Company) moving in one confounded lump. In front one man (Captain, like those egg laying insects with a little head and a tremendous body. Over sandy, bumpy ground, and then gorse and fir trees. It all seemed so just right. I was just ready to receive

212 Physical exercises used as part of the daily training routine for soldiers being prepared for active service.

all this. At length we got to the road again over a little hillock and down into the road arcaded with beech trees making the sunlight green, because the light we got was coming through the leaves. We were to have worn packs yesterday but they thought it was too hot for such untrained men. Afterwards our section were told that we did well. We had a lot of compliments from the officers, greatly exaggerated by our very excellent Sergeant. He is so naturally virile and keen, intent and yet extraordinary expansive. His boyish energy, intelligence and interest are beautiful. We are going through very strict training. Practically all my hair is off. Clipped right close like a criminal; in fact, I feel like a rejoicing criminal.

Last night I had a bathe down in the canal, which is quite beautiful. Where we bathed was a little enclosed space on the bank. Almost in the centre was a plum tree in bloom and by its side a man drying himself. This morning we had a grand parade and were inspected by our Commandant. There were two whole companys on the parade ground, 'V' Company and 'W' Company, and all dressed in full marching order. It's lovely the way the Sergeants talk. On the heels, rise, on the knees, bend. And all said so horribly mechanically, but this Swedish drill is not bad for you, in fact it is good for you; but it is ridiculus. Can you imagine what it is to me after going to the wards in the early winter morning when all is dark and close and stuffy and lazy, and then getting up at the same early hour and going out into the country lanes with just slippers and trousers and shirt on for a nice walk, and then a double, and then this drilling which is very stiff and that shows it is wrong. We are always in the open and that is just what I longed for. I got your two letters you sent to Devonport when I was there. The first part of this letter was written there. When we were pushing great wagons along the other day, I thought of the *Odyssey*.[213] What a glory there is in doing! It will be a great stimulus to me when I get back to painting. Write to me at this address:

No. 100066 Pte Stanley Spencer
No. 3 Hut. D Lines 'W' Company
Tweseldown Camp
Near Farnham
Surrey

213 Homer's epic poem chronicling Odysseus's ten-year journey to return home after the Trojan War.

I am afraid that some of your letters have gone to Devonport and have not been forwarded. That is my fault.

Yours always
Stanley

When on our route march we were marching under the beeches, their shadows simply poured down the soldiers' backs. The sun was right overhead.

* * *

Tweseldown Camp

Dear Flo

Thank you for your dear letter. It is a long time since I have written to you but I never felt much in the mood for writing at Bristol, it seemed as if I had no thoughts when I was there. Every thought I had dried up as soon as it realised where it was. But I did get ideas there. When I used to have a very full day, full of every kind of job you can think of, I felt very deeply the stimulating influence 'doing' had upon me. Every act so perfect in its necessity seemed like anointing oil on my head. It was wonderful sometimes to wash up, to scrub, and then to dress nearly every wound in the ward. Such simple work and then such thoughtful work, all done in the same spirit.

It used to be rather a strain when Major Morton used to come, and operations had a terrible influence over me. I remember when it was eventually decided that they would have to operate on a patient named Hawthorne. An elderly man with a sweet nature. He had been operated on for appendicitis in Salonica and the abscess, which was a big one, had burst and flooded his body before the operator had time to clear it out. He was sent to Beaufort, and there his wound discharged heavily for three weeks without stopping, then it slacked off but it was thought that, owing to the position of the operation wound and the position he had to lie in bed, the sinus from which the stuff was flowing was at the wrong angle.

I saw this operation and it was a fascinating thing to see. I had

always felt excited to see some of the internal organs. He went in at 10.30, and came out at 1 o'clock, and all that time was a strain. You should see Sister Horsley, the operation Sister, watching Dr Morton, if you want to know how to concentrate. I should think she knew every thought that was going through Morton's mind. Dr Reynolds, while Dr Morton was scrubbing his hands, sat on the high chair and anyone who went by him, if he asked them to do anything would say 'fetch so-and-so, don't touch me. Do so and so, don't touch me'. He is so complete, so compact. I wish I could draw a picture of Reynolds sitting on a chair in a perfect state of sterility. I saw other operations there, but none so exciting.

It greatly inspired my confidence in operations when the next day Hawthorne seemed quite his old self and hardly in any pain. And yet he was as near death as he could be. Do you know it takes three years for the chloroform to get clean out of the system? It was wonderful to get away from the smell of this stuff and to get into Surrey and sunshine and push wagons about and play leapfrog.

Chute has today sent me a translation of *Odyssey*, Book 6. The coming of Odysseus to the Phaeacians. As I was hut orderly today, I was able to go through it this afternoon. It is also nimbly written that you go through it and feel that you have the original wonderful rhythm with you. When I used to visit him [Chute] he used to translate so much and then read it in the original. Mind you, if he was to read about two pages he could go through it to order, whether he had the book or not. Sometimes when we have been out for a walk, wonderful walks, I would begin to ask him about some particular novelist and he would go through a whole novel, quoting pages and pages verbatim, quite unconsciously. He writes to me every day, and each letter is as perfect as some of those early letters that you might have seen in the British Museum written by James I of England, and others. Of course, he, having studied at Downside, has got a natural grace that makes it very satisfying to be with him. I do not mean that grace which is forced, to mean a greasy, slimy manner. I mean he has a mind so quickened by God that you can do nothing but live when you are with him. You would love to hear him quote some of those little early English poems and ballads. A lot of his letters to me are in a parcel I sent home from Beaufort. You can read any of them. In them you will find a whole

store of poems, translations from some of the saints. Particularly one from St Augustine. I remember in a thing about God he says: about God 'fetching and carrying'. I am always thinking of these words. It makes me want to do pictures. The bas-reliefs in the Giotto Campanile give me the same feelings.

You will be interested to know that your Bible has been with me on every route march. It has been put in the top left-hand corner of my valise to get it 'square' and to keep me from the guard room. These route marches make me think of the history of England and all sorts of glorious national feelings like that.

This evening we raided the hut at the back of the Sergeant's hut for straw for our sacks which we sleep on. I had noticed there was a cartload of it being unloaded into this place and I thought, and then acted upon that thought. Tonight I shall roll about on a cylinder. Oh, it will be grand. It was 'grand' at Devonport where a dear old respectful married man had to tie his 'biscuits' together onto his bed to keep them from running away.[214] These three 'biscuits' formed our mattress.

Have a complete volume of Shakespeare here. I carried it in my kitbag here, also my Giotto and Basilica da Assisi.[215]

Your loving brother
Stanley

* * *

*c.*May 1916
Tweseldown Camp

Dear Jacques and Gwen

I left Beaufort War Hospital a few days ago and was transferred to Devonport, where I went to Plymouth Hoe and took in a view of the sea. I did not know we would be leaving Devonport for certain until we were told to fall in on Monday morning and given instructions to get our kits and packs ready, which we did.

My valise was chunk full, also my pack, but the bottle was empty. Then my kitbag was bulging full and all this I carried from

214 'Biscuits' were small, hard, mattresses, 2ft 6in square. Three made a bed for one man in a barracks.

215 *The Masterpieces of Giotto*, published by Gowans & Gray, 1909, which measured 15 x 10 cm, and had been given to him by Edward Marsh. Stanley owned a number of books in this series, which cost 6d (sixpence) each (see p. 120).

Fleet station to this camp and I felt as fresh as I could wish. I am writing in bed, that is on the usual sack of straw. It looks very fine, the rows and rows of lumps like that. It is so wonderful. Beaufort War Hospital, with the feeling of night, night, slippers, go quietly, terrible operations, uncanny, supernatural atmosphere and then later lights out.

I cannot see the Meadows in sunlight, dusty roads and gravelly, bumpy plains covered with gorse and blazing furze, and then you go over a little hillock down into a road all overhung with beech trees. The sunlight comes through the young transparent leaves and makes the light green, and as I march along I think of all the romantic parts of the History of England. Marching is wonderful, I think, don't you? There are 200 and sometimes 400 or 500 of us go out for a route march, and when you look at the long files and watch the arms swinging, it gives you most extraordinary feelings. And then when you have your rest en route to lay down and bring out a book of English poets or that little 6d Giotto book.

I think that being at Beaufort Hospital and being here has made me realise more definitely the glory of doing. St Augustine says in a wonderful thing about God 'fetching and carrying', and so on.

Everything I do inspires me. Even emptying bedpans, and that is the truth. This afternoon I go cutting grass, and I expect you will be doing the same thing. I mean that everything that is to be done should be done. I feel that I shall be able to go straight at my work when I get back to it. But can you imagine what I felt like coming here after my year's imprisonment in the grey, loathsome walls of Beaufort War Hospital. Everything down here is so horribly square and tidy and patched up and 'finished'; even down at Plymouth Hoe everything is all set out like so many pieces of a puzzle.

Well, I have done my afternoon's gardening, and this is what I had to do. I had to go across the road down into a gravel pit, where I was able to find some good soil for the garden outside the guardroom. I had to keep getting barrowfuls and heaving them up and down an undulating track and then casting it across the dry soil of the beds of wallflowers.

Our Sergeant (section commander) is a splendid trainer. When he gives an order he gives it in such a way that it makes it seem impossible to move as soon as you have implemented the order.

There is nothing unnecessarily 'military' in the way he trains us, just that firmness and severity, the direct result of experience of the awful results arising from lack of discipline and uncleanliness.

He gave us a fine lecture on latrine building, and as these duties go I found it most interesting, and also on water supply. Some of these things are so simple and yet absolutely necessary, as in the case of finding a stream of water, to notice its direction and place your three flags in accordingly: the white for drinking water, the blue (about 200 yards from white in direction stream is flowing) for ablutions, and red onwards, for washing clothes, etc. And then in purifying water to dig a hole about 12 yards from stream and deeper than stream level, loosen the earth at bottom of hole and leave it till stream has found its level in hole.

Gilbert is still quite well and in Salonica, where he has been since last November.

From your ever loving
Cookham

<center>✳ ✳ ✳</center>

1916, before embarking for Salonica
Tweseldown Camp

Dear Flongy

Thank you for your letter. You must, in spite of the war, which is doing much good, be very happy in your home. I remember reading a little bit about Sir Thomas Wyatt's[216] life in his home and with his library, and the peacefulness of your home reminds me of it.

He had to take a commission as ambassador to somewhere or other and he did not like leaving his home and books…

The Sergeant Major presented us all with wills the other day and then the Chaplain gave us Testaments and said goodbye to each of us. We began to feel mighty skittish with all these holy goings-on.

<center>✳ ✳ ✳</center>

216 Sir Thomas Wyatt (1503–1542), lyrical poet and diplomat.

James (Jas) Wood

James (Jas) Wood (1889–1975), painter and writer, was part of the intellectual circle in Hampstead to which the Carlines belonged, and a friend of Stanley and his family. Stanley later painted him lying on a tomb in The Resurrection, Cookham *(1924–6).*

Spring 1916
Tweseldown Camp

Dear Wood

I have not written to anyone for ages and it is quite extraordinary to be able to write again now. Being at Beaufort Hospital was a most blighting atmosphere, the trees were not trees but just things that were there so as to make things look respectable. The big tree that stood in the centre of the quadrangle (I think it was a lime) was a fine one but I had a feeling that it had been splashed over with gravy. No gravy had been near it but somehow that was just how the world of that place made you feel.

I do hope you will forgive me for not writing to you before but I serve everybody the same trick but unwittingly, no, I wrote several letters to you but always forgot to post them. But if I remembered to post letters, I fear I should forget to write them, so there it is.

Well, I am here at Aldershot and having a grand time after the spell of indoor life at Beaufort. After leaving Beaufort I went to Devonport. Horrible hospital. Came here after that, thoroughly enjoyed the journey. This life greatly quickens the soul. I am making a goodly store.

We sleep on straw sacks: you know how fine it must look when all are in bed. It will be lights out in a little while so I will cease.

Yours ever
Stanley Spencer

I should very much like you to have just what you like of my work. You are the only person who has made mention of those two particular works of mine. I mean the one of the woman on a bench and child comforting her. I think I called it 'the window'. And then that other one of a mother and father examining a shawl hanging

over the shoulders of a child in the mother's arm and a boy to the left leaning on a table and a staircase to the right. Yes, there is something in those works which I have lost completely in later ones. I should quite like you to have them.

⁜ ⁜ ⁜

Undated
Tweseldown Camp

Dear Jacques and Gwen

I am looking forward to hearing from you. Life here is very dull and as far as I can see we are doomed to disappointment, which we get whichever way we turn. If we go I expect it will be to some such place as Bombay in a hospital or some other such place. It is only special men of the RAMC, Jacks of all trades, resourceful men who get attached to a regiment and actually fetch the men from the firing line down to the Field Ambulance advanced dressing station. But we shall not even be Field Ambulance. We are doomed to hospitals. In fact we are an expense and a nuisance, and we shall end up by providing fatigues permanently in this camp.

The other day we had a 'field' day and I carried a 'gassed' man in his overcoat from the fire trench to the East Lancs RAMC Field Dressing Station.

We have just finished our week's special drill and we have to go under yet another medical exam tomorrow or sometime during the week. Our work during the week has been water cart, gas helmets and disinfector, with lectures on each subject. The only thing that really was fine, I thought, was water cart and purification of the water. We went down to the Basingstoke canal and drew water and purified it, standing in the long grass with dragonflies gliding about in all directions and lizards in the grass. The horses that draw the cart are unharnessed and have a good feed. You know the blunt type of carthorse.

I should love to fill all the 100 square spaces in this hut with hospital work. But I have a lot to get over, especially my 'bed picture' propensity.

I have good reason to be very much on my guard about my work. There is something absolutely lacking in unity in my riverside picture[217] and it makes a worried, incomplete appearance to the thing. And there is a 'quaintness' in it that is destructive. It is a pity because there is greatness in the picture. I will not do a picture till I can do it in the unity of the spirit.

I very much long to hear from you.

Cookham

* * *

25 May 1916
Tweseldown Camp

Dear Desmond

I got the page out of the letter you sent to Devonport. It was forwarded to me from there. It is grand to take your translation out of my haversack and read it during the intervals of drill. Tomorrow is another long route march with full packs. That will mean some more reading under the tall pines. The fact that there is a definite time given in these rests by the roadside enables me to read, whereas when I sometimes had an hour to hang about at the hospital, I could not grasp what I read. You always had a feeling that someone would pounce on you for something to do.

I feel I would like to draw the land and trees and tents here but I doubt if I should be allowed to, but I shall see about it. The camps and tents make me want to do a big fresco painting.

This afternoon we had racing on the greens. It was grand. We just went out in our slippers, trousers and open shirts, and we ran just as swiftly as we could. Running in time along with a hundred men is fine. I am reading again . I want to go over again all the plays I have read before because it is very important to do so.

In that little book of English poems you gave me is some Milton. But I cannot keep away from the thought of the Odysseus thing. It is a part of my day, part of the, doing part of the day. I also have a little book of Giotto and the book of the Church of St Francis of Assisi,

217 *Swan Upping at Cookham.*

both books I carry in my pocket or haversack according to the dress, so that even Giotto is dragged into this drill. I will close this now.

 With love from
 Stanley

It seems quite funny to think of you being out. I'd like you to write out some Beethoven that I know as you have done. The Gluck would be useless for me to try to read unless I knew it, and I am nearly sure might with a struggle be able to remember some of those things you mentioned out of Gluck that you have played to me.

 Yesterday I went gardening in the afternoon, well, I had to go into a gravel pit and dig several barrowfuls of good manoeuvring soil (lovely colour) and take it to the garden on the other side of road. This, without exaggeration is the nature of the track along which I had to wheel a big barrow of soil to the garden. Not only was it hilly but it had the most distracting twists , and the track was sometimes like this and immediately after like this, so that the only thing to do was to trust to faith and simply charge. If you did not go as hard as you could, the barrow would get stuck at the bottom of a steep place and there you were. These lines [drawing] give you some idea of the angle of the wheel of the barrow.

<p style="text-align:center">✳ ✳ ✳</p>

26 May 1916
Tweseldown Camp

Dear James

Thank you so much for the book of Gaudier-Brzeska, which I have just received. The trees are wonderful about here and it makes me mad not to be working. I must try and get a portable paintbox and canvas. The canal here is quite wonderful, you can hardly call it a canal, it is so overgrown with trees of all kinds. There is a place where we bathe in the evening, which is a plot of ground surrounded with young black poplars and behind that fir trees, and in the centre of this plot, which is only about twelve yards across, is a palm tree in

bloom. All the grass is long and tangled in this little bit of mud and somehow adds to the wonder of this tree being where it is.

28th

Yesterday I went to a village called Crondall, it is a very 'jocund' village. This little meadow is full of children and buttercups and is enclosed on one side with tall elms and on the other side by a hedge, beyond which is the village. In the further end of the village are a cedar tree and a church with a red brick tower.

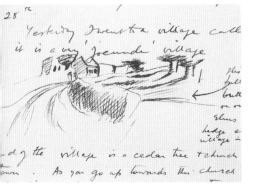

As you go up towards this church is a funny hop kiln. Well it is getting on towards the damnable church parade (C of E). What a hateful, injurious thing the church is. I must go if I can to RC church, see if I can stand that and if I can't bear any of it, I shall go and empty the latrines, that would be finer than any of it. It would be doing a very serviceable act for a very important reason. But to do an act of that nature on a Sunday is almost impossible. If only these Army people would take us to a church of ancient build, I should not mind so much, but we just have to crowd into a hut and try to recollect what we are about, whether we are at Mass or Kit Inspection.

Don't you think that coming out into the open air like we're doing here, after our long stay in doors in hospital, is wonderful? It seemed to be too great, I could hardly realise it. I think there is something wonderful in hospital life. I think doing the dressings when you are allowed to do the things, in peace and quiet, is quite inspiring. The act of 'doing' things to men is wonderful.

Desmond Chute read me out some of St Augustine's writing and I remember in a contemplation on God, St Augustine talks about God 'fetching and carrying'. Whenever I am doing anything I do not think of those words but I feel those acts. I think Gaudier had a wonderful sense of living and being, but it is his kind of being that I hate. I think it is true that we can never say why we should enjoy things. We just do. For instance, what a subtle thing is the change from one thing to another, no matter what it is. After sweeping up, cleaning the plates and dishes. Now I am sweeping … now I am cleaning dishes … now I am polishing. There is such unity and yet variety in it. I think this feeling is in those things (bas reliefs) in the Giotto Campanile. I know that sometimes after my day's work

at the Beaufort War Hospital I have wanted to draw a picture of everything I have done. Why I should want to do so I could not say. Well I will close now, with kind remembrances to Hartley: do you know where he is?

* * *

10 June 1916
Tweseldown Camp

Dear Desmond

I went home on Saturday for a day and a half. I had been quietly longing to see my brother Sydney, and I went home and opened the door, and there was Sydney. We embraced one another while my Pa stood wondering when my brother would introduce me to him. My hair being cropped close like a convict's, my daddy did not know me.

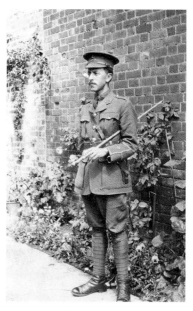

Lieutenant Sydney Spencer on leave in Cookham, 1916

As all the men are having an after dinner sleep, the hut door will open and a voice which frightens will cry 'Fall in!', I will stop. I hear the Sergeant's cane on the neighbouring hut doors.

This afternoon we have had hell. There are a few dull and a few don't cares in our company, and that means we shall go on doing squad drill for the rest of our lives. You march along, and in right wheeling one man does not keep his dressing; that section of four men is taken out and put into the backward squad. If they make a slip there, they are in for fatigues and CB.[218]

The Captain commenced training us in this manner: 'Oh, I see some of you don't want any dinner. I can see we shall have to stop your weekend passes. If you were at your depot you'd be doing CB all day.'

Next day
This morning we have been doing right and left inclining.[219] Awful. I think that the translation you have just sent is not quite as fine as the Achilles one, but I think that is partly due to the original Greek.

218 Confined to barracks.

219 Drill movement, turning through 45 degrees (whereas a right or left turn is through 90 degrees).

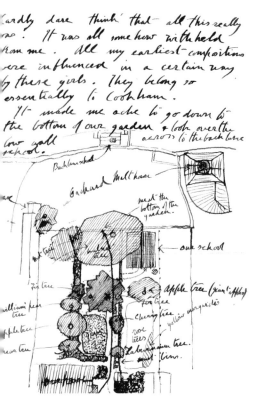

Later

Now the day is over, I feel I can breathe more freely. This afternoon there was a great thunderstorm. One flash made us flinch as we marked time under some trees just off the parade ground. Some of the men forgot they were marking time and halted. When we got to the parade ground we noticed a man walking off with a dirty khaki hat in his hand with the hatband broken and the badge all burnt, and we afterwards learnt that a Lance Cpl of 'V' Company had been struck dead under the tree just on the other side of our parade ground. It struck the tree, which has a lot of nails in it, and down the side of the man's face and his toes. I believe it is route march tomorrow. I hope it is. I accidentally left my *Canterbury Tales* book at the Beaufort Hospital but George Saunders sent it on to me, and it is just the thing to read here. Especially the very beginning of the book.

When I was home I went to see some girls that live opposite us.[220] Out of their window you see the signboard of the King's Arms Hotel, a very old place, and further up to the right one of my precious cowls appearing over the cottage. And then these girls. I felt I could hardly dare think that all this really existed. It was all somehow withheld from me. All my earliest compositions were influenced in a certain way by these girls. They belong so essentially to Cookham. It made me ache to go down to the bottom of our garden and look over the low wall across to the back lane school.

This morning we went on another wonderful route march. This time we went through Farnham, which is a broad-streeted town with a very heroic 'knights of old' atmosphere, at least it had for me this morning as we entered it going downhill; that going downhill and the broadness of the street and the tall old buildings had a lot to do with this feeling, and the stick in the air like this you cannot calculate where the arm comes from or to whom it belongs, but it keeps shooting up, and then the other. It is awful to feel your pack gradually getting at you, but the land is a great boon and relief.

I am just going to write to a man named Wood. I want him to come and see you, if you don't mind. His military life is getting on his nerves and in fact he has had little chance at any time of doing anything he would have done. He has just sent me a book of Donatello and the other day he sent me a book of the life of

Gaudier-Brzeska which you mentioned having seen in George's.[221] I hated Gaudier when I knew him, but I agree with you that he is extraordinarily certain and true in his drawing.

Love from
Stanley

❋ ❋ ❋

12 June 1916
Tweseldown Camp

Dear Jacques and Gwen

I used to enjoy a 'full' day at Beaufort Hospital when I had to do practically everything. They used to have slow movements and adagios and climaxes like a Beethoven sonata. It is quite extraordinary how some days used to have 'form'. Every act of the day seemed to have perfect position in it. It could not have been done at any other time but then and there. I had to think there, Jacques. I had to remember what to do and what to do first, and second and third... Sister Cockcroft used to give me whole month on dressings. And I had to do other work as well, which was great. I liked our old nurse: no matter what a dance one or other of the Sisters was leading her, she always had a cup of coffee or tea and a piece of toast ready for me at a quarter to 11am. She had that wonderful capacity of bringing something out of nothing.

I believe if she had been on a desert island and had no tea or anything with her, she could conjure some from the ground. I believe in such people. She has old-fashioned curls and hobbles along like an old woman, though she is young. She is as true as steel. After about three months I went from that ward (4A) into 4B. That was a big ward and possessed a Charge Sister who was rather fine. She was so active and vicious, and yet peculiarly sympathetic. She never said anything in any way nice, in fact she was always fighting. But she sometimes looked at the patients in a way they could not observe. She had such an extraordinary face. Just the Charge Sister type. She had long and rather thin lips. The difference between one ward and

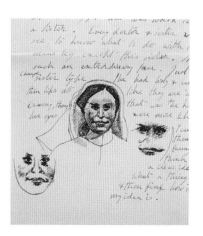

221 A bookshop in Bristol.

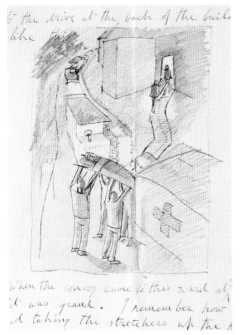

another was as beautiful when conceived as anything in music or painting. Not every ward excited these feelings in me. There was one ward, 19 Ward, which was away to the left of the building and at the back of it, where the land sloped sharply down to the drive at the back of the building. When the convoy came to this ward at midnight it was grand. I remember how I enjoyed taking the stretchers up the path and not know what the man's face was like.

Now that we are here I realise how hard we had to work when we were at Beaufort and what a lot of real valuable work we did. They will feel it, us being gone.

I itch to get back to painting. I often feel I would like to make a picture of what I have done at the end of the day. Doing things is just the thing to make you paint.

I have washed up the dinner things a hundred times, yet when I see someone doing so I immediately want to do it myself, and it would be impossible for me to say why. But how much more wonderfully could a man washing plates be painted by me now than before the war? Every necessary act performed is like ointment poured forth.

Love from
Cookham

* * *

18 June 1916
Tweseldown Camp

Dear Desmond

I hope you will be able to keep up your standard of letters to me, even if I do not keep writing to you. I should like a photo of you. Now that I am here I look back on the time I spent with you and it appears so beautiful to me. It clears my head, which gets muddled at times. I get muddled because I keep straining after something and that something ends up with a desire to paint or draw something and then I feel how impossible it is and then I don't know what to do. I shall be glad when we get to the manoeuvres, which are more interesting, especially when there are night ones, and one has to go

out and search for wounded, who are previously distributed over the country.

I do not expect we shall go out for a year perhaps. The thing we have to do now is latrine building, which is not bad. This morning was the memorial service for Lord Kitchener.[222] There were over a thousand men on the parade ground. The above drawing is this: [drawing] only I could not quite explain that shape. Just at the juncture of the two hedges is a tree with shining leaves and they glittered in the sunlight. This below is rot, it is nothing like what I meant to show. I was trying to show you a row of may trees just at the back of Crondall Village. They all go one way, and the clumps of foliage are more separated, like this: [drawing] But the thing at the top of the page did move me. There was something that was so definitely full of sacred meaning to me.

The little book of Duccio (which goes nicely into my pocket) is feeding me. I have looked through it once. To look through a book for the first time is a very exciting performance for me. I always like to wonder what a picture is going to be like before I look at it.

On our route march today we got off the road and on to a wide track which got narrow and muddy and we had to scramble through the bushes surrounding us. Over a thousand men in single file going through this narrow space and round corners, where they disappeared, though you could still hear them talking.

I must get my pack ready for tomorrow's general inspection by the Commandant. He sees everything, he has eyes all over his head.

The general inspection is over and we have come off well, I mean our section – section 4 of 'W' Company. The Commandant was full of praise as he walked down the ranks. I have heard that he said our section was the best section of the whole lot. He was particularly pleased with our packs. I have also heard that as a result of our 'soldierly' and 'intelligent' appearance we shall be on the next draft. This morning our Section Commander 'put us through it' for some reason. We got up expecting our mild double, but when we saw the Section Commander we knew we were in for some fun. He just made a beeline for a certain place, and no matter what was in the way, made straight on. We just carved our way along. We went up on to some land which is in a state of upheaval owing to the trenches

222 Famously the face on the 1914 British Army recruitment poster, Secretary of State for War Field Marshal Lord Kitchener died at sea on 5 June 1916.

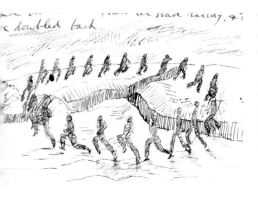

there. When we got there we had to run round and round in a huge circle and keep leaping over these trenches. Then we had racing, and then we doubled back.

Yet another day, and I feel as different a person as if yesterday had been a year ago. I am going to do a composition, I believe. Somehow I feel I can here. The photo you have sent me today is grand. Are there many of these corbels? I have been having another look at the angels in Giotto's *Martyrdom of St Paul*.[223]

With love from
Stanley

* * *

June/July 1916
Tweseldown Camp

Dear Jacques and Gwen

Thank you for your letter. Desmond Chute is a youth of twenty. He is nervous and generally not sure in 'Society'. If anyone says to him 'Isn't this charming weather', it paralyses him. He was 'educated' (I know you must want to know where he was educated) at Downend in Somerset.[224] He does compositions and paintings. He does drawings of heads. I have never seen anything in modern drawings so clear in their purpose, so final and conclusive, and exciting in their idea. You feel you would like to make carvings from them. His drawings of plants are wonderful when he is drawing an individual plant but when he does a great number he (adopts) conventions which are meaningless and very unpleasant.

In appearance he is tall with a round head and large round eyes which are very searching, contemplative, severe, gentle and charitable, in the one and only sense of the word. His eyes used to look heavy and pained when he had had an attack of his stomach trouble, which was horrible. He would have to stop reading to me and twist about in the bed until he could get at ease. He has been living for the last three months on olive oil and other such liquids.

He has told me such wonderful things about the mountains and

223 The right-hand panel of Giotto's Stefaneschi Triptych (Pinacoteca Vaticana, Rome).

224 St Gregory's, Downside.

waterfalls in Norway, and he has a never-ending supply of places to tell you about and he tells you about them like a kid.

Next day

Today I have had a wretched time with the Sergeants. By the mercy of the Section Commander, I am not 'in clink'.

Yesterday I got, as did many others, a 'right turn' for haircut and was told to parade at Sgt's hut at 5 pm. I did so and reported to section commander at 5pm punctually, with hair so close that you could feel the skin; horrible.

Next morning, Sgt Tuflits, a young, insolent youth with the meanest face I have ever seen, beckoned me with his cane. When I got up to him he looked at me with a cruel smile on his face. Do you know the first duty of a soldier? I said I did not know. 'Obey orders.' I asked him when I had failed to do so. 'You did not report at the hut yesterday.' 'I did do so punctually at 5.' The other sergeants reluctantly corroborated what I said. Then came the trouble. I said: 'You should have seen the Section Commander before you said that.' Sgt Bull: 'If he'd said that to me, I'd have made him parade at company office in the morning.' I reported this to the Section Commander and he said he would see about it. In the afternoon the Sergeant who was watching us at Swedish drill called out to me: 'Now then what-you-should-do – get on with it. You're only b– shirking.' After that and fire drill we were dismissed and Sergeant Section Commander called out: 'Spencer, come to Sgt's hut.' I went and there the Sergeants, with the exception of Wiggins and the Section Commander, looked at me as if he were looking at a worm.

Of course the Section Commander was furious, but then of course what I had done in the morning was a 'crime'. I had to say what I had to say. The Section Commander said, 'you were insolent'. I said, 'no'. 'I forgot I was speaking to a Sergeant' (even that was too dark for them), which was the fact. 'Don't forget this, boy', said the Section Commander, 'if anyone so much as smiles at the Sergeant today, he's in trouble. I've a good mind to take you down to the guardroom now.' Long pause. And so on. All the time this goes on I have to stand at attention and stare blankly in front of me. Of course all this has got to be put up with, but I doubt if you would stick it. I am convinced that Stg Tuflits wants to crime me. The only reason

Desmond Chute

I want to avoid that is because of the possibility of going on foreign service. Which possibly seems a long way off.

To return to Chute, which I do very willingly, the things he has told me about Italy, Rome in particular! He went down into the caves where the Romans went in time of trouble, and he said the walls were a mass of carvings which you could only just see.

When I first met Desmond, which was one day when I was on the way to the stores, he was up and able to do long walks and we used to go over Clifton Downs and we used to wind up by going to a house containing a widowed Scotch lady possessing two daughters. This good woman was not like a Scotch woman: she did anything for me, and sang anything Desmond or I wanted her to, and nothing else. When you think that I used to go to these people every time I was 'off', and that every time I heard some new thing, and it was always of the Byrd[225] period, in fact much earlier than him, and French and Italian things of the same period. And then she used to do some Mozart and Gluck (I should like to hear a Gluck opera). Desmond used to play parts of *Alceste*[226] and it quickened my appetite for him.

When I think of the wonderful quiet evenings I have spent in Chute's bedroom with the sunlight filling the room, and Desmond surrounded with wild flowers, which he loves. He loves sorting them out. I used to sit looking out of the wide open window and listen to him translating Homer's *Odyssey* and *Iliad*: the Cyclops and the men escaping under the sheep. Oh my goodness, it really did frighten me (Cyclops seems so awful when Odysseus is speaking to him 'horrid' words). He has read me all those books from the Nausicai (pronounce it as it is written please), books to Circe and further. Of the *Iliad* he has read me of the fight between Achilles and Hector and the funeral games over Patroclus, which book he has translated and had typed for me. I have looked at different standard translations of Homer but nothing to approach Desmond's. I also feel somehow that no one can read the *Canterbury Tales* with such a perfect understanding of the rhythm and the nature of them. Do you remember the prioresses tale? That's English, that is good old England.

Our evenings were so satisfying. He read me the *Midsummer Night's Dream* one night, and another night he read *As You Like It*.

225 William Byrd (1543–1623) was an English Renaissance composer.

226 Opera by Gluck.

I think it is a wonderful play. I must stop now. The colour of Chute's hair, I forgot to mention, is a brilliant, rusty gold colour. It glistened as the sunlight fell on it as he sat up in bed reading. He used to hold his hand to his forehead when he read in most thoughtful attitude. He reminded me in his character of John the Baptist.

Your loving
Cookham

* * *

This is something like a photo of soldiers making their way between ruins in Verdun, which I saw in the *Daily Mirror*.

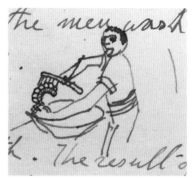

I have had descriptions of Gallipoli by men who have been just the same way of thinking as I am, and they say that when you are fighting you realise you have awakened a desire or instinct which makes you more spiritually living than you ever have been before. I remember a Sapper telling me how intense and wonderful he felt when, in Gallipoli, he was mining and heard the Turks' picks going above and below him. Another boy told me he used to know when the Turks were going to make a charge, because he used to hear them mumbling their prayers.

Gil is still in Salonica and seems very fed up. I am here wasting the country's money and being a general nuisance. To see about 2,000 men on parade. What are they doing? Wasting. This is how the men wash their teeth in the wash house: this is not an isolated case, but without exaggeration 50 per cent have false teeth. The result of the doctrine of 'smartness'.

Our kit inspections – listen to the detail: blanket 1yd wide, reach to 16th board. Falaise at head, blankets folded on top. Spare tunic and trousers on top of that. Overcoat folded so that small button of tail appears, and no other. Placed in front of falaise, and so on.

I do not think there is much hope of our going out, and if we do I expect we shall be nursing orderlies just the same as we have been, and if that is the case we might as well remain here as doing that work is the same on foreign service as it is here in England.

I do wish I was in France or Russia; if I could see my way clear I would desert to get into another regiment. I cannot think

of anything more wicked than this fooling about here on a lot of drills. Which are practically done away with on active service, and I have heard that there is none of this in the French Army. And after all, most of us here are men who have earned the money they have received in the Army. I should feel happy I know if I woke up to find myself at Verdun.

* * *

9 July 1916
Tweseldown Camp

Dear James

I feel with you very much when you say you think you will give up smoking etc. There is a man just opposite me. He holds the cigarette delicately between his slightly parted thin lips. But it isn't that – that only irritates – it is when you can look at a piece of sculptor work and say that man smoked cigarettes and that man a pipe. There is something else that riles me and that is watching men play cards.

I never say a word to these creatures. I have smoked a cigarette sometimes, but no, it is wrong: God hates it and that is why. I *cannot* see or feel and smoke at the same time. And that ought to be the same with everyone else. It makes him write in a certain way, that is a damnable way.

I was very pleased to hear you had read Desmond's letters as they are very cheering, as you say, and I agree with you in overstepping all principles at the sight of the letters.

I have received the Donatello: it brings great peace to me. It has a reproduction of one of the panels in the Ghiberti door, comparing it with Donatello.[227] But oh, the Ghiberti: I once had the whole lot lent me. Big reproductions. He is a most heavenly man, don't you think?

* * *

227 Lorenzo Ghiberti (1378–1455), Florentine sculptor, made two of the three bronze doors in the Baptistery in Florence. Donatello (*c.*1386–1466), the greatest Florentine sculptor before Michelangelo, was apprenticed to Ghiberti and worked on the first doors.

*c.*July 1916
Tweseldown Camp

Dear James

You must see Lamb about the cowl picture and fight it out with him. I very much appreciate the fact that Lamb likes the picture and I should like him to have it as much as I should like you to. I can quite understand you having some misgivings when you saw it as it has a sort of 'expressing emotions' tendency. But I did that thing not because of the 'composition' it made: some people might say it has a 'fine sense of solid composition'. Such people know nothing of the feeling that caused me to paint it. There are certain children in Cookham, certain corners of roads, and these cowls, that all give me one feeling only. I am always wanting to express that.

 The angel is fine. I had no idea till about a year ago that our cathedrals contain still some of these carvings. I thought they had been destroyed. Chute has been sending me a series of corbels in Exeter Cathedral.

 We are on fatigues tomorrow (Monday) so I do not feel very inspired. Officers' mess. A most pitiful waste of time. Awful.

<div align="center">✳ ✳ ✳</div>

*c.*July 1916
Tweseldown Camp

Dear Lamb

Did I answer your postcard of Salisbury Cathedral? I do not think I did.

 I think I would rather be here than at the hospital, though of course hospital work was infinitely greater than this, which is just a waste of time. I only like this better because I am out of doors and go for long route marches.

 I used to romance greatly when I was in hospital. I wish I could do a picture of each different thing I had to do in the hospital, so wonderful in their difference.

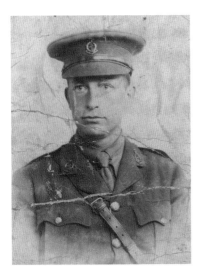

Photograph of Henry Lamb that Stanley
kept with him while serving during the
First World War

I can't help feeling you get everything in the world in a big
hospital. But I wish I was in France, I have such feelings about
France. I do not think I have earned a letter from you but I should
love to hear from you. The men here do not seem to care when the
Sergeant bullies them but I do. I often think I shall cry. I am not
brazen faced and the Army will not make a man of me because I do
not intend it to.

With love from
Cookham

Have you a photograph of yourself to give me?

* * *

Fragment, 1916: letter to Flongy

The man sitting next to me persists in singing in my ear, 'oh, they call
me Icky Moses and I've bought a shop in the verst; won't you pa-
ter-ro-nize a Sheenyman?' He is full of songs. When he returns from
leave he comes rolling in, knocks everything over, wakes everyone
up, keeps all the hut in uproar and when he has arrived at his bed
and all is once more still, he announces in a low apologetic mumble:
'I've come, I have'. When he goes to Middlesbrough he brings me a
long stick of Middlesbrough rock. In the same grumbly voice: 'here's
the Middlesbrough rock it is, Stanley'. He lives off wild life when
on leave and last time he came back he had bought some clay pipes
with him for his mates. The morning following his return from leave
he felt in his pockets for the clay pipes. He looked very doubtful
as he felt for them, as much as to say 'if they aren't broke then my
name's not Clarence'. He takes them out unbroken and looks at
them and smiles quietly to himself. He, after musing gleefully on
the thoughts of what he and the pipes have gone through the night
previous, hands them to his mate.

I shall never be in danger if I go away as I shall always be in a
hospital. I think it will be Salonica. The SM says so anyway. He also
told some men that if they went on six days' leave it would be too
late for the draft. Which looks as if we shall not be long. I thought I

told you I was inoculated against typhoid at Bristol and vaccinated there by Major Beaver. He was very nice to us orderlies and his lectures on disease were wonderful, he went to no end of trouble to let us know as much as he possibly could in the little time he had. He lectured to us as if we were all learned doctors. He is an elderly and very quiet, rather fat man, and he seemed to just revel in talking to us. He is the most cultured man I have met, quite on a par with Lord Boston.[228] He was delighted with the heart of a woman who had heart disease that he got to show us, but it had been dissected badly. He also showed us through the microscope consumptive germs and diphtheria germs. He also showed what a lot could be found out about diseases in anyone by separating the urine into its parts. It was mysterious when he separated the blood from it. I wrote all the lectures down and they are inspiring. There was none of the book of knowledge about them, no, it was the man hot from his work.

Yes I still have and treasure your Bible.

St John's Gospel is most expert. I have realised that lately. This Gospel and Christ is like one thing. You do not feel that with the other Gospels. St John's meekness is as terrible as an earthquake. It is most wonderful. Have you ever seen St John's head in Masaccio's picture of St Peter healing the halt and blind?[229] It is a profile and I wish I had a large reproduction of it. St Peter and St John are becoming necessary to me.

I will get this off, so goodbye for the present and give my love to J.M.I.[230] and thank him for his little bit at the top of the letter.

Will write as soon as we move.

Your loving brother
Stanley

* * *

228 Patron of Stanley's father at Hedsor, just across the river from Cookham. In 1910 Stanley had been awarded a scholarship at the Slade to cover the fees, which had previously been paid by Lady Boston, herself a former pupil at the Slade.

229 One of Masaccio's frescoes in the Brancacci Chapel is *St Peter's Shadow healing the Sick* (or *The Lame Man healed by the Shadow of St Peter*).

230 John Maxwell Image, Flongy's husband, an elderly Cambridge classics don at Trinity College, Cambridge, who died in 1919.

bar


horrify me. This afternoon we had them on again. This morning we had a lecture by the Staff Sergeant, which, had it been delivered to men in trenches, it would have saved their lives. For instance, in some cases men have ripped off their gas helmets because the smell of the gas became stronger and they have thought the gas was getting inside. Of course they have died. The gas affects the stuff the hat is dipped in so as to cause it to smell twice as strong. He impressed upon us the fact that the gas is sometimes white and sometimes black, and he said they can use colourings in the gas. He told us and proved to us the futility of liquid fire. The jet of flame goes at the furthest 30 yards. It has to be sent off at such an angle as to cause it to be almost exhausted by the time it reaches the trench. It cannot last much over a minute. If you get into one of those little firing places and the direction of the fire is this [drawing], you are as safe as if you were on the inside of a waterfall. Very obvious, but how essential to the dull of understanding!

Today is the only day in the week I like. It is route march day. And this afternoon we just did Swedish drill and lots of foolish, rather risky drills, such as bending back stretched across a form like this.

I got your letter this morning and the ballad 'The Frigate' was great, though I felt I wanted to sing something to it all the time. I wish I could read other things such as the other quotations in the letter with the same amount of freedom. I have to tax myself very hard to read those other bits in your letter. But I got well away with 'The Frigate'. Your photo greatly pleased me. You can't expect me to understand Mass or to feel all that Mass would make you feel, so if you can, you might expound. I shall be glad when I can get back to raising altars. I must get on with my kit.

With much love from
Stanley

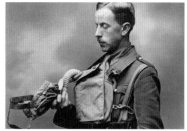

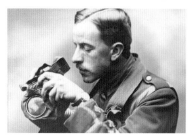

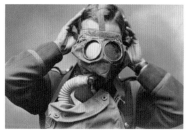

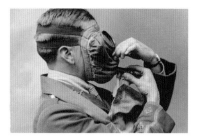

Sydney Spencer demonstrates the use of a gas mask for an Army instruction booklet

*The following letter is not dated, nor is the recipient named, but it is
assumed to be Desmond Chute.*

Thank you for that beautiful letter. It is impossible to concentrate
down here because there is a continual noise. The man who sleeps
next to me has a noisy brain, if you know what that is like. I do not
get one minute's quiet since I have been here except when I have been
home. There are thirty men present when I write these letters to you.
Today it has been gas helmets again, and disinfection. When I was at
hospital the work was actual. Here it is trivial. There is no binding
the spirit. Geoffrey Keynes, a young doctor I know, was saying that
he had got to go on duty for two years without a stop. That is how
human beings ought to be. That we may obtain everlasting life.
This is how I am always wrong. Sometimes I feel alive but only
sometimes. There is something so unsteadfast about that.

Later

This morning we were on the watercart down at the Basingstoke
Canal. I should just love that job. It is so fine. The horses have thick,
fat necks and short ears set back. As they lurch forward to pull the
heavy watercart their glossy skin wrinkles upon their backs and
buttocks. They have wonderful bow noses. This afternoon we went
'doubling'[233] with gas helmets in the blazing hot sun. How lovely it
is to get a wash afterwards; they are so greasy, these helmets, and are
composed of two layers of thick flannelette, greasy and dirty, and we
breathe and suck through a rusty bin tube covered with a piece of
transparent India rubbery stuff which you grip with your teeth (you
wonder who gripped it last). You must not breathe through the nose.

It is awful the way the Sgt Section Commander threatens his
men. He has a proper red-hot Irish temper and when he loses it he
walks slowly towards the offender, swishing his cane up and down
in front of him. Just before he stops before offender he brings his
cane up with a sweep over his shoulder and stands in the position of
a man about to strike someone.

What is so exciting to me is the thought that the water we are
pumping into a tank has got to go through two close wire netting
circles smeared with alum. All this goes on in a cylinder round the

233 Army drill: running 'at the double'.

inner cylinder, which is perforated all over, is wrapped in a very closely sewn sheet of canvas, wrapped so many times round that it makes the water pass through three layers of canvas instead of one. It passes through two sheets of alum, as said, but in getting through it is checked by the blind end of inner cylinder; but there is a small space between inner and outer cylinder and water has to go there. At the end of inner cylinder is a hole and a pipe leading to the tank, which holds 80 gallons. When we begin pumping we have to wait a long time before we hear the water trickling into the tank. During the silence we know a great struggle is going on inside. The water begins to trickle out of a crack here or a screw there. Then there is the next thing to do: we have to test the water and purify it, which is so beautiful.

I do not remember what it is we remove from the water but it is great fun doing it. We have six cups, nice clean ones, set in a row and filled with water from the tank to within an inch of the top. Three drops of testing solution is put into each pot. We have a black pot, a tin full of bleaching powder and a two-dram measure. We fill the black pot up to the mark with water and put one little measure full of bleaching powder into it, and mix it into a thin paste. We then put one drop in the first pot, two drops in the second and so on to the sixth. Then the pots are left for one hour. We return when time is up and notice that nos 1 2 3 4 and 5 are no longer blue and no. 6 is not as blue as it was. In this case we have to empty the pots and put 7, 8, 9, 10, 11 and 12 drops respectively into each pot. No. 7 would be the one and we should put 7 measures of chloride of lime into it, mix it up and pour it into tank. And behold you have pure water. The alum causes a cloud to be formed inside a partition into which the water flows and all the impurities in the solution are separated there. The canvas collects all impurities in suspension. The chloride of lime destroys all bacteria.

I want to finish *Crime and Punishment*;[234] could you get me one? I could read a good 'novel' like that down here. I find the jump from some foolish duties I have to perform, or some rows I have, to the poets is too great. I can't concentrate. I associate the poetry with the unpleasantness. But a book would aid me first by exciting my idle curiosity, then my real and great curiosity, and then I get inspired, and then I want to read Shakespeare. I know in theory this

234 Dostoevsky's novel published in 1866.

is not right, but under these circumstances you would realise how difficult it is.

Surrey is jammy and sticky like a tin of golden syrup, but that is how Surrey makes me feel. There is something definite, clear and concluded about Clifton and thereabouts, but it is just morbid and to me the essence of melancholy, a kind I used to enjoy. You see Desmond I feel so disturbed unsettled and sometimes desperate about what I am going to do. If I was in a place where I had got to stay for duration of war I might be able to collect myself, but when you are told you will be away in ten days you can't settle down at all. But I know what you mean, that a man can 'live' in perfect felicity under any circumstances and remain unsatisfied, and of course that is true, but I can't do it yet.

With love from
Stanley

* * *

26 July 1916
Tweseldown Camp

Dear Desmond

Even though you seem to be in the same impossible condition as I am, yet your letter was very fine. The annoying thing is that I am not in this condition really, only superficially. Today I have soaked through two shirts. This morning was a route march, too hot to be anything to me, except at moments. It rather gave me contemplative feelings when, passing under some trees with spare foliage, we heard, gradually becoming more decisive above the din of our band, a church bell ringing; the church is on us before we think we are within 20 yards of it. I was not contemplating anything, I was just contemplative.

I have never seen that part of *Paradise Lost*.[233] I have only read a little bit, but God, isn't that wonderful, incisive? And isn't it lovely to think of him, Milton? I always feel very peaceful when I read him or think of him. When I hear Bach I desire nothing better, but I still crave to create.

235 Epic poem in blank verse by English poet John Milton (1608–1674).

The news is very bucking tonight. The capture of Pozières[236] seems to be a great advantage, yet another step on the road to Bapaume.[237] I was watching the sun helmets coming in and the lovely cool 'drill' suits coming in for the 100 men going out of our Company this week, and thinking of the fact that their dull training had come to an end. They are going to Salonica. I have heard that 200 are wanted for Mesopotamia. I hope some of us will be picked out.

The great arguments that go on in this hut are between trades, and some are great fun. There are two fine, fiery youths out of a cotton factory in Bolton, spinners they are. There is also a very 'shoppy' ginger-headed man who has come from behind the counter in a Co-Op store in the district of said factory. There are a lot of coalminers in this hut.

My friend in this room is a man who is cross-eyed, gets drunk and always puts an 'I did' on to the end of any of his achievements. He comes from Middlesboro', he does, and there isn't a better place in the world, there isn't. He is a carpenter and joiner on one of those big monitors in Middlesboro' docks, he is. He always talks in a low, grumbly voice. I love the way he used to live. He used to earn sometimes £4 a week, piece work. He used to give £2 to his mother, the rest he saved to the amount of about £20 and then he spent all that in about a week. But his knowledge of carpentry – you think of mallets and chisels when you look at his face. If he gave you anything he would not know that he had given you anything ten minutes after. And perhaps you have noticed that in these 'disgraceful characters' is the true power of forgiveness. He went home for his six days and when he came back he was assisted into the hut by his mate. I woke up to hear this in a resigned apologetic voice: 'I've come back, I have.' The next morning he produced a long stick of 'Middlesborough Rock' and then he put his hand into his pocket and slowly drew out two new clay pipes, but before he took them right out he looked doubtfully into the pocket, then a smile came into his face and he handed the pipes to his mates. 'Its alright, I thought they were dead, I did.'

I will write again later on, and God bless the Middlesboro' rock.

From your loving
Stanley

* * *

236 The Battle of Pozières, which continued until August 1916, was one of the middle stages of the Battle of the Somme; there were almost 23,000 Australian and 8,000 British casualties.

237 One of the towns of particular strategic importance during the Battle of the Somme.

27 July 1916
Tweseldown Camp

Dear James

I rather envy you being in the RFA[238] and for the draft. Certainly better than being where you were. I am still thinking about the Beaufort Hospital, which the more I think about, the more it inspires me. I am determined that when I get a chance I'm going to do some wonderful things, a whole lot of big frescoes. Of the square pictures there will be The Convoy (I have that alright) The Operation (and that). Then the narrow hospital panels. A nurse (oh such a beauty for that) an orderly (very good). I can hardly bear to think of it. Think of the different things there are in a hospital. A storeman, an engineer, a carpenter, a surgeon (I have that and it exasperates me not to be able to do it). I shall not yet be getting any divisional leave so we have nearly arrived at the S's. I think what will be wonderful in doing what I have seen in hospital, the places where things go on and all is still and quiet, and then outside all tumult and hurry. I am too hot to write and the smell of meat for our dinner is sickening.

<center>* * *</center>

Summer 1916
Tweseldown Camp

The enclosed dirty sheet is the beginning of a letter but I could not go on with it. J. Wood is in London for a week or so. I have given you his Trowbridge address at the end of this letter.

Dear Desmond

I have received goodness knows how many postcards from you since I wrote to you last but I cannot help it. And I have not been in the condition to enjoy such beautiful things as I would wish. I am not brazen-faced and I shall never be able to stand the bullying of these sergeants. At least I shall stand it but it will always hurt me, always shock me. It is useless to say to myself 'ok they are ignorant', etc. Do

238 Royal Field Artillery.

you know what it is to be watched all day persistently by a Sergeant who is trying to crime you? I can't write letters and enjoy anything much while this kind of thing goes on. I have stood in their hut and asked them to crime me but the Section Commander will not. He is rather fine in some ways but there is something dreadful about him. When he closes his eyes you can't see where they are closed because his eyelashes are the same tone as the flesh.

I will think it over about coming to see you (we are having divisional leave in six days) but I must and will see Jacques Raverat, who I have told you about. He is helpless in both legs and goes about in a wheeled chair. They, he and his wife, were very curious to know about you and I told them. I do not know how it is, but though they hardly ever write and have not done anything particular for me, yet to go without seeing them gives me real pain. I have not seen them for over a year. Although I feel so vacuous for writing, I feel rather pleased with a composition I am doing of the Flight into Egypt. Jas Wood's address is RGA, Cadet School, Trowbridge, Wilts. He was very disappointed not to see you. This is just to let you know I have received your cards and letter.

Love from
Stanley

* * *

Summer 1916
Tweseldown Camp

I am on the RC parade on Sunday and I want a book of the Order of Mass. I have found it impossible to go to these C of E parades.

Dear Desmond

I am receiving one corbel per day from you.[239] I agree with you that the one you said was the best is the best. The way the leaves go at the top of it. The same sort of work is going on here. Insolent sergeants with good permanent posts. They are not in a hurry for us to go away. I have not read Shelley except *The Spirit of Solitude*[240] and I

239 Desmond seems to have been sending Stanley photographs of corbels.

240 One of Shelley's major poems, *Alastor, or The Spirit of Solitude*, was published in 1816.

also read nearly all of *The Revolt of Islam*[241] but could not follow it at all. *The Spirit of Solitude* was wonderful to me. I remember reading it in our dining room at home one afternoon and I remember what a lovely feeling came over me. The lines that you quote I do not like a bit. I think that it is just a scientifically 'thought out' thing that any man with an academic knowledge of the language could compose. It is not inspired.

I have been looking at the Old Testament lately and at some of the parts I used to like reading most. I used to love nearly all the books. Samuel. Do you remember, I think it is in the first or second book of Samuel, how God speaks to David and says, 'And it shall be that when thou hearest a sound of going in the Mulberry tree then shalt thou know that I am with thee...'?[242] I cannot find the place where this passage is but I think these are the words. They are nearly correct.

Love from
Stanley

* * *

Summer 1916
Tweseldown Camp

Dear Desmond

I have just been home and when I got back I found the Order of Mass waiting for me. I am looking back on 'Beaufort' days and now that I am away from the worry of it, I must do some pictures of it – frescoes. I should love to do a fresco of an operation I told you about.[243] And have the incision in the belly in the middle of the picture and all the forceps radiating from it like this: [pencil drawing] It is wonderful how mysterious the hands look, wonderfully intense. There was something very classical about the whole operation. Major Morton looked away from the incision when he was searching and feeling in it. What is so wonderful also is the stillness in the theatre and outside the swift, silent steps of those 'fetching and carrying'. I would like to do a figure on either side of picture of operation of a nurse and a man with frock bringing sterilisers. This does not sound much, but leave it to me.

We are still training. We go into the trenches and bring the

241 Shelley's epic in 12 cantos was a symbolic revision of his *Laon and Cynthia*, and evoked a hostile reaction when published in 1817.

242 2 Samuel 5:24.

243 At one stage Stanley intended to depict an operating theatre in the chapel at Burghclere, as can be seen in his working drawing for the north wall, 1923 (Stanley Spencer Gallery). This scene did not appear in the final scheme, where it was replaced by *Kit Inspection*.

wounded out. We have to keep our heads down because the Captain tells a party to pelt us with stones if we show ourselves. I love to watch long rows of men in front of me in trenches.

The trenches are so solid and sometimes the communication trenches are so narrow that the gassed man we are carrying in his overcoat gets wedged, and it gives me such an extraordinary feeling. When we came out this morning we were caked in clay. Then those ledges you know, let into the side of the communication trench. We put our patient there for a rest and it looked fine.

I believe we are going to the East. I have heard that it will be for Mesopotamia, but that is just what I hear. As a matter of fact I think that we shall never go at all. It is dispiriting, there are men here who just do the dull work in a sort of hangdog manner, and the CO sees it and that puts us further away from the time when we leave – and if we do leave, we shall be sent as nursing orderlies to some damned hospital in Bombay or some other vile place.

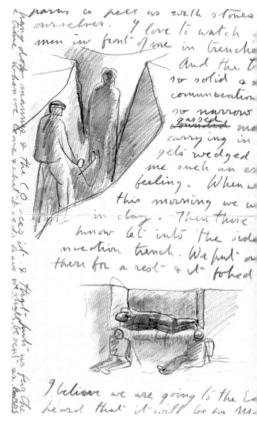

* * *

July 1916
Tweseldown Camp

Dear Henry

It is true that we are just going. We are ready, even down to writing out our wills. Could you come on Sunday as I shall be sure to be free? Or tomorrow if you get this in time? If you have your clothes, come in them as you will then have less trouble in getting into the camp. Today we had a gorgeous inspection in our drill and helmets.

It seemed almost too good to be true when I saw you coming down the street. I felt that these times were over. It seemed almost uncanny, just as Cookham seemed to me when I was at Bristol. Devonport Hospital is a wicked, sinister-looking building. There are green trees in a row in front of each grey 'block'; they used to give me the creeps.

Yours ever
Cookham

✻ ✻ ✻

August 1916
Tweseldown Camp

Dear Desmond

I have not been able to write lately as I have been very busy preparing to depart for the East somewhere. I am now ready, even down to having made out my will, which I did this morning. Budden[244] and Drinkwater also did theirs. We were given forms on parade and found them to be wills!

Of course we shall be in hospitals but I shall stick it alright, though I wish it had been a Field Ambulance. I went home for four days' leave and saw no one except Pa and Ma and sister, and Henry Lamb came down to Cookham to see me on the day of my departure. I have been reading St John's Gospel a lot lately, and it is great. I think it is the greatest. This verse, and many other like ones, is so plain and beautiful: 'And he brought him to Jesus. And when Jesus beheld him he said, thou art Simon the son of Jona; thou shalt be called Cephas'.[245] It is so much the way I always imagined Christ to speak. How it sets my mind in order! I have sent my large volume of Shakespeare home. Impossible to carry such a book. Much better have a play sent as desired.

I am able to take *Canterbury Tales* as it is more packable. Also the little blue book you sent me, and some Gowans & Gray art books and, if possible, *Crime and Punishment*. In any case, if we are in hospital it will be better than wasting time here. Your letters do seem such a contrast to this life. This morning was a grand parade in our khaki 'drill' and sun helmets. It looked fine.

Yours always
Stanley

I will let you know as soon as I can of our next move and new address.

244 Young lawyer Lionel Budden was one of Stanley's close friends, with whom he shared an interest in music.

245 John 1:42.

✻ ✻ ✻

Postcard to Flongy

I am going tomorrow early. Reveille goes at 2.30 am. Romantic, isn't it? 'Orribly so. Still it will not be tiring as all the work of getting ready is over. We even had to give our beds in, so there will be no nothing tonight, but here are the letters.

I do not know where we are going, but think it is India. There are about 350 of us going. We go from London docks as far as I know.

Much love from
Stanley

* * *

23 August 1916
Tweseldown Camp

Dear Desmond

We are going early tomorrow morning for the Far East. Reveille goes at 2.30, breakfast at 3am or thereabouts. Rather dramatic, isn't it? I will let you know my further address as soon as possible.

I have been reading St John's Gospel, isn't he wonderful? I have not realised him so much or so clearly as I have these last few days.

We sleep on the baseboards tonight as everything has gone back to the stores except the blankets. I have all the books I wanted except Shakespeare, which would have been unpackable; you see, the others I was able to 'pad' my kit with.

I think what you said about the liturgy and tradition was saying all that was necessary to make things clear.

Love from
Stanley

* * *

As I approached the Macedonian life that was to come, my feelings went through certain transitional stages, as the outside changes forced upon me a spiritual parallel transmuting of feelings. For

instance, when at Beaufort I felt anything rather than this (namely my experience there); then, as we herded our way through that gap in the Tweseldown Camp hedge, I again had misgivings, feeling anything rather than this. It was all rabbit-warrened, with trenches dug for practice through the years, no grass. Pines – so that I don't know to this day if I like them. Seldom a village. We bathed in the Basingstoke Canal and kept out of the way of the young Staff Sergeant's oar as he rowed in a boat on Sunday. There was a whole history of my life there. I have a pencil drawing of an orderly I did in the hut I was in. Here also was a privileged orderly who never went on any parades. I was very bad at drill and so was often in trouble.

From Bristol to Devonport and from there to Tweseldown, the changes that took place in me changed me into no longer having that caged feeling I had at Beaufort. While there, the men from the Dardanelles seemed to have come from just over the high wall. When at Tweseldown I heard that we were for the 'draft', and when I saw the pith helmets and drill clothes and usual kit for the East, I felt pleased. All night, as is often the case when soldiers are going off early in the morning, we were up, with some playing about and general excitement. At crack of dawn I liked going through Fleet and seeing the streak of dawn and heads silhouetted against it. The women of the houses lining the railings outside Paddington Station waved and also waved pith helmets. I think the docks were Port of London docks. Much sound of steel and repairing of ships. Lascars in white scurrying about. We dribbled on to the boat *Llandovery Castle*, a big hospital ship, The one I could still see (until 1944) going up and down the Clyde. There was no food and we were there for two days. No doubt those in charge of us wanted to ensure our being on the boat in good time and ceased to draw our rations from Tweseldown, imagining we would be rationed as soon as we were on the boat. But we were not rationed until the boat left.

The widening wedge as we moved away from the quayside, the throwing of letters to be posted to the ostrich-feathered Cockney women come to say 'Goodbye'. Someone picked up mine to put it in the letterbox for me. The seagulls swinging and swirling about the masts, all this was enhanced by the sudden appearance of food. Up until then the sailor crew had taken us to the fo'c'sle and were sharing their own rations with us as best they could. We did not know where we were making for.

We sang the 'Marseillaise' in the starlight of the Bay of Biscay, the mast, now and then, eclipsing one or two stars here and there. One can understand the phrase 'the trough' of the sea. Our ship was all lit up along the sides. It was like a cruise. The sea goes a pale, delicate green as it shallows a little before the Strait of Gibraltar, then one is through. I have seen the huge pumice-stoned corner of land that is Africa and the sea going a dark blue lapis colour. Looking west as the sun was setting, a blood red band is seen. Changes are taking place; more in the nature of outrage than change, like if one could travel as fast as light. What would we see and how would things look? Outrage because one is going beyond what as a human, one is made by God to do. So that there is something a little gross about it. One should grow with experience and one does not do so at that artificial speed. Had I walked to Salonica I should have changed in the exact proportion to wherever I got to on the journey. I should have shown myself as fitting all the changing stages. I liked it in the Gulf of Salonica as the boat swung on its anchor and the Turkish town slowly seemed to move round it, with its lights at night and minarets just visible in the blue darkness.

* * *

Postcard to Flongy

Just a note to say I am on board the *Llandovery Castle* and if I do not soon throw this overboard to some kind stranger to post for me, it will not be posted. We have nice wards to sleep in.

Tonight we shall go from here, Royal Albert Docks London to, I believe, Southampton, and then I do not know where we shall go.

Love from
Stanley

We had to be up at 2.30 this morn, and we feel somewhat tired.

* * *

August 1916

Passed by censor
On active service

Envelope to Mr and Mrs Raverat

Saturday

We are passing a big bit of land which rises and rises as it recedes, until it goes sleeping up to a mountain consumed in a cloud. The sunset on this is wonderful. On the sloping green plains are villages and churches, white ones. I can see the little houses and garden plots. Oh, I must go to this place some day. Yet this is Portugal, about which you hear very little. It all has such a wonderful atmosphere and it excites a feeling in me that I have often longed to have, it was not just the shape and colour of the place that affected me so much, but it was the place where I saw it and the position I saw it in, which excited a purely abstract feeling, a feeling I sometimes get which is very productive.

I wish I had had my ballad book when I was in the Bay of Biscay. I felt just right for a good old ballad about the sea. I feel sure this is the Spanish Main but perhaps it isn't; anyhow, let's suppose it is. I must say 'Spanish Main' – it sounds so fine.

Just before we entered the Mediterranean, the sea has been changing a lot. Soon after we had sighted Africa the sea became green, and then calm and very green, then a little before we got to Gibraltar Rock the sea became a little choppy, then it became blue and rougher still, and now today quite suddenly it has become dead calm and blue – as Budden said, Reckitt's Blue.[246] Its calmness is quite another kind to that calm that occurred just outside the Straits. The calmness then was really a stillness, it was expectant, but this calm is a proper settle down, creamy calm, just as you would imagine the Mediterranean to be like.

Opposite is still the African coast (Algeria). Towards the east the sea is bright and a delicate green, and it is bright against an opaque crimson horizon, which is darker than the sea. It looks very foreign. I can hardly imagine that that shore and those rocks are inhabited by man yonder, but I could quite easily believe that a Cyclops inhabits

246 Reckitt's Blue was a laundry product used for whitening clothes.

that land. Yesterday there appeared, inland a little way and to the east of a mighty rock, an Algerian village. It looked very mysterious to see the smoke rising, it was just like being in the Bible. Now it is a white, ghost-like sea with a dark, dusky blue horizon which clears towards the top and the mountain tops appear above.

It is dark and the lighthouse off the town of Algiers, in the port, is working round and round.

<p style="text-align:center">⁎ ⁎ ⁎</p>

August 1916
On board ship

Dear Desmond

I am looking at Africa, the Moroccan coast, and smoke is rising from behind one of the peaks. I have got my Odyssey that you wrote out and I am thinking about Cyclops. I do wish you were with me. It is nice to have Budden. I really did not think it was going to be so just what I wanted. It is like discovering yourself. I want to post this at Gibraltar. It makes me tremble down in my inside every time I look at yonder coast. We are just opposite a huge African rock, which is just the colour of pummie stone and feels like pummie stone.[247]

Later
We have passed the Strait of Gibraltar and Africa is almost out of sight. On the African side is a big sailing ship full of sails, absolutely Shakespearean.

I am thinking of the Jew of Malta and him looking down at his ships coming into the harbour.

I think we must be off the coast of Tunis as this is the nearest we have been to the coast of Africa. It is not mountains now, but great, rolling sandy hills that of course go up to a great height. Each hill is peculiarly rounded and dome-like and gives a slight hint of what Egypt is like. It is dotted all over with white buildings that look like palaces or mosques. If we go to Malta we shall not, I think, be able to see Tripoli, as it will be too far south. Out to the left the hills rise to a great peak, on top of which is one of these large white buildings,

247 Pumice.

and the sun which is nearly set is shining full upon it. These hills are peculiarly wrinkled like the wrinkles on the back of a bullock's neck, most wonderful.

A canary has been bobbing up and down alongside us for some distance. They fly in much the same way as a fieldfare.

* * *

Processed 22 August 1916

No. 100066 Pte S Spencer
M HH Reinforcements
BMZ Force
C/o GPO London

Dear Jacques and Gwen

The photos are fine, so unphotographic and characteristic. I think I shall be off this week. I have been reading St John a lot lately and it has moved and impressed me very deeply. I think he is wonderful. St John and Christ seems one thing, doesn't it? In a letter from Chute he says something fine about the liturgy: 'the liturgy is to me – the liturgy and the accompanying plainsong, the one great form of art and really living. The greatest art is always a tradition – a store of anonymous beauties – impersonal, like the Homeric epics, both sung, Gothic cathedrals, plain chant?'

I am now going up the Aegean Sea. All down the Mediterranean we kept to the African coast.

Love from
Cookham

The porpoises are very amusing.
I will write soon.
Smoke was rising in Africa at Gibraltar Strait.
We are in Salonica harbour and now a terrific thunderstorm is coming towards us in the gathering gloom.
We are in a perfect inferno of fork lightening now; it is wonderful.

ACTIVE SERVICE IN SALONICA

By the time Stanley's troopship arrived in the Gulf of Salonica in September 1916, morale was low and the troops on board were lethargic. As they disembarked, military discipline had to be firmly enforced. It was at this point that Stanley was separated from his friend Lionel Budden.

In the lighter we were a jumbled mass and on the quay when we were lined up, the Sergeants seemed to find their voices again. I had been all the time at Bristol very friendly with a man, Lionel Budden, who was very musical. He is now a schoolmaster somewhere; we two had managed to keep together until we were on this quay. Then, maybe because of the laws of the Army, one of which is 'tallest on the right, shortest on the left', we were separated beyond all hope. It was our only difference. So we were marched off to different camps. We grinned as we solemnly marched off to our several destinies. I saw him in about 1929, when I was painting the Fernlea front gate in Cookham High Street, so I was able to introduce him to the exterior of the house I was born in.

I do not quite how to continue this because there is always the mixture in me of good qualities with bad and there is no separating the two. The tares are of various kinds. There is the kind that seems to make me need to enlarge on distressing details, and that is in no way my purpose. What I wanted here was to write of the changing stages of arrival at Salonica, and the growth of the atmosphere of Macedonia upon me. At first I was intensely homesick so that I could hardly bear to look at the water staining gravel dug from my bivouac.

On the hill at the back of Salonica I felt that the Front was miles away and it all seemed as incredible and unlikely as it did in England when I was at Beaufort. I liked the look of the marshland away to the north-west that disappeared in low-lying mists that lay between Mount Olympus and ourselves. The Vardar river could be seen wandering up the wide plain. At night we were in tents and the sociable lights of our candles and the talk going on mixing with the general hum of conversation from the other tents made everything very cosy and I liked the feeling that the darkness, that seemed to

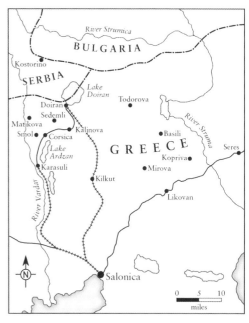

The British sector in Macedonia, northern Greece, in 1914

have a reddish glow, had a Bulgarian feeling in it. Some man had just arrived from some sector. If he had been Hermes straight from Olympus with messages from Zeus I should not have been more moved. I could hear his voice as he went to some of the adjacent tents for a chat, getting nearer and finally arriving at our tent. I don't know if he heard our very untechnical and un-soldierlike questions such as 'What's it like chum?' and 'Where's the enemy?' He was big and jolly and looked a bit hunted and said in a manner as if he was giving us the most reassuring news, something about '40 kilos, it's out of the question chum, they couldn't do it', and then he went.

At Beaufort I had tried to visualise what wounded soldiers looked like when on active service. I have now just seen one and I hope he was never wounded. From the first day and for about five days a sort of sand storm was blowing in from the sea direction so that I was unable to gaze across to Olympus until this ceased. In the early morning as the sun rose it was grand. From Salonica or Mars Hill, it seemed in shape rather symmetrical, a sort of wounded eagle shape, wings out and plopping on the ground. In the centre just a small peak and the great shoulders reaching out either side. There were one or two stratas of mist obscuring the base. The upper bands were a pale emerald green, then blue-red, and then the main widest band was magenta of a warmest tinge. The land and most of the sky was quite darkish before the sun rose, so that when we gazed towards Olympus one could see only rather solid-looking dark mists and night gloom. In the midst of this would suddenly appear, softly but there, what looked like a star but which was really the early morning sunlight catching the little peak that rose from the shoulders and left the rest in dusk. But I longed to be up that Vardar Valley: it had for me a most alluring appearance. Somewhere in the valley I saw some thin trees and behind them what looked like a small bridge and I thought I saw some Macedonians. It began in me a course of longing for something findable in that country, which lasted for the two and a half years that I was there and for years after. It became the goal and place wherein spiritually I wanted to find the redeeming and delivering of myself in all the activities the unexpressed me had lived through and in.

It was when I was in the Field Ambulance in Macedonia that the deepest impressions were made: of my first going up the line; the quiet atmosphere, muffled. Some man on a horse or mule conducting

us to a place near Kalinova and some way from Karasuli. The oxen swaying from side to side, heads stretched forward under their yokes. The sleeping on the side of the hill above Lake Ardzan and a grass fire looking like a huge dragon stretching the length of the lake and reflected in it. The wild dogs and seeing during the night they did not get at the meat in the tub. A heavy stone on top to prevent removal. The wolfish dogs' symposium at night.

* * *

Autumn 1916
Salonica

Dear Desmond

I have just got your letter, which was written the day I left England. A helpless, suspended feeling seized me as I suddenly noticed the side of the dock we were in begin to slide away from us. It was a wonderful voyage, but I will describe it when we return. My address is 68th Field Ambulance, Salonica Forces, Greece. I am glad to be away from the Training Centre and doing something and not in a hospital. But oh, for an English sunrise, that seems so charitable and to bring abundance in her arms!

 I used to feel that my day's work and desires rested in the lap of the morning sun, and I used to love to contemplate it there, when I had my bathe, before taking it, so to speak. You know, Desmond, it is awful the way I am suffering, being kept from my work like this. It will not, I think, do me harm, but it is exasperating. I can hardly look at pictures sometimes. If you can send me any book, do, please, as I am longing to read something. I had to leave my Shakespeare behind at home, but I took the *Canterbury Tales* as a substitute.

 Your letter was a wonderful thing to read, especially in this barren country. Just before your letter came I was reading another, old letter from you with the wonderful bit of Milton out of *Paradise Lost*. Description of the garden, '– airs, venerable airs. Breathing the smell of field and grove',[248] which words you underlined and compared them to Sonata Op. 28,[249] which I cannot recollect. Write down some bars of it. I think John Ruskin, though such a bore and

248 *Paradise Lost*, Book IV, lines 264–5.

249 Beethoven's piano sonata, known as the 'Pastorale'.

so absolutely wrong, is a very fine man and fine writer and says some fine things. Anyhow, I enjoy reading him and rather wish I had some of his *Modern Painters*. I had to part with dear Lionel Budden at the rest camp out here. I do not know where he went to. I wish you could send me a drawing block and some pencils. I can get nothing here. But it is a joy to hear from you. Send me some St Augustine's *Confessions* and St John of the Cross.[250]

I must reserve all descriptions till I get back. I am safe and well, and I think I shall keep so. I have read St John again and also the Epistle of St Paul to the Romans. There is great unity in it, I think.

<p style="text-align:center">* * *</p>

Soon after arriving in Salonica Stanley was posted to the 68th Field Ambulance. His journey began with a journey on a troop train from Lembet to the rail-head at Karasuli, a remote village between two lakes. From there his unit moved to the village of Corsica, which was nearer the front line, and eventually to the uninhabited village of Kalinova.

In the train I think from Lembet to which we were marched after a few days, I sat on the wooden seat and was entranced by the landscapes from the window: low plains with trees and looking through trees to strange further plains or fields, and here and there a figure in dirty white. It was not landscape, it was a spiritual world. I would go there again if I could. I was hungry and a man gave me a couple of Horlicks malted milk tablets. I did not think at the moment he had given me much, but when I had had one in my mouth sometime I began to express my thanks. They were wonderful things.

My life in Macedonia begins just after I had got out at Karasuli and with a small group of Field Ambulance assembled on the little road track similar to the one that goes along the bottom of Cockmarsh Hill. Along this track, which wandered along the foot of some line of hills between Lake Ardzan from Karasuli to Kalinova, most of what was vital to me in Macedonia was felt: every kilometre of that track is a part of my soul.[251] When I think of the places along it on the different parts of this continuous hillside, for me to describe each item is to describe something of myself. The other side of this

250 A sixteenth-century Spanish mystic, saint and religious poet.

251 Kalinova was to become important to Stanley (see *The Resurrection of the Soldiers*, 1928–9, Sandham Memorial Chapel, Burghclere). In 1928 he wrote to Richard Carline: 'The place where the *Resurrection* takes place … is called Kalinova, where I spent the happiest time I had during the whole War…'.

line of hills was unknown to me. The impression I now have is of a line of irregularly shaped hills, one running into another or divided here and there by ravines. Some way along there is now a cemetery, the first graves of which were dug by a Corporal and one or two men, including myself. We thought it a suitable place.

Away in the hills to the left and nearer Karasuli is a casualty clearing station, which I was once sent to, when, due to a tight puttee: the new kind not being so elastic, a small abscess formed on my shin. Then one comes to a place I think called Corsica, which is where the first Field Ambulance I was in was situated. This was the 68th. I slept on the side of the hill with another man. Stars overhead. Grass fields and Lake Ardzan twinkling below. Looking front and north-east, an old Greek fort. Quiet murmur of men's voices, rather comforting. It was dark when we arrived and I had the feeling of not knowing what world I should wake up in. I peered into the hillside and seemed to discern the white shape of a bivouac or glowing object of a tent with a candle or hurricane lamp in it. This place is the scene of the left-hand wall as the spectator faces the altar in the Burghclere Chapel.[252]

The mules were quartered on the flat, at the foot of these hills. In a general rehearsal turn-out my arm ached with pulling them round and round, circus-wise, which was the kit inspection rehearsal version of going elsewhere. I was glad when one day they were experimenting with a new kind of cacolet, or litter, when I, being light, was the patient. The cacolet was a kind of chair in which a patient would sit on either side of the mule. These were made so that the patient could recline, deckchair fashion. Poor mule. I noticed that one of the bits of this wooden chair was touching the mule and the officer had it altered. I was told that you could tell when it was a cold morning by noting the mules' backs: if they curved upwards, poor things, they should have had warm blankets. As long as the way was difficult and pitch dark the mule was sure-footed and did not lose the way, but I found a mule difficult on a good easy road and sunshine. Then he could not keep awake, and would sink down quietly on the road. One could not be ever pulling at their bits; that can't be very nice for them, but unless one does and does so continually, under the circumstances, it goes slap off to sleep. I was at the head of the front mule conveying a man on a 'dooly', that

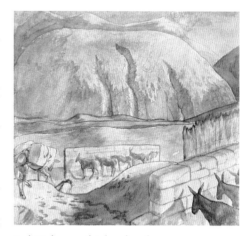

Pack Mules, pencil, ink and wash on paper, 1918–19

252 *Camp at Karasuli*, 1930, north wall, Sandham Memorial Chapel, Burghclere.

is, a stretcher, resting on two shafts harnessed for and aft to a mule. The mule, in spite of my efforts, went to sleep and sank down on the road. The patient, who was not badly wounded, just slid a little on the stretcher and was greatly amused. In the case of travoys,[253] that was the difficulty: if a patient was badly wounded or seriously ill, and because of the shafts sloping down from the one mule to the ground, with the bumping along he would slide down it, and in order to prevent this I had to hold him under the armpits. This for kilometre after kilometre was a very exhausting job. The shafts of the travoys are different, one longer than the other. This prevents a bump if it goes over any narrow trench or gap.

When at Bristol, I seemed remote from any 'outside world' activity. Ordinary activities of life were to me the things that the wounded soldiers told of in their beds. The same division or hiatus that seemed to exist between them and what, not so long before, they had been doing, gave me a feeling of removal from such things. I thought in a dreamlike way of the life in a Field Ambulance. The word 'field' had a nice, unhospitally sound, and ambulance suggested cart wheels and possible shouldering thereof. It was outdoors and there might be patches of countryside here and there which were pretty free and unmilitarised. But these were romantic pictures in my bedpan-fetching mind; impossible romanticising.

The men from the Dardanelles were bolts from the blue. I could hardly credit that the crusted mud on them was Dardanelles earth. I kept getting these reminders of that hot Eastern place and was often thinking of it and seeming to see it. One patient, who wanted me to be present when he was operated on, was from Macedonia, and I once or twice heard of Doiran Lake. And now I was somewhere near these places, sleeping on one of those hillsides I had tried to imagine. I thought as I lay there, I will be an active part of whatever it is at the back of the hillside darkness. If it had been that I was to be metamorphosed on the morrow into one of the animal inhabitants of the hill, I could not have felt more curious.

I saw the little glows coming from the bivouacs and a few nights afterwards I was seeing to it that they were put out at 9 o'clock. I was now that special being: a soldier 'on active service' – although I felt the nature of being it a little unconvincing when I used to get the YMCA 'On Active Service' envelopes. And when the distinction

253 A mule-drawn mountain sledge comprising a canvas stretcher strapped to a pair of steel-tipped wooden shafts. Stanley later explained why the length of the shafts made them suitable for the terrain in Macedonia: 'The shafts of the travoys are different, one longer than the other. This prevents a bump if it goes over any narrow trench or gap'.

fell on all about one, it was difficult to feel it. Like the Gilbert and Sullivan 'if everybody's somebody then no one's anybody'.[254] But still this place came up to expectations. I did not like it when it was my turn to see lights out; I was afraid of offending the men in the bivouacs and one night when I tentatively peered through the crack and apologetically reminded the man I had said lights out and he said, 'I'll see you in the morning', I felt very disturbed. But he was joking and was very charming the next day. When we had shifted further along these hills to Kalinova, he missed me when I was having the abscess removed from my leg.

While still at Corsica Camp (68th F.A.), I used to go with parties of about ten or twenty men, with stretchers folded and carried 'at the slope' assembled in the evening to go 'up the line' about five kilometres to where we will meet the regimental stretcher bearers and take over from them.[255] As the walking was in the dark, one could only tell whether the way was bumpy or easy, wet or dry. In the Sedemli Ravine it was often a river, shallow enough to wade in.[256] I could have done with that sort of thing when I was in the Bristol Hospital: now one was in a world where things happened and some sort of process of development could be felt. But at Bristol it was a nothing-happening place by profession. One heard of things happening as a story that is told, and was told by the patients. I had at least swung over to the 'patient' order of being, an unwounded and not ill one.

One night it was so dark that the officer nearly walked us into the Bulgar's lines. I saw some big artillerymen, shirtsleeves stripped up, drying their faces after an evening wash. A little man I was with one night up the Sedemli Ravine said he thought he could smell something, and then became silent. He was in hospital next day, still silent, and remained so. I don't know if he recovered: he got some sort of shock. In all changes we looked and dared to hope for a sign of this business coming to an end. When at Bristol there was no change but, on the contrary, any new thing was clearly to further ensure the continuance of its unchangeableness. I looked in the stores there at the mountains of blue-wrapped cotton wool with feelings of concern at the thought of how long I might be at that hospital and how long things would go on for, rather than the thought of its purpose.

Wounded being carried by Mules in Macedonia, pencil, ink and wash on paper, 1918–19

254 From *The Gondoliers* (1889): 'When everyone is somebody, then no one's anybody'.

255 The regimental stretcher-bearers brought casualties down from the front line, to be transferred to the mule-drawn 'travoys' by medical orderlies from the Field Ambulance and taken back to the dressing station behind the lines.

256 This was the subject of Spencer's *Travoys passing up Sedemli Ravine on the Way to Le Naze*, pencil and wash on paper, 1919 (Imperial War Museum, London).

<center>❄ ❄ ❄</center>

Undated
RAMC, 68th Field Ambulance, Salonica

Dear Flongy

I believe I have not written to you yet, well I have written but could not send them. When I was on duty the other night I noticed a big man sitting in the room whom I had not noticed before. After I had been chatting to a friend for a little time, he spoke and asked me if I came from near London. I said I came from about 25 miles from there. And he said 'Do you know Cliveden?' I said yes. 'Oh', he said, 'I had a chum who came from near there.' 'Well', I said, 'my name is Spencer and I come from Cookham'. 'Well do you know,' he said, 'that directly I heard you speak I thought how like old Spencer's voice, Poor old "Cookham", I wonder how he is getting on, and that made me wonder if you came from anywhere near him.'

He did not know Gil had a brother in the RAMC and that must have made the surprise greater for him. He said that Gil had wanted to go into a Field Ambulance and that he was put onto a hospital ship, and this man who came out with Gil, Edmonton is his name, wanted to serve on a hospital ship and came here.

My address is Pte S. Spencer, No 100066, 68th Field Amb RAMC BMEF, Salonica, Greece.

I am very well off for clothes. This is me with <u>all</u> my clothes on [drawing], which consists of 2 vests 3 shirts 1 pair of shorts 1 pair trousers 2 pants 1 tunic 1 leather jerkin 1 overcoat and 1 Macintosh 1 cap with ear flaps and Macintosh cover for it 1 pair woollen gloves and 1 pair of leather sort of boxing gloves.

The mackintosh cover to my hat is rather too big for me. Of course I don't go about with all these things on at the same time. It is only just to show you what I could wear if I liked. Well, this will have to be a short letter as I want to send others now. Much love to you and J.M.I.

Your loving brother
Stanley

* * *

Received November 1916
On active service, Salonica

Dear Desmond

I do not know if any letter from me has reached you, and I cannot remember if I answered your letter you sent to Tweseldown, which was forwarded to me out here. Since then I have had no letters from anyone, and this is, I think, 28th October. You will have to wait till I get back to England before I can give you any news. I am still keeping well. I have no idea where Lionel Budden went. My address is: Pte S. Spencer No. 100066, 68th Field Ambulance RAMC, BMEF, Salonica. I still have several of your letters with me, I am determined not to 'shed' any 'feathers'. I am more than thankful that I brought some little books and things with me. I only wish I had brought my Shakespeare, though I do not think I could have managed it. Oh how I long to paint! A man told me that Malta possesses many old churches full of frescos, and one in particular called the church of St Paul,[257] which contains the life of St Paul on its walls. When this man told me this I began to long. I could not help thinking what a glorious thing it was to be an artist, to perform miracles; and then I wanted to work and couldn't. If I see a man putting a bivouac up beautifully I want to do it myself. And when I read of Christ raising the dead, I want to raise the dead myself.

Write out little scraps of music that I know. I am starving for music. Would it be too much to write out or send me out a copy of some of those songs that Mrs Daniell used to sing? By Jove, I shall not forget those times.

I shall visit Bristol when I come home and we shall have to 'go our rounds' once more. I shall have a lot to tell you. Do send me out some little book, a good Dostoevsky that I have not read, or something by Hardy. I have not read anything by him except poems. Send me some more Milton and Shakespeare.

Please remember me to your mother.

Much love from
Stanley

257 The apse of St Paul's Roman Catholic cathedral in Mdina, Malta, is decorated with frescoes illustrating St Paul's shipwreck.

* * *

Now and then the bivouac glows, one after another, would go out and appear again as one of these big wild dogs passed along for any possible titbit. One big white one, like a white Alsatian, made friends of me and our camp generally.[258] When I was on night patrol, just patrolling the camp, that was all, I would listen to the dogs higher up the hill where in the clearance they would sit round, wolf-like, and do their heads-up whining, especially on moonlit nights.

* * *

The move of the 68th Field Ambulance camp to further north along this track to Kalinova was a big change. Here I was aware that compared with Bristol and the place down the road towards Karasuli, namely Corsica just left, I had, together with the whole camp, 'lost caste' a little. The established war atmosphere, and being natives thereof, seemed not so tense and strong. There was a faint slackening somewhere. Instead of a hillside, we first bivouacked in an enclosed walled space. This seemed unprofessional. I thought we were more like children 'camping' in the garden: no use at all. The war was going to the dogs. Coming as I first did to the then old-established 68th F.A. and apologetically insinuating my way into it, is one thing, but at Kalinova we were all given birth to from the same place-womb and felt a certain kinship. I don't remember doing anything in these places other than to go on these occasional night trips or be inspected. Together with my little bivouac friend I made with mud and some chaffy stuff some bricks, drying them in the sun.

I did here a drawing of the Cockney who said he would 'see me in the morning'. Some 'dud' aerial torpedoes or some such thing came down while I was doing it, but both of them (there were two) were no good. This picture was a recovery from a long feeling of disability I had felt in my drawing.

* * *

258 In *Camp at Karasuli*, Sandham Memorial Chapel, Burghclere, a Greek dog picks over discarded Fray Bentos bully beef tins. Perhaps this is the 'big white dog' described by Stanley here.

14 December 1916
British Red Cross and Order of St John, Salonica

Dear Flongy

I have just got your letters – one dated 11th Nov. and the other the 16th. Thank you very much for them, Flongy dear. They do make such a difference to my life out here.

You must not ask me questions in your letters. You must be satisfied to know that I am quite well, I happen to be in hospital getting over a bad leg, which will be alright in a day or so. I draw heads all day long while I am here.

I still hope that Gil will be able to get with me, but this delay caused by my being away from my unit will upset the chance, as I cannot see the CO I feel that if I could, he would see it through.

It was such a fine letter that I had from Gil, and it did annoy me that the morning it arrived, about three weeks ago, I could not walk. If it had come the day before I could have tracked myself to the office, and by now it might have been effected. But it will be alright if Gil can keep where he is, and is not detailed.

There is a Cockney man in our lot, and he is a real delight to me. I loved drawing him. I pictured what he would be like in civvies in London. I saw the blazing, many-coloured neckerchief and the tremendous buttonhole. It was all there. And he has such a humorous face, and quite a gentleman to speak to, though to look at him he would positively frighten you. He used to dress my leg, and his hand and his manner were as gentle as a mother's. We have another Cockney in this ward, he is one of the 'Law love a duck, gaw blimey' type, bless him. You would marvel at the splendid spirits that our men possess. You would see a man of about 39 or 40 gambolling on the bed of another patient like a child of six. But what I like is that at the same time as being this apparently flippant being, he is in fact a most thoughtful man.

<p style="text-align:center">* * *</p>

One night I was at Smol, near the little Greek church being used as an operating theatre. It was a memory of this that I had when I did

Travoys watercolour in Gwen
Pinder-Brown's autograph album, 1919

the *Travoys arriving with Wounded at a Dressing Station*.[259] Here I shared a bivouac with a youth the same size as myself. He was very nice and we found we had other things in common besides being the same height. This height was convenient because it left a certain space at the foot of the bivouac in which to put things. We carried out extensive improvements. We dug down a little. Casting our eyes over the landscape one day we saw something shining in the sun away towards Lake Ardzan. It proved to be an old petrol drum. This we procured and buried at the foot of our bivouac, the open end on the inside. It formed a cupboard which took our equipment. We also built a little fireplace and a mantelpiece and a chimney stack. The outer bivouac sheets had yet another roof of sheets of petrol tins. As I describe this, I think what a different me this was from the me at Corsica a few weeks earlier.

In the cookhouse, beginning early in the morning, I would cook rashers for 60 men, two each. On my left as I knelt to a little groove cut in the ground for a wood fire, I had a wooden box full of cut rashers. On the fire was a dixie lid on which the rashers were fried. In my hand I had two flat pieces of wood with which I picked out bunches of rashers and stirred and turned them about in the frying pan. And on my right was the dixie which I gradually filled with fried rashers.

The cookhouse, a limber[260] tilted up and a tarpaulin thrown over the shafts, had a cook known as 'the Black Prince', a grim-looking man who kept away in some darksome, dugout place I did not go near, and who, Arabian Nights Genie-wise, usually appeared when one had done something wrong. One day I was reading *Paradise Lost* and was supposed to be watching a side of bacon that was simmering in a dixie when I smelt faint burning, but I was too late. He loomed out of the darkness with his big black dog, gave a kick at the dixie and sent the lid flying and up went a column of smoke.

* * *

259 Now in the Imperial War Museum, London, this was painted in 1919 after a pencil sketch that had to be redrawn after Spencer lost the original, which he made in Macedonia.

260 A two-wheeled cart used for field service.

Then in December I got this abscess and had to go to the Casualty Clearing Station further down this line of hills and then to the 4th Canadian Hospital, Salonica. Here I had my first attack of malaria. While in the 4th Canadian Hospital I did several drawings of

soldiers. These, all of which were nearly life size, I did on the only paper I had, namely the pages of a Sister's large autograph album. The wave of improvement continued throughout these drawings.

My portrait drawing history and the thought of it in the war takes me back to number 4 ward, 4B and MI wards at Bristol, where I did a few drawings. The Orderly in 4 ward had, as did the MI orderly, a room opening into the ward, and with the orderly on tenterhooks because he was 'on duty', I drew him. Then, belonging to the same ward, a patient who slept and was in bed under those octagonal open-sided shelters I have spoken of, submitted to be drawn. I was rather pleased with the drawing and so was he. I was proud of the achievement for several reasons. He had a painful hip wound and a thing I believed called a suspension extension splint or some arrangement which meant that the faintest touch to the bed caused a painful jar. I had for weeks swept under his bed and he had learnt to trust me so that he could read and fear nothing while I did so. He was, I believe, quite a nice man really, though there were reports of books and language hurled at anyone approaching his bed. It must have been infuriating for the poor man.

I don't remember doing any portraits in 4A. In 4B I drew a patient. I did not like the drawing. Then one day I was asked if I would do a drawing of a Sergeant (named Spencer: no relation) in MI ward, and I felt things were improving. I was accorded a certain degree of courtesy, which I thought nice of the Sister and the others. The drawing was quite a good one for me and the Sergeant was very pleased to have it. It was quite a job getting back to being the ordinary 4B orderly I was. I don't remember other drawings done at Bristol.

At Tweseldown Camp (Fleet) in an Army hut I did a drawing of what had been the theatre orderly at Bristol and who came with us. I did not like this drawing but I still have it with me. I also have the 4B 'failures' I was allowed to keep. They mark my state at that time, and I feel the interest in them that I feel in myself. I think I did one or two more here but have no recollection. Sometimes when I meet someone from that time, they tell me they have a drawing I did of them of which I have no recollection. But I have not done so much work as to have lost memory of much of it.

<p style="text-align:center;">* * *</p>

British Forces Christmas card, 1916

20 December 1916

Dear Flongy

I have had a beautiful letter from Gil. He is in Mustapha, Egypt now, and he wrote to me about getting to be with me, but on the day his letters arrived my leg was so painful that I was unable to walk on it, else I should have seen the CO there and then.

I had a swelling on my shin and at last it was opened and the matter removed. It was an abscess, but it was deep down under the flesh so that you could not see it. It is healing up well now and all the matter is gone.

I have great hopes of Gil getting into our ambulance, that is if he does not get detailed for something before I get a chance of seeing about it.

I am sorry I did not write to thank you for your letter before,

Flongy dear, but I did write a long one, and then I mislaid it. My leg puts me off food for days and gave me a temperature, but now I'm getting my pecker up and making up lost time.

You need not worry about clothing, you could send me a pair of socks. I get as much food as I want, and all I desire is books and drawing paper and pencils. But if you send anything, send only a little bit at a time. Always get the cheapest edition of a book, as after reading the book I might have to get rid of it, though I doubt if I would. I am still clinging on to the little books that I have got. If you send me a book, send me a Dickens novel. Everyman's Library have a lot of Dickens. In *David Copperfield* I have come across parts that have in my opinion being comparable only with Shakespeare in dramatic power. But of course, it is quite unconscious in Dickens, whereas it is conscious in Shakespeare. That is how the Greeks appeal to me, their conscious and obvious art. [Desmond] Chute was telling me how their plays used to be acted, and it is also plain and obvious that what they are acting is a drama, not a representation of human things classified. The result is they do not care about costume or getting the correct number of people for the play. One man does the whole play and stands on a small platform, and goes clean through, wallop, from beginning to the finish. Of course, some of the plays necessitated more players and perhaps costume, but only when it was an organic part of the drama. But the people had to take the essential beauty of the play or else nothing at all.

I am not quite sure that I know what I am talking about, but still it is very interesting, and if you do not think so, you ought to.

With much love to you and to J.M.I.

Your loving brother
Stanley

* * *

4 January 1917
British Red Cross and Order of St John, Salonica

I am now back at the base awaiting return to unit.
I am still here, remember me to your mother and to all my friends in Bristol.

Dear Desmond

I am so keen on drawing patients that I spend my whole time on it. This is really how it is that I write so seldom. I believe my drawing is getting more definite; it begins to mean something. Though it is still exasperating.

I do anything for these men. I do not know why but I cannot refuse them anything and they love me to make drawings of photos of their wives and children or a brother who has been killed. A diary of a man who was killed chronicled the weather day after day, and as you read these monosyllables it gives you an intensely dramatic feeling.

It is a most wonderful thing speaking to men; a great privilege. I could not help thinking of St Francis's reply to the robbers that met him in the wood, when I was speaking to an Irishman. I had not said a word and he was arguing with someone and he turned to me and asked me what I thought about the 'afterlife'. I said that as the very being of joy exists in that it is eternal, it is only reasonable to suppose that life which only lives by joy must necessarily be eternal.

If these men have not gripped the essential, there is one grand thing: they are part of the essential.

I wish you could see the sea here. On a sunshiny day the deep blue sea, all ribbed, like in a Claude Lorrain, and the gleaming froth along each 'rib', and the shadows of the ships on the surface of the sea. I am sure you would say it was 'blithe and debonair'. And the hills beyond all, bronze with the sunlight on them.

A man told me last night that an old man in France used to bring his trap and pony round and sell sweets to the men, and one day he had gone into a pub and this man, who is a most magnificent man to look at, noticed his cart and knew also that by reason of the old man having left his cart for a drink, that he had 'sold out' – and trotted the pony off to a place where was a five-barred gate. On arriving at this gate he unharnessed the pony, shoved the shafts

of the trap through the gate and harnessed the pony into the shafts on the other side of the gate. So there it was, the pony and trap harnessed together, the trap on one side of the gate and the pony on the other, and the gate shut. This patient described the way the old man went to the pony's head and carefully pulled it a little bit forward and then backed it a little, fearing he might pull the gate down if he went desperately at it. I think the story is so French. On another such occasion the spirit moved him and he simply smarmed the cart and horse all over with green paint, and the poor old boy simply cried when he saw it. The brute. But at the same time it was only because he had the paint with him and a big brush, and the temptation must have been very pressing.

I am glad you describe your visits to your friends in Bristol that I know. It is great to get a glimpse of Miss Krauss's studio. I shall come to Bristol again after the war.

Your affectionate friend
Stanley

* * *

19 January 1917
RAMC, 68th Field Ambulance, Salonica

Dear Jacques and Gwen

I could not have wished for any book nearer to my thoughts than a book of Claude.[261] I think that Claude is the medicine I most need. I believe that when I get paints I shall do some landscapes. This morning I went on a wonderful tramp. I get very affected by these mountains and hills. I am out of hospital now and am writing at the base to return to my unit.[262] I am absolutely well now, save for a slight headache, which sometimes comes on when the sun comes out. I have heard that you have a baby. I hope it is true and that you are all well. You might let me know this as all I heard was that a baby was expected and that's like dying before the war has ended. In our tent was a young man named Siefield (Swiss extraction) who knew Dr Vaughan Williams, he is in six Field Ambulance and he

261 Claude Lorrain (1600–1682), French landscape painter.

262 Having been hospitalised with a swelling in his leg as a result of wearing poor-quality puttees while stretcher-bearing, he then caught malaria and could not be discharged for another four weeks.

seems to be a very fine man.

Gilbert is trying to get with me from Mustapha,[263] where he seems to be getting on well. I am living in hopes that I shall be sent up again as I much prefer it to being at a base. I had my fill of hospital work when I was in Blighty. Gil, when he is with me, and since he and I have been in the army, looks at me in such a worried way as he looks at a burden. I am sure there is no need as I am quite happy and although I am not actually painting anything on canvas or paper I am still making, praising and giving thanks more than ever I was before. Everything I do for anyone is an ointment poured forth and it is an exercise creating joy which is eternal and it is the Army that has caused me to learn this.

I do not mean that by being happier in the present state that I am satisfied. But what is wonderful is that by praying for the Power to love purely and absolutely you get that power. I feel ashamed of what I would do when I first came out here in comparison to what I would do now. The Army ought to make any man an artist because it ought to give anyone those feelings that I have just expressed and which are essential to an artist. But I do wish I had my paints out here.

I would love to have Marlowe's plays. *Edward II* is great, and *Tamburlaine*, oh yes, I should like to read them all again.

Could you send me some sweet biscuit Pat-a-cakes, or 'Nice' biscuits or combination biscuits, but not ginger nuts or ginger of any kind. That Claude book is an extraordinary comfort out here.

Love from
Cookham

* * *

21 February 1917

Dear Jacques and Gwen

263 There was a large RAMC convalescent depot for sick and wounded servicemen at Mustapha, near Alexandria.

264 The Raverat's first child, Elisabeth, had been born on 26 December 1916.

If it was not for my sister's letters I should know nothing of how you are getting on. I hear that you have a baby girl[264] and that you are both well. I wish I could hear more often from you, Jacques, it is

unfair to expect me to write a letter when for a limit of the 'News' I tell you, I have the Field Card to draw this news from.

I am not in the 68th Field Ambulance now. I am, for some reason unknown to me, in the 66th Field Ambulance. So you might address your letters to me to the 66th. Anyhow, I am glad to be back 'home' again after hanging about down at the base for nearly three weeks. I have got a rotten cold and continually running nose and I think the Lord is against me, though honestly I am very happy and I think my stay in the Army is getting rid of a lot of much out of my mind. You have to think of other people's needs. I have come to the conclusion that if a man is a good man, he cannot waste his time. He is always, as Desmond Chute said in a letter to me, 'making, and praising and giving thanks'.

My head is feeling heavy and so I will excuse myself, as writing with my head like this is no pleasure.

From your ever loving
Cookham

I acknowledged the receipt of the book of Claude in a letter I sent to you from the base. He has put a new song in my mouth.[265] I should love to hear about your little child.

* * *

When I was drafted back after about a month or five weeks in the 4th Canadian Hospital, I was sent to the 66th Field Ambulance, not the 68th, and here I found myself on my original Corsica 68th F.A. spot. To be the person who took my place after I left, my successor, gave a strange feeling to my stay in the 66th. I still felt that a lost or un-get-at-able me was continuing in the 68th. Instead of being the musician's son I am, I was the son of the butcher who lived over the road, something I had always distinguished myself from. Now I was what I felt I wasn't. Yet I fitted in and became the 66th Field Ambulance man and was pleased to note that families in their nice characteristics are not so dissimilar. The Sergeant Major here was quite kind to me and often had me in his tent, giving me little treats.

Of the 66th F.A., which as I said was on the ground where

265 Psalm 40:3.

the 68th had been, the only thing I seem to remember is a lot of nose-bleeding, and the kindness of the SM, and the somewhat discomforted feeling that the glimmer of hope I felt at Kalinova when under that wall, and with all that independence and bivvy building, was perhaps a false alarm: 'I must be careful not to let things like a place and appearance of walls and local surroundings arouse my hopes.' I was a bit disappointed. If this Snakes and Ladders casting of a dice (this case of having malaria) was going to send me in a twink from the high hope of the 68th at Kalinova to what was too substantial a ghost of what the 68th Field Ambulance had been, there would certainly be a shaking up of my confidence in the sort of visions of hope I had. So strong were these hopes I would at times feel – such hopes, as far as I could see, produced by some harmony between myself and my immediate surroundings – that in my recollection they seem to date just at the end of the war. When I come to describing the last few days of the 1914–18 War you will see why and in what way it is related to the actual end of that war. I also felt that that hope and consequent constructive and productive results in me, my simple drawing heads and so on, would make the war just melt away like a snake charmer. The snakes would all forget. I had a copy of Gowan & Gray's *Claude Lorrain* in my pocket and a reproduction in it of his *Worship of the Golden Calf*, a wonderful pastoral scene, and a lot of vases, women and men dancing. 'What has happened?' I thought. 'Why doesn't everybody chuck it and behave like this, only a change of clothes and country dancing instead of shooting?'

* * *

24 February 1917

Dear Jacques and Gwen

In spite of of this tiresome cough, which is now abating, I will try and write a bit more to you. I still have no books to read. The book of Claude has been a continual something to fall back upon, and that is just what I want out here. I am still in the 66th F.A. and you had better address your letters to me accordingly.

My dear little Bible that my sister Florence and her husband gave to me has disappeared. It went when I was down the line sick. I have the New Testament.

The mountains have been looking wonderful in the sun the last fortnight. They are snowcapped and the highest points just pierce the long, flat cloud which hangs along the range and cast a great shadow part-way down the side of the mountain. The end of the shadow is sharply defined on the rocks and gives you a grand idea of the solidity and shape of it. And down below it is all magenta colour, as I sometimes think, with my old English idea of colours. Oh, it's almost too gorgeous to be true.

Yours
Cookham

* * *

24 February 1917

Dear Flongy

I do not know how many letters I owe you, but I will do my best.

I got the London University College Pro Patria and Union Magazine today, which contained a lot of really interesting news about a lot of my old Slade friends.

I am aching and aching for a good book to read. Of course the boys have a few cheap novels, but I would rather waste my life away than read a sentence from one of these 'books'. Do tell me all about Mrs Raverat's baby. Oh, what would I not give to see it. When I heard about it I laughed for sheer joy, and when the chaps in the tent asked me what I was laughing at I said, 'I don't know, I think we must be winning'. The photo of J.M.I. has not come yet, but I get mail every day just now, so I expect it will be here soon. Much love to him and to you, Flongy dear.

From your loving brother
Stanley

∗ ∗ ∗

66th Field Ambulance, Salonica
*c.*February 1917

Dear Flongy

Thank you for your three beautiful letters. I have also received your present of drawing paper in a roll. I am doing drawings of several fellows in this ambulance, 66th. One I am doing of the SM ought to turn out well. I loved those little extracts from Walpole's letters.[266] There is a lovely feeling of the 'Hell of a swagger fellow' about him, only in him it is natural.

I think that Dostoevsky would not suit you at all. I think you will hate him. But I think you will only hate him for a little while. Dostoevsky has been 'the fashion' as you say, but of course that is nothing to do with you or the writer. His books are unlike anything you will have ever read before. He is a terrible writer, and all the time he writes he seems to be going on, on, on, and your head swims and you say to yourself 'for goodness sake, stop' but you can't, you must hear this man out, you are like the people in the novel itself, you keep saying 'oh, I must go', and yet you do not go. No, you are certain that something is going to happen, and yet nothing does happen. But he is noble. Think, for instance, of Stepan Trofimovitch[267] in *The Possessed*, but Dostoevsky has added glory to the great tradition. I did not understand the Gospel so clearly as I did after reading him. Shakespeare also greatly opened my understanding of the Gospel.

All those old feelings I used to get about 'wasting my time' are passing away. I feel more and more convinced that when I return to my work I shall be fresh to it, and though I have done nothing for the last 16 months I have improved in my work more than if I had actually been at my work all the time. That is my belief.

I am quite happy in the 66th and I was quite happy in the 68th, in fact everywhere I go I am well cared for and meet good fellows. I often think it would be interesting to get together all my best chums since the war began. A good half the number would be drunk.

I'll tell you about the big artillery man who was delightful in his descriptions, and the way he would make an Indian native

266 Horace Walpole (1717–1797), Whig politician, historian and man of letters.

267 Liberal idealist and philosopher, one of the main characters in Dostoevsky's novel.

understand what he wanted. If it was chicken he wanted, he would shut one eye and hitch one leg up and make out she was on a rafter. He said that you would see a long row of men all imitating different animals: snorting would not be sufficient for the native, he would have to 'bore' like a pig to make himself understood.

I am quite well now, and happy, and you must believe what I say. I did not give you my hospital address because I could not. The censorship orders I am complying with, that is why I tell you nothing, and absolutely nothing you will hear from me. I should have thought that your common sense would have shown you why my letters are so newsless.

Thank you for all your letters. When I got to the part of the history of Binny and Joe, where they hear of the German note to America, I had to laugh aloud, and old Revelly, a great big, kind-hearted, genial man laughed and said 'ah, he made him laugh'.

You ought to hear the wild geese out here. They fly over us night and day and it is mysterious to hear them in the night. I was once looking to the horizon at the little clouds, and I suddenly noticed one do a sort of serpentine dive, and then it would roll itself up and then out again, then disappear altogether and then appear stronger than ever. This was not a cloud, but a huge number of starlings, which you see in great solid masses that would nearly cover Widbrook Common. These masses you can see miles and miles away, and when they disappear, as I said above, is when they alter the direction of their flight, so that the light on their bodies and wings is the same tone as the cloud behind.

I was very pleased to hear that Mrs Raverat was looking so well. Tell Jacques Raverat to write to me. Tell him I am happy and well.

Love to J.M.I.
From your ever loving brother
Stanley

* * *

In March 1917 Stanley suffered another bout of malaria and was sent to the 5th Canadian Hospital. Also suffering from bronchitis, it was several weeks before he was well enough to return to his duties.

12 March 1917
RAMC, 66th Field Ambulance, Salonica

Dear Jacques and Gwen

I am longing to have a letter from you. Had it not been for my sister Florence I should have known nothing about you having a child.

When we are up line we see nothing, only mules and men, no women. We shall eventually get to sing in the ambling sing-song monotonous way the Greeks do. You can imagine under the circumstances what great pleasure it gives me to hear this bit of news about you.

I am now in the 66th Field Ambulance. Why they transferred me from the 68th I cannot say. All I know is that when I looked on my card prior to leaving the base to return to my unit I noticed 66 instead of 68 written on it. It was too late to see if by chance it was a mistake, so off I went, and I have been so well treated that I have no particular desire to return to the 68th –though I do not like leaving the CO of that ambulance.

I have to go 'sick again' with a very bad cough and waking up several mornings and discovering big clots of blood on my pillow, which came from the back of my nose. I used to nearly choke at night. And of course just my luck, in spite of my pleading, down the line I go again and here I am in hospital again, and do not know if ever I shall be sent back to that ambulance again, though I shall try to get back to the 66th. It has rather knocked the heart out of me. There were such nice men in our tent. There were two big men, one named Tilly was somehow most lovable. He was a time-serving man. He was a 'Kentish man', next to him slept 'a man of Kent', a very different thing, as the man of Kent frequently pointed out to Pte Tilly. Our gags in the tent were in a quiet conversation to interrupt with 'well, don't argue', and when we were all snuggling into bed, 'I think we'll get on very well together my lads'.

The other big man was also a regular. His name was Reveley and he was the great pal of Tilly and he was a very big, red-faced man with rather wild, but kind, eyes and he used to wake me up at reveille and give me a hot cup of cocoa, which he made himself and got from the canteen. 'Now then Stan, drink this drop of how do ye do' – and it was a relief to have it. He was a Cockney and one of those with a big heart, and there are a number of those.

I love talking to such men; they talk about their 'missuses' and children. It's rather great sometimes. I can somehow picture them in the bosom of their family. After the war I shall try to hunt up some of the men I have met out here. Many have said that after the war they hoped I should visit them.

I had a letter from home three days ago enclosing four photos of Cookham. One was of lambs in a huddled enclosure in the corner of the small meadows. The photo is a clear one, and the sheep are quite near the camera so that you can see them eating the young turnip tops. One is thinking he has got a fly in his ear and has lifted his back leg to give it a tap, but he looks sort of doubtful as to whether he will or not. I feel sure I know some of these lambs, but I won't interrupt them as they are all very busy eating. If they are the sheep Mrs Assner introduced us to ('us' being me, Sydney, Gilbert and Percy), then they will have been mutton two years ago.

My sister or parents do not know I am in hospital again, so say nothing to them about it. I did not tell them as it is only trivial, the mucous membrane of the nostril was congested. But it is all so 'aggravating', as Gil always used to say.

There is one thing that pleased me. In this good hospital I found two Tom Hardy's: *The Mayor of Casterbridge* and *The Trumpet Major*. I love it where Bob Loveday walks up and down with his lieutenant's clothes on, having just got his commission after his return from HMS *Victory*, and having got hitched up with a girl in the port where for a few days he stayed before his return to his parents and to his first love. The first love, Miss Garland, is disgusted and naturally won't have anything to do with him. But she can't help seeing him from the window and after a while she doesn't try, looking at him first from behind the curtain, then not from behind the curtain, then she would lean out of the window and watch him and answer his salutation. I did not laugh while I was reading the

book because I took everything so seriously, and I felt very deeply for Miss Garland. When it leaked out that Bob Loveday had been courting a girl, when Miss Garland began to 'come round' again to him, well I finished the book and put it down with disgust. If such a ridiculously conscientious girl could change her sentiments so quickly what would an unconscientious one do?

I am being discharged from this hospital tomorrow and I expect to be kept at the base as usual for some days and then sent back to the good old ambulance.

I will write again soon and hope you will write and tell me how you think things are going on (nationally).

I know that your child's name is Elisabeth, my sister told me.

Much love from
Cookham

* * *

March 1917
RAMC, 66th Field Ambulance, Salonica

Dear Flongy

Your letters come regularly, and a boon it is to have them. I am now out of hospital and waiting at the base to go back to my unit, and I shall not be sorry when I am 'back home' again, back to the unit.

I have been a little ill with a fever that Horace contacted in India, that is what kept me in hospital such a time, but I am alright now, in fact I feel in the pink. Send me some dry eatables such as 'Nice' biscuits or any good sweet biscuit, but not ginger nuts. Do not send many as they might go west.

A Sister in our ward is very sweet, and though quite young, was like a mother to us all. It used to make me die to see a good-hearted artillery man having a slight argument with this Sister. He was tall, about 37, with goodness knows how many years' service in India. He has the most magnificent walk in a man I have ever seen. Full of grace, as is his nature. To see him up against her was very amusing. He laughed hard afterwards. 'Poor little beggar', he said, 'if I had

thought that I might have hurt her feelings I wouldn't have said a word.' As it is, he managed to make her see his point without any recourse to drastic measures, or, as Jacques says, 'without recourse to the one and only argument with woman, that is, the poker!'

I will close now and will write again soon, Flongy dear.

From your loving brother
Stanley

Much love to J.M.I. and thank him for the little message. And I look for these messages whenever I hear from you. The socks are just what I wanted. All who see them covet them. One pair was so much coveted by a wee Jock who wears kilties that after much arguing and haranguing I agreed to change for a pair of new grey Army socks. I only did this because Jock wanted to look 'posh', so the brown socks are now being worn by the most gallant little Scotchman, who has been through many wars in France.

* * *

Having eventually been discharged from the 5th Canadian Hospital, Stanley was once again posted to a new unit, this time the 143rd Field Ambulance. This was an eight-day journey away at Todorova, just behind the front line.

I tried my magic in the 143rd Field Ambulance. When on final arrival at Todorova, about 40 or 50 km from Salonica, I was given the job of painting the letters indicating men's and Sergeant's latrines, I felt that hopeful slackening. I made a big letter S for Sergeant's and painted some dog roses round it.

I can remember three portrait drawings I did, one in this place of a man in the cookhouse and two at a camp we went to from there. I have none of these drawings, having given them to these men. At the time I did not wish to part with them but I felt uncomfortable refusing any request for them. It is a pity now, when I would like to have them before me and others also, to see what I would say of them. But I want to talk of these drawings as I shall want and need to talk of a great many things which I shall not be able to reproduce.

As it sloped down to a shallow stream, the hillside on which our camp was at Todorova broke off into a few escarpments, the last one immediately by these shallows being a convenient height to stand one's glass on as one shaved. This stream was sometimes nearly dry, then if a storm came there would be about a quarter of an hour's pause and all at once a roar would come from the hills and the stream would be a fast rushing one about two feet deep. At this time basins formed by rocks further up in the hills would fill and we would bathe in them: they would be deep enough to dive into. At these times I and the cookhouse man and others betook ourselves to such places and tested depths and diving possibilities. I can remember this man so clearly, yet I did not know him at all. Whether becoming a soldier made everybody just that and nothing other, I don't know. The cookhouse here was close into the dark, shadowy side of one of these small cliffs, and I used to like when I was on night patrol to sit and chat to him. He seemed not over-friendly, but nice in a way, and rather critical. I expect he was really quite a person. But at that time I seemed not to have the inclination to discover personality and I was rightly not wishing to ask who and what a man was in peacetime. I couldn't even say whether he was a scientist or a gardener, or both. I can remember his idiosyncrasies as I might of a horse. But those things – his diving his long lengths into a small basin of rock and not knocking against anything, and the place where I went to see him – were all one thing which had more meaning for me.

Anyway, there is when I think of these three head drawings a wish to express something of the meaning of the occasions of doing these drawings. It is that I came across these different 'me selves', a whole something to which all myself comes, each time manifesting a different me. God had a unique way of doing this, by making man in his own image and thus seeing himself over and over again. Self or an image is meaning: a cow and a horse each have a different meaning, both clear. And so God sees himself also in a number of varied images.

* * *

25 March 1917
RAMC, 143rd Field Ambulance, Salonica

Dear Flongy

I have been down to Salonica in hospital again, though only for a trivial thing. I had bronchitis, but it was more really nasal catarrh. I am out again now, and after a day at the base was drafted into the 143rd Field Ambulance. That is three ambulances I have been in.

The flowers are out. The primrose, violet, celandine, and many other flowers unknown to me. I passed by such wonderful ones today. It is getting dark and I have no candles and want this letter to go tonight, so goodbye, Flongy dear.

Your loving brother
Stanley

If you send me anything send some currant biscuits or bread and butter. We get bread and you get butter sometimes but you know what a boy I am for bread and butter, and it is better to send that than these eternal tinned stuffs. Send me some of your own home-made bread, Flongy dear, and I will love you forever.

* * *

27 March 1917
RAMC, 143rd Field Ambulance, Salonica

Dear Flongy

I am no longer in the 68th or 66th Field Ambulance, so note my new address. Simply alter number of Field Ambulance to 143rd; the remainder of the address is the same. I was sorry to lose the CO of the 68th and I was getting on well in the 66th. If you think you can afford it could you send me some eatables of some kind? Those tinned cakes in airtight tins. Send me one of those little 6d Gowans & Gray books of masterpieces of art. Send me Raphael.

You must not think that I ask for eatables because I am not

getting enough food. On the contrary, I am getting good rations, as we all are, but I get so ravenously hungry up in these hills that I could eat a hayrick. It is being out of doors so much. And about books, it is impossible to get them here. A field ambulance is not like the hospital, where you can buy books etc. Robert Louis Stevenson is a man whose writings I love.

I do not know if any parcels containing eatables have been sent to me, if so, none have ever arrived. With the exception of the wonderful 'daily news' Christmas pudding, which I never got, and would like to know why, I do not think anything in that line has been sent to me ever since I left England on 22 August last.

With much love from your ever loving
Stan

* * *

Undated
143rd Field Ambulance, Salonica

The Mass companion, Keats, Blake, Coriolanus, Michelangelo, Velázquez, Claude, Early Flemish Painters, drawing book, box of chocolate.

Dear Desmond

I was feeling rather homesick the other day so I wrote the enclosed. I do not feel like writing now but reading. All the books came today. Yesterday I came to that bit in *Paradise Lost* where Sin and Death are making the broad way from Earth to Hell: 'Death with his mace petrific, cold and dry'.[268]

I feel relieved that your operation is over. I used to love yet hate going to operations. I am going to do something about the sea. My love for home and my love for the sea seem both to stimulate my thoughts. Well, I must read, with much love to you Desmond and thanks.

Your loving friend
Stanley

268 *Paradise Lost*, Book X, line 294.

* * *

A letter from Stanley Spencer, published by Eric Gill in The Game *in 1919.*[269]

Lent 1917
Salonica

I am walking across Cookham Moor in an easterly direction towards Cookham Village, it is about half past 3 on a Tuesday afternoon and I have just seen mama to the station. Walking up on to the causeway between the white posts placed at the eastern end, is Dorothy Bailey; how much Dorothy you belong to the Marsh meadows, and the old village. I love your curiosity & simplicity, domestic Dorothy. I can now hear the anvil going in Mr. Lanes Blacksmith shop, situated on the right of the street, & at the top of it, as I walk towards it. The shop is over shadowed by a clump of pollarded elms which stand just outside the old red bricked wall which is built around Mr. Wallers house. Appearing above the elms & part way between them & a Ceda tree which rises from the garden enclosure formed by the wall, are Mr. Wallers malt houses with their slate roofs & heavenly white wooden cowls: the work of the cooper; I love to think of that. Everything is so dull, the sun shines, the sky is blue, out there is an occasional young girl with some wreath which she is taking to her mothers grave. She has a pair of new shoes on, all shiny black. So unhappening, uncircumstantial & ordinary. The girl is going to the new Cookham Cemetery built halfway along the lonely road leading from Cookham to Maidenhead. Mama is safely packed off to Maidenhead & now I can let the bath-chair swerve all over the causeway and go where it likes while I enjoy the eternal happiness of this life irresponsible. And now as I enter the village I hear the homely sound of the Doxology, which the children of the 'back lane' school are singing. The 'back-lane' cuts at right angles across the top end of the village, and being semicircular in shape it appears again at the bottom of the village. The sound of the children's voices as they come teeming along the lane; prisoners set free; comes across the top end of the street & hits the Thames side of the street causing echo upon echo which getting in between the maltings become scary

269 Verbatim transcription, as published in Paul Gough (ed.), *Your Loving Friend, Stanley* (2011), pp. 106–13.

and hollow. I am now walking down the street. Mr. Tuck's milk cart is standing outside his shop having just returned from one of its rounds. The ice is being taken under the arch by the side of Mr. Caughts butchers shop, it is being dragged along the ground by a big king of pair of callipers. He has an awful yet fascinating way of clutching this ice. I enter our house, close the front door and look down the passage. At the further end the door leading into the kitchen stands wide open and the kitchen is flooded with sunlight. The plates and dishes on the tall dresser, in serried ranks along the shelves arranged, one plate overlapping the other glisten sparkling bright in the sunlight. The shadow of the maid shifts about over different parts of the crockery as she buises about getting tea. I go into the dining room, the cloth is laid & I sit down to the piano & look at my Bach Book. Tea at length comes in and I sit down and take 3 pieces of bread & butter and a big cup of tea. Then I have some more. Then I get up and look out of the dining room window down our garden to the bottom of it where rises a big Walnut tree which spreads out over our garden and over the gardens on either side of us and over a big orchard at the bottom of the garden but I am more particularly looking at the yew tree which is framed by the Walnut tree, forming the background. This fir tree has many apatures, openings etc which greatly excites my imagination. They all seem holy and secret. I remember how happy I felt when one afternoon I went up to Mrs. Shergolds and drew her little girl. After I had finished I went into the kitchen which was just another as our own (only their kitchen table and chairs are thicker and whiter) with Mrs. Shergold and Cecily. I nearly ran home after that visit, I felt I could paint a picture and that feeling quickened my steps. This visit made me happy because it induced me to produce something which would make me walk with God. 'And Enoch walked with God and was not.'[270] To return to the dining room I remain looking out of the big window at the Yew tree and the Walnut tree which nearly fill the space of the window, and then turning to Sydney ask him to play or rather try to play some of the Preludes. He does so, and though haltingly, yet with true understanding. And now for 2 or 3 hours of meditation. I go upstairs to my room and sit down to the table by the window and think about the resurrection then I get my big bible out, and read the Book of Tobit; while the gentle

270 Genesis 5:24.

evening breeze coming through the open window slightly lifts heavy the pages.

I will go for a walk through Cookham Church yard I will walk along the path which runs under the hedge I do so and pause to look at a tombstone which rises out of the midst of a small privet hedge which grows over the grave and is railed round with iron railings. A little to the right is a simple mound, guarded at either end by two small firs both are upright and elliptical in shape. I return to our house and put it down on paper. I think still more hopefully about the resurrection. I go to supper not over satisfied with the evenings thought, but know that tomorrow will see the light, tomorrow 'in my flesh I shall see God'.[271] And so I go to sup: Mama is home from Maidenhead, where her business has been chiefly in making bargins at 6½d. Bazarrs and in nearly getting run over. There are cherries for supper cherries and custard. It is dusk and the cherries are black I have a good gossip with Mama or anyone good enough to give me some gossip. Then I go out and walk up to Annie Slacks[272] shop and sit in the shop and watch the customers. After the great doings of night are over and the shops closed I have just one deliberate walk round by the 'Crown Hotel' down the Berries road along the footpath to the riverside then along by the river through Bellrope meadow to the Lethbridges garden end of the meadow and then I stand still and the river moves on in a solid mass; not ripple. I return the Berries Road way to the village and when I come to that part of the road where you can look across to the backs of the houses running down the north side of the street I stop again. Then I return home and go straight up to bed having Crime and Punishment under my arm and a candle which would last a life time. I get into bed and after reading for about 2 or 3 hours I blow out the candle, and whisper a word to myself 'Tomorrow' I say and fall asleep. I do not ever remember the exact moment of waking up any more than I know the moment when sleep comes.

But although the moment of waking is not known; yet the moment when you become aware that it is morning; when you say 'its morning' is the most wide awake moment of the day; I lay on the bed and look out of the open window across the road to Oveys Farm, then I turn my eyes to the room and let them rest on the wall paper which is covered with small roses. The reflection in the

271 Job 19:26.

272 Annie Slack was a cousin. She appears by her shop in *Sarah Tubb and the Heavenly Visitors*, 1933 (Stanley Spencer Gallery). Gil wrote that her shop was the talking centre of the village.

western sky of the sun rising in the east, casts a delicate rosy bloom onto this part of the wall. How everything seems fresh and to belong definitely to the morning. The chest of drawers now is not anything like the chest of drawers of last night.

The front of our house is still in shadow and casting shadows across the road but the Farm house opposite with its long red tiled roof is receiving the full blessing of the Dawn. The white doves are circleing round and round the farm yard: now over the barn, now casting shadows slanting up the side of the roof of the old farm house now rising up, and nearer and nearer, now they are over our house I can hear their wings going. A slight breeze comes in through the window. Annon they appear a little off to the left and slanting downwards. Then they rise a little to the farm roof and then 'banking' a little, they alight on it and bask in the sun.

The sun has now just reached the street and the shadow of passing veichels sweeps slowly across the ceiling. I hear a rumbling cart coming. It is coming round by Mr Llewellens house. I hear the stones scrunching under the wheels, it's the mail cart. I know when it reaches the Bell Hotel because the scrunching of the stones suddenly ceases and you now only hear the plop plop of the horses hoofs, and a muffeled rumble of the wheels. I hear Mr. Johnsons little boy call 'Harry, Harry!' down below in the street, and annon I hear his scuttering feet across the gravel as he runs past our house. Our back iron gate swings open and hits the iveyed wall out of which it is built, with a bang: then quick steps up the passage, then the sound of the milk can opening and of the jug drawn off the window cill. After fully enjoying the thought of all the varied and wonderful thoughts I am going to have during the day I get up & go & look out of the window Mr. Francis the baker is returning from doughing he is white all over with flour. He has long hair white with flour, and a white meek face. I go and call Gil in the little bedroom. Out of the window which looks towards the west is Elizer Sandalls garden. Then Elizer walks down the ash path, she lowers the prop holding up the cloths line and begins hanging cloths on stretching her skinny arms to do so, the rooks are flying overhead; they are going over to Mr. Lamberts Rookeries. I go down stairs, and takeing a towel I strole into the street. I walk down to the bottom of the street and call a friend, we all go down to Odney Wier for a bathe and swim.

My friend has an Airedale terrier, a fine dog with magnificent head neck and shoulders. He jumps leaps and bounds about in the dewy grass. I feel fresh awake and alive; that is the time for visitations. We swim and look at the bank over the rushes I swim right in the pathway of sunlight I go home to breakfast thinking as I go of the beautiful wholeness of the day. During the morning I am visited and walk about being in that visitation. How at this time everything seems more definite and to put on a new meaning and freshness you never before noticed. In the afternoon I set my work out and begin the picture. I leave off at dusk feeling delighted with the spiritual labour I have done.

<center>* * *</center>

14 March 1917

Dear Jacques & Gwen

I forgot in my letter to tell you I have not got a Shakespeare. I left it behind as I had too much to carry. I have just copied out nearly the whole of *Lycidas*[273] to take with me to the base.

> … return Sicilian muse
> And call the vales & bid them hither cast
> Their bells & flowerets of a thousand hues
> Ye valleys low where the milde whispers use,
> Of shades, and wanton winds & gushing brooks
> On whose fresh lap the swart-star sparely looks
> Throw hither all your quaint enamelled eyes
> That on the green turf suck the honeyed showers
> And purple all the ground with vernal flowers
> Bring the rathe primrose that forsaken dies
> The tufted crow-toe, & pale jessamine
> The white pink & the pansy freak'd with jet
> The glowing violet.
> The musk-rose, & the well attir'd woodbine
> With cowslips wan that hang the pensive head
> And every flower that sad embroidery wears;

273 *1637 poem by John Milton.*

I do not know the names of many flowers and it is a pity. What is the 'swart-star' and 'rathe' primrose or 'tufted crow-toe'? But isn't it great:

Throw hither all your quaint enamelled eyes

Doesn't it give you an awful feeling when he says

Where thou perhaps under the whelming tide
Visitest the bottom of the monstrous world

Could you write me out some of Milton? When I read him I rest myself upon him. I could no more think of 'giving my opinion' of Milton than I could of St John. If you liked you could make little drawings of the flowers I have mentioned. Your letters will reach me alright and I should love to recognise these flowers.

Go to base tomorrow at 8.

Cookham

* * *

Easter Sunday, 8 April 1917
YMCA Salonica Forces

Dear Desmond

I received your letter on Monday last. I have been shifting from one Ambulance to another, so my address has been altering all the time. My present address will be a reliable one.

Having just washed some clothes in the stream, I feel more able to write. It is very hot in the daytime, which rather takes the guts out of one. I read the Psalm: 119th in our book. I had a beautiful little Bible and when I looked in my valise for it on returning from the base, it was gone. So now I have no Bible, only a Testament. *The Garden of the Soul,*[274] which you gave me, I gave to a very earnest Catholic in exchange for a soldier's edition of the Ordinary of Mass. I gave it to this man because I felt that he had more right

274 Richard Challoner's 'Manual of spiritual exercises for Christians who (living in the world) aspire to devotion' was published in 1775.

to it than I had. He lent me a book called *Catholic Belief* and though it was only just an uninspired 'explanation' of the Catholic Belief, it led me to understand a great deal. What you say about the Protestants is true. But I do not look upon the Protestant belief as an existing thing at all, and therefore out of the argument. I think that what my friend Jacques Raverat said about the Protestant is true: that they are 'mean, unforgiving, hate the poor to get drunk, and think soap is a virtue'. I quote this because it is so deeply true. That is what the Protestant has become, because he has, as you say, lost the personal idea of God, and only because of that. But the Protestant will be forgiven because he is ignorant. For instance, if he once realised the awful necessity of understanding that Christ said 'I am', and not 'in me is the Way', he could not remain in his ignorant former 'belief'.

I did miss my hot cross bun. I did not have one last year. You cannot imagine how home appeals to me now. When we were at home we used to sit round the dining room table and each one of us had a big hot cross bun for breakfast.

Remember me to your mother. Any news of the friends you have introduced me to would delight me. How are Miss Krauss, Miss Pierce, Miss Smith, the Misses Daniell, Mrs D. and Mrs Press?

In my bedroom at home, when I woke up I used to look out of the open window across to the farmhouse opposite. I simply had to sit up and look in front of me, and the long red roof of the farm (Ovey's Farm) with the lovely white pigeons basking in the early morning sun would be right in front of me. All at once, up rise the pigeons off the roof and begin to circle round and round, they rise as they get to our villa and go over our roof part way and then sweep down again (I can hear their wings going) and appear in my view a little before they check their flight before alighting on the farm roof. I used to watch these pigeons when I was about six years old when – if I was not well – I used to sleep between my Mother and Father, who then slept in my room. You can imagine what lovely feelings I must have had as those doves rose up over our roof. I would get up and lean out of the window and look across to a clump of trees a little to the right and behind the farm roof, and through the trees I could just see the clock of Cookham Church (partly Norman): 7.30.

I go downstairs and up the passage, open the front door and out into the street. I go for a bathe. The sun catches the water; a long, sparkling shaft of light. I swim in the shaft of light. I saunter back home to breakfast across Odney Common (once thought to be called the Isle of Odin) and as I walk I think of what joy is before me: a whole day. I was longing for the day the night before, because 'I am going to do "that"', I would say; and when I do it, it seems veritably to make the day a 'whole' day. A day full of prayer, and so definite and clear, you can divide the prayer into parts, one part actually in the stone or on canvas, or in me when at tea time I look out of the dining room window at our yew tree and the walnut tree framing it.

(My address: No 100066, Pte S. Spencer, 143rd Field Ambulance, Salonica Forces.)

Your loving friend
Stanley

I am longing for a book of some sort. It does not matter much about the size. I should like anything like biscuits or cake or chocolate, or anything except gingerbread or seed cake. I don't like that.

<p style="text-align:center">❖ ❖ ❖</p>

27 April 1917

Dear Flongy

Day before yesterday I received the book. I tore the parcel open and discovered the name John Milton. I thanked you most for the book at that moment. By that post came also from Jacques and Gwen Raverat *Lavengro*[275] and Marlowe's plays. It nearly laid me out.

At the beginning of Milton there is a short bit of poetry and these lines are perfect I think.

Thou sing'st with so much gravity and ease,
And above human flight dost soar aloft,
With plume so strong, so equal, and so soft:

275 *Lavengro: The Scholar, the Gypsy, the Priest* by George Henry Borrow (1803–1881) was published in 1851.

Marvell is more perfect than a flower, I think. Doesn't it make you feel proud when you think of belonging to a nation that has produced such beings?

From King David and through a letter from Desmond Chute I have this wonderful passage out of the Psalms. This is what Chute says: 'work must be meditation. How David knew: the Psalms are everyone's prayers but next to the saint, the artist's above all: "I have loved thy commandments above gold and Topaz!"'

I had another letter from Mrs Raverat and she says a lot about 'Elisabeth' and she has sent me a photo of her and herself which she says might do well for a Mellin's food advert. I quite believe her: at the same time it might come in 'andy for a 'Virgin and Child'.

✳ ✳ ✳

8 May 1917

Dear Flongy

Thank you again for the Milton and Shakespeare. I think that getting the Milton was the more wonderful experience of the two, though Shakespeare means more to me. I was just ready for Milton. I am absolutely satisfied now, thanks to you, Flongy dear. I can live on what I have now for years and years. I am reading *The Winter's Tale* and have just read the part where Autolycus sings:

Autolycus: Get you hence, for I must go where it fits not you to know.
Dorcas: Whither?
Mopsa: O, whither?
Dorcas: Whither?[276]

I have had a very nice letter from Gil. He says he gets letters regularly from home, that he has had a new edition of *Pickwick Papers* and thinks they are 'absolutely rich'.

He says, 'tomorrow is taking place one of the most enjoyable of all events, we are having a kit inspection, one of those delightful occasions when the orderly sergeant loses his left lung shouting out

276 Shakespeare, *The Winter's Tale*, Act IV, scene iv.

the different articles we are accused of having'. I love that 'accused of having'.

I am seeing the CO about Gil's transfer, as this is the first time that I have been settled enough to risk getting Gil transferred. I get such awful aches to see my dear Gilbertry once more. His letter was absolutely sweet, but rather pathetic. He can't get anything to draw except cookhouses and sheds, but these he says are very interesting and I agree.

I think your article in *Punch* is by far the most humorous thing I have read in *Punch* of that nature. When Binny and Joe look at each other over their cup on hearing Devonport's latest. I can just see that look.

> Well, dear Flongy dear, good night.
> From your loving brother
> Stanley

I watched ants shifting camp the other day. It is most wonderful to see. The bally marvel to me is that they never collided with each other.

<p style="text-align:center">✳ ✳ ✳</p>

12 May 1917

Dear Flongy

On Tuesday I saw the CO about Gil's transfer and today (Saturday) he told me what to do. He said that Gil must make an application to his present CO and ask him to transfer Gil to Salonica, and then when Gil is in Salonica I was to inform him (the CO of the 143rd) and he would see what he could do.

Sunday 13th
I have just had your letter of 14 April all about 'Hengy the Henker' Sydney.[277] Bless his heart, how I would love to see him! I would love to have a letter from him but I've not written to him, so I suppose I cannot expect it.

277 Sydney Spencer (brother).

I did nothing but talk about the sea, I feel still that I do not want to talk about anything else. I think after the war I shall be a sailor. I used to feel, when looking over the side of the ship at the sea that I could live forever doing so. To suddenly see a narrow, crinkly strip of gold in the distance and say to yourself 'that's land' and then you get a little nearer you can just see a row of sailing boats, all with their pure white sails moving along the coast in even procession. Such a feeling of peace it gives you.

* * *

13 May 1917
RAMC, 143rd Field Ambulance, Salonica

Dear Jacques and Gwen

On Tuesday I saw our CO about Gil's transfer. The Colonel told me the only way it could be done would be for Gil to apply to his CO. He thinks there will be difficulty in transferring Gil from Egyptian forces to Salonica forces. I told him that Gil had already been in Salonica and that that might make a difference.

The weather is simply wonderful here. We only had a little snow in February and there were hot days then and from March until now it has been practically all sunshine. Great storm clouds are nearly always on the mountains, but they seem to hang there all day and cast great shadows from the side of the mountain, and where there is one big flat cloud which puts the whole range in shadow it is like a cave.

But oh, I long for the sea. I feel when I am inland a good way as if I cannot breathe. This feeling I have had since my journey out here. I would just like to be one of those little boys who do all sorts of odd jobs. I loved it when the ship suddenly stops or the siren goes deep and long, and the flag flaps about the masts. The whole world seems to be 'held up'. The words in Cowper's hymn 'On Africk's Coral Strand'[278] have always given Gil and me a very 'foreign' feeling – and Africa is – oh I don't know what it is, but it moves me. I could live for ever leaning over the side of the ship and looking down to its shores.

278 This was actually by Reginald Heber (1783–1826), and the lines referred to are:

From Greenland's icy mountains,
From India's coral strand,
Where Afric's sunny fountains
Roll down their golden sand;

I like the photograph very much. I should like to hear from you again, Jacques.

Love to you both from
Cookham

Thank you for all you have sent. Desmond Chute read me from the Greek six books of Homer's *Odyssey* and I forget how much of the *Iliad*. He also read some of the grandest parts in Greek to give me an idea of what it sounded like and it sounded like the sea…

* * *

19 May

Dear Flongy

I have just received your letter in which you are so annoyed that I have not received any of the things you have sent me, but by now you will know that I have received everything. That is: Milton, Shakespeare, one tin of biscuits, and letters by the hundred, and in a few days time will come the Dickens and the bread, etc. Everything will come in time but it will take time.

Today we all determined to behave like pigs and eat and eat and eat, just out of spite for the days we were unable to get canteen stuff. My esteemed comrade 'Twister' said he would eat till he was like this, and he described half a circle, the fattest half, with his hand. I do not pine for anything now that I have got Shakespeare. He beats the best bread ever baked.

I cannot write just now, as I'm simply gorging the historical plays, but I must write this:

Enter STEPHANO, singing, a bottle in his hand.
Stephano: I shall know more to sea, to sea,
Here shall I lie ashore–
This is a very scurvy thing to sing at man's funeral.
Well, here's my comfort.
(drinks)

The master, the swabber, the boatswain and I
The gunner and his mate,
Lov'd Mall, Meg and Marion and Margery
But none of us cared for Kate,
For she had a tongue with a tang,
Would cry to a sailor 'Go hang'
She loved not the savour of tar nor of pitch,
Yet a tailor might scratch her where'er she did itch.
Then to sea, boys, and let her go hang.[279]

About three quarters of an hour ago a heavy storm was hanging over one of the points. It swept away and we got none of it. Just now as I was writing, I heard the sound of many waters, a distant roar, and the roaring got nearer and nearer, so I went down to the stream, and lo, it was quietly running over the stones between the rocks, just in a tomorrow-will-do sort of way. But oh, there was such an 'orrible surprise in store for it, for up the stream a little and over great pieces of rock, came blustering on in great leaps and bounds the water.

It goes at terrific speed as it is falling, falling, falling. It is great fun to watch.

Your ever loving brother
Stanley

✢ ✢ ✢

21 May 1917
RAMC, 143rd Field Ambulance, Salonica

Dear Flongy

The parcel from you containing *Pickwick Papers*, *Bleak House*, a drawing book, two pencils, two pairs of socks, a Bible and a piece of India rubber has just arrived.

It is so beautiful how in Shakespeare's historical plays chivalry gives birth to chivalry. Just as God in the natural flesh has given us natural desires for the means of perpetrating life, so in the spiritual

279 Shakespeare, *The Tempest*, Act II, scene ii.

world He has given us spiritual desires, to uphold and keep alive for ever His glorious traditions.

I think that those nobles of the early Henrys did well in placing their allegiance to their king before their own honour. Had they not done so all would have been purposeless and chaotic. By this sinking of their own honour, sank also any petty individuality (ugh, how I hate that word), all bloody 'personality', but instead was created a great being: great through his acts, and the light proceeding from which, we'll add great beams through all the regions of eternity. Today I read about Lord Talbot and his son John Talbot. I will send this off, Flongy dear, thank you darling for the presents.

Your loving brother
Stanley

Cry God for Harry! England and St George![280] This is how I have been feeling all day long. Oh! I wish I was a 'ero.

* * *

24 May 1917
RAMC, 143rd Field Ambulance, Salonica

Dear Flongy

Thank you for your letters – two: one yesterday, and three days ago. I have yet to receive the bread and butter.

A few nights ago I saw a firefly. Its flight is rather like the flight of the fieldfare. Every time it drops in its swooping flight the light goes out or dull, and flames bright as it goes upwards. It makes you believe in fairies. Yesterday we laid a snare for a hare. So far I have seen a hare in every part of this country I have been. Tonight I was returning from a swim and I looked up in a tree. I saw in the top branches a big nest. Globular shaped and about the size of a melon, and made of clayey earth and sticks and little stones. So I got up and had a look in and saw them. From their appearance I guessed that they had not been expecting me. They were two young magpies. They had carefully selected vine branches – which climb all over

280 Shakespeare, *Henry V*, Act III, scene i.

the trees – for means of support of the nest. I gathered some garden roses today, and picked a pomegranate blossom. There are many pomegranate trees out here.

25 May
Have just received the bread, biscuits, butter and Raphael.[281] All are alright, except the bread which is napoo. But we have plenty now, and we are better off than you. Thank you especially for the Raphael.

* * *

2 June 1917

Dear Jacques and Gwen

Thank you very much for your letter, Gwen, which came yesterday. It was dated May 8th. I have received the biscuits, Marlowe and Borrow's *Lavengro*, which I have already acknowledged twice. It seems to me my letters are going west. I am expecting the Milton etc. today. My sister sent me a complete Shakespeare about a month ago and I have been through the historical plays. I read the lot as they came in their order, and I am glad I did as there is such a wonderful continuity about them. Except Henry VIII, which seems to be written at a different period. I feel as if Henry VIII was an earlier play.

I love it how Shakespeare takes great solid chunks of confused time and gives it form, as for instance the Wars of the Roses. It's like a Bach fugue, isn't it?

I told you in a previous letter about my having seen the CO about Gil's transfer to this, 143rd Field Ambulance. The CO, on hearing that Gil's transferring back to Salonica, will do what he can, but Gil must first get to Salonica before he can do anything. I have written and told Gil this.

Gil's address is 36th Stationary Hospital, Egyptian Expeditionary Force, Egypt.

This morning I tried to catch one of those rock snakes but there were too many leaves about. One stone hit him and he hissed terribly. They are the commonest kind of snake there is out here, I think.

281 A Gowans & Gray pocket book.

We are living right on the top of the world. Have you ever seen the firefly? I saw one the other day. We caught a tiger moth this morning. This fly is a terror: he digs his spike right into you. The fly has that loathsome way of flopping onto you that that sleepy big fly in England has, which you find on walls in bad latrines.

I will get this letter off now as man is about to collect them. So I will write again soon.

With love from
Cookham

* * *

7 June 1917
RAMC, 143rd Field Ambulance, Salonica

Dear Flongy

Thank you for your letter of May 10th, which I have just received. It is a mystery that you have not got any of my letters acknowledging parcels from you. I have thanked you in about four letters now. That was beautiful butter you sent. It had no nasty tinny feeling about it. In fact, you could shut your eyes while you ate it and imagine you were in 'Blighty'. If you send me a tin of that butter, that is all I shall need, as I have as many books as I can carry and I have Shakespeare.

It must be rather a heavy expense when there are so many of us to send parcels to, but I am making a remittance to father and I will direct him to send £1 or so to you, to be used for the purpose of sending me butter only. It is rubbish for anybody to say that they could afford to send us parcels as you do, so you won't be offended at my suggesting this, will you, Flongy dear?

I just now had a new pair of shorts and in the pocket was a short and loving letter from a young miss. The love was for her brother and the 'God blesses' for me, so now I am writing to you in a blessed state.

The other day I was having a rest after working in the sun, and I was thinking and thinking, and pursuing this exercise in much the same sort of way that our brother in distress, the tortoise, does (I say

'in distress' because a tortoise is so distressful, he always is trying to do the most impossible things). Well, when I had got any think left I began reading Joshua. Goodness knows why!

Well, I saw the high priests and the mighty men of valour going round the walls of Jericho and blowing on their rams' horns, and then I heard the awful shout and the sound of the falling walls and buildings, and then I saw the men rushing in on every side, massacring man, woman and child. Well, I thought, this all seems very nice, but something very nearly stopped me from getting to this 'very nice' part. It was the part where God commands Joshua to detail one man out of each tribe to carry a stone from out of the centre of Jordan where the priests' feet stood firm, and to take them to where he would lodge that night. Oh, if God is going to begin 'detailing parties', I'll be a 'un. Can't you just picture a swarthy son of a tribe of Israel writing to his girl, 'darling Zip, sorry, nothing doing, clicked for fatigues. Love Reube'.

I think this is beautiful:

> And it came to pass, when the people removed from their tents, to pass over Jordan, and the priests bearing the ark of the covenant before the people;
>
> And as they that bare the ark were come unto Jordan, and the feet of the priests that bare the ark were dipped in the brim of the water (for Jordan overfloweth all his banks all the time of harvest),
>
> That the waters which came down from above stood and rose up upon an heap very far from the city Adam, that is beside Zaretan: and those that came down towards the sea of the plain, even the salt sea, failed, and were cut off: and the people were passed over right against Jericho.
>
> And the priests that bare the ark of the covenant of the Lord stood firm on dry ground in the midst of Jordan, and all the Israelites passed over on dry ground, until all the people were passed clean over Jordan.[282]

I saw a photograph yesterday of Miss Lillah McCarthy,[283] and I think she is definitely made for comedy, and particularly Shakespeare's comedies. I only met her once and I did not observe

282 Joshua 3:14–17.

283 Lillah McCarthy (1875–1960), actress, appeared in many plays by George Bernard Shaw; also in plays by such contemporaries as J.M. Barrie & John Masefield.

her particularly, though I observed her hat, I could not help it. She makes me think of Claude and Giorgione. Or she makes me feel the romance of the life of Lorenzo de Medici, the Magnificent. I do not much care if she is not that, so that she makes me feel that. What a sentence! Love to J.M.I.

From your ever loving brother
Stanley

* * *

10 June 1917
RAMC, 143rd Field Ambulance, Salonica

Dear Flongy dear

Here comes yet another letter to you.

I have sent several letters to you but not one seems yet to have arrived. Yesterday I was going for a bathe and I was walking under some trees and imagining I was walking along the Row. It did not look unlike a park, except that it was all overgrown. It turned out to be a churchyard, or rather a place where the Turkish Macedonians bury their 'dedders': they put brushwood round the newly made graves, and extra special 'dedders' have tombstones – very oriental and wicked.

It looks just as you might imagine old Bible characters to look: to go through a village and see the labourer returning from his labours in the fields, you think of that part of Kings, the boy in the field crying to his father, 'My head, my head!'.[284] All that about Elijah and Elisha I think is so intimate and natural. And as really inspired utterances come so suddenly upon you, their dramatic effect is intensified. It's made me go all shivery when I came to where Elisha cried 'My father, my father! The chariots of Israel and the horseman thereof. And he saw him no more'.[285]

12 June
Well, I have just done some washing. A shirt is an awkward article to

284 2 Kings 4:19.
285 2 Kings 2:12.

wash. I wash mine by sections, this is how I do it. First I tell them off by sections, giving them the order 'section number!' I do this to make sure that all the sections are there. This is how the old Greek women do their washing. The rain comes down in torrents, the woman works like one possessed all out in the rain the mud splashing up all round her. The drainage of water is insufficient to keep the water from the fire, so the woman gets the spade and digs the trench deeper while the man stands majestic, contemplative, a far distant look in his eye.

I have had a letter from Gil and he describes the 'glories of Egypt' to me.

Your loving brother

Stanley
My love to J.M.I.

Scrubbing Clothes, oil on canvas, 1919
(Fitzwilliam Museum, Cambridge)

✳ ✳ ✳

15 July 1917

RAMC
143rd Field Ambulance
Salonica

Dear Jacques and Gwen

I have just received your most welcome letter. Your two pictures are beautiful I think. I think a picture is beautiful when the painter knows their thing. When the painter has known the power of his visitation and I think you have in your two pictures. They make me want to paint.

I think your ideas have a fine unity one to the other, like the several parts of a great architectural altar.

I do not know what I shall do when I get home. I shall feel overwhelmed. I am going to paint the sea. I want to paint the western sea looking from a ship in the Bay of Biscay and I want to have some green islands in the distant south-west.

I bought a *Canterbury Tales* with me but it has no glossary and it is impossible to read him without, so that with the exception of the Prologue, the Knight's Tale, the Prioress's Tale, and a few others, I have read none of it.[286] I still have your Marlowe and *Lavengro*.

I will write again soon, but I have a lot of Blake and Keats I want to read and there is not any time. I think Blake's songs are as perfect as anything can be. I love reading 'Gwin, King of Norway'. 'The Book of Thel' is beautiful, but I do not understand the end of it.

16 July

I long for a peaceful English sunny afternoon, for a walk across the causeway from the station to home; to see the rooks flying across the street from Mr Lambert's rookery to Hedsor woods; to hear the echoing of the children's voices as they come teeming along the back lane, to hear the kitchen door open to see May Wooster, with stiff white apron and rosy face, to hear her cutting the bread for tea, to hear the clock ticking on the high mantelpiece. Next to the clock,

286 Geoffrey Chaucer (1342–1400) wrote his *Canterbury Tales* between 1387 and 1400, in Middle English.

and in the centre of the mantelpiece, is the copper kettle; it lives for one purpose, the same as I do – he lives to shine.

But though I do long for home, yet I am far from blind to anything beautiful I feel. The sea has set me free, it has had a wonderful spiritual effect upon me.

With much love from
Cookham

* * *

17 July 1917
On active service
RAMC, 143rd Field Ambulance, Salonica

Dear Henry

I hear that you have sent a letter home to be forwarded to me. I also hear from men in this ambulance that your ambulance is in this country. So I conclude that you must be somewhere near me. I got your photograph and have it with me. I have these books with me: Chaucer, Shakespeare, Blake, Keats, Milton, Borrow (*Lavengro*), Dickens (*Bleak House*, *Pickwick Papers*), Marlowe, Bible. High art is represented by Giotto (Ruskin's), Donatello (Hope Rea's), and the following Gowans & Grays: Giotto, Fra Angelico, Basilica de Assisi (the one you gave me), Carpaccio, Giorgione, Michelangelo, Gozzoli, Raphael, Claude, Velázquez, Early Flemish Painters, and I think that's the lot. When it is possible, several chaps offer to carry one or two each. Please write and let me know if this reaches you.

With much love from
Cookham

Have you heard anything of Japp yet?

* * *

17 July 1917

Dear Flongy dear

I know it is very naughty of me not to write to you more often than I do, but writing letters under these circumstances is a very dull occupation. I only write of home, not so much because I am homesick, but because I am free to say what I please then, and because it gives me most pleasure.

I am doing something very interesting. I am reading Keats and Blake at the same time. Can anything be more scathing then Blake's epigrams on the artists of his time? I wish he had been alive today. Fuseli[287] is the only man he speaks well of, and I am quite ignorant of this man:

> The only man that e'er I knew
> Who did not make me almost spue
> Was Fuseli: he was both Turk and Jew,
> And so, dear Christian friends, how do you do?[288]

Don't you think Blake's lyrics such as 'My silks and fine array',[289] and 'How sweet I roamed from field to field' are comparable with Shakespeare's? Yet the man who wrote 'When the voices of children are heard on the green'[290] was, according to such men as Flaxman, a madman. I love Keats more than Blake, but I think Blake is an infinitely greater man than Keats. Blake is free. Everything comes from Blake, with apparently no effort, clear and pure as the light of God. But Keats is only at times inspired. As Jacques Raverat said of me, so I say of Keats: 'he interfered with the Holy Ghost'. Blake had perfect faith, which accounts for the ease one feels in reading Blake. There is not this ease with Keats. Desmond Chute showed me how very bad was Keats's metre. He read me out some Milton and then some Keats written in the same metre. And I came to the conclusion that Blake did not strictly adhere to the several forms he used simply because the 'visualisation' said nothing about his doing so, whereas Keats could not write in the Miltonion metre if he tried, because he had no visitation. Keats was a perfectly good man, but he did not realise the importance of always knowing the time of his visitation.

287 Painter Henry Fuseli (1741–1825) was a close contemporary of the poet and artist William Blake (1757–1827).

288 Blake, 'On Friends and Foes', from his *Notebook c.*1808–11.

289 Blake, 'Song: My silks and fine array', and 'Song: How sweet I roam'd from field to field', *Poetical Sketches*, 1783.

290 From Blake's 'Nurse's Song', *Songs of Innocence and Experience*, 1794.

His faith was shaky and that is why I do not feel as happy when I read Keats as I do when I read Blake. But I cannot read Blake for long. He is like Bach, rather overpowering. I have been living with that most gracious and benign comforter, John Milton.

The silver birches out here are particularly beautiful. I saw some beauties the other day. I am quite well.

Love to you both
Stanley

* * *

18 July 1917

I have had a nice letter from Eddie Marsh, bless him.

Dear Jacques and Gwen

I feel rather ashamed when I get a letter from you picturing me as a poor ill boy when I am living the life of a very lazy healthy youth, very likely getting more food than you are getting, and certainly making a little pig of himself on canteen's stuff.

Your letter catches me red-handed, having chocolate in one hand, and a tin of condensed milk in the other. This rather takes the colour off things but it's sadly true. I no sooner get paid than I seek to burst it.

If you ever go out bonfiring when I come to stay with you, I will have you secretly dispatched; no, when I come you will have to have your meals in good Victorian style. If you don't, I will do what my Mama does when Papa makes unfortunate remarks about the mutton: I will have my meals alone.

I do not understand the E. Bronte you have written and yet I think it is very fine. Can you explain at all what the fragment written 13 May 1843 means? I don't suppose you could if you did understand it. I think many most beautiful poems, which I am quite capable of understanding, will not ever be understood by me, just simply because of my muddle-headedness and slowness. When I see anything I see everything and when I cannot see one thing, I can see absolutely nothing. I am reading Blake and Keats. How much I thought of home when you mentioned that dear old picture of mine.

I love to dwell on the thought that the artist is next in order of divinity to the Saint. He, like the Saint, performs miracles and also, like the Saint, he has – and a friend of mine quoted these words of the Psalms – 'Loved Thy Commandments'.[291]

I will write again soon.

I am quite well, with love from
Cookham

I am sure I should like Mr Vaughan Williams[292] from what I heard of him from a man in his Ambulance. But I don't know where he is or in what ambulance.

* * *

18 July 1917

Dear Henry

Are you doing any painting or drawing? I have done a lot of drawings of heads; some are exciting when I have really felt something definite but there is something I can't get that is exasperating. Does not this country have rather a melancholy effect upon you? The sound of the Dardanelles has an awful fascination for me. When I was in the Gen. Hosp. in England we used to have mostly wounded and sick from the Dardanelles, and each patient had the same wonderful and majestic look in his face. It might have been my imagination but it does not make any difference if it was. I have got all sorts of 'feelings' to be made into solid matter when I return. But I think of the sea most of all, and Africa.

During the last three months I have read all the historical plays. Really read Marlowe's *Edward II* and *Jew of Malta*, Milton's *Paradise Lost* and others of his, re-read *Romeo and Juliet*. *The Winter's Tale*, *Love's Labour's Lost*, *All's Well That Ends Well*, occasionally dissipating myself on such a wasteful, destructive stuff like Borrow's *Lavengro*. It's good and amusing of its kind, and that is the most bloody thing I can say about anything bad.

291 Psalm 119:127.

292 Gwen Raverat's second cousin, the composer Ralph Vaughan Williams (1872–1958). See also p. 247.

I am reading Keats and Blake together. I think Blake is a great poet but he makes me long for Marvell and Donatello.

I like this in Proverbs 30, verses 18–19:

There be three things which are too wonderful for me
Yea four which I know not:
the way of an Eagle in the air;
the way of a serpent upon a rock;
the way of a ship in the midst of the sea;
and, the way of a man with a maid.

There is something remote and secret about Andrew Marvell.[293] I think Claude is very great. God knows why Turner should have his name coupled with such a great magnificent man. It would be most odious blasphemy to imagine Claude painting 'Rain, Wind and Steam'.[294] Claude excites worship, not admiration, in me.

Some time ago (about 2 months) I had a strong desire to do a series of drawings of heads of Irish men. Sort of like a theme with variations but I did not get the chance of carrying it out. The Irish give me a solid feeling, the same as Dardanelles men do. I think I am going to do something marvellous in a portrait.

If there is any possible chance of my seeing or getting with you, do what you can to arrange it; though myself I cannot see how it can be done. My address is now No. 100066 Pte S. Spencer, RAMC, 143rd Field Ambulance, BSF, Salonica.

Don't you just ache for Gluck, Mozart and Bach and Beethoven? A friend of mine named Chute played me great books of Italian music written years and years before Palestrina. He also played me a lot out of the Gluck operas; you remember you did not get the chance of letting me hear much of Gluck up at Hampstead.

I had a great time at Bristol owing to Desmond Chute, who used to get hold of mysterious ancient books of British composers, and used to translate from a lot of early French writers. He translated a lot from the *Confessions* of St Augustine, and if I can I am going to get him to translate a lot of these *Confessions* as they have wonderful meaning to me. Chute is very keen on Walter Pater,[295] and what he has read to me has made deep and lasting impression on me. Of *Marius the Epicurian* Chute has read nearly a whole volume

293 Andrew Marvell (1621–1678), English metaphysical poet.

294 J.M.W. Turner, *Rain, Steam and Speed*, 1844 (National Gallery).

295 Walter Pater (1839–1894) English essayist, critic and humanist whose 'art for art's sake' was at the heart of the Aesthetic movement.

to me. The marvel is that he very often does not have a book before him. His compositions and drawings of heads have a wonderful atmosphere which seems to surround them.

I think Raphael would have been a greater artist if he had kept to pagan subjects and not ecclesiastical ones: *The Council of Gods* and *The Triumph of Galatea* are the only things of his which move me in any way.

I feel very ready and in good form for painting a picture, and yet I have been feeling like this ever since I came out here. Brother Gil is in Egypt and hates being there.

❖ ❖ ❖

Undated
143rd Field Ambulance, Salonica

Dear Desmond

Please remember me to your Aunt Sybil.

I do not think I can get Gil with me.

I have to acknowledge three letters from you in this but I will write properly when I feel more patient.

I have a complete Shakespeare and Milton now. Isn't this wonderful, out of Proverbs? I forget if I reminded you of it in my last letter.

> There be three things which are too wonderful for me
> Yea four which I know not:
> the way of an Eagle in the air;
> the way of a serpent upon a rock;
> the way of a ship in the midst of the sea;
> and, the way of a man with a maid.[296]

I think that last the way of a man with a maid, coming as it does after the other three, is most beautiful.

❖ ❖ ❖

20 July 1917
Salonica Forces

Dear Henry

I have just received your letter dated 25th May. You must be quite near me. I am now in the 143rd Field Ambulance Salonica forces, my number is 100066. If you can find out where this ambulance lies, and if you have a noble charger, you might be able to get to me to see me. I think it would be to exasperating to think of you and I being perhaps so near and yet not quite getting a glimpse of one another.

The day before yesterday I sent a letter to you with your correct address on it. I think about the money, you had better 'hold it over' until later on, perhaps until after the war. You are a Private in the Army. I feel quite wealthy and am able to send home an occasional remittance of £5, and I think my parents can get along quite well with the monies sent to them by my many brothers, who are all in the Army, therefore all wealthy.

Just to spite anything that would cause me to rot away out here, I defy the blight and bloody, empty, gutless opaqueness that would possess me. I am a thousand times more determined to do something a thousand times greater than anything I have done before when I get home, and am storing up energy all the time. And would you believe that after I had more or less got over the horrible feelings I had when I was in the 68th – feelings which I got over about 3 months after I came out here – I began to feel not exactly happy, but somehow something put something tranquil into me. I felt I would remain quiet for years and years. I no longer feel that most awful mental torture, that empty void, that awful and fierce wanting, and yet nothing to hand to satisfy. In the cookhouse of the 68th were some nice iron wedges and on the hill were some big pieces of rock. I thought I would sit astride one of them and carve and carve and never stop. I did get some small and rather soft pieces of rock and cut heads out with a knife. But oh, how bitterly wretched I felt. My brain felt like a tin of marmalade that has been opened and fallen over and got full of flies and sand.

When I was in the 68th I asked the CO who gives me grand feelings (that was the only reason why I went to him) if I could draw the hills and positions. He gave me plenty of material and told

me I could have a mule and go all over the place. There was a certain brigade near them and I knew that at the depots they were looking for draughtsmen, and I had faint hopes of our CO doing something for me in the direction of getting me a job as a draughtsman. But I think I am too much of a bloody artist, and of course I know nothing about an engineering draughtsman's job. He gave me all day to draw and told the staff that I was to be excused duties. But about 3 days after that I was unable to walk, owing to a big abscess on my leg, and I was 3 weeks with my leg bent. I had to go down the line as the ambulance was moving. I had malaria soon after entering hospital.

I have a fine collection of books now, and you would come miles to see them. I think after all it has been for my good that I am in the RAMC and not infantry. I should never I think have been strong enough for that, though I can't help feeling that men who are always in the thick of the fighting in France must in spite of the continual strain find life more tolerable. What poor Gil must be going through in the desert land of Egypt I cannot imagine. It hurts my head to think of it. I think the Dardanelles campaign must have been wonderful. Gilbert's address is No. 22360 Pte G. Spencer, 36 Stationary Hospital B, Egyptian E,F.

With much love from
Cookham

* * *

July 1917

Dear Flongy dear

I think in your letter dated 17th June you have expressed my sentiments. I don't want to go about killing dragons, but I want to kill one dragon like the knight does in *Faerie Queene*.[297] You know, with a nice sedate 'ladie' with a great long train standing by, having perfect confidence in the good knight's valour.

Although the war seems so horrible, yet it is nice to know that some valour as was shown in King Arthur's most valorous knights has been seen in George Wallace, who used to clean our boots.

297 Edmund Spenser's epic romance, published in two instalments in 1590 and 1596.

I had a nice letter from Eddie Marsh. He is now in the colonial office. He is doing another 'Georgian Poetry' book. But I think he is too ready to recognise a man as a poet. However, it is better to have someone ready to publish almost anything, as Eddie seems to be, as there are plenty of critics about, writing like hungry wolves for their prey.

Its rather funny: you know yesterday I wrote in a letter to you that I thought I should be alright for money as I felt sure Lamb would have money for me. Well, yesterday in a letter I had from him, he says he has £35 for me, only does not want to risk sending it on crossed cheque. I have told him to keep it until I really need it. According to the place where Lamb says he is, I must be quite near him: isn't it exasperating? He is a captain in the 5th Inniskilling Fusiliers. He wishes he had gone in the gunners with Darsie Japp, whom he says has been decorated but he does not know where he is. Japp is a remarkably sociable fellow but has a rotten way of quite suddenly giving the world the slip. He disappears from everybody. He is generally found to be in some unfrequented province of Spain. Oh, for another walk with him and Gil across the Buckinghamshire hills, and for a good feed on poached eggs on toast in some inn round about Fingest and Turville, famed for good old Marlow ales!

Japp says, his eyes looking across at me over his mug, 'just think, Cookham, tonight I shall be having a pigeon pie at the Carlton'.

He was the dearest man in the world, was Japp. I do hope he is alright. Lamb says he is a magnificent rider, and I myself believe that he knows all that is to be known about horses. I used to love going with him to the saddlers and walking behind him up and down Tite Street and along the Chelsea Embankment while he laid about him with a great long tandem whip, swishing and swashing at every dog he met. The joy of going about with Japp was that he knew who everybody was. 'See that gent in the top hat? That's 'Old Moore'.

David Sassoon,[298] who used to take me all over London in his spare time, told me such startling things that I came to the conclusion that I was being misled and that David was a stranger to the truth. He had a particular spite against some of the wealthy jewellers in Tottenham Court Road; they were so slimy and such swindlers. He would go into one of these shops and carelessly ask to see one of the most valuable cases and open the case and look at the articles as if they were dirt: of course the manager would smell something Sassoony in

298 Artist David Sassoon (1888–1978) was a contemporary of Spencer's at the Slade.

the air and left David to do as he pleased (though had he known that David had a comparatively small allowance, he would have behaved differently). Sassoon, after having a good look around with such a sly smile on his face, would bid the manager good day without making a purchase; after torturing the manager in this way until he thought he had teased enough, he would go in and make a handsome purchase. Oh no! Though David was a Jew, he was a generous Jew.

> Will write again soon.
> Love to you and J.M.I.
> Stanley

Had a nice long letter, one from Jacques and one from Gwen. Henry Lamb seems as fed up with this country as I am and expects to go down with malaria.

<p align="center">* * *</p>

30 July 1917

Dear Flongy dear

I will write you a nice jolly letter with a *Balkan News* over my knees to keep the flies off them, and the delightful headlines greeting my view. I will never believe that Russia is anything but perhaps the greatest nation in the world. My hope is that the mischief-making English papers will not start to say ignorant things against Russia, as it is their delight to do so on such occasions as these. I do not know if you have read Dostoevsky, but if you have you will realise what a wonderful country she is and see how impossible it would be for the English to understand and realise the cause which is giving rise to such apparently extraordinary behaviour. I know that Papa hates the Russians, the result of the bygone days when England fought for the Devil.

Yesterday I finished 'Endymion'. In the poem 'To Charles Cowden Clarke' came those lines:[299]

> But many days have passed since last my heart
> Was warmed luxuriously by divine Mozart

299 Poems by John Keats, written in 1818 and 1816 respectively.

Not long before I 'joined up' I spent some time with Henry Lamb, up in his room on Hampstead Heath, listening to practically nothing but Mozart.

We are losing the CO of our section. It will be hard to find another one as good.

In Keats's poem 'Teignmouth', taken from a letter to Reynolds,[300] came these lines:

You know the Enchanted Castle – it doth stand
Upon a rock, on the border of a lake,
Nested in trees, which all do seem to shake
From some old magic, like Urganda's sword.
O Phoebus! That I had thy sacred word
To show this Castle in fair dreaming wise
Unto my friend, while sick and ill he lies!

He then goes on to describe it and gives its history, but before I read further I read a small extract from the same letter prefixed to the poem which says, 'you know I am sure Claude's "Enchanted Castle", and I wish you may be pleased with my remembrance of it'. I pause for a moment, then simply put my head out and pick up a small book: Open it, and lo, there before my eyes is Claude's *Enchanted Castle*. If I had been reminded of some very old friend and then had seen him coming uphill towards this bivouac, I could not have been more pleased than I was when I actually saw the *Enchanted Castle*. Yes John Keats, I was very pleased with your remembrance of it.

I have not had any letter from Capt. Lamb yet, perhaps he is down the line, but it would be hardly time to hear from him yet. Somehow Keats reminds me of Lamb. Keats was a surgeon, but could not stand it and forsook it for poetry. Lamb was a surgeon and threw it all up for painting. Keats, who rarely seems to mention anything about music, finds it in the muse to mention Mozart: half of Lamb's life relies on Mozart. Both lived at Hampstead. But this is rather funny: the mouth of John Keats, as it is in a photograph I have seen of John Keats' death mask, and Henry Lamb's mouth are almost identical; at any rate, they give me the same feeling.

Much love to you both from Stanley

300 Keats's close friend John Hamilton Reynolds; this letter was written on 25 March 1818.

Could you kindly forward the enclosed letter to Will, as I have lost his address?

<p style="text-align:center">✳ ✳ ✳</p>

30 July 1917

Dear Will and Johanna

I am looking forward to the time when I shall once more be hearing you play some of the 48 Preludes and Fugues which you used to play to us just after breakfast. They used to give me such a desire to paint a great picture. That is just what all great music or great pictures make me feel. If I ever do anything great through the inspiration of these preludes, then I shall know that God is carrying on this beautiful tradition. I like to think of one miracle sowing seeds of other miracles to come, and great works are surely miracles, for they have the essence of eternal life in them. I look upon the words of the Gospels as the first 'works of art' pronounced by the Giver of that life, by which means a work of art can only live. But the words of the Gospel were 'In the Beginning'[301] and the spirit of those words is in Pagan Art.

Since I have been out here I have dreaded the awful empty silence and, just as if some divine being has seen my fear, he has intensified my memory and has caused me to hear four or five of the Preludes so clearly that I have instinctively stood still to listen. There is one which Sydney used to play just before I went to Somersetshire to stay with a retired farmer. I shall always have the atmosphere it then created in me, with me.

I feel when I return home I shall be fresh for work.

From a letter I have received from Capt Henry Lamb, in which he names the place in which he is stationed, I conclude I must be quite near him. It will be very nice if we can manage to meet. I have received a book of Keats's poems, and Blake's poems. Also some of Gowan & Gray art books – Velázquez. I think Francesco Goya and El Greco are both far greater than Velázquez. Raphael, I think, was greater when he was painting such works as his *Triumph of Galatea*[302] then when he was painting madonnas.

301 John 1:1.

302 Raphael's fresco in the Villa Farnesina, Rome, was completed *c.*1514.

Yesterday I drew the head of an Asiatic man. It was nearly as exciting as Columbus discovering America.

＊ ＊ ＊

Undated

Dear Flongy dear

Thank you so much for the R.L. Stevenson books. I think *The Wrecker* is far beyond *The Master of Ballantrae*.[303] There is a man here who tells me about the sea, mostly about the South Seas. He told me last night about the waterspout, how that if a ship happened to strike one, the spout will immediately break and fall bang onto the ship, and the report of the fall would be heard for miles and miles.

I have both written to and seen Henry Lamb. He is hoping if he should go to Egypt, he might come across Gil.

When I was in the 68th I used to work and bivouac with a little chap named George Dando. He was the first boy I drew out here. There was something shiningly innocent in the way he looked at anyone, and wonderfully fearless. He has been wounded in the elbow, and I believe he will get to England. He and I built a perfect little home for ourselves, we even had a fireplace and a 'chimbley', out of the top of which the smoke gaily soared into the 'helements' above.

Fried iron ration biscuits (when the biscuits have been soaked in water for about 268 hours) are delicious.

With love to you and J.M.I.
Loving brother, Stan

Give my love to Perce when you see him.

＊ ＊ ＊

303 Robert Louis Stevenson (1850–1894) published his adventure story *The Wrecker* in 1892 and *The Master of Ballantrae* in 1889.

30 September 1917

Dear Flongy dear

I feel it is a long time since I wrote to you. The butter was delicious, fresh and solid. Two Welsh boys who shared it with me winked approval. One of these Welsh boys went to Malta with 'rapid respiration' and a 'delighted heart', so he told us. I enjoyed the Stevensons: I think *The Wrecker* is beautifully written.

The glee songs, which Henry Lamb sent me, are being sung by a glee party which has been got together in this section. The photograph of you which you gave me, or rather sent me, the one in the case I mean, has been very nearly defaced by a terrific storm we had the other day, which nearly washed my house and belongings away. I was away at the time. Thank God for that. I started salvage operations when I got back next morning. In the words of the song,

> The scene was one I'll ne'er forget
> As long as I may live[304]

> Well, Flongy dear, I feel in a perfect state of preservation.
> I had a most tremendous washing day you ever saw. It lasted all day, right from rosy morn till dewy eve.

> Your ever loving brother
> Stanley

Could you send me another photo of yourself please?

<p align="center">✳ ✳</p>

October 1917

Dear Flongy dear

Thank you for your letter dated October 16th. I think what you said about the young cadets and the old men of the cloisters was very beautiful and true. I think the men from the Dardanelles have a wonderful 'look'.

304 From the chorus to 'The Volunteer Organist' by Henry Spaulding, 1893.

Captain Lamb sent me a book called *Suvla Bay and After*. It was written by a friend of his and it is full of that 'remoteness' feeling. He has also written one on the Struma Valley. When he speaks of the Annafardh Mountains, you seem to see them glaring down on our troops.

About two months ago I transferred into the Royal Berkshire Regiment, and it is very nice to be with Berkshire boys. If you address me thus: No. 100066 Pte Spencer, Royal Berks Regt, No. 3 Infantry Base Depot, British Salonica Forces – your letters will reach me alright. I am in training and I never felt so well or looked so well in all my life. Yesterday I had an amusing and pleasant experience. I went to the mess as usual for my cup of tea, and the man on duty at the door stopped me and said 'tea only'. Directly I heard him, I knew who it was. It was one of the old Bristol Lunatic Asylum attendants who used to give us the tea for the patients when I was orderly there. And would you believe it, I met about a dozen old BLA RAMC chums of mine. You remember a little fellow named Smith? You knew him when you were at All Saints. He has had both his legs blown off in France. You also knew that rather superior young fellow (but nice) who used to be in Smith's stationers? I met him yesterday. One of Gil's greatest Bristol pals named Bishop has been killed in France. He was a great big, rosy-faced, good-natured ex-policeman, a nursing orderly, and he used to make Gil and me roar. He always called Bishop Mr Bish-ch-h-bosh. He used to say it so drawlingly, which was very characteristic of the old Bishop's nature. This ex-policeman we called 'Chummy' had a gorgeous curl, not thus it was, but similar [drawing]

I'm living and moving and having my being in my book of Crashaw. Do not send any books now.

Your loving brother
Stan

* * *

12 February 1918

Dear Flongy dear

There is about a quarter of an inch of candle left to write a letter by. I have finished training and I'm waiting to go up the line.

written for [long] such a long time

instructor

me falling in at

I have had about forty letters from you during the last two months and I believe I have not answered one. I am quite well, have a rotten cold which I have had since October. But on the whole I am feeling it less than I did last winter. I had a very nice letter from Percy. I have received your photographs: one of you, head and shoulders; one of you in your garden; one of Mr J.M.I. on his sofa, looking very contemplative and happy; one from Percy of him stroking his men – dear old Blighty tree on the bank. The Christmas card was enclosed in today's letter. Thank you, Flongy dear I don't know what to say for not having written for such a long time. The candle is about to collapse.

Your loving brother
Stanley

* * *

12 February 1918

Dear Will

It was a great pleasure to me to receive your letter dated 4th January. Since I last wrote to you I've received the little book of Richard Crashaw, *Steps to the Temple; the Delights of the Muses*.[305] You remember that our dear old *Oxford Book of English Verse* contained examples of that great poet's works? This little book fits into my top left-hand pocket, which, next to the poetry, is the best part about it. Much better than the introduction, which is very biased. I wish I could be with you to be able to discuss the big and subtle differences between Milton and Crashaw. Although I have had to leave a lot of my 'heavenly armour' behind in the ambulance unit I was last with, yet I am still well armed with the above-mentioned poets and Shakespeare. My breastplate is a series of reproductions of Donatello's statues of St John the Baptist and St Mark and St George. Milton is the 'glittering spear'.[306] The day before yesterday I read *Comus*.[307] It is a pity that people try to think of it as a drama. It could not have been written as a poem and it has no dramatic force, but I think for all that it is one of his sublimest and greatest works, and quite justifies its existence in the form in which it is

305 Richard Crashaw (died 1649), Anglican cleric and Catholic convert, published his books of religious poetry in 1646 and 1648 respectively.

306 From Habakkuk's prayer, Habakkuk 3:11.

307 Milton's 'masque in honour of chastity' was first presented at Michaelmas, 1634, at a celebration in Ludlow Castle.

written. Crashaw's 'Hymn of the Church in meditation of the Day of Judgement' has two lines in the first verse which make me feel that Milton is very near in spirit to the Spirit of God. The verse goes:

> Hearest thou, my soul, what serious things
> Both the Psalms and Sybil sings,
> Of a sure Judge from whose sharp ray
> The world in the flames shall fly away?

Milton, I think, has something of that divine 'sureness' and also that 'sharp ray'. I have now left the Suf. training school (I left this morning) after three months of hard training, which was made very interesting. I expect soon to be sent to the battalion. I remember you said in one of your letters to me that you thought I would be glad to get back to my painting. Yes, am sorry to be checked from carrying out my greatest desire. But I feel as truly happy as ever I have felt; in fact happier. At last I am back up the line. It is much colder and the snow-covered mountains look a ghostly white in the moonlight. As I walked along the road I realised, as I do more and more, how God has given to the true artist his blessing. King David's Ark could not, I think, have been a more beautiful moving altar of praise than I was at the day before yesterday night. I think the one and only perfect joy is the joy of giving perfect praise, and although I was not able on the night I speak of, to give that living spirit of praise, a 'material body', yet it was every bit as clear in my mind.

I have the photograph of you and Johanna standing outside your house in Hergiswil.

* * *

I think the censor has an almost stimulating effect when after the censor is lifted one can describe a place and experience. At this distance of just on thirty years I can still feel how glad I am to be able to express what I felt in those places.

GOING UP THE LINE

After his transfer to the Royal Berkshires, Stanley became a Private, and so was no longer a medical orderly. Hence his four months of training, his reply to the question as to whether he had done any bombing practice and his writing of their taking two bombs each from a box (p. 300). His comments to the Raverats (p. 302) and his vivid account of ten days at the front in 1918 (pp. 325–41) reinforce the fact that he was now a soldier.

I cannot remember clearly but I think I was about two months or more in the line before this eight or nine days march began. When I first went up the line in my new position as a Private in the 7th Battalion, the Royal Berkshires, I went with one other man only. I felt rather strange as this man had had a lot of war experience, having been wounded and returned for duty. I was also worried at the darkness, the extreme roughness and the awful speed this man walked at. I was terrified of losing sight of him, as everything else in front of me seemed to be a whole mass of chaos and he the only fixed star to takes one's bearings by. At last we heard behind us some limbers coming along, forging their way through blackness and, like my man, seeming to know every inch of it.

The man said: 'Look here; these are the rations coming up; we'd better keep up with them.' This meant that when they were passed, we had got to hold on to the back and keep up, as the mules were going it in good non-stop style, I thought, as I felt and dreaded the stitches in my side from having to hold my arm up over the backboard of the limber, 'How am I going to keep this up for miles and miles? But I must keep up', and the dread of being left behind tightened my grasp.

Sometimes the wretched drivers lashed the mules to a gallop and I just had to hang on. I often used to think how much better it was when some officer gave one help and instruction that was clear, and which, when you came to experiencing what you had been instructed to do, served as a help and guide. I will describe a case showing what I mean later.

At last the mules seemed themselves a little more puffed and slackened their speed a little, and we went silently forward, the riders

on the mules just discernible in the darkness looking spectral and awful. We were skirting round a road cut into a hillside, sweeping up to the right and sloping down from the road to the left to where the land turned and sloped more gradually up to the extreme left, when suddenly a long clear shaft of light began to veer round towards us over the crest of the hill on the right. The mules started as the drivers pulled them silently to a standstill. I watched the shadow of the right-hand crest of the hill, over which the searchlight was just skimming, being cast on and moving slowly as clean-cut shadow on the left slope below us. The brow of the hill on the right just – and only just – concealed us from view but did just pick out the drivers' heads upon the mules. When I looked at the shadow as it moved I was, I think, able to pick out the shapes of the drivers' tin helmets. I think one of the men said quietly: 'That's 535'. This rather impressed me as I had for months and months gazed across the plains and seen among other high hills one great elephant's back that culminated in a few little domes called 'the pips', and right on the end a bigger pip which was called '535', and which commanded, I think, Lake Doiran.

We then hurried on until once again it came sweeping round but again missed us, and I could see that further on it would miss us altogether. Then the limber wrenched itself around to the right of this hill so unceremoniously and began to descend into greater darkness still, and pulled up with a jerk so that I nearly jabbed my chin against it. The driver called out 'C Company', and out of the darkness and in a place I thought that, but for this limber and its drivers and the man with me, I would be alone in the world, at once surrounding the limber were men feverishly taking out the provisions, etc. My companion then said to me, 'Come on quickly, quickly', and started to climb what I could now see was the side of a steep hill. It sloped up directly from the left of this narrow track we had turned into. I felt very tired and could not at first understand hurry, but I thought this man is experienced and there is a cause for all this.

I could now discern the curious contour of the top of this hill, which was a row of very amusing-shaped dugouts and a sort of long tortoise-backed earthwork, which had inside it (as I saw afterwards) a trench to put your feet down in and sit and have your meal. I was now on M4 sector, which was what this hill was called, and it had

a character which is as clear in my mind to this day as I am myself. After being taken hurriedly to the Sergeant Major's dugout with the other man and answering the cold questions of the Sergeant Major, one of which to me was 'Have you done any bombing practice?', to which I said 'Yes', we were then dismissed. I rather wondered at the humble pretensions to knowledge of my man until I got outside, when he informed me that he thought I must be up the pole for admitting that I had done bombing. 'You don't want to be detailed off on a bombing raid, do you?' he said, or words to that effect. But I don't think to this day I could have said 'no' when a special part of my training for this period up the line had been bombing.

It seemed a little less dark as I went along and looked at the dugouts, all of which seemed different. I at last got to one I very much liked the feeling of and was about to occupy it when I was told it was condemned and I reluctantly had to leave it and go to one which I did not like nearly as much.

As the only contact with the Bulgars was during the night, I got the impression of them as beings which came from an essential and permanent night, and that each night we approached their dark abode as midnight drew near and as the morning came descended and came away from it. I never felt that they liked us and descended to their day as we descended to ours, but that somewhere further up in time, in a place more midnight than midnight, they were in some way still existing in my mind. Some nights it was extraordinary to me to hear the ground crunching under the wheels of some cart, when I was told it was the Bulgars' ration carts coming up, just as ours brought ours up. No looking-glass world was ever as intangible as that seemed to me.

It seemed to me a queer arrangement that our activities consisted of outpost duty and patrolling the wire at night and in the daytime just doing odd fatigues, just outside our dugouts. The line of trenches while I was there were not, as far as I could see, used at all. There were communicating trenches to them but the system seemed to be quite other than what might be supposed. When we went to our positions we formed up outside the dugouts in the evening, just before sunset, and walked along to the right past the entrances of them, taking two bombs each from a box as we did so. It was always suspected by the Bulgars as being the time to start a barrage, and

as I looked to the left on reaching the end of M4 sector I could see dimly the slanting slope of this hill as it spread into the plain we were walking.

The shells dropped uncomfortably near and I was glad when, for a further part of the nasty job of getting to the outposts, we were able to take cover in a communication trench. This continued not very far, however, and then we had to get out and go along what was called the Makikova track, which was just a faintly indicated foot-trodden track wandering along the left side or reach of a shallow-looking ravine full of undergrowth, which it was difficult to make out in the dark. This led to where the outposts were, which were little new moon-shaped ruts in the ground, some not more than 4ft deep, as it seemed to me. I was very glad to scramble into them.

One night, when shrapnel had begun before I had got to the outpost and was still on the Makikova track, I could not understand why the two men in front of me did not slip down into the gently sloping ravine on the right and walk along a little below such a high and exposed ridge. I thought, well I can't stand this, and started off boldly down into it. But I had not stepped more than a few yards before I found I was walking in a mass of barbed wire with which the entire ravine was matted. I managed to stop before I got too stuck, but I had to extricate myself very carefully and not get flustered. The feeling of being caught in every way was alarming. One of the men said something about 'You'll get yourself into trouble'. I can only relate those isolated incidents and feelings. I remember when in the outpost I gazed into the darkness into which the ground sloped slowly and very gradually downwards, taking at intervals into its confused appearance the lines of barbed wire.

* * *

Between October 1917 and February 1918

Dear Jacques and Gwen

I do not remember if I thanked you for the Dante and *Canterbury Tales*. I have been unable to read either. You sent me out Marlowe and *Lavengro*, also I have been transferred to the 7th Royal

Berkshires and I have wrapped those books which I could not carry in a sack and have left them with the ambulance in the hope that when I get to the unit (I am now at the base depot) to which I now belong I might be able to find some means of transport for them, and in that case write to the ambulance for them. I have in my pocket a little book of the English poems of Richard Crashaw 'Steps to the Temple' (and they are steps indeed) AND 'Delights of the Muses'.[308] I read these poems almost every day. Every time I read in it I feel I am being feasted. You could never imagine what these poems have done for me. I find I am much better able to understand what I read than I used to be.

You must not worry about my being now in the infantry as I think I did right in transferring. (notices were sent to all the ambulances asking men to volunteer for infantry) and beyond that too, I do my best; I do not care a rap what happens and you ought to follow my example and not care a rap either. I am at the base training now, and I expect I shall be here some time. There are two or three Royal Berks boys in the same tent as I am in, and very nice fellows they are too.

With my love from
Cookham

Try and reconcile my parents to what I have done; they will think it very wrong of me I fear.

<div align="center">* * *</div>

24 February 1918
7th Battalion Royal Berkshire Regiment, Salonica

Dear Flongy dear

At last I am back up the line. I get very fed up at the base. The weather is bad and fine about ten times a day. It snows and blows and blows and snows when it is bad.

The mountains look beautiful, covered with snow. It is rather funny, I am back on the precise bit of land that I was on when I was

308 Metaphysical poet and Catholic convert Richard Crashaw (1612–1649) published his anthology of sacred poems, *Steps to the Temple*, in 1646, and his secular *Delights of the Muses* in 1648.

in the ambulance a year and three months ago. My cold is a lot better and this winter I have not known what it was to even feel unwell.

In some ways I like the merciless wildness of this country. It makes one curse at times, but the cursing is a very fitting part of the 'wildness'. It's just like being in Purgatory. At such a time the tents look as if they fain would leave the earth and we fain would that they would not.

It is absolutely impossible for me to carry out any work of an ambitious nature under the present conditions, nor in the time I get for doing 'works of art' in this country. When I get into a nice, quiet place to myself I might attempt something, but I mean to wait until I get back to England before I think of carrying out any idea I have had since I have been out here. I would not have missed seeing the things I have seen since I left England for anything, but I do not want to touch any of these things until I can do so in the free time of civilian life. I could only do things out here in rather a slipshod way and that would be 'meddling with the Holy Ghost', as Jacques Raverat would say.

I enclose a letter for Will. Please, Flongy dear, send it on to Will for me.

My love to J.M.I.

Your loving brother
Stanley

I will write again soon. You may read the enclosed letter to Will if you like.

* * *

3 March 1918
No. 41812 'C' Company 7th Btn Roy. Berks Rgt Salonica forces
On active service

Dear James

I think, although I am out here about as isolated as anyone could be, that you must be having a far rottener time than I am. I have not written to parents or anybody for ages. I was at the base training

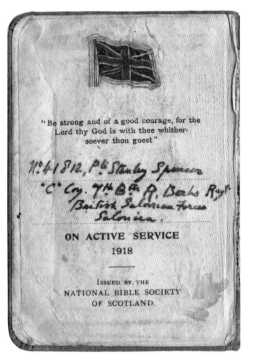

Private Stanley Spencer's Army issue Bible

(infantry) and it dried me up. But now I am up the line again, the sap of life has returned. I would far rather be out in the infantry than be working as an orderly in a gen. hosp. in England.

When I transferred I hoped to be sent to a certain part where I had been before, and where I wanted to be again, and here I am right in the very place. It has a very great spiritual significance to me. These mountains fill me with an eternal joy, which joy is created by the desire to give perfect praise. I think my period of 'service' is not a period of degeneration, but a period of being in the 'Refiner's fire'. I began to read Dante out here, but have now had to leave the book behind. I think when he is speaking about hemispheres and cones and light and things like that he gives one a feeling of the spiritual geometry of things.

I do not know what to think about the picture business. You know Lamb's address… I do not know if he intends to buy the cowl malthouse picture, but he has already made provision for the bed picture. The matter rests between you and him. I will write to him and ask him to let you have the malthouse pic, if you should write to him for it.

Could you send me out a sketchbook about the size of this sheet of paper (cartridge paper I like), some pencils also.

* * *

7 March 1918

Dear Flongy dear

This pencil is enough to keep anyone from writing.

I have not had any letters since I've been up the line but I think they will still be chasing about after me down at the base. They usually come in bunches when they come.

I think the worst of the winter is over now. Rich green grass shows itself under the dead, trodden-down grass of last year. Outside there is one solitary tree, a very 'Claude-esque' tree, and it is dotted all over with hundreds of starlings, all talking as hard as they can talk, which reminded me of 'ome.

The rain is drizzling down and it makes one feel in that sort of

mood that I used to get into in 'olden' days, when Gil and I would be in the nursery and the rain would be coming down and Agnes would be singing in a sing-songy voice

> Come in, you naughty birds
> The rain is pouring down

It is not an altogether soul-inspiring mood. Last Sunday a little Church of England padre came over and conducted a service under this tree. The rain came down but we carried on. I thought it was rather pathetic; he was so apologetic, and I am sure that we would have stood out in the rain till doomsday rather than shorten the service conducted by such a fine little man.

But do you know, Flongy dear, I hate the C. of E. I wish I had been born and baptised an R.C. I do not think a man can perform a pure act of faith through the Protestant religion. I deplore my ignorance of the Roman Catholic faith. You will generally find that the Protestant, when asked to give his ideas on the Roman faith, will almost always start expounding on its history, and a very superficial and biased knowledge he has of that. I do not think our Book of Common Prayer has any form; it is merely a collection of moral and highly philosophical thoughts and desires. But the Order of the Mass has a most perfect form: Office follows Office in perfect sequence, has its true relative position to its surroundings in the same way as a movement has in a Beethoven sonata.

To have certain Roman forms in our Common Prayer is to me every bit as ridiculous as if we were to take certain movements from a Beethoven sonata and were to insert them in a very bad modern composition by some loathly creeping Rosenbergstein.

The same 'unfitting' sense comes to me when I am attending a C. of E. service in one of our fine old churches, the feeling that this service has no relation to this architecture. Well, well, I am glad I was not born in the time of the 'Reformation' so-called – oh, the insolence of that word!

I know that owing to the subtle beauty of some of the R.C. traditions not being understood by many of the more ignorant R.C.s, many R.C.s had tendencies towards becoming superstitious; yet these things are unavoidable, since even the word of Christ has not yet been half understood.

I was recording an article in our U.C.L. magazine on the difference between education and instruction, which showed that instruction was in many ways enemy to education, that is, against the promotion of growth. In this way, I think of Christ as the heavenly educator. I make this remark because it has an important bearing on what I said on the other page.

I hope, dear Flongy dear, you will agree with my sentiments.

From your loving brother
Stanley

* * *

8 March 1918

Dear Flongy dear

I rather like these Greek churches; they have that sort of owlish creepy feeling about them, but I do not think they have much that is awe-inspiring or noble in them. I like the idea of the tower being built into the wall which goes round the church; standing like a Sentinel guarding it.

This morning I went a short journey with a man who was very entertaining in his conversation. He had the rare gift of 'summing up' the whole state of affairs in a few 'fitting' sentences, but before I treat you to these few fitting sentences I must tell you first about the man (this gives the true biographical touch). He has a stiff neck which causes him to hold his head on sideways a little. He has the true Buckinghamshire drawling way of talking. He's about 32 and very settled and complacent, which is refreshing in a way. He smokes a pipe in a way that makes me think that there could never have been a time in his life when he didn't smoke. Before he would answer any sentence of importance the index finger of his right hand would appear above the bowl of the pipe, bend forward and press the burning ash home. This would be followed by a few quick repeated draws, then a sigh, then 'you know, Spencer, this is a terrible war' uttered in that tone of voice as if he would say 'you know, if this war goes on much longer, it'll get serious'. This will be

followed with a sentence which only concerned himself. 'Per-son-ally I shall be glad when the whole thing's over. The worst-of-it-is it doesn't seem to show any sign of… etc'. Then, after a pause: 'what a ter-ri-ble-world we-live-in-to-be- shour.'

The funny thing is that he quite cheers everybody up, instead of making everybody miserable.

9 March

The sun has not shone all the week, and now this morning, although at first it showed no signs of shining and I was thinking that the washing I did this morning would never dry, it has suddenly come out and it won't take long now for them to dry. The sun is now very fierce, then directly it goes in again it becomes cold.

The starlings out here fly in wonderfully uniform ellipses.

Your loving brother
Stanley

* * *

18 March 1918
On active service

Dear Henry

Have you been able to get to see Gilbert?

I am at last back up the line after a weary time at the base from October till the end of last February, doing infantry training all the time. I am now back on the same ground as I was on when I was in the 68th Field Ambulance. When I transferred I hoped to get out to this front which I am now on. I feel so much more alive since I transferred. I am in the 7th Battalion Royal Berkshire Regiment and my number has been altered to No. 41812.

Jas Wood wrote to me a long time ago asking about the malthouse[309] and bed pictures.[310] I think he could have the malthouse picture, unless I promised it to you, but I do not remember. I believe that Wood's perception and his receptive powers are as clear and as unaffected as an intelligent child's. I think the enjoyment that you get from my pictures

309 *Mending Cowls, Cookham*: the study, c.1915 (private collection), was given by Stanley to Jas Wood in 1915; the larger painting of the same name was bought by J.L. Behrend in 1915. Presumably Stanley had forgotten (by his own admission) that he no longer had 'the malthouse picture'.

310 *The Centurion's Servant*, 1914 (Tate), bought by Henry Lamb in 1915.

is quite different from that which Wood would get.

I think it is wonderful how men are a part of the spirit just as the corner in the wall of the slope of the land is part of it. That is why I thought it was so right for you to like my bed picture. I do not think it would have been possible for Raverat to understand the big picture and I don't think he properly understands the John Donne picture[311] but Gwen Raverat does.

I enjoyed re-reading those parts out of *Paradise Lost* when Milton is describing the hellish Army.

> The imperial ensign; which, full high advanced,
> Shone like a meteor streaming to the wind.

And then later on:

> A forest huge of spears; and thronging helms
> Appear'd, and serried shields in thick array
> Of depth immeasurable

Can't you see that little pointed flame (the ensign) showing up against a background of dark mountains gaping with great gloomy crevasses?

With much love from
Stanley Spencer

<center>❋ ❋ ❋</center>

12 to 21 April 1918

Dear Flongy dear,

I am feeling very well indeed, having got rid of my coughing.

Isn't it sad about John Redmond?[312] I had an instinctive regard for him. I think it is wicked the way the government have procrastinated over the Irish business. To me it seems as insolent to suppose our government is capable of understanding Irish politics as it is to suppose it being capable of understanding Russian politics.

311 *John Donne arriving in Heaven*, 1911 (Fitzwilliam Museum, Cambridge).

312 John Redmond (1856–1918), Irish nationalist leader and conciliatory politician who oversaw the passing of the Home Rule Act in 1914. He died on 6 March 1918.

Well well, I don't know what the devil to talk about unless it is about that particular gentleman, and how he gave Battle in Heaven and how Abdiel, the faithful angel, gave him a great blow.

> Ten paces huge
> He back recoil'd; the tenth on bended knee
> His massy spear upstay'd.[313]

That's the sort of thing I live on, along with Army rations.

It is a hard job to write nice chatty letters. I don't feel exactly stale, but I can't keep ramming Milton down your neck. But to tell you the truth, the only thing I do is to dig, love God, read Milton, and go on the scrounge occasionally. When I come in in the evening I wash and brush up and then I sally forth from the tent, and I have a few pieces of cardboard and I do a little drawing on them, or else I contemplate the heavens and wax poetic. Of course, during the hours of labour the world is discussed, and kings and nations and 'principalities' and powers are cast down and set up like a lot of skittles. Tonight I finished the drawing of the Corporal, who is a very quiet young fellow, rather like C.S. though much gentler.

I began this letter about ten days ago, and before I received your letters which are very nice to have, Flongy dear, you wouldn't believe. The box of paints and biscuits and the sketchbook have all arrived undamaged.

I should like very much to make a very studious chronology of plants and leaves, not in the approved South Kensington art school method, but to make a solid painting of a square yard of the unshaven earth. Leaves, aren't they wonderful? I ask the gardener what they were for; he said 'to breathe with, only'. He said the leaf gives off oxygen and takes in carbon acid gas.[314] It adds to the beauty of a leaf to think of it as a 'lung'.

The storks fly around and I think of dear old Hans Christian Andersen. The dear little children in the village streets of Denmark crying to the storks:

> Stork! Stork! Fly away home,
> Your house is on fire and your children are gone.

Stanley's study of grape hyacinths, using paints sent to him by his sister Florence

313 Milton, *Paradise Lost*, Book VI, lines 193–5.

314 Carbon dioxide.

I had a lovely swim tonight in the lake and the young rich dark green weeds growing up among last year's reeds now dead and pink were so luminous, you could not define the blades.

The poppies are out.

Your loving brother
Stanley

* * *

22 April 1918

Dear Jacques and Gwen

Your letter was very nice; thank you for it. I would give anything to see little Eliz running about on the green grass. We never see children except when we are at the base and then they are Greek children and I don't like them; they are knavish.

The storks are nesting on the top of a neighbouring Greek church, and one big one with long ridiculous legs which now stick out from behind the tail and are now helplessly hanging down; it makes me think of dear old Hans Andersen's fairytales; you know, the one about the storks and the children in the streets sing when the storks fly over their heads: 'stork, stork, fly away home, your house is on fire and your children are gone'. But I think that comes in the Marsh King's Daughter.[315] I must read them all again when I come home.

I believe I saw a pelican the other day; it loomed ghostly white against the growing dusk. It was flying over marshes and I thought how beautiful was the symbol. A pelican of the wilderness, which turns my thoughts to Crashaw and the lines

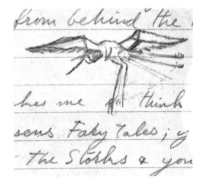

O soft, self-wounding pelican,
Who's breast weeps balm for wounded men
Ah, this way bend thy benign flood
To a bleeding heart that gasps for blood
That blood whose least drops sovereign be
To wash my worlds of sin from me[316]

315 In fact this comes from *The Storks* by Hans Christian Andersen (1805–1875).

316 From Crashaw's 'Hymn in Adoration of the Blessed Sacrament'.

Crashaw is more spontaneous and feels more what he writes than Milton does, although I feel more 'respect' for Milton. I think that it would be very good discipline for me to make anatomical drawings of the mountains but things are too disturbing to permit any concentrated effort from me. In fact I just do enough to depress myself with and make me feel what an obtuse, dull brain I have. And yet Henry Lamb saw the drawings I did last year (when he came to see me when I was near to an old village with a Muhammadan church, having the usual minaret) and said he thought I had taken great strides and that my drawings of the Balkans gave him the exact feeling of the Balkans. The drawings of heads he thought were far better than any drawing he had ever seen of mine. This was encouraging and he greatly cheered me. Meeting him was like coming across a cool running stream after a hot day's march; casting all the hateful clobber off and having a gorgeous bathe.

Henry declared me to be in excellent good health, the malaria not having done me any serious harm. And considering that Lamb was one of the most experienced MOs in the country on the subject of malaria and has lectured to several MOs of Field Ambulances on the subject, I think the information on my health reliable.

I am right back behind the line, safe and well. Gil wrote me a very nice letter; pleased I am in the Royal Berks and wants to come into the same lot.

With love from
Cookham

My number is 41812 not 418112 as you put on envelope. I might have made this mistake in giving you my new number.

* * *

In early May 1918 Stanley received a letter from Alfred Yockney (1879–1963), Secretary to the British War Memorials Committee, which supervised the official War Artists scheme. The purpose of the scheme was to build a record of images from the front line, as well as a memorial through its art collection.

Dear Sir,

In connection with the scheme for utilising the artistic resources of the country for record purposes, it has been suggested that you should be invited to paint a picture or pictures relating to the war. It is proposed that an application be made to the War Office for your services in this connection. Mr Muirhead Bone,[317] who takes a great interest in your work, has suggested that you could paint a picture under some such title as 'a religious service at the front'. When I spoke to him on the subject he had an idea, I think, that you were in France. I write to ask whether in the event of this scheme maturing, you would be disposed to do such artistic work, and I should be glad to know at the same time whether you have noticed any subjects in or about Salonica which could be painted by you before your return, if desired, or nearer home.

Yours faithfully,
A. Yockney

[*Stanley's note*]

It seems wonderful after being in the Army nearly three years suddenly to get such a letter as this. It will be wonderful to be able to actually express on an ambitious scale some of the impressions that I have received in these hills: it will be like coming to life again. This letter was sealed with the royal arms. (I say this because you have doubt about letters of this nature.)

✢ ✢ ✢

317 Sir Muirhead Bone (1876–1953), the first official war artist, was an influential champion of young artists. Spencer was to lodge with him for a short time from 1920.

When I showed my letter to the Colonel which I had received from the Ministry of Information, he was very pleasant to me but I needed

no persuasion to remain in the line when he said how short of men they were. I said 'Of course I understand'. I brought the letter to his notice because I thought if it were possible to do without me (and they certainly did not seem to appreciate my services and the great – and I think now mistaken – sacrifice I was making), why should I not have the benefit of what I was offered? But what I am suspicious of is that I had never seen the cable and message; the matter of remaining in the line would almost entirely have rested with my choice. But of course I heard nothing of all this. The Ministry of Information in these kind of intellectual activities was not loved by the Army authorities.

But anyway, I was thousands of miles away and a nonentity as far as the Army authorities were concerned and, possibly because of their jealous hatred of intellectual people, they meant to and did preserve me as such for the whole of the war. It was not until I was back in England, and even then not until I had left Reading depot for an ordinary 15 days' leave, that I deemed it safe or in any way likely to be efficacious for me to look into this matter.

It was not until I was back in England and at home on a visit that I heard anything of the Ministry of Information cable being sent, and when Yockney informed me of it I did not then on that visit know of the very high position he held during the war. It must have been received by General Headquarters at Salonica, and the Commanding Officer there and the officer commanding the seventh Royal Berkshire Regiment must have known something about it.

* * *

12 May 1918

Dear Flongy dear

The other day I received a rather exciting letter, at least I should say it excited me. It was a letter from the Ministry of Information gorgeously sealed with a lion and the unicorn, and the contents stating that in connection with the War Memorial scheme, it has been suggested by Mr Muirhead Bone that an application be made

to the War Office for the purpose of securing my services in painting war pictures for record purposes.

So you see, Flongy dear, I have been out here all this time, not so long as many, and have not received any intimation that my works have been remembered, yet you see I am remembered. You are aware, I suppose, that Muirhead Bone is the chief draughtsman employed by the government in France and has been most of the time with Sir D. Haig. I was not even aware that he knew that I existed.

It is wonderful how the wild flowers and shrubs have come on this spring, you could see the marked effect after every warm shower, and yet these same plants were burnt to an ash last year by grass fires caused by the sun. 'Grass fires' have taken their course across the green fields of my ideas and desires, but now (as I hope) the warm showers have come, and each separate idea has singled itself out and tingles with this new life, but no sooner does the idea think of what it 'we'll be' than 'it is', so swift is the work of creation.

Milton says:

Immediate of the acts of God, more swift
Than time or motion, but to human ears
Cannot without process of speech be told,
So told as earthly notion can receive.[318]

How passionately and ponderously Milton states these vivacious truths (you might not agree with the word 'vivacious' but it is the correct word to use in this instance).

I am taking this job on, and already have several ideas ready for the canvas.

I intend to write to Mr Bone later on, when things have developed a bit, about Gil in Egypt. That would be grand.

The walrus and the Carpenter
Were walking close at hand;
They wept like anything to see
Such quantities of sand:
'If this were only cleared away',
They said, 'it would be grand!'

318 Milton, *Paradise Lost*, Book VII, lines 176–8.

'If seven maids with seven mops
Swept it for half a year,
Do you suppose', the walrus said,
'That they could get it clear?'
'I doubt it', said the Carpenter,
And shed a bitter tear.[319]

A copy of the full letter from the Ministry of Information I have sent to Father.

Your loving brother
Stanley

* * *

25 May 1918
Salonica

Dear Desmond

Thanks very much for your letter, which did not arrive until about four days ago. I was glad to have it, as I did not know how you were and I hardly knew whether to write or not. My address is now No 41812, Pte S. Spencer, 7th Btn Royal Berks Regt, British Salonica Forces, Greece. I transferred last October but I have not yet been in the line.

I had a letter about a fortnight ago from the Ministry of Information, saying that I had been suggested by Mr Muirhead Bone to be employed on 'artistic' work, in connection with the War, for record purposes, and that a proposal was being sent to the War Office to secure my services in this connection.

Since I have so many things all gasping for the canvas, as Mrs Raverat says, 'Spirits seeking about for a body of flesh', I am gladly accepting the offer, and I hope the scheme matures.

3 June
I will let this letter go as I think all my letters will have to be fragmentary. If I get this job, I shall be able to show God in the bare, 'real' things, in a limber wagon in ravines, in fouling mule lines. I

319 Verses 4 and 5 of Lewis Carroll, 'The Walrus and The Carpenter', from *Through the Looking-Glass and What Alice Found There*, 1872.

shall not forget what you said about God 'Fetching and carrying': it was something like that out of St Augustine's *Confessions*. Please re-quote them. And that wonderful gradual passage out of the Book of Wisdom. Please give my best remembrances to your mother, who I hope is in better health. Have you any news of our Bristol friends? I shall come to see you when I return, but this place has a great hold on my mind. Mountains and mule lines is all my thought.

Your loving friend
Stanley

✳ ✳ ✳

3 June 1918
7th Btn Roy. Berks Rgt, Salonica

Dear Henry

A letter from the Ministry of Information (signed A. Yockney) said that in view of the War Memorial scheme it had been suggested by Mr Muirhead Bone that I should be asked to paint some war pictures (in Macedonia if I liked). A proposal was being made to the War Office for my services in this direction. I have written to say that I am ready to enter an agreement for the purpose of doing this work.

I am aching to paint ideas I have for men asleep in a tent, that bivouac idea I showed to you. Of men at drinking water. 2 pack mule pictures. A picture of a lecture on mosquitoes, 2 mule line pictures. A picture of one limber wagon bringing grub.

I am as much influenced by this particular sector as I was by Cookham in peacetime, I do believe.

I want to do some 'ravine' pictures …

With love from
Stanley (Cookham)

✳ ✳ ✳

Undated

This is not much of a letter: do forgive me.

Dear Jacques and Gwen

This is only going to be a short 'Family' letter as it is impossible to write or to concentrate the attention on letter writing under existing circumstances. I am still well. Gilbert is in a Line regiment. My brother Perce has been severely wounded in the scalp and wrist but is now going on well.[320] My brother Sydney has no time to write from France. I had no reply to the letter I wrote to the Ministry of Information about the 'War Artist' job. About a fortnight ago I spent a day with the regimental Sgt Maj of the unit of which Major Darwin is the CO.[321] Do you think Major Darwin could do something to help me to get this job? It would be a great relief to me if he could. I can do nothing for Gil until I know something definite about myself. Do please write to me.

> Your loving friend
> Cookham

<p style="text-align:center">* * *</p>

3 June 1918

Dear James

I wrote to Lamb about the pictures and he says he has no claim to the cowl picture and that you can have it (it is, he believes, in his London rooms and says you could get it), applying to Miss D. Lamb. But you are not keen on that one are you?

I think you will find that Lamb's particularly keen on possessing the big picture. In your note you said you thought he was not.

I had a letter about a fortnight ago from the Ministry of Information to say that it had been suggested by Muirhead Bone that an application be made to the War Office for my services in an artistic connection to paint war pictures for news purposes. Here is

320 Stanley's brother Percy, Lieut. P.G. Spencer, was wounded in France on 7 August 1918.

321 Major Bernard Darwin (1876–1961) was a cousin of Gwen Raverat's, a grandson of naturalist Charles Darwin, and served in the Royal Army Ordnance Corps in Macedonia during the First World War.

a list of some pictures I shall do. There will be a bivouac picture, two mule line pictures, a travoy picture, a picture of a lecture on germs, two drinking water pictures, a stretcher bearer picture, a limber wagon picture, a tent picture (inside a tent), a donkey picture. But the most moving thing about these pictures will be that wonderful remote feeling that this particular sector gives me. If I had the chance I would not leave this place just now. In winter it is more wonderful.

With love from
Stanley

* * *

3 June 1918

Dear Flongy dear

It would be a surprise to me if I did not get a letter from you in the course of a week. I had a nice long letter from Gil. He says he is qualifying for a 'job' at the Imperial School of Instruction, Zeitoun, Cairo, and will let me know how he gets on. I am at work behind the line so you need not include me in the Balkan fighting you read of.

I have already got plans out and ready for the time when I start on this War Memorial scheme, which I hope will be a success. It will be great; a little space of ground will be as it used to be to me, a universe. As I have previously said, this sector, which I am now on, has a grand and somewhat mysterious meaning for me. This is not on the Front that your girlfriend spoke to you about, though I have been there. It has quite another meaning for me.

I do not want to leave the Balkans until I have carried out some of my plans, so if I went to France I should, I dare say, find something there as I have found something here. When I return I want to do some spiritual portraits. One of Sir George Young, one of Henry Lamb, one of J. Raverat, and one of your husband, Flongy dear; he makes me think of Masaccio and Masolino.

Your loving brother
Stanley

* * *

3 June 1918

Dear Flongy dear

Yesterday I received the socks, the two handkerchiefs and the toffee, which is the sort I like. I think you must have too much to do. Since the news came to me about the proposed War Memorial scheme I have hardly known how to restrain my desire to be 'at it' again.

Just now I was crawling into my bivouac and I noticed on the grass outside a *Sunday Pictorial*. I picked it up, and the first photo I noticed was a little photo of Phyllis Boyd,[322] daughter of Lady Lilian Boyd, who, it is stated was seriously ill. I wish you could find out from Mrs Raverat how Miss Boyd is. I don't like this sort of a dying off game among these girls.

The book called *The Jesus of History* which Pa sent to me I think is a wonderful book; it is by T.R. Glover. It contains some short quotations from St Augustine (*Confessions*). The sentence he quotes was one which Desmond Chute read to me when I was in Bristol. This was it: 'thou hast made us for thyself, and man will know no rest until he rests in thee'.

* * *

27 June 1918

Dear Flongy dear

The day before yesterday I received the Hans Andersen[323] book and the big drawing book and a little tube of white paint. I think there is the Brer Rabbit book to come, and then when that arrives there won't have been one thing that you have sent to me lost in the post.

After the war I can see myself doing some strange things. It will be something like this: I arrive home, two days after, get the train for Bristol, get out at Bath, stand on the railway platform and look towards a certain loathsome suburban church standing in the side of a big hill. Take notes and get back into train. Get out at Bristol, on

322 Aristocratic English beauty Phyllis Boyd (1894–1943) was a contemporary of Spencer's at the Slade.

323 Stanley read Hans Christian Andersen stories throughout his life.

tram up to Fishponds. Go up a certain hill, a slummy street on left, small cottage, windowsill; on the windowsill, earthenware animals and flowerpots. On the other side of house, small cottage garden on a steep slope; on opposite slope, little orchard. Take notes and return to Cookham. Then off I go to Plymouth and from thence to the coast of Portugal and there sail up and down the red-cliffed coast. Then away again down the blue Mediterranean, and see those great pillars of smoke rising off the top of the grey African mountains. Then up the Aegean Sea and gaze upon the isles of Archipelago, which now appear and now disappear – a rusty red colour from out of the thick purple mist, in the east as the sun sinks down behind some great Grecian mountains in the west. Then back to England and to Cornwall and off to Jersey and Guernsey and then to Ireland; to Belfast, and then to America (R.M. Ballantyne[324] is responsible for this, also some photos I saw of some blue lakes and great trees and shrubs and mysterious unknown mountains). Then I would return to Cookham and work, and I would not stop working. I would be like one of my mates is with a pick and shovel, you can't stop him; as soon as he gets a pick in his hand, a gleam comes into his eye, his face becomes 'set' and he's off, and the only thing that would stop him would be to hit him over the head with a crowbar. This man was a fire eater in civil life; in other words, he was a stoker of one of the big furnaces in the Black Country.

But I don't believe a crowbar would stop me. I would then go to Norway (Desmond Chute gave me a wonderful description of his visit to Norway and it made a great impression on my mind), then I would come down to Denmark and into Germany, to Weimar, the land of Goethe. In those volumes at home called *The Grand Duchess and her Court* there is a lot about Goethe and his wonderful doings in the alfresco theatre which the grand Duke had built for him in the forest. Yet in spite of all the grand Duke did for Goethe, when the Napoleonic Wars came on, Goethe would have nothing to do with it and would not do anything to help the Duke; he lived in retirement. But he was a great man though.

In a turnip bed out here there is a yellowhammer's nest right up against a big turnip. It isn't every turnip that can boast of living next door to society, but this turnip obviously does, he is very puffed up. The little young yellowhammers nestle and sidle up to him and say

324 R.M. Ballantyne (1825–1894) was a Scottish artist and children's author.

'us and the turnip'. I expect they will remember in later life the old, old turnip under whose gracious shade they used to sleep.

I can see Binny (my cat) sitting mesmerised, gazing up at the bird and coming in all cross-eyed. I can picture it's little nose going (I don't know how, but you know what I mean).

I read 'The Snow Queen' again: about the reindeer resting in the Landmark woman's hut with a block of ice on its head and a woman reading the message written on the herring sent from the Lapland woman.

I have had no further news of my prospective job, but I expect to hear in a few days.

Your loving brother
Stanley

* * *

16 September 1918
7th Btn Roy. Berks Rgt, Salonica

Dear Desmond

I quite agree with you in thinking that everybody is becoming conscious of a desire for Truth, but I feel that the poorer classes (only poor as touching filthy lucre) are not being given a proper chance to live. It is well to give them enough to keep a family going, but still they will be heavily hampered and their progress seriously impeded towards attaining a really high understanding of Truth, purely through the fault of unnecessary, petty material inconveniences.

There are three quite capable and deep-thinking young men in this camp, one a great friend of mine – all of them can neither read nor write. We know that to attain the kingdom of heaven it is not necessary to be able to read and write. But imagine him picking up the Testament!

I pray for the time when it will be counted a sin in anybody not to know the Diabelli Variations. There is no such a thing as 'individuality', 'personality', and 'originality'. Every man has the same Name. His Name is the Resurrection and the Life. I know from

my own experience that to have the main employment of the days of my life on doing 'necessary' labour, which in the majority of jobs is brainless, has had a direct influence on my mind in keeping me from the knowledge of God. Whereas if a man were employed a small part of his day on a menial task such as I have spoken of, it might be an assistance to him in feeling his true relation with the Spirit, at the same time giving him ample time to work for the Spirit. I can conceive an ambition and spiritual desire to make boots, but I feel that as soon as I had partly realised that ambition I should be craving for something better, and so on. This should be so in every man. There ought to be an equal distribution of labour. If any man is ignorant or a fool or a knave, you and I are largely responsible.

I do not think this may be what is wanted but it is just how I think. It is wicked to think that we might be able to keep a man from the Kingdom of Heaven.

I will write at a more convenient time when it is not so hot.

Your loving friend
Stanley

A lot in this letter is clumsily written and a lot is not quite to the point, but where I am now I cannot concentrate and so this letter must go. Do write to me as often as you can, especially just now. Forgive me for not writing. Same address.

* * *

16 September 1918
7th Btn Roy. Berks Rgt, Salonica

Dear Flongy dear

I am still keeping fit and well. There is nothing to report except that I have left the Gardens and am now with the battalion for the first time. Do not let father or mother know this, else they might worry when there is no need to.

How is Percy? Is there any fracture or any shrapnel in the

wound? I hope he is not suffering. It must be a joy to him, if he is well enough, to feel that dear old father Thames is rolling along just below. You know how Percy loves London. So do I.

Have had no reply whatever from Ministry of Information or War Office and I begin to give up hopes. I wonder if Major Darwin could do anything for me. Let me have news of Syd. I believe he is having a rough time.

I try to be patient, but this sort of life is so empty and so meaningless, to keep 'doing' these things and yet be doing nothing. Machinations are so dull and yet men seem to live on them and the little vainglories that attend their success. I thought what Henry Lamb, who, as you know is MO in charge of the 5th Inniskilling Fusiliers, said about winning the MC was true, that it only added absurdity to feelings of despair, but it would please his vainglorious parents.[325] After all, what availeth it a man?

Capt. Lamb, who was when out here one of the cleverest men on malaria and the like – he gave lectures to some of my medical corps OCs – said that he loathes the job and would turn it down at any time if it were not for the fact that he is needed, and he says that, like me, he aches to be painting again and 'musicating'.

I have had no letters for a long time but I think they have got hung up somewhere.

Ever your loving brother
Stanley

Flongy dear, send us a bit o' soap. I have told Father and Mother that I am still miles behind the line safe and well.

* * *

ON M4 SECTOR

I disliked the fact that whereas in peacetime teatime was a happy time when one could slack off a little and the day's work had been more or less mastered, here a terrible sinking feeling and loss of spirits assailed me as I walked into the dark channel-like dugout carrying my dixie of tea and a portion of bread, because it was immediately after this that we had to 'stand-to' outside our dugouts and then go into the outposts, which I have described.

325 Henry Lamb had been awarded the Military Cross.

This dugout was just a deep gash in the side of the hill, and on the sloping sides of the slit our kit had to be carefully spread out in such a way as to make it possible to immediately don our equipment in the event of emergency. This dugout features in the picture in the Burghclere Memorial called 'Stand-To', when I was saying how helpful it was to have clear instructions from an officer previous to engaging in some affair; I was thinking of one night when we had to go on some job which could so easily have gone wrong if we had not each clearly understood what we were to do. It was simple enough, in one sense. A piece of ribbon wire had got to be attached to the Bulgars' wire and conveyed over the space at ground level between their wire and ours. It was to be like a little single-wired fence that had to be erected across no man's land. It seemed to me a job about which one could say nothing polite at all, and when after dark we were assembled outside the Scout Captain's dugout to hear from him all about what we had got to do, he talked about it as if it was the greatest joke ever hatched by the mind of man.

I – and we all, as a matter of fact – were nevertheless impressed by the very pleasant nature of this officer, as we certainly were not by the very unpleasant nature of the brainwave he had suddenly had. But there was something really amazing in this Scout Captain and his own scouts, whom I used to see sometimes, and I felt there were men evidently made for this kind of thing. While I by no means felt the least contempt for my own natural cowardice, I did feel admiration for those men's courage and pluck. It was so absolutely right with them. It was just the time when those specialists, as they were, began to feel cheerful when there was some nasty ticklish business afoot. There was something intoxicating about this man. He grinned at us a big grin and said something about 'Are you frightened?' And then: 'It will be quite alright, nothing to worry about at all; but all you have to do is not speak one word, and hold the rivets well apart and see that they don't touch each other'. Somehow his saying it would be 'quite alright, quite alright' made me feel it would be quite all wrong.

He told us all and each one what to do. We were then ordered back to our dugouts. I somehow felt how unfair all this war business was on such as myself and men of my calling. If my life had been devoted to going on escapades of this adventurous kind, I think I

might have not minded it so much as I did on this occasion. It was going to be useful, but it was just a sort of schoolboys' prank with great danger to one's life as well. The only schoolboy part I felt I could like was not the mischief part of it, because that is not like me, whoever else it may be like, but the daring: a slight feeling of daring seemed to help me drown the funk.

TEN DAYS IN 1918
It is difficult to remember the exact happenings of the last ten days of my experience in the active part of the war. I remember that a day or so before we packed up to come down the line from M sector I was reminded of the routine life of being at a base camp: I had to join a squad of men from the other dugouts and go down into a ravine which was fairly safe and do squad drill, etc.

A few days afterwards I was surprised and delighted to find that contrary to what I had feared, namely that we were preparing for a fresh attack, we were being relieved by the Oxford and Bucks Light Infantry. And were indeed going down the line. I can only remember that luckily I was attached to some goods that had got to go down the line and were to go in a limber. I remember careering all through the night across Macedonia, as it seemed to me. But this was as far as I can remember: only to a place where our valises were dumped in a big stack in the midst of a grassy place full of trees.

The next memory is our arrival at the camp where we were to rest. It was strange getting back to bivouacs, but I somehow did not like the place. It was like a very big, shallow disused gravel pit, but all hard and bumpy. I was at once busy filling the mosquito net pockets with sand and sewing each one up. This took a long time as there were, I think, about 20 or 30 pockets. But first I tried to get water. In the inner slope of this place, toward the cliff end of it, was a tap with a collection of men near it. I walked down and approached the tap, and then I remember Jack-in-Office Sergeant shouting that the tap was not to be used and a whole row ensued. Whether or not I got the water I cannot remember, but somehow I wondered why it was that in spite of my being away from danger, there did not seem to me to be the cheerful atmosphere prevalent that I had hoped to find and experience. I felt there was something sinister in the cursed atmosphere of this tap incident.

I went back to where my bivouac was. After midday I decided I would go to a place nearly a mile away where I had heard there was a big bathhouse. Tired as I was, I managed to find it; while having a good time and beginning to feel more cheerful, I suddenly heard a hubbub of conversation among the men, in the midst of which I could hear: 'Yes, you have' and 'Who said so?' I thought this sounded like those alarmist bits of news which men so love to give to each other and which are usually false. But there was no doubt about it. A man came up to where I was and said, 'Hey you, you'd better get back to your camp, they're packing up'. I said, 'What's up?' and someone said: 'Going back up the line tonight and you'll have to be ready in about an hour'. With a ton weight on my spirit, I dragged myself back and it was horrible as I approached to hear the infernal shouting of orders. I hardly knew how to walk into the midst of this clapper clawing of shouting Sergeants. I knew that in a moment I would be more feverishly packing and more loudly shouted at than the rest.

We at last began to move and somehow for that day the shock began to subside. We went by a special track which had been very much camouflaged. As the track turned among the hills, the screens reached across the track over our heads like a grim reminder of triumphal bunting. This consisted of chicken wire and bits of rag. It was very mysterious to see them emerging from and passing over our heads in the increasing darkness, like bird-like heralds coming from what I was walking into.

As far as I can recollect, we had marched from about three in the afternoon until nearly midnight. We arrived and halted at the side of a dark riverbed. In the moonlight we rested on the lower part of the hillside which sloped up from it. We were informed that we were in the supports just at the back of M sector. I settled in a rut in the hillside. Then we were surprised to receive an issue of letters, which seemed rather ominous to me since no issue or any of my letters had come to me for several months (about two months I think it was, because my father had been writing to me since September informing me of my brother having been killed). One letter was from Mrs Raverat congratulating this bit of humanity, lying in the Vardar Valley waiting for orders to enter what was called the Dome, on the important appointment, I was supposed to have been doing

some work for the Ministry of Information. She supposed I was in England. All the information I could have given her at that moment was that the deliverer of the letter (a Corporal or Sergeant) was telling us as he handed each letter that they were to be destroyed as soon as read, and that the Sergeant Major was calling each of us to him and asking us how many rounds of ammunition we each had.

When I told him how many I had, he handed me another bandolier of 50 rounds. We were told that the advance would commence at about 2 o'clock am. And I was informed that the last move had lost 1,000 men between two near hills over to the right, which I had being gazing at night after night and which was called the Dome. I did not relish the prospect. As I thought what in an hour and a half's time I should be experiencing, it seemed to me inconceivable what would or might be happening to me. That was a mercy, namely that being so inhuman and becoming fantastic, it seemed unbelievable, so that every time I tried to particularise in my mind what it could be like, such as coming into contact, for instance, it all quickly became lost in a welter of horror out of which it was difficult to get any coherent impression. But I could not believe it either, although there was the most glaring fact staring me in the face: that this was the place where if I had shown myself yesterday beyond the second belt of barbed wire for 10 minutes in the dark would have got a machine gun bullet through me, and where shrapnel was almost a continuous occurrence. And here we were, we who for two and a half years had scarcely dared to make one change at all in our front, about to suddenly and calmly tread over our wire and over the Bulgars' lines, right bang in amongst them.

Privates were usually not told anything. I felt a kind of disagreeable gloominess and taciturness settle on my spirits as the night wore on. But 2 o'clock came and no move. Then 3 o'clock approached and no one seems to be preparing for anything. I began to look about me from where I sat on my groundsheet, rather like a bird that feels morning is near. Soon I saw men walking about, dividing in dark vertical streaks the crack of dawning light. The disappearing night seemed to take my dread with it.

It was a clear dawn and I remember we were all told if we wanted to shave we could. My spirits revived as I did so and as the sun rose. Then the whole camp began to get news of what had

happened: apparently the Bulgars had fallen back but they were not at all sure how far. When the sun was up and we were ordered to get ready, we knew that something had happened. I remember looking curiously about at the ground in front of me, which I had only ever seen in the darkness of night. In the night I had gazed and strained my eyes to see what some object was on the left and now I saw it was just the straggling remainder of a tree and a slight rise in the ground on which it stood. Away to the right the two hills, one small and one bigger, which had presented such an eerie appearance at night when the Bulgars had been sending up Vader lights looked now an innocent bit of Macedonian country. The Bulgars were gone completely. In one sense it was disappointing, but when I thought how ghastly it would have been if they turned and began to attack instead of retreat, I felt very hopeful that we could continue to be disappointed by their non-existence.

It was amusing to notice how their kind of barbed wire compared with ours. Theirs was like a thick matt of rusty stuff only about a foot above the level of the ground, which one was mostly able to tread on and over. The Bulgars seemed to have used any very slight rise of ground as cover. I wish there had been time and opportunity to go in to the Bulgars' deserted lines and see how they made their dugouts.

Eventually, after a long march, we halted by the banks of the Vardar and were all allowed to bathe but not to drink. This was agony as we were all short of water and thirsty in the great summer heat. The current of the Vardar was very fast, so that where we entered the water had to be some way upstream from where we left our clothes. Then we were told that the water was alright, by this time I had taken a few furtive sips; now we nearly drowned ourselves. But now all that tense and fixed routine life that had become our daily bread and to which we were so accustomed, all that consciousness of the war and its awful immovableness, seemed to be long in the past, another world. The war was still on but something indefinable that seemed an unshiftable symbol of its presence was gone. I think it may have been that while a crisis of some sort was approaching, the mere fact of having this sudden walkover signified a change. One of the striking things in a war is its awful lack of variety. One's mind is claimed and exerted and exercised all the time by utterly boring

things. This sudden breaking up of that monotony, which was a part of one of the severest parts of Army discipline to be borne, was indicative at once that some extraordinary thing had occurred. I began to feel in a sort of dream.

Once, when we were all resting at midday on the crest of some sloping bit of land, where there was some sort of grass and the usual lemon thyme, I felt as though some organ was being played and psalms were being sung. Purely imagined, it was just the dreamlike atmosphere produced by exhaustion and the heat and the soothing effect of rest. On the first or second day of the advance, after we had wandered across one of these wonderful nondescript plains, amongst which the lines of hills nosed about aimlessly, completely confusing one's sense of direction or whereabouts, in the afternoon I was detailed off by the Captain of the company I was in to scout with two other men a line of hills slightly to our right front and going away to the left at a slight angle (from the direction we were taking) to the left. To the left could now be seen Geogeli quite clearly.

I was quite pleased and proud to be given this job and we three of us took our separate gradients of this line of hills. I was scouting this middle gradient of this line of hills and stopped among some projecting bits of rock to have a drink of water, but noticed my water bottle was missing. I was in a desperate state over it and was searching about for it and felt so distressed by this new and unlooked-for misfortune that I began to whimper and at last weep, and while I did so I noticed away down below on the road a platoon of Berks Regiment coming along. They seemed to pause for a moment and one man was detached and started off up the hill, making straight for me. There was something menacing and damnable in his hastening towards me and as he drew near enough his face had a demon expression on it. He held his rifle from the hip and said, with his hand on the trigger, 'I have orders to shoot you, I've got it cocked'. I could see there was no use or time to remonstrate. I blurted out something about my water bottle. But he was stealthily walking up to me with the muzzle levelled at me and hissing at me, 'Go on, you – go on, get to the top of the hill or I'll shoot'. I had very little strength and here the slope had become steeper. I exerted so much of my strength in getting to it (by the way, of course this meant that the middle gradient would now remain

unexamined) that when I did get to it I was only able to continue my journey by crawling and if I came to a slope by rolling. I am so thankful that I did do this, as otherwise I should never have arrived at the place just by Geogeli.

This incident I regard as an attempt on my life by officers of the British Army and they will ever be regarded by me as men who tried to murder me. No wonder they wished me well out of the way. No wonder they were annoyed to see that I still existed. What was particularly disgusting was to have this sort of behaviour to put up with when every scrap of evidence of my services goes to prove my goodwill and my efficiency, in spite of my extreme physical unfittedness for the tasks set me. I arrived exhausted at a place where we rested in the evening, and where for the night all I was called upon to do was to stand in a little dried-up ditch by some young trees and gaze out across the plains and listen to the Macedonian owls. After such an ordeal this was very refreshing. But when next day we started off again across this next plain, the vast expanse of it began to be more formidable.

We had been going for about four hours when on one of the halts it was said that the man who had shared my dugout was missing. A Sergeant came along to me and detailed me to go off and search for him. The only objects of any sort in view were some dead oxen, which I think had been killed by our aircraft or guns. I wandered off among these huge carcasses, inflated and stinking in the hot sun, to look for this man; I could not see how he could have got away, as in a great desert like this one could have spotted anyone leaving the long column. However, I was sent off with no provisions for myself or for him if I found him. They knew I also had no water, and it is, I should have thought, a strict order that anyone sent off on an errand of this kind should be given at least ordinary provisions. I had no sort of provisions except the remaining biscuits of iron rations. I felt very suspicious as to the true purpose of this errand I was sent off on and, seeing that it was very unlikely that the man was lost at all, decided to keep an eye on my bearings and not get lost myself. I tried to keep in mind the direction the column had taken, and as the day wore on I could see clearly that unless I could get some help – I had no food or water or supplies – I should be left to die.

Sometime in the afternoon I saw a lot of dust and a column

of what turned out to be Artillery coming along. I didn't have the strength to catch up the regiment and I knew I would have to have assistance. I shouted to the leading driver of one of the gun carriages and he motioned me to the Major riding a little way back. I hardly had strength enough to stand and ask him to let me get on one of the gun carriages. He motioned me to get on one of the limbers and there the men commiserated with me and sat me across the pommel of the limber and promised me a water bottle when they got to their camp, where they said they had several spare ones.

When at last I rejoined the regiment, there was the lost man: he apparently had only been further back in the column, not really missing at all. I was very fond of him and was very glad he wasn't lost. He had a drooping moustache and a hooked beak of a nose and a receding underjaw and overhanging upper lids to his eyes, rather thus: [drawing]

Seeing at last a line of hills at the far end of this plain told me we were getting to land at last, so to speak. At the foot of this line of hills was a sort of square plantation of young trees. The night we slept under these trees and some men began to amuse and entertain us with comic songs, etc. Some men walking down the avenue between the row on the side I was lying on and the road, who had their feet towards us, stopped at the man lying nearly opposite me and, while the singing and laughing was in full swing, bent down towards him. I could not understand what they were doing until one said that the man had stuck a bayonet into himself. I had not noticed and none of us had noticed any movement or anything unusual. He was taken off to hospital and I heard snatches of news of him, that he was still living and that he had been in so much of the war that this last attack was too much for him. He had asked to be given leave to go down the line and it had been refused, and now the Colonel was nearly distracted with anxiety on the man's behalf. I advised the men, who were being very amusing, to continue their good work, though I cannot imagine anything more terrible than the anguish that man must have been experiencing.

The next day we walked a little way to the right and got some tomatoes, I presume from a young farming Bulgarian or Macedonian who sold steel helmetsful for one drachma. Then there seemed some hesitation in the turning at the left extreme corner of these hills and I

could hear once more the air being combed with approaching Bulgar shells, which seemed to be bursting just round this nasty chalk cliff corner. We were told that the bridge away to the left, which we had purposely been warned not to go over, would shortly blow up, and so it did. It looked as if it was a slow motion cinema and rather unreal. There seemed now a rather less tranquil atmosphere. I heard the Colonel swearing at Mr Childs, who was the acting captain of our Company, and as we turned the end of this line of hills I looked across to the left front, where across another plain I saw flanking the left border of the plain a range of mountains. On turning this chalk cliff corner I noticed that it more or less continued the same line of hills, only now turned right to a sharp angle with it.

I went with some men into a sort of shed place built into the hillside where were some big German overcoats and the never-to-be-forgotten German helmets hanging up, and I thought how romantic they looked. They were just the same in feeling as the helmets we played with as children; possibly the ones we had as children were made in Germany and consequently at that time were made after the same model. Anyway, these were real Kaiser ones, just the sort the men used to bring back as trophies. I wish now I could have brought one, but I could not have carried a pin.

When we were around this corner we found a deserted dispensary and remains of what had been a Bulgar hospital. I only went into the dispensary, where I took some bandages and a little thermometer. But they thought it a bit risky as they said it might all be poisoned. I felt less fascinated by all these discoveries when a man pointed to a note written in English which said: 'We will be back soon', addressed to the English.

Then I began to feel the terror of these wretched shells, which made us all cower in little places among the chalky sides of the hills. This eased off sufficiently to enable us to move a bit further on, keeping to this line of hills until we turned into an opening among them and there came to an enclosed dell where we all rested. This was as evening was coming on. I remember someone explaining to us what was happening and showing where we were and why the Bulgars had had to fall back so quickly and precipitately. I was just hoping for a good night's sleep when I heard the ominous calls down among the mule lines, of 'load up', and soon we were all off once

again as it was growing dusk across this plain.

I suppose the fact was that we were now under observation and could not have got across the plain in daylight. As we started across, some Greeks riding mules bareback to be watered, and looking like simply one kind of animal on the back of another animal, gave us further information which I think amounted to very little, and what there was to impart not understood. When these Greeks were riding aimlessly along on the mules, the men did not seem to like their sing-songing (I liked it very much) and shouted 'you want to get it seen to' and 'write to John Bull about it'.

Arriving in the dark at the foot of the mountains, the air was being rent with the firing of our field guns and a terrific echoing among the mountains, and we heard snatches of British officers bawling at the top of their voices among the din: 'same target, same range, fire!'. In the midst we could also hear our Colonel raging at some red cap.[326] We were ordered to sleep for one hour in this din. Then we began to make a narrow track up into the mountains. As we got higher it began to get cooler and I was glad to fill my tin helmet from a little waterfall that gleamed in the moonlight. But just before we began to move off into the mountains in single file, we sat for a moment in a long row at the side of the track. I could just discern the Colonel sitting about 12 men off from me, and after a time I noticed that the men by me on one side were being visited by a Sergeant who just tapped each one and seemed to detail him off. Anyway off he went into the darkness. None of these men said anything to me and I thought, when the man next to me got up and moved off into the darkness, well this is a queer proceeding; so I whispered to the man next to me. As far as I can remember, he said 'watch where he's gone', but of course I had not.

During the whole of my training, and of all the repetitions of it many times during the war, I had never been told of this system of what they call connecting file, possibly one of the most important of all the orders to clearly understand and carry out. I felt that somehow the men and officers were maliciously pleased to think of the trouble my altogether excusable ignorance might get me into. I did what I could: when I got to the Colonel I was going to say 'which way, Sir?' But I was met by such a volume of oaths and swearing from the silly ass that I was obliged to go on and I cared not which way I took

326 Member of the Military Police.

and only commiserated with myself for the terrible consequences that their incompetence was probably exposing me to. I did not go the right way and landed mercifully at the Sergeant's cookhouse. The Sergeant there told me simply to retrace my steps quickly and re-join the regiment, which I did. I had by good fortune only gone a few yards and was soon back with the man who was supposed to follow me. I somehow felt from his reception of me and his manner to me when I was sitting waiting my turn that he could see that I had of course had not known what was happening, and he had been rather pleased to have an opportunity to express his malice. He evidently knew the right way. The Colonel was quite impossible; all he said when I paused in front of him was: 'What the hell are you looking at me for? Get a move on.'

They wanted to think badly of me, even at their own expense. We continued until we reached the summit at midnight. It was terribly cold and we only had our scanty summer drill shorts on. We did what we could for warmth. I turned my flaps down and rolled my puttees in such a way as to make a covering of my legs up to the hips. I felt very sleepy and the cold made me more sleepy, and I could tell from the way that, while we were all being told once more to rest, there were a lot of Generals or red caps of all kinds conferring busily here and there, and it was evident something was brewing.

About an hour before dawn we began the descent and the sun was well up as we came out on the Bulgarian side, into a valley and a Bulgarian village. It seemed rather nasty to see some villagers who had remained and were milking cows, now, as we emerged from the mountainside, beating them and fleeing in all directions. Some message was sent to try and reassure the peasants and villagers, I think. But it turned out that there were great stores of rifles in the village and they were intending to cause us trouble if they got a chance.

We were now, I presumed, in Bulgaria and assembled at the village end of a long gulley, dried up and full of broken rock. Away in a sunlit grassy corner abutted by mountainsides, I seem to remember horses as well as mules. At about 11 o'clock or so and in the blazing hot sun (we were down in the valley once again), it was strange to notice men smoking; they had fixed bayonets and I knew some new cause for anxiety was afoot. Apparently in among the hills just in front of us or a little to the left were some Bulgarians.

Up the gradual incline of this row of hills, we were single-ranked in extended order and were quietly ordered by the Sergeant to fix bayonets. The little squares of shining tin we were supposed to have fixed on our shoulder in order to give the British planes an indication of our whereabouts were removed for this occasion. The Sergeant said 'keep as much a line as you can'. We had only got a few yards when the Staff Sergeant came up to me and hissed threats into my ear as to what would be done to me if I did not keep up or behave myself, etc. I thought, 'what's the matter with this man?' I noticed about ten men from me and in the centre of the line was the Captain and I kept my eyes on him. I seemed to remember his saying to some Sergeant or other on the previous day, 'Poor old Spencer's lost his water bottle, has he?' He had been very watchful when before all this happened we were on outpost duty on M sector. It was he who in the dark one night said to me: 'what belt did you go round?' and I had to confess I had only done the second and not the third, so I had to go out and round the third.

But that kind of thing, vigilance etc., in no way excited in me any resentment: it was an important matter. But the Staff Sergeant had made a mistake. On one occasion in the winter he was doing the usual business of saying I was dirty, so to his and other men's astonishment I stripped and bathed in the stream. But as a matter of fact I was always naturally clean and did not need so much washing as some seemed to.

He had been singing 'I'm going back to the shack where the Black-eyed Susans grow' and was shaving and ticking me off as an accompaniment. I could see on this occasion now that he was after me again. It is very shocking to me to find this unaccountable ill-will towards me, as I was then in no particular ill-will mood. We were moving to the left over three hills; at the foot of each was the ravine. Nothing was noticed on the first or the second. When we got into the second ravine and had rested, the moment before starting the third hill the Captain seemed to anticipate how exhausted we were. He started up and began to go up the third hill, turning to the men and saying 'come along'; but no one that I could see stirred. I was especially wanting to keep up with him. I got up and followed him and he and I continued together, the men below shouted in jeering remarks about V.Cs, etc. However, perhaps if I had been through as much as some of

them had been through, I would have felt much the same.

We went on up among little oak bushes. Then we ran across a plateau of long dried up grass on the crest of the hill, and down into another ravine, and then began to go up the other side of this ravine among some more of these bushes. After a while he sat down and began to look hard at this ravine and over to the side we had just come from where I could see that there was another hill behind it. Roughly the hills were thus [drawing]

He got out his field glasses and had another good look. He then told me to undo his valise at the back and take out his map and writing book, and while he wrote a note which, he informed me, was to give the planes and artillery the locality of some Bulgars, he told me to have a look through the glasses. I got them beautifully focused so that I could at last see them moving behind a hedge. It was like watching the movement of some sort of germs through a microscope that were extremely dangerous to human life. Or seeing a tiger in the jungle: queer, jerking, marionette movements in which the foreignness of the men could be noticed.

When he had written the note, he told me to take it down. So down I went into the ravine where I found the man who had been his runner and he took the note on down to headquarters. I then made my way back to the Captain, who was still sitting where I left him. He said when he saw me, 'I did not expect to see you back'. I sat down again and he fired a round at what seemed to be a machine gun company. I could not see the point of this, as he had said, 'We are cut off'. Now and then the combing of bullets in the air wafted unpleasantly near. After a time he said: 'We can't stay here, we must try and get back. There is nothing we can do if the Artillery don't get on to them' – or words to that effect.

We had only walked a few yards when he said 'I am hit', and felt his leg. He then said in a dreaming voice, 'I am going up, up'. And I held him as he sank down to the ground. I could not discover where he had been hit but slowly his hand went up to his neck and I saw a gaping bullet wound in it. I made a movement to get these bandages that I had found in the German dispensary, which were much bigger and far better than the meagre bandage supplied to all soldiers sewn in their tunics, but he (perhaps wisely) waved his hand and tapped his coat. So I got out his bandage and bandaged him as best I could;

but they are very short bandages and not adequate at all. I then stood up and called for stretcher-bearers. Within about a quarter of an hour I heard men coming and in a moment he was surrounded by men, one of whom gave him water, which I had quite forgotten to offer him. While waiting, he quietly murmured for a hospital and pillow. Among the arrivals was a Corporal who stretched him out more as he said to me, 'He's paralysed'. When the stretcher-bearers arrived, they were so exhausted that I had to give turns at carrying; when I was not doing that I held the tin helmet between the Captain's face and the sun, which was blazingly hot. But before I began to go down with him on the stretcher and the others, I noticed that a particular officer had arrived. This officer showed solicitude and sympathy to his fellow officer but must have been a little surprised when the Captain, his voice weak, said, looking very hard at this officer, 'and understand, Spencer is not a fool, he is a dammed good man'. He just said, 'yes, yes, of course', coaxingly, rather like talking to a drunken man who could not be held responsible for anything he said. I thought that was very kind and not really deserved, as I was quite unreliable and it just happened I was alright for this affair. But I also thought, 'what's all this; who has been saying otherwise?' I couldn't fail to notice that that officer did not look my way at all.

The Captain, I understood, was wounded in the spine, the bullet having entered it, and that was why he first felt the effects of it in his leg. I was very annoyed and fed up at not being able to accompany him, at least as far as our own regimental headquarters. Once he been taken away, I lay straight down, utterly exhausted, and remained there on a bit of grass in the gulley which led back, as I felt it might, to where our company was and where we had started from. I was not left a moment before another officer, all fresh and morning gathered, saw me and said 'come along'; but I did not move and he went off up the ravine I had just come from. After a few minutes I began to feel very worried and everything was still, not a soul to be seen and only a deafening sound of a machine gun. I stealthily made my way to where I thought the officer had gone but the ground in front of me, which was chalky in this ravine, was now and then being kicked up by what must have been bullets. I was scared and in a state of abject fear I turned tail and made for where I had come from. I still found the stillness eerie.

The left side of this grassy sunken riverbed was flanked by a cliff of chalk and I tucked myself in one of its recesses and became absolutely stiff with horror and dread. Suddenly I saw a man of the Worcestershire Regiment walking along in the riverbed and coming near to where I was crouched in this recess. He said: 'What are you doing here, son? You'd better not stop here. Several men have been taken prisoners: you'd better get back to your regiment.' I said, 'Where are they?' and he said, 'Down there: you'll come across them if you keep on down, but don't stop about here'. So I made my way along the gulley and soon came to where apparently the others of the Company had returned sometime before. I just spread myself among the broken bits of rock, I cared not where, and in a drowsy state heard the SM who had had a slight wound bidding us farewell and wishing us luck. I cannot remember much more that day. I rather liked the place I had to mount guard over that night: it was a sort of pit and not very big, and I liked its darkness; also, I felt that somehow it was safe, and there was a feeling of relief from the tension.

Before daylight we were off again and I was once more shocked at the way a man marching just in front or just behind me shot a big dog, which I don't think for a moment meant to harm us. I felt what a vast distance intervened between the minds of these men and my own. I was just thinking, for instance, how cosy and pretty it looked to see the early morning lamplight in the cottages just by us here, and this old dog, and the fact that we had not seen any ordinary living people in houses or cottages for years, and then the whole scene blasted before my eyes. When I said 'What did you do that for?' I was met by much abuse.

Then as the sun rose we found ourselves getting onto the real country roads of Bulgaria, which skirted round the other side of these hills. I passed a big dump of shells which I should think, because of their being so near the villages, the retreating Bulgars had been unable to blow up. This blowing-up of the shell dumps had been on these days of marching, especially the first two nights, a pleasant reminder that the war was possibly ending. When we first saw the sudden distant rosy lightening up of the sky, we wondered what it was and we were told it was the Bulgar shell dumps being destroyed. Along this road the smell was terrible. Two dead Bulgars lay in peculiar positions on the side of the road. I was fond of the

look of Bulgars and I felt sorry to see these. Even swollen as they were, they still look very attractive. I am sure they are wonderful people. Further on was a horse and cart and the driver, all dead and still. The driver was down between the shafts and horse. It was very difficult to breathe with handkerchiefs over our noses in the heat and great dust, so that in order to get enough oxygen for marching we had to bear the smell.

The road bent out away from the hills and began to wander through the country. Whenever we rested I found it so difficult to rise that the men next to me had to put me on my feet. At last they seemed to take a serious view of my condition: I seemed to have become dazed. I hardly realised what was being done to me when I felt a cool, wet sponge been turned about in my mouth, and noticed that the man who had been so exhausted as to be unable for a time to carry out his job as a stretcher-bearer when the Captain was being taken away so that I took a turn at it, was now pouring his own precious water on the sponge and cleaning out my mouth. I tried to persuade him not to but he went on. The Padre then gave his horse up at the request of the MO, who had been walking for some time. And I was laid across the saddle somehow and tried to go to sleep.

I heard a church bell ringing loudly and saw a town before me. As we passed through the town the women and men came out of the houses with jugs of water, for which we were truly grateful. This was Strumnitza. I felt that the blessedness of peace was drawing near. I wished I had been less exhausted, as I longed to talk or show some pleasure at meeting them. But I was pleased to see that the Tommies were apparently behaving very well. I had still some further impudence to put up with from the Colonel, who when I got to the camp and, being on this high horse, could not dismount without assistance, said: 'Who is that, wandering round the camp as if the whole place belonged to him?' But I somehow felt that his day was over. Some men helped me off and, as it had been a rest for me, I felt fairly recovered. So I was detailed off to do some blanket carrying, ten in each bale.

This soon tired me again. While I was doing it I was struck by the appearance of a dark, middle-aged, rather good-looking man. He was, as I seem to remember, stoutish, like a Sergeant Major should be, with large dark, roly eyes and thick, black, bushy eyebrows. I had never seen him before and was a little surprised when he said to me

as I went by him, weighed down by one of these rolls, 'I expect you'd rather be painting, wouldn't you, Spencer?' The man next to me said 'Don't you know who that was?' And I said 'No, never seen him before', to which he replied: 'That's the Regimental Sergeant Major'.

I recollect that and one other singular incident, which I'm tempted to connect with the same Regimental Sergeant Major, which I heard since the war and my return to England: a high official of the Army had cabled for me and sent a message, neither of which I received or heard of. I now ask the 7th Royal Berkshire Regiment why was that message, which came from someone who was said to be at the head of the War Office at that time, not conveyed to me?

I was then taken under some trees and, while I was not really ill, the nursing orderlies thought I should get on one of the stretchers. Finally I was taken off to the nearby row of sheds and I seem to remember in the evening wandering out onto the crest of ground where the sheds were and feeling a little more tranquil.

I think it was from here that it was possible to see two Army corps and the French and the Serbs, all like moving sand, beginning to converge on each other. My memory is dim, except for isolated incidents. I remember being on the lorry being taken back, and thinking 'But where is back now? Surely we may as well continue now, on and on, until we arrive at England?' Macedonia and Salonica seemed only a distant recollection and going back that way seemed like going backwards in time, so much so that as I went further back and we came to Lake Doiran, which I did not see clearly, I felt we were once again drawing near to war because we were drawing near to those old tense experiences of it. I remember stopping at some place which had been a German hospital, but the hospital was crowded out so I had to sleep on the ground outside. I only had my drill clothes and it was cold. I noticed some straw mats were being issued, but I of course was too late. I wandered round, hoping some man might let me share his or just a slip of it at the edge. But no. Then some Serbian soldiers who had the same things beckoned me and slipped me under the edge of theirs.

I dozed off to the comforting babble of these Serbs chatting animatedly to each other: they were obviously more keen on what was taking place in the war situation than the British. They gave me some tea. I woke to find myself being lifted up and I was furious and

said 'Can't you leave me to rest?' and then noticed that certainly one if not both the carriers were officers and red caps. They said not a word but dumped me, as I seem to remember, under a good strong kitchen table in a clean board-floored room, and I seem to remember seeing the Regimental Sergeant Major standing silently in it and remaining there, just looking straight before him out of the open door. The next day I must have been wandering about again, as towards the evening I remember some saying that there were rumours that the Bulgars were counter-attacking, and then others said a lot of us may have to go back, and so on. As they were saying this I must have been getting feverish, as I remember sitting in the sand and starting up, thinking I saw men being lined up, but when I looked they were only some men standing about talking a little way off. Then I began to doze off, and again as I did so I thought I saw them being ordered into line and again had to rouse myself to make sure they weren't. This went on until at last I was taken into a long hut. I remember seeing a square wooden hole with 'Private Sprach' and several exclamation marks over the opening, which seem to be just the shaped opening for a German's head.

I was put on one of the stretchers and then a long night of delirium began. Every time I roused myself I saw the nursing orderly quietly sitting by a table. But the moment I began to doze off I found I was lying bang in the track of a great column of mules, loaded with everything, the clatter of their trappings getting nearer and nearer, and the feeling how can I shift and I'm not ready and we are moving off and hooves and legs are all over me and then struggling and confusion and then there was the orderly sitting peacefully as usual. This went on steadily all night; I think it was dread that caused it. Then at last, in the morning or later the following day, a train suddenly showed itself. I was determined I was not going to drag all my heavy equipment with me and I left all such stuff and resolved that being ill, I would see to it that all my needs were supplied. I was furious at the suggestion of carrying a thing and flatly refused to do so. I was then put in the train and given a comfortable bunk, and there at last I found some real rest. A man in the opposite bunk discussed with me how marvellous it was to once again see a woman (the Sister on the train had just been through): he said he had not seen one for three years.

* * *

The days, as far as I can remember, seem to have been thus:

1st day
March to dump and leave valises, etc. Some part of journey on limber. March down the line to camp, having marched through the night.

2nd day
Arrive in early morning, pitch bivouacs. In afternoon, bathe at baths. In late afternoon pack up and start march back up the line. Remain in supports from midnight until early morning.

3rd day
Start the advance, get across first great plain to line of hills where I am ordered to be shot. Arrive beyond Geogeli and I am on guard in dried-up ditch all night.

4th day
Begin march across second great plain and I am sent off to search for the man not lost. Re-join regiment. Rest most of night.

5th day
No great distance covered at all in daylight. After tea begin march across plain and two mountains. Short rest, then climb up into mountains until midnight at the top.

6th day
After midnight begin to descend into Valley of Bulgaria. Attack in the morning a row of hills and the Captain badly wounded. In evening I guard a dark pit.

7th day
March along country road amidst awful smell. Am put on Padre's horse, arrive at Strumnitza and later camp. Sleep near hospital hut.

8th day
Motor in lorry to German disused hospital and cannot get in. Lying under Serbians' mat until taken into room by officers.

9th day
Don't remember, except getting very muddled. Awful night thinking I am being trampled on by mules.

10th day
Put on train for Salonica. Arrive at a hospital and made comfortable and happy.

I hope these details may show how seriously they have affected my life since that time. Had they been matters I could with safety have dismissed from my mind, I might have done so if I had been able, but I have not yet found it at all safe to forget the nature of the race to which I belong. The matters I have spoken of are by no means bygones and I am sufficiently reminded of the behaviour of men in the war to me by men's behaviour to me now not to need my memory jogged at all on the subject.

I never had any choice or say in the matter of where my services were to be given in the war, and whatever period of time I had in it that happened to be in less dangerous areas was due to pure good fortune and luck.

I was always prepared for anywhere and to do anything I was ordered to do, and I had no say whatever in the matter. Whether or not it would have been more sensible for me to try and 'wangle' a 'cushy' job, all I can say is that I never attempted it.

All I joined for was because I felt that I was enjoying a peace that entailed someone doing some very dirty work for me, and I could not see why they should be expected to, no matter how excellent what I myself was doing might be. And so I did do my own dirty work, and on some occasions, where I found men who had had a harder time in the war than I had, I attempted to do theirs also, by volunteering to take their place when they were ordered into the line. And I did this at a time when I also had had a considerable experience of its terrors.

* * *

3 October 1918
7th Btn Roy. Berks Rgt, Salonica

Dear Flongy dear

I am now in hospital, and I expect only for a few days, with malaria. I have had a very trying time and feel very weak. The irony of it – receiving a letter from Mrs Raverat congratulating me on my 'job' and I was within about two hours starting the move you will know all about from the papers. I still prayed to hear something of the 'job' but I get no letters or anything now. I expect some most important letters have gone west. I can tell you nothing as you know how it is. With Syd it is different. I saw our Colonel about the Ministry of Information, and of course he could do nothing, would be glad to help me if he could you know, and all that, but – oh Flongy, I long for a bit of real, decent society.

I could write to you such a thrilling letter, darling, full of interest and excitement if I was allowed, and much to my own credit, but it is all vainglory, and I long for glory, the Fra Angelico *Gloria*. I long to be, to live. My only life-giver now is my Crashaw and a Tintoretto. How is Gil? I feel very anxious about him; and is Sydney going on alright?[327]

I was glad to know Percy is going on well.

If you should see or write to Mrs Raverat, thank her for her letter and tell her how sorry I was to hear of Maurice Gray's death.[328] I knew him well at the Slade, I read Mrs Raverat's letter by moonlight and directly I finished it I had to tear it up as we were not allowed to carry correspondence, so that I did not get all that she said in it. Let Father and Mother know that I am well. Excuse such a rough letter.

Your loving brother
Stanley

Can you ask the Mi. of Information if they have received my letters?

327 Tragically, Sydney Spencer MC had been killed in France on 24 September 1918, the last casualty in his battalion before the end of the war. His name is recorded on the Cookham War Memorial.

328 Artist Maurice Gray (1889–1918) was a contemporary of Spencer's at the Slade.

* * *

5 October 1918
Field Hospital, Salonica

Dear Desmond

I am in hospital for a few days with malaria, though that has I think cleared off now. I have had a trying time recently and cannot write, my experiences seem to have quite unmanned me, so excuse me and write one of your beautiful long epistles like that last one to cheer me up and take my thoughts. The one and only book I have now is the little Crashaw book you sent me; it has been a continual comfort to me. Send me any little book you think I would like. I like Eric Gill and Douglas Pepler's ideas very much.[329] I would like to read a pamphlet of theirs, or a book. I can get to hear nothing of the job of War Artist that the Ministry of Information proposed for me. I feel very weak. Do write, and forgive me for not writing. Send me a Bible with Apocrypha, could you? If not with, then without.

> With love
> Stanley (Spencer)

* * *

6 October 1918
Capt Henry Lamb RAMC, France

Dear Henry

I am in hospital for a few days with malaria, after some trying experiences. Don't these experiences make you feel awful afterwards? I feel depressed and long for something nice: to do some fine paintings or to read some fine literature or hear grand music. I have had no news at all about the Min. of Inf. job. I am afraid they have forgotten all about it. I have written twice to Yockney. It will be a cruel disappointment to me if I can't do any painting. I suppose you will be having a tough time of it now. Did you meet your friend Kennedy?

I have to do something so I read a book. The book isn't 'solid'

329 Artists Eric Gill (1882–1940) and Douglas Pepler (1878–1951), with Desmond Chute, developed the idea of uniting craftworkers in a religious association during 1919, and formally founded the Guild of Roman Catholic Craftworkers at Ditchling Common on 10 October 1920.

so I begin reading the history of King David, as written in the 1st and 2nd book of Samuel; very fine. I read the Psalms meanwhile. I have my little book of Crashaw's poems still with me. It is awful when it becomes painful to dissipate, when one must either be getting some good stock into the brain or else creating.

I can get to hear nothing of Gilbert. Brother Sydney had shell-shock but has returned to his battalion. Perce (you remember him – with the hair on end) has had a bad wound but is going on alright.

Do you think things are going well? They seem to be. My address is still No. 41812 Pte S. Spencer 'G' Company 7 Btn Royal Berks Regiment Salonica Forces. I feel as weak as a kitten.

With love from
Cookham

* * *

6 October 1918

Dear Jacques and Gwen

I am now in hospital for a few days. I have had some trying experiences which have rather disturbed me but during the actual time I stuck it and did well, I think. I did not like seeing such things and I don't want to again. I feel so weak, and it is awful to feel weak when it is no use feeling so. I received your letter, Gwen, on the side of a hill and had to read it by moonlight, and then a sergeant called out that all letters were to be torn up, so yours was torn carefully into eight pieces and then afterwards I pieced it together as best I could and read it.

I think you are counting my chickens before they are hatched, don't you? Yes, I knew Maurice Gray very well. Oh, it fairly gave me the pip on the side of that hill to read about it. There are some men I don't feel it much when they get killed but Gray was so intimate and so terribly natural (he was nearly as natural as you are Gwen) that makes it hard to conceive. I feel that if God made him an angel, he would not take the job seriously enough.

My desire to get back to painting becomes almost unbearable

at times, and my hope of getting the job proposed by the Min. of Inf. seems hopeless. Cannot you write to Major Bernard Darwin for me, or to anyone you think could help? I have heard absolutely nothing further than just that one letter from the Ministry last April. I get no letters now: I fear Gil is not having an easy time in Egypt. Sydney is back with his battalion.[330] I have only my book of Richard Crashaw poems with me now, but he is a great comfort. Send some little book (not a valuable one) just to give my mind a refresher.

> Your ever loving friend
> Cookham

* * *

10 October 1918
7th Btn Roy. Berks Rgt, Salonica

Dear Flongy dear

I am still 'in dock'. I am going on well though the slightest exertion makes me bad, but I'm having a good rest. I was pleased to be able to help the Capt. of our Company in his need and he did not forget to tell the second in command when he came to him. I hope he will be alright but he is paralysed. It would hearten me so if only I could get to do some painting.

I have just finished reading a biography called *A Revolutionary Princess. Christina Belgiojoso Trivulzio*, by H. Remsen Whitehouse. It gives you a good idea of what an awful thing the Austrian regime must have been to the Italians. The princess was too much of a damned enthusiast, not realising what her enthusiasm might lead to. But the book has made me feel deeply for Italy. Oh that deadly numbing stultifying effect has everywhere been the result of German power and influence. I say German in the case above because it was all Prince Metternich and the Habsburgs' doings and they were under German supervision I think, at least they smell as if they were. This is the sort of smell I mean [drawing]

I saw a notice with over a 'hole' in an enclosure, which 'hole' was exactly the size of this sheet. The 'nodice', a German one, they

330 Stanley was unaware that Sydney was already dead by this date.

are fond of 'nodices' and exclamation marks, said 'Privatsprach' and it made me feel twice as ill: I could seem to see the 'hole' which was square filled by a bespectacled Bosch head, also square.

Of course this Belgioso had her intellectual 'salons' at which one meets Chopin, Rossini, Verdi, Liszt. Then Cavour, who is rather fine, Heinrich Heine, Bellini the composer. The original Heine singled out the timid Bellini as his especial butt, turning into ridicule the 'gaucheries' of the Sicilian genius. Bellini was morbidly superstitious. Aware of this infirmity, the malignant Heine prophesied to Bellini that genius died young and that as such Bellini must expect to quit the scene of his early triumphs at an early date. Bellini got the wind up and died within a week.

Goethe was just such another man as Heine, he did some similar 'acts of kindness'.

I do not know when I shall get any letters now, much love.

Your ever loving brother
Stanley

* * *

10 October 1918
7th Btn Roy. Berks Rgt, Salonica

Dear Flongy dear

I do not know if my writing so often – often for me – is altogether to be commended, for the fact is, I am in bed and have finished the two books the Sister got for me, and in desperation I am having to resort to *Daily Mirrors* and *Punch*, which latter paper I find more than boring, intolerable. That Charivari page in particular. Why do you send your articles to *Punch*? I know there is not much choice. No matter what paper or magazine – literary magazine – you pick up, it is all war articles, war, war, war. O we love it.

So, Flongy, in desperation I write to you; I haven't the slightest idea what about; I know what I won't write about; if this letter remains a blank sheet I will let it retain its virgin purity rather than that. Everything around me bears some sort of relation to that, the

only thing of interest, having no relation to it are my thoughts, and they just now seem like a row of dustbins; but one can find interesting and very nice things in dustbins and incinerators; oh, there it is again, but I was thinking of a time when in poking about for cartwheels and haddocks' eyes I disturbed a whole bevy of unopened tins of bully beef in good condition. The incinerator gave me a feed every night for a fortnight. But I honestly think that looking for treasures on dust heaps where there is not too unpleasant a smell is a distinctly entertaining and elevating pastime. I used to love scrimmaging about on Farmer Hatch's rubbish heap. There I could find beads, pieces of old china with all sorts of painted flowers on them, old books with engravings. I was almost always sure to find something that really satisfied my highest thoughts. You remember that huge Bible I have at home (containing Apocrypha), well Mrs Hatch found that and afterwards gave it to me. Mr Hatch's house was always an undiscovered mine of lovely old things. Oh, dear, to think of those sweet spring afternoons when I would sit up in the front bedroom and with the window open, sit and read out of that big Bible the book of Tobit. The type was so clear and restful and you could lay your arms out and still be holding the book, it was so big. The story of Tobit is so mellow, and the pages were just the right colour, slightly sunburnt round the edges. I have enjoyed reading about David. There are parts that are so Jewish and make one smile. Can't you picture Mephibosheth, who did eat continually at the King's table, and was lame on both feet?

Well, Flongy dear, I have just had my dinner and I do not feel so shaky: the quinine makes my hand unsteady. I get 30 grains a day, ugh! I do hate the stuff, but it is the right stuff for malaria. Well, the sun shines and the sides of the hospital marquee are open, but this morning when it was dark, just before we washed, there was a terrific storm. But we may get a lot more fine weather yet. Last Christmas out here was beautifully warm and for weeks previous to it. The Christmas before was the same. It is generally about Jan., Feb. and March that the bad weather comes out here. I saw out here most beautiful plain in Bulgaria; it was so romantic, and here and there were those tall poplars or 'Lombards'. I lay under some thick-trunked elms, when I was 'sick'. My mind still rejoices in my little book of Crashaw. You ought to get this little book if you have not already got it. It is called

The English Poems of Richard Crashaw. I should love just such a little vol. of Andrew Marvell's poems, but I doubt if it could be got. I used to enjoy reading those poems of Edmund Spenser's in the Oxford Book of English Verse: the one in which the last line of each verse ran:

Weepe sheapherd weepem, to make my under song
And another where the last line in each first went:
Sweet Thames run softly, 'till I end my song.

Oh, dear, I'm sweating on another dose of quinine… Good God, it was a tonic, dark colour, quite good stuff. The patient who brought it to me says 'Here you are, Spencer, a drop of the best'. I quite thought it was going to be quinine. They never give you a sweet tooth suck after taking like they used to at the 4th and 5th Canadian hospitals.

When I come home I mean to learn fresco painting and then, if Jacques Raverat's project holds good,[331] we are going to build a church and the walls will have on them all about Christ.[332] If I don't do this on earth I will do it in heaven. I do not know if you will be able to read this. Let me have news of Gil or any of the boys.

With much love
Your ever loving brother
Stanley

* * *

22 October 1918
7th Btn Roy. Berks Rgt, Salonica

Dear Flongy dear

It is dull without the letters; not your fault darling but mine, if going into hospital is a fault. You see my letters may first have to go to the place where I was before I rejoined the Batt: from thence they have to chase about after the Batt: but when they arrive I have just left for the hospital: so they follow me to the hosp: but when they get there I am gone to some Depot, so off they go again to this depot; but I have left for the GBD.[333] And by the time my letters arrive there I am back

331 This was a scheme for an illustrated edition of the Gospels (to include Eric Gill and Spencer).

332 Jacques wrote to his friend Dudley: 'Meanwhile, we make pictures of the life and death of Christ, against the day when men will build churches once more. Even before this, I hope we may use them for woodcuts in [the] St Matthew or St Luke we mean to print within the next six or eight years' (Frances Spalding, Gwen Raverat: *Friends, Family and Affections*, 2001, p. 205).

333 General Base Depot.

at the battalion. And there is some hope that they may catch me up there. But I always get them through in 'lots' of 14 and 8 and 5. But the news makes me feel that I can breathe more freely somehow; the air seems clearer.

The Padre (who belongs to the Catholic party of the Church of England: bitter enemies of the 'Mod. High' Church of E.), with whom I spent many enjoyable moments while in hospital, wished me to meet the Bishop of London when he visited that hospital. Well, I was discharged yesterday and came to this camp. Last night I looked down onto the hospital and noticed all the patients: a long string of hospital blue, into the large YMCA marquee, and afterwards I understood that the Bishop of London had been and given a speech. I hope when he returns to England you will read or go to hear anything that he has to say about Salonica troops: he will have something to tell you that will interest and perhaps surprise you; it will certainly surprise some people.

I should like to have met the Bishop, but he just came and went. But I cannot seem to fall in with this 'Catholic' party, though the Padre spoke to me and explained it to me and gave me a little book on it.

Cannot get rid of that feeling that the Church of Rome is the only church (except perhaps the Greek orthodox) and any other church is just a pseudo church; a 'got up affair' 'manufactured' void of 'form' and even 'godless'.

Have you read *Marius the Epicurean* by Walter Pater? When I get home I mean to read it again. I have only read about three parts of it and since then my mind keeps going back to it. He explains so clearly the difference between the late pagan life and its joys and the early Christian life: the heaviness and sumptuousness of the pagan and the light 'blithe' spirit of the Christian. The sort of 'Fra Angelico' 'St Francis of Assisi' feeling. The early Christians are like children going to the meadows to pick flowers, and become frantic with delight to find a meadow full of all kinds of flowers and grasses that they hadn't got, and you know what a great feeling that is.

I am 'marking off' passages in the Acts of the Apostles which I mean to make pictures of. The first is Acts 1:10–11, chap. 2:1–4 44–5 chap. 3:1–8, the Apostles all dreamily gazing upwards and the two angels standing on the ground gazing at them. The next one I hope to be capable of doing. The next (44–45) all the good men

doing good in different ways, all in one picture. The next must be done.

23rd
I have just got my winter slacks, in exchange for my summer shorts. I hope I have said goodbye to shorts. The feeling I have about the C of E is that it is 'formal' and entirely void of 'form'. It is not 'conceived' as all form is, the conception of the Holy Ghost, but it is a sort of judicious 'hash-up' of different miscellaneous prayers and offices, and the most feeble, gutless hymns. To hear a dull hymn sung after singing a psalm is to me like putting a top hat on the head of a saint: it is vile. I can't think of anything more void of inspiration, more 'forced' in their composition, or rather manufacture, than the collects of the C of E.

24th
Must go on writing this letter as I have no envelope. My letters must seem awfully dull, Flongy dear, but you must by now know the reason for their dullness. To think of the wonderful experience I have had out here, all the inspiring scenes that I have seen, about which I have been able to say nothing. I wish I could get to know how Gil is, how his 'war' life has affected him. I think in spite of his saying that all his feelings for painting would be crushed, that he will be feeling more of an artist than ever, the same as I am feeling. I do not feel as if my life has begun: not my real life. I am getting ready to live: going through a sort of purgatorial schooling. But hope is stronger in me now than ever it was; to be poetic.

Crashaw says in his poem on hope:

Thy generous wine with age grows strong, not sour

And in the next verse he says:

… above the world's low wars hope walks and kicks the curl'd heads of conspiring stars

25th
It is raining, as an elderly man persists in walking up and down the

marquee, kicking his heels with each step and whistling all the time, I expect he has been 'put on' the 'Y' scheme.[334]

Some marquees on the opposite hill look quaint and, as the Padre said to me when I was pointing to them, 'they look almost Chinese'. He has been in China a lot. These marquees are white and in the early evening as the sun is setting and the moon rising opposite from behind the hill behind, the marquees look a delicate pink. Immediately behind the marquees are deep, deep, almost black – warm black – green trees shrubs and poplars, the Lombardy kind, and behind the trees a rocky hill or mount which appears phantastic: a light mauve colour and above that the full moon which – the sunset still giving that peculiar twilight that we get out here – is surrounded by a halo which is a daffodil yellow colour, and the moon itself is a lovely silvery yellow. Nothing could look more romantic, just as if it was taken out of some fairytale. There is a temple in Salonica surrounded with these mysterious firs, poplars and yews. The dome of the temple is all one can see and when passing you can see the doorway between the trunks of the trees. Strumnitza is the most romantic looking place I ever saw.

<div align="center">∗ ∗ ∗</div>

I have managed to send off a letter to Pa and Ma, having been issued with ONE green envelope. Tomorrow is payday, and then I hope to be able to get some envelopes from the canteen. Since last August it has not been possible for me to get any 'dough' – pay – though something else kept me, as well as a good many others, from realising the painful fact that we were broke. But now that I am once more in the land flowing with EFCs[335] and YMs the strain is something orful.

I felt so lonely last night when I passed a huge canteen queue and did not enter it: but tomorrow, tomorrow is the day. We have just received an extraordinary good bit of news; and it was given out as 'official' but I will wait and see what the *Balkan News* has to say tomorrow.

But I hope we do not release the grip we have just now on the German, before her power to retaliate is exhausted. It is just in things like these that the most fatal blunders can be made.

Well, Flongy dear, I must leave the world and what is happening

334 War Office scheme to place malarial men in a temporary Army Reserve category (rather than removing them from service altogether).

335 Expeditionary Force Canteens.

in it until I finish this 'yer' letter – though the world is every day getting nearer to the kingdom of heaven – and think about high art. Christ was a great artist. Glover in his book does not seem to think so. It is peculiar why Glover's 'artistic outlook' should be so narrow, because in his book he shows you most clearly how great a lover of art Christ was. Take anything that Christ said and put it in another part of the Gospel; for instance, take the answer that Christ gave to Martha when she said: 'I know that he shall rise again in the resurrection at the last day'. And read them, say, in the Sermon on the Mount, and see if his answer comes with the same fresh crisp meaning as it does when it comes immediately after Martha's words.

As I pointed out to Pa in my letter to him, that outburst of triumphant joy that comes from Christ when the 70 return and tell him that even the devils are subject to them, 'I beheld Satan as lightening fall from heaven', and later how 'in that hour' Jesus 'rejoiced in the spirit'; it is the true Artist rejoicing in his work.

I am afraid that I am too strong a Christian to speak on these matters: I mean that to me the 'whole' of art is Christ, and that, according to many, would exclude all pagan art because it came before the Christian era. Christ preached the gospel of art; his words and acts are an exposition of the three great laws of art: Charity, Faith and Love.

Early Egyptian art or clearly Greek art is very great, but it is all unconscious. Christian art lacks something of the guts of Egyptian or Greek art: it seems little and mean in proportion, especially when one thinks of some primitive Italian master and then to think that Praxiteles, that great Greek sculptor, has said his last word: Christ has not yet said his first word. I do not know how you are enjoying this, darling; I have just had a bottle of stout ('start', a Londoner next to me calls it). I get it three times a week. I am getting a tonic in this camp as well.

You see, the MO inspected us and those that wanted strengthening he 'put on' stout. I do not like it, but I try to drink it as I must get strong. Sgt Day out of our Company of the Berks, who came down the line to the same hospital as I came to, met me today in this camp. He is a young, biggish chap with black hair and a very white face. He said when he met me today that I looked properly

done when I collapsed before we got to ———— [censored]: but I could have carried on if I could have had my equipment carried, but as it is I was put on a horse and rode in grand style for the last four kilometres before I came down the line.

But the news makes me feel as if I had had more than my share of stout. I can see the war ending before Christmas, and then, oh then… Every now and then a marquee of men set up, cheering apropos of nothing: we are all tapped but I must close this letter and do my share of the cheering, so cheerio darlin'.

Your ever loving brother
Stanley

* * *

23 October 1918
7th Battalion Royal Berkshire Regiment, Salonica

Dear Father and Mother

I am waiting and waiting and waiting to get my shorts changed for a pair of slacks. As each man emerges from the marquee doors 'changed', his appearance causes a sensation. When I come out I shall cause an incident. The pair deposited will be the shortest they have.

I understand that the Bishop of London said many complimentary things about the British Salonica forces, today the *Balkan News* published an article out of the 'weekly dispatch' which was gratifying to read, a very good article. It is time something nice was said about us in England. We have had to 'perform' before an unappreciative audience: this has not been heartening, then we have ignored it. I shall be safe now for a long time, so do not worry about me. I am down at the base and that is about 100 miles from the line I should think; it seems about 500 miles away to me.

The Bishop of London came to hospital the day after I left, or rather the evening of the same day.

Oct 28th

And now that I have in my possession an envelope, I will add a little, though there is little to relate. We are having rain and rather cold winds. I am recuperating my strength every day, and with my feeling stronger I feel in better spirits.

I am afraid my letters must make very dull reading, but in a camp at the base one is rather cramped and society is not always choice, though nearly always interesting.

Lionel Budden, whom I met at Bristol, and you remember I lost sight of soon after I got off the boat out here, was the only 'pal' I ever had in the Army. Since I lost him I have been silent. My conversation is reduced to 'yea' and 'nay'. Not that I am unsociable, but I feel like Gulliver when he visited the Huodonymns[336] or being with some such name as that. They were the horses that were very superior and regarded Gulliver as curiosity. Not that these, my comrades, are like unto these horses, which are very learned and dignified philosophers, but in the way they regard me, they are. I feel estranged from them. They like cigarettes: I hate them (but I do not begrudge it them in the least). They like beer and rum: I hate it. They like sports: I loathe them in the spirit in which they are enjoyed. They like smart modern novels: I never under any consideration read them. I have made their acquaintance. They do not like Dickens and have never heard of Meredith and Hardy. Their knowledge of art extends no further than the 'Picture Palace'. I find Indians more intelligent. Serbs seem to have more active brains. But what is a mystery to me is, if I can enter into these men's little interests and hopes, why can't they enter into mine?

I read the Testament nearly all day, and because I do so, they presume I must be one of those priggish 'holy' sort, whereas in many things I have paganistic sentiments. I read the Testament as I would read Dante.

Of course it is foolishness to expect anything more from men who have not had, as they should have had, a decent education, when one has lived in it for three years and over, it taxes one's patience. If I were to speak to these men as I would to a friend he would think I had the Balkan tap properly. So it is that I have in my conversation to remain silent, and in my letters speak of the things that really interest me.

336 Houyhnhnms – *Gulliver's Travels* part IV, by Jonathan Swift.

I am longing for letters from you both, I expect there are several but out here held up until they can find out where I am. The war is coming to an end and that very soon, I feel sure, and don't forget when we come home to have the old clothes horse airing the sheets by the kitchen fire.

Your ever loving son
Stanley

* * *

October/November 1918
Field Hospital, Salonica

Dear Desmond

I am still in hospital with malaria but I am a bit better, though I feel very weak.

In some of the awful moments I have felt the need for greater faith, and afterwards I found myself asking the question: Christ has been adequate to me in all things, but is he in this? You must know something of what I mean, Desmond. It is an awful shock to find how little my faith has stood in my stead to help me.

I have just read the life of King David as written in Samuel. I am slowly and with great joy reading the Psalms. I wish I had my great big Bible, which I have at home, containing the Apocrypha and a lot of old steel engravings. It is about three times the length of this half-sheet and about three times the width of it. Isn't a big Bible grand?

Jacques Raverat (a great friend of Eric Gill's) has an old edition of Milton's *Paradise Lost*. It is great book and Jacques reads in a great voice. 'In something combustion down to bottomless perdition, there to dwell in adamantine chains and penal fire.'[337] I wish I could remember these Milton's lines better. Aren't his words wonderful: 'careering' wheels of the chariot.

I shall always be grateful to you for having sent me the little book of Crashaw. It has been my great stay and comfort. I can't feel that he is as sublime as Milton, yet he is more delicate and tender, and more sincere; that is, he feels a thing more nearly, more personally.

337 *Paradise Lost*, Book I, lines 44–8. The lines begin (in place of 'In something'): 'With hideous ruin and combustion…'.

But Milton is so great in stature, but perhaps only because he wrote an heroic epic.

> With much love, your loving friend
> Stanley

Send me any little thing to read. Do send me some of St Augustine.

<p style="text-align:center">* * *</p>

7 November 1918

Dear Jacques and Gwen

I am still at a convalescent camp. It is Sunday afternoon and even out here one does not escape its awful influence. An ordinary Englishman is a dull-looking object when compared with a Serb or a Frenchman. An Englishman if he is not washing himself is shaving, if not shaving he is blacking his boots, and if not that he is cleaning his buttons or putting his puttees on, or combing his hair down the middle; this last drives me to distraction and makes me want to shout at them 'when are you going to think?' The Englishman's ambition is to look and be 'smart' – pah! If you want to see the picture of smartness you have only to walk down the hill to the latrines opposite to where I am sitting and have a look at the Military Police on duty there; I can see their polished buttons shining in the sunlight from here.

My brain feels just like that MP's brain. I feel absolutely hopeless about doing any drawing. When I see mountains I have to climb them and I become exhausted and curse them and am in no condition to do any drawing of them. Everything is so damned harassing. There have been many places where I badly wanted to stop and draw, but if you had seen me at those times you would have seen a walking mound of dust. When I sweat the hair on my knees sticks out and the dust clings to it and makes it look like a Cornfield, very pretty. The men that have moustaches and thick eyebrows look most peculiar. I am being given stout, and I try to drink it as I hope it may make me feel stronger. It's quite a new sensation to me, this pouring stout from a drunken-looking bottle into a mug. It makes

me feel kind of reckless. My knees have been bad; I tore them about in hedges at the line, not getting a chance to turn the flaps of my shorts down. I did not notice until afterwards and they healed up. Then they broke out in septic sores and I had them seen to. They are now also all healed.

Do send me *Crime and Punishment*: I want to read it again. I get to hear nothing of Gil. I have not had one letter since August.

With love from
Cookham

* * *

17 November 1918
On active service

Dear Jacques and Gwen

I have just had a letter from Gil. He is still at the base training. The letter is dated 28th Sept. 1918. He is fed up with training and says that in Cairo he felt just like being in a dead city: 'the people, chiefly gaunt, stiff-necked Egyptians, seemed like moving corpses, I think they probably hate us, but not so much as I hate them and their damned faith.' Later he says: 'one day I went into their finest mosque. It was built in 1100 by the first Sultan of Egypt. It is a marvellous building all of pure alabaster. Inside it is just a bare floor covered with a huge Turkish carpet. The ceiling, which is a dome, is all of mosaic of brilliant stones and gold. There is a gallery all the way round, all of alabaster, where the ladies of the harem worship as they are not allowed to mix with the men. In one corner is the pulpit, all handcarved wood of the Cedars of Lebanon. At night it is all lit up with four thousand lamps, which makes it all transparent.' It must be a wonderful building even though I think it would give me the creeps.

* * *

It was not until about 1936 that Stanley wrote the following reflections on his experiences during the First World War, and in particular his treatment in the Army.

WAR AND THE ARMY

Of course Colonels and Army men and their wives are forever talking war talk and inciting and bullying everybody to prepare for war. It's the only time in their lives when (as they think) when they are not nonentities and when they can have and enjoy and achieve the ambition of their lives. With characteristic egotism, they are completely indifferent to the needs of classes of people other than themselves. And that such a person as myself is forced to sacrifice my more worthy and less selfish ambition is a thing that matters less than nothing to them.

Their physical powers and the effect of the alarmist propaganda (which is their most effective instrument), in its appeal to vast hordes of humanity, distorts these people's sense of proportion as to their own importance, and it needs to be pointed out that while the question of the rightness or wrongness of war may remain, it is certain and proper that in this life it is not, and neither should it ever be, the business or duty, let alone the occupation, of everybody to be forever considering what is the most efficient way to damage and destroy each other. I will make it emphatically clear that whatever may happen in the near future that may show signs of interfering with me in the execution of my work will be forced and obliged to respect me in my capacity. The last war was exploited and used as a means of abusing people in their professions so as to be able to give vent to their jealousy of distinguished persons. Professions (such as mine) did not (AS THEY THOUGHT) serve in any way the immediate needs of the country.

Everyone knows, and everyone experienced, the leg-up the war gave to the anti-intellectual prejudice. It is not to be supposed that the crucial services my painting does for the world would be perceptible to the ordinary run of people. Nothing I did occasioned, excused or laid me open to the kind of treatment that I was subjected to during the war. The fact that I was in it is no reason to suppose that I should have expected such treatment. I don't expect to be, nor will I ever tolerate being, ill treated under any circumstances.

I shall continue to try to get redress for what I then went through, no matter what present circumstances may bring.

If a war comes now, I shall, while this village itself is being attacked, be still wanting and insisting on an explanation of the behaviour of British officers to me during the years 1915 to 1919.

Any sort of prevailing circumstances are used in attempts to cover up and obliterate and override past circumstances. But I have a great capacity for preserving the freshness of matters which others would gladly see in oblivion, and when the terrors of a war which might come in a few months are forgotten, the least and smallest complaint I am making will be forever remembered. The thing which remains is the thing that has signification.

Of course other people in other callings than mine have not the dislike I have for war or anything like it. If they lived in the true spiritual human life I lived, if they were the model of essential humanness I am (I mean of what it should be), they would know as I know that they are all but in fact living a militarist life. They have virtually no sacrifice to make in a war because what they now do is practically war work.

EFFECT OF WAR TREATMENT

As far as what is significant to me in this life, the matters I am about to discuss have themselves no significance whatever. But they have affected me in different ways in my work, and in that sense might explain to some degree some of the changes that have taken place in it. Also, it seems to be in the minds of many people that war, for instance, can excuse anything and so a whole lot of irresponsible and bad behaviour is glossed over.

Then there are others, especially a lot of the men and officers who were in it, who try in vain to shame me into silence on the subject, by saying pompously and sensationally: 'Such matters are a closed book', etc. Are they? Then I will open it. I hope I shall have the honour of performing the opening ceremony of this book. It seems to be the prevailing idea among the Army authorities down to NCOs that there is no check on a species of bad behaviour, the nature of which I shall speak about. In their behaviour to me they seem to have depended far too much on the book remaining forever closed.

To this day, when I see certain types and natures of Englishmen I can sympathise up to a point with a woman who has been attacked by one. I can so vividly see what the acts and looks men give me today would have quickly become, and those acts and looks occurred in Macedonia in 1918. Only because their power over my conduct has been temporarily taken away from them have they altered in their demeanour to me, and also because I have since that time been able to avoid almost entirely their society. I have felt it necessary since the war to remain on guard against men's personal jealousy and pique against my wellbeing, and I have been able to do so more effectually than I was able to do during the war.

When I complain of the treatment that was meted out to me during the war I am at once met with some such remark as 'You're not the only one'. I will say this: 'No, I am possibly not the only one, but I claim the distinction of being one of the few, if not the only one, with the sense enough to complain. Insofar as I suffered two minutes of unhappiness as a result of the behaviour of officers and NCOs, I shall complain.' If they imagine that under the cloak of the need in a war for discipline being maintained they are going to escape from me, they are not. Quite apart from the war, these men merely wished to be rude and impertinent to me personally, and saw that they had an excellent opportunity for being so.

I discount any excuse that might be brought forward and which is usually put forward. The reason why in the Burghclere Memorial I have avoided any too unpleasant scenes is not because I had any jot of respect for the 'closed book' school, but because in this scheme, as in all my painting, I wish always to stress my own redemption from all that I have been made to suffer.

Index

All works are by Stanley Spencer unless otherwise stated.
Numbers in *italics* refer to illustrations.

Acknowledgements

Stanley Spencer, my grandfather, was a prolific artist. He had to paint. He also had to write, a lot.

Thank you to my aunt, Shirin, and Unity, my mother, for trusting me with editing their father's autobiography. Shirin worked on Stanley's writings and read extracts to him during the last months of his life. She was unable to complete and publish this work after his death in 1959. Shirin is now truly happy to see *Looking to Heaven*, the first volume of her father's autobiography, in print.

Shirin, Unity and I thank:

Harriet Bridgeman (Bridgeman Images), the catalyst for all we do. Carolyn Leder, whom we consulted for her encyclopedic knowledge of Stanley Spencer. We are forever grateful.

Thank you Jo-Anne Fraser for transcribing; Robert Upstone for advice and support; Johanna Stephenson, our Project Editor. 'John and I have got you the best editor for this project': Ian Strathcarron, 2014. Ian was right. Thank you Ian Strathcarron, Lucy Duckworth and everyone at Unicorn Publishing Group; Ray Watkins; Adrian Glew, Tate Archive, and his patient team; and Jon Snow, a champion of Stanley's.

Many people lovingly continue to look after Stanley Spencer's legacy: Tate Britain; The National Trust, Sandham Memorial Chapel, Burghclere; Bridgeman Images; and The Stanley Spencer Gallery, Cookham.

It is a pleasure and a privilege to work with you all.

John Spencer

Picture Credits

Every effort has been made to trace the copyright holders and to obtain their permission for the use of copyright material. The publisher apologises for any errors or omissions in the list below and would be grateful if notified of any corrections that should be incorporated in future reprints or editions of this book.

© The Estate of Stanley Spencer. Photo © Tate: pages 3, 12, 71, 77, 127
© The Estate of Stanley Spencer. Photo Bridgeman Images: pages 50, 64, 152, 159